THE SCULPTURE OF
NANNI DI BANCO

MARY BERGSTEIN

PRINCETON UNIVERSITY PRESS

PRINCETON, NEW JERSEY

Frontispiece: *Assumption of the Virgin* (cat. 1-12, detail),
1414–22. Santa Maria del Fiore, Florence

Published by Princeton University Press
41 William Street
Princeton, New Jersey 08540

In the United Kingdom:
Princeton University Press
Chichester, West Sussex

www.pup.princeton.edu

Designed by Diane Gottardi
Typeset by Sam Potts
Printed by South China Printing

Printed in Hong Kong
10 9 8 7 6 5 4 3 2 1

Library of Congress Cataloging-in-Publication Data
Bergstein, Mary.
 The sculpture of Nanni di Banco / Mary Bergstein.
 p. cm.
 Includes bibliographical references and index.
 ISBN 0-691-00982-1 (cloth : alk. paper)
 1. Nanni di Banco, ca. 1375–1421. 2. Sculptors—
 Italy—Biography. I. Nanni di Banco, ca. 1375–1421.
 II. Title.
 NB623.N3 B47 2000
 730'.92—dc21 99-047383
 CIP

THE SCULPTURE OF
NANNI DI BANCO

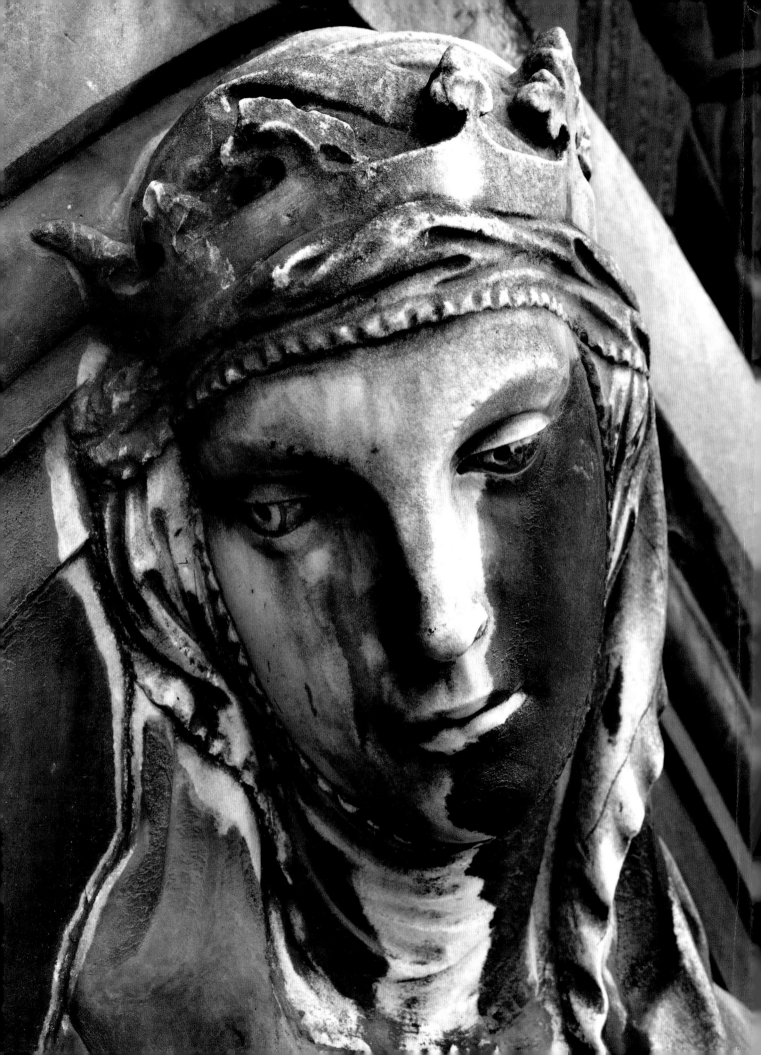

For Norberto,
Ego valeo si tu vales

CONTENTS

ACKNOWLEDGMENTS

Most of the research for this book was done in Florence at the Kunsthistorisches Institut, the Archivio di Stato, and the Archivio dell'Opera del Duomo. I am extremely grateful to the staffs of these institutions for their assistance. I have also relied upon the libraries of Columbia University, Princeton University, Brown University, and the Marian Library at the University of Dayton.

The research and writing of this book were facilitated by grants from Columbia University, the Whiting Foundation, University Faculty Research Grants and the William Hallum Tuck Memorial Grant at Princeton University. Many of the photographs were purchased for me by the Spears Fund at Princeton University and the Humanities Fund and Faculty Development Grants at the Rhode Island School of Design.

From the very start of this project, I have benefited from the kind interest of many scholars and colleagues; among those to be thanked individually are Gabriella Battista, Janet Cox-Rearick, Aldo Galli, Ralph Lieberman, Margrit Lisner, Enrica Neri-Lusanna, John T. Paoletti, David Rosand, Pietro Scarpa, Anne M. Schulz, Maria Sframeli, Marica Tacconi, and Mons. Timothy Verdon. I would like to express my appreciation to Patricia Fidler, Curtis Scott, and Ken Wong at Princeton University Press for having guided this book to publication. I am also grateful to Diane Gottardi for the book's elegant design and to Kathleen Friello, who prepared the index.

Throughout the course of this project Margaret Haines has provided a great deal of encouragement, knowledge, and rich historical insight. Diane Finiello Zervas has also shared information and ideas with me in a most generous way. I am particularly indebted to James Beck, who sponsored this project as a dissertation and who has been a most valuable advisor and friend.

The Sculpture of
Nanni di Banco

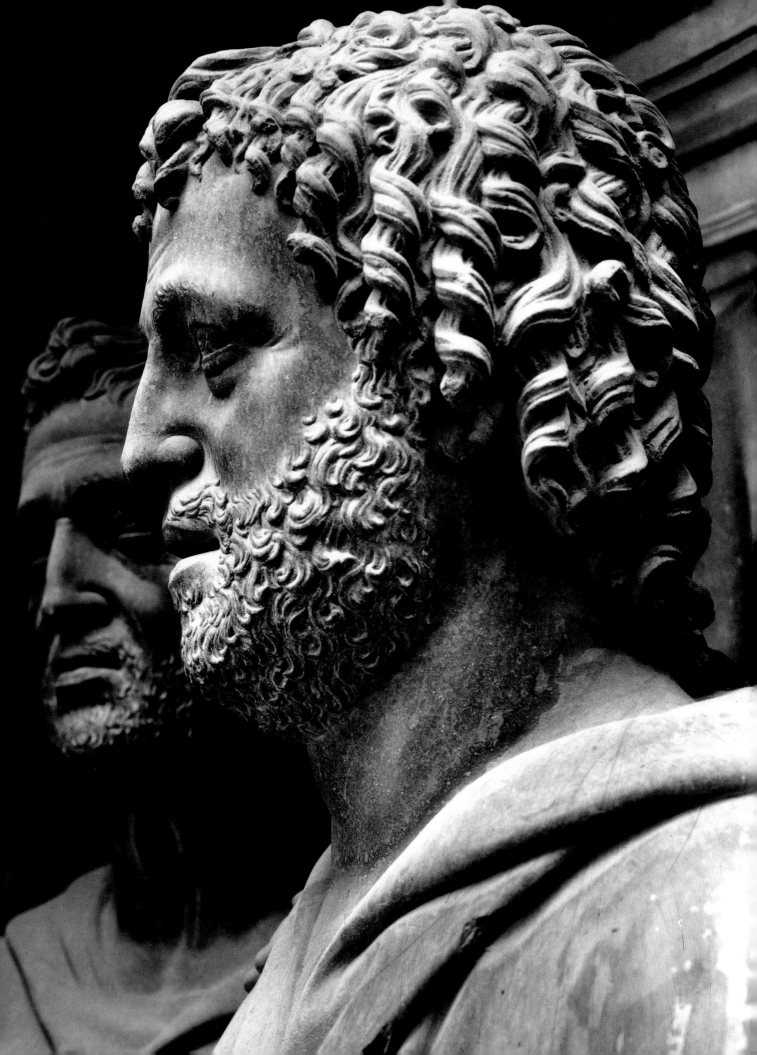

INTRODUCTION

Nanni di Banco (ca. 1374–1421) created an imposing body of sculpture that in many ways determined the course of Renaissance art in Florence. All of his known works were public commissions in which the human figure played a primary role, including the strongly classicizing *Quattro Santi Coronati*, which he produced for his own guild at the church of Orsanmichele. At a time when the early humanists characterized virtue in terms of friendship and *patria*, Nanni's sculpture expressed a gravitas of character as well as physical presence, nuanced by a profound awareness of human mortality (fig. 1). His approach to immortality, on the other hand, in works like the *Assumption of the Virgin* at Santa Maria del Fiore, was imaginative and transcendental, seeking to link the spiritual concerns of the city-state with those of the entire Christian cosmos (fig. 2).

Nanni di Banco's major works, including those made for the "middle guilds" at Orsanmichele — the *Quattro Coronati*, the *Saint Philip*, and the *Saint Eligius* — as well as the seated *Saint Luke Evangelist* and the *Assumption of the Virgin* for the Florentine cathedral, were made within a span of about thirteen years. These were the years in which he, together

Fig. 1. Nanni di Banco, *Quattro Santi Coronati* (cat. 1-6, detail), ca. 1409–16/17. Marble. Orsanmichele, Florence

with Ghiberti, Brunelleschi, and Donatello, self-consciously and deliberately set into motion the issues that would occupy painters, sculptors, and architects throughout the fifteenth and sixteenth centuries in Italy. Nanni di Banco was a protagonist among protagonists in an age of great invention, and his interactions with individuals such as Brunelleschi, Donatello, and Lorenzo Ridolfi were richly productive in the historical process.

There need be no apology for a book-length study of such an artist: this volume consists of five introductory chapters, which address Nanni di Banco's life and works thematically, followed by a catalogue raisonné of authentic and attributed works, and a register of documents. In 1936 the noted historian of Florentine sculpture Ulrich Middeldorf took the opportunity "to protest solemnly against the ascriptions of the most various and often insignificant works to the great artist Nanni di Banco." In this spirit and after much consideration I chose not to deal with far-fetched attributions (e.g., two drawings at Chatsworth; a statue of *Minerva* at the Biblioteca Marucelliana) because discussion of these works would be of no value in defining the artistic character, surrounding ambience, or historiography of Nanni di Banco's sculpture. Spurious attributions

Fig. 2. Nanni di Banco, *Assumption of the Virgin* (cat. 1-12, detail), 1414–22. Marble and granite. Santa Maria del Fiore, Florence

such as the mysterious pair of "Annunciation" statues in the Museo dell'Opera del Duomo, are taken up in the catalogue insofar as they relate to the art of Nanni di Banco.

Several twentieth-century scholars have written on the sculpture of Nanni di Banco with passion and insight. Perhaps foremost among them was Giulia Brunetti, who in several articles (beginning in 1930) attempted to place the life and works of Nanni in historical context with some precision. Since Brunetti was prolific on the topic of Florentine sculpture until her death in the early 1980s, her many articles and catalogue entries represent a great contribution to the study of this period, almost all of which is at least tangentially pertinent to this book. Jenö Lányi (1935, 1936, 1937) provided a "missing link" in Nanni di Banco's art by identifying the *Isaiah* in the Cathedral of Florence as Nanni's lost buttress figure of 1408, and clarified the attributions of other pertinent works as well; Lányi's observations have great validity. Paolo Vaccarino's monograph entitled *Nanni* (1950) was the first book to discuss Nanni's oeuvre in its entirety, to publish an extensive photographic documentation of the works with photographs produced

by Brogi, and to probe the artistic personality of the sculptor even at the risk of championing his art for its nobility and restraint. H. W. Janson, who is best known for his Donatello monograph of 1957 (many times reprinted), explored the visual and iconographic importance of Nanni's *Assumption of the Virgin* in an important essay in 1963. Manfred Wundram sought to analyze and reevaluate the relationship between Donatello and Nanni di Banco (1969), resulting in an exhaustive book-length study entitled *Donatello und Nanni di Banco*. Luciano Bellosi's brief monographic essay published in the "Maestri di scultura" paperback series (*Nanni di Banco*, 1966), accompanied by several color illustrations, remains, in my view, the most elegant introduction to Nanni di Banco and his place in history.

Art historians such as Lányi, Vaccarino, and Wundram have attempted to redress Nanni's eccentric *fortuna critica* and his relation with other artists, especially Donatello. Nanni's career as a sculptor was inextricably interwoven with that of Donatello, and so have been his critical fortunes. In the long run Nanni has come away with faint praise, profiled in general art history surveys as a traditional stonecarver who took up a kind of verbatim archaeology of classical forms in statuary, but lacked the overarching sense of pragmatic imagination that made Florentine artists genuinely original. This *fortuna critica* began with Giorgio Vasari, who cast Nanni as a lackluster foil for Donatello, his younger, greater, more versatile, and worldly colleague. Vasari put the words in Donatello's own mouth: "This poor man is not as talented as I." Vasari's literary method, based on *paragone*, or comparison, was designed to elevate Donatello as an evolutionary prototype for Michelangelo, who in Vasari's historical view was the most evolved of all Renaissance artists. This literary technique has become transparent to us, and so Vasari's critique of Nanni di Banco can be evaluated according to its own terms, i.e., taken with a grain of salt. What remains problematic in an analysis of Nanni di Banco's work is the phenomenon of Donatello himself, who not only outlived Nanni di Banco by almost forty years, but outdistanced almost all figurative artists of his epoch. In the history of art Donatello obviously means far more than a stepping-stone to the "High Renaissance" per Vasari's schema. From a twenty-first-century perspective, it appears that Donatello transcended material limits to become the most communicative artist of the fifteenth century. In order to understand Donatello's strengths in such a way that they do not diminish Nanni di Banco retrospec-

tively, Donatello's early career must be seen in historical terms. Donatello was in the right place at the right time: his was an artistic personality that took root in the ambience that he inhabited together with Nanni di Banco, Ghiberti, Brunelleschi, and Masaccio in the opening decades of the century. Therefore Nanni di Banco need not be studied in the shadow of Donatello, nor does his work need to be brought forth with an *apologia*, or championed for its "innate nobility," as opposed to Donatello's reckless expressionism. Rather, the relation of give and take between Nanni di Banco and Donatello should be seen as one of extreme fecundity, an intellectual exchange to be opened up and explored, rather than to be seen in terms of qualitative *paragone*. I have attempted to do this in the chapters and catalogues of this study.

In a recent critique of traditional art history, Donald Preziosi (1989) has pointed to a Vasarian "auteurist ideology" in the discipline. According to Preziosi, Giorgio Vasari's biographical matrix ("the-man-*as*-his-work") is a formula that is reinforced with every art-historical monograph, the inevitable result being a "tedious Michelangelism." There is no question that this book is a monograph — a monograph that leans heavily on biography and even points to Michelangelo as the ultimate heir to some of the ideas initiated by Nanni di Banco and his corporate patrons. But I hope that biography need not conform to a prescribed intellectual collusion between the author and the biographical subject. Nor is biography bound to serve as a reductive lionizing of a particular artist or patron. This is one reason why I have chosen to address Nanni di Banco's life according to the method of what cultural anthropologists call "thick description." My description of the infrastructure of the Albizzi-dominated agency of the Opera del Duomo and the mechanisms of electoral and guild politics is designed to depart from biography of the narrowly structured "man-*as*-his-work" kind, and to examine a multigenerational family of stonemasons and their fortunes in a guild-driven oligarchy. I have done this not simply for the sake of microhistory (although that, too, would be valid), but rather because I am firmly convinced, as Clifford Geertz suggests, that art and the ability to understand it are made in the same shop. The more we know about workshop production in the literal sense, including patronage, workshop hierarchies, the acquisition of materials, and the awarding of commissions, the more we understand the objects. But it is also important to approach the "work-

shop" in the figurative sense, in terms of what Michael Baxandall (1972) has called "the period eye," or an integral close view of the whole society in order to be primed for an historical apprehension of the works of art.

This book is unapologetic in its orientation as a social history of art. In the past two decades, art historians such as Norman Bryson, Michael Ann Holly, and Keith Moxey (1994) have articulated the stance that visual art does not merely reflect, illustrate, or synthesize sets of ideas already verbalized and enacted in a particular society, but rather that visual images and monuments have agency and impact of their own. Works of art, be they made for public or private use, generate meaning and thus contribute directly to social and historical processes. The work of art is therefore not merely the aesthetic "end product" of a society any more than a written manifesto, for instance, or a system of taxation, is. Visual images play an active role in the social ethos and cultural formation of any society, but this was particularly true of the Italian Renaissance, where great numbers of works of art were commissioned, made, and consumed.

Specialists on Renaissance Florence, including Gene Brucker, Dale Kent, and John Najemy, have stressed the importance of the network of support systems including family, guild, neighborhood, and political affiliations for the protection and advancement of men of the enfranchised classes who steered cultural life. Jacqueline Gutwirth recently summarized the position of these scholars, stating: "Not the severing of ties, but their multiplication was the condition most devoutly to be wished. In short, connection was all, and the individual, even the most prodigiously talented, with neither family nor powerful allies to advance his cause, would find ambition cold comfort indeed."[1]

Throughout her writings Margaret Haines has demonstrated the role of established organizations and consensual bureaucracy in the public patronage of architecture and art in Florence. Corporate patronage was steered by a system of competition and consensus: this was the ambience, as demonstrated by Haines, in which some of the most inventive minds of the early fifteenth century flourished. It is not to diminish the achievements of Nanni di Banco, therefore, but to better understand them, that I have attempted to trace the ways in which the corporate and political activity of Nanni and his family demonstrates their firmly consolidated position in a minor guild establishment for which the primary corporate and professional locus was the Albizzi-dominated Opera del Duomo.

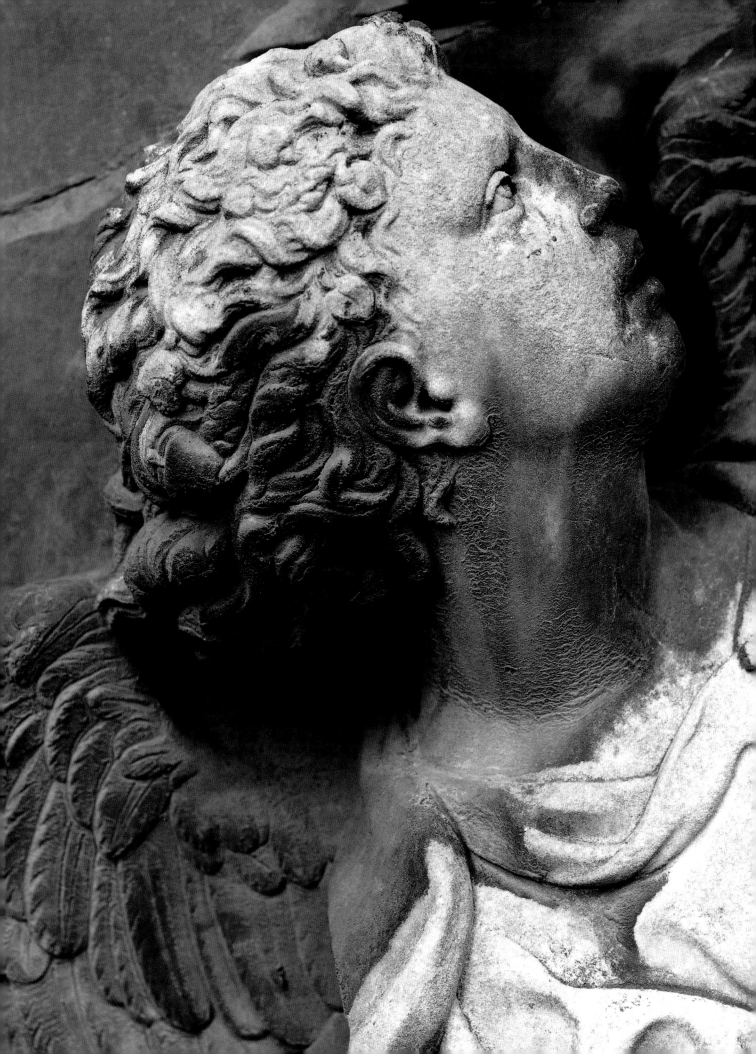

1 . THE WORKSHOP

IN THE PAST, AND ESPECIALLY IN MORE RECENT TIMES, THE CITY OF
FLORENCE HAS HAD MANY MEN OF A BEGUILING AND AMUSING SORT.
[. . .] THESE MEN WERE FROM THE GOVERNING CLASS AND FROM AMONG
THE MASTERS OF THE MORE INTELLECTUAL AND IMAGINATIVE OF THE
CRAFTS, SUCH AS PAINTERS, GOLDSMITHS, SCULPTORS, WOODCARVERS,
AND THE LIKE.

—*Antonio di Tuccio Manetti*

NANNI DI BANCO produced some of the most important public sculpture of the Florentine Renaissance. His topics ranged from the corporate ethos of the guild-driven commune to the purifying nature of the Virgin Mary. Personal, political, and cultural experiences merge seamlessly in his art to produce complex representations that appear to be normative and visually irreducible. This synthesis was possible because Nanni di Banco was a person extraordinarily well integrated with his historical time and place. Far from being an outsider, Nanni's seemingly unconflicted life experience was at the very heart of the public monuments he created. If art and the ability to understand it are truly made in the same shop, we may understand Nanni di Banco's sculpture by looking at his personal development in the living cultural "workshop" of Florentine society around the beginning of the fifteenth century.

Vasari claimed that as heir to a wealthy patrimony Nanni di Banco practiced sculpture for love of the art rather than the trade of his livelihood.[1] In fact, the situation was quite opposite. Nanni's people were neither wealthy nor aristocratic, but rather a family of prosperous artisans residing in the area of the Borgo Allegri near the church of San-

Nanni di Banco, *Assumption of the Virgin* (cat. 1-12, detail), 1414–22. Marble and granite. Santa Maria del Fiore, Florence

t'Ambrogio.[2] Giovanni d'Antonio di Banco (Nanni) was descended from generations of stonemasons and carvers who had, like Nanni himself, worked for the Opera of Santa Maria del Fiore in their day. In terms of family background and training Nanni was a quintessential Florentine artisan. His grandfather Banco di Falco and great-uncle Agostino di Falco were named in the records of the Opera del Duomo as master builders in the architectural engineering of the cathedral and the campanile.[3] And Nanni's father, Antonio di Banco di Falco, carried out a great deal of decorative carving — brackets, cornices, consoles and frames — for the cathedral, as well as being a purveyor of materials there.[4] Nanni di Banco's mother, Giovanna Succhielli, was herself from a family of stonemasons; and the Succhielli maintained a prominent position in that trade long after the patrilineal side of Nanni's family had died out, well into the middle of the fifteenth century.[5] Even the matrilineal surname — it was unusual for minor guildsmen to have a surname at all — had associations with stonemasonry, for a *succhiello* was the tool used to puncture stones for hooks and nails. From a social perspective, Nanni di Banco would have had even more claim than Michelangelo himself to have imbibed marble dust with his mother's milk.[6]

Fig. 3. Fra Angelico, *Crucifixion* (detail of Saints Cosmas and Damian), 1441. Fresco. San Marco, Florence

Fig. 4. Giorgio Vasari, *Portrait of Nanni di Banco* from the 1568 edition of *The Lives*

Nanni di Banco's birthdate is unknown, but primary documentation indicates that he was born in the 1370s, and the date "ca. 1374" as proposed by recent scholarship is reasonable.[7] In 1368 Antonio di Banco married Nanni's mother, Giovanna Succhielli, who outlived both husband and son. Described in her own testament of 1423 as "wife of the late Antonio di Banco," she died "of old age" in 1424.[8] It is unlikely that Giovanna (termed elderly in 1424) would have given birth to an only son after her first decade of marriage (post-1378). Another factor in determining Nanni's year of birth is Florentine law: Nanni had to have been at least thirty years old when he was seated as *podestà* at Montagna Fiorentina in 1414, and candidates to the major councils (Nanni was elected to the Twelve Good Men in 1419) were typically well into their forties.[9]

Although Nanni was probably about forty-seven, middle-aged according to fifteenth-century reckoning, when he died in 1421, the legend that Nanni di Banco "died young" has had a tenacious appeal, and more than one monograph on Nanni is prefaced with Leonardo da Vinci's dictum "Vita ben spesa lunga è." (A life well spent is a long life.)[10] The statement was first made by Antonio Billi (ca. 1516–30) who claimed that Nanni "died young as he was becoming most accomplished."[11] This theme was continued throughout the century and picked up by Vasari, in his life of Nanni di Banco of 1550.[12] In this first edition of the *Lives* Vasari claimed that Nanni had died at age forty-seven in 1430 of an abdominal illness which had been the cause of much suffering, and that he would have created many more works had he not died "so soon."[13] G. B. Gelli also main-

tained the strand of the "died young" theme in his *Lives* of ca. 1550–63, declaring, significantly enough, that had death not tragically interrupted his "youth" Nanni would have been a worthy fourth to the famous triad of Brunelleschi, Donatello, and Ghiberti.[14] In 1568 Vasari followed Gelli in the notion that Nanni di Banco would have enjoyed much more fame had his life not been cut short.[15]

According to local tradition, Fra Angelico portrayed "Nanni d'Antonio di Banco," sculptor and "his friend," in the figure of Saint Cosmas in the *Crucifixion* in the Sala del Capitolo at San Marco. The supposed portrait "from life" as recorded by Vasari would be the second figure from the viewer's left in the lunette (fig. 3).[16] Vasari's own rendering of Nanni di Banco (as published in the 1568 *Lives*) followed this type, representing him as middle-aged, bearded, balding, and benign (fig. 4). Fictional as these little "portraits" obviously were (the fresco at San Marco was painted in 1441), they retrospectively befitted a man who died in his prime, at the age of forty-seven. The apparent contradiction in Vasari's own terms between dying "young" or "soon" and dying at age forty-seven (maturity) is resolved in the fact that Nanni died an *untimely* death both historically and personally, especially compared to Donatello, Brunelleschi, and Ghiberti, who lived to relatively old age, continued working, and received great fame in their own lifetimes.[17] Nanni, on the other hand, outlived his father by only six years and predeceased his mother; he outlived his teacher, the important (if elusive) fourteenth-century sculptor Giovanni d'Ambrogio (1345–1418) by only two years.[18] Had Nanni lived on for another decade or so, he would have entered an epoch that thrived upon the personal recognition of artists and architects. Had he been alive to meet Leon Battista Alberti between 1428 and 1435, his name, too, might have found a place, together with Brunelleschi, Donatello, Ghiberti, Masaccio, and Luca della Robbia, in the dedicatory preface to the treatise *On Painting*.[19]

All factors considered, Nanni di Banco probably began working as a stonemason in the last decade of the fourteenth century under the auspices of his family, and then in the Opera of Santa Maria del Fiore under the *capomaestri* Lorenzo di Filippo and Giovanni d'Ambrogio respectively. Nanni matriculated to the guild of stonemasons and carpenters in February 1404/5, at the age of about thirty-one, an age that was not atypical.[20] The years 1408 to 1421 were filled with some of the most prestigious sculptural projects in Florence, including three of the outdoor tabernacles at

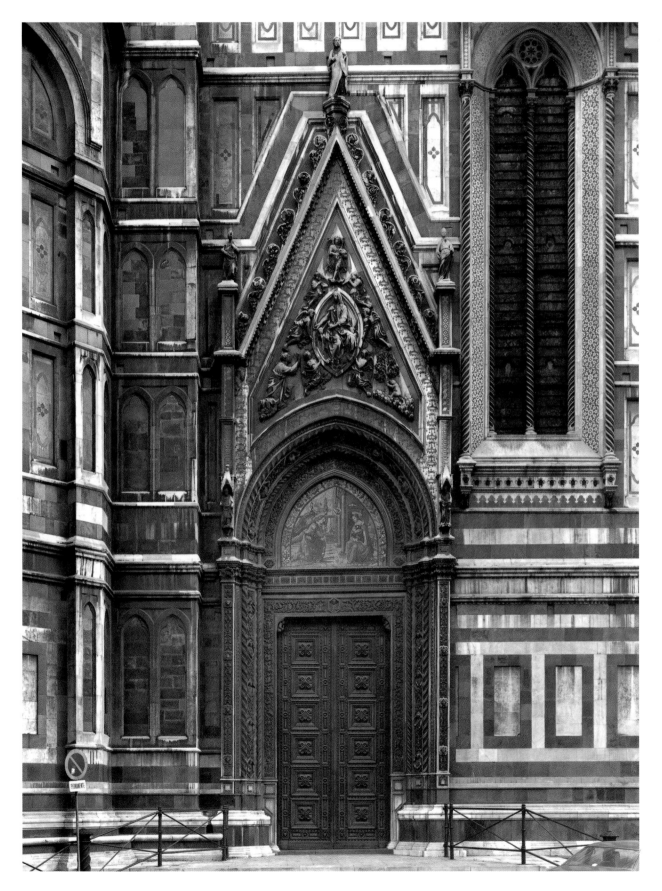

Fig. 5. Porta della Mandorla. Santa Maria del Fiore, Florence

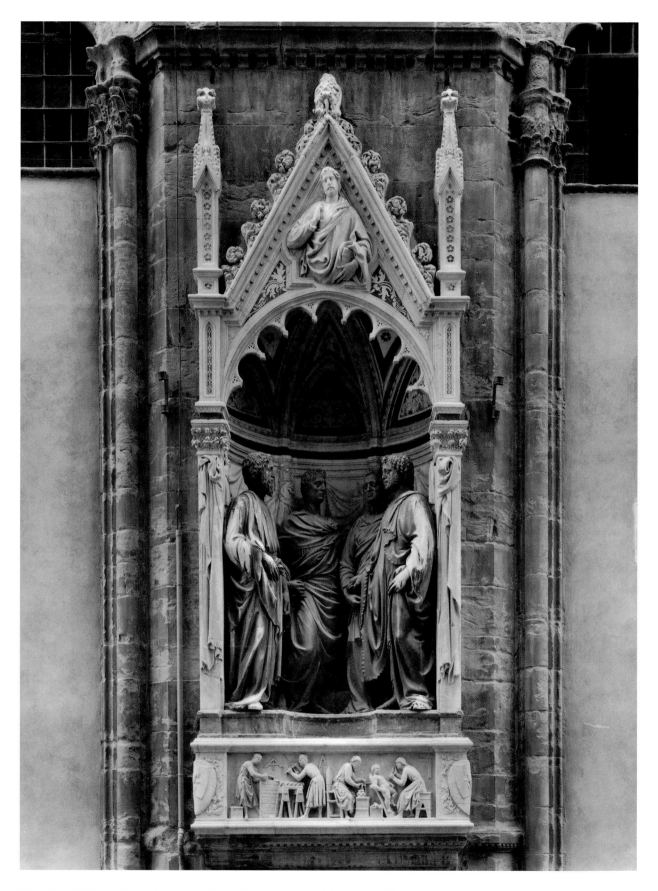

Fig. 6. Nanni di Banco, *Quattro Santi Coronati* (cat. 1-6), ca. 1409–16/17. Marble. Orsanmichele, Florence

Orsanmichele, and the imposing *Assumption of the Virgin*, which has since given the name Porta della Mandorla to the northeast door of Santa Maria del Fiore (fig. 5). Nanni's *Quattro Santi Coronati (Four Crowned Martyrs)* for the guild of stonemasons and woodworkers would have been planned and underway by 1409, very likely commissioned under a guild consulate that included his own father, Antonio di Banco, who was elected to a four-month term in January 1408/9 (fig. 6).[21] By 1419 Nanni had risen to an eminent social status, frequently at the helm of his own guild as well as sitting on elitist government councils.[22] He was at the summit of his career when he died in 1421.[23]

In order to envision the texture of Nanni di Banco's life, we may turn to one particularly germane text, Antonio di Tuccio Manetti's story of "The Fat Woodcarver," which is specified as taking place in winter of the year 1409.[24] The well-known novella deals with an elaborate prank masterminded by Filippo Brunelleschi, played on a woodcarver nicknamed "Grasso" (Fat). The scheme of the joke was to confuse the woodcarver as to his own personal identity, to persuade him that he had become someone else entirely, a certain "Matteo." Brunelleschi's joke was in fact a masterpiece of what I would call "false perspective" imposed upon his credulous colleague, in order to entertain a brigade of clever artisans including Donatello. In the telling, so much is revealed about the social identities and interactions of the group of men involved, that the novella can be consulted as a valuable historical source whether or not the humorous incident was "real." "The Fat Woodcarver" has been recognized by social historians as a text that is unusually, even uniquely, rich in describing the ideals and social structures of early quattrocento Florence.[25] The particulars of the story are seen from two viewpoints: that of the most ingenious protagonist of the story (and of his historical period), Filippo Brunelleschi, and that of Grasso, an esteemed artisan and "new man" in the upper echelons of Florentine social life. Most scholars believe that Grasso is to be historically identified as Manetto di Jacopo Ammannatini (d. 1450), a specialist in wood intarsia, and that the nickname "Grasso" refers not so much to his physical girth as to his position in the "Popoli Grassi," the comfortable Florentine middle class.[26]

It would, of course, be spurious and contrary to historical inquiry to cast the woodworker, Grasso, as an alter ego for Nanni di Banco. Nor can Nanni's worldview be precisely identified with those of Brunelleschi or Donatello. But in terms of social history both Grasso and Nanni were typical of their class and professions, and both were intimates of Brunelleschi and Donatello. Beginning on a simple material level, Nanni di Banco had much in common with the prominent, if gullible, craftsman of Manetti's story. Stonemasons and woodworkers belonged to the same guild, the Arte dei Maestri. Just as Grasso kept a workshop behind the Baptistry of San Giovanni, Nanni's father, Antonio di Banco, kept the family *bottega* in that neighborhood; and just as Grasso's mother had a *podere* in the Florentine countryside, Nanni di Banco's mother, Giovanna Succhielli, owned a farm consisting of eleven pieces of land in the parish of Santa Maria in Settignano.[27] Grasso (Manetto di Jacopo Ammannatini) had a father and grandfather who sat on the major councils of the Florentine Republic; and we shall see in the following chapter that civic activity was an important social factor for Antonio and Nanni di Banco.[28]

The theoretical comparison between Nanni and Grasso can be extended toward an understanding of intangibles, such as Nanni di Banco's somewhat drab critical fortunes. Antonio Manetti characterized Grasso as a bit simple (or air-headed) compared to the genial and pragmatic Filippo Brunelleschi. In a similar literary mode, Giorgio Vasari, in his zeal for exalting Donatello as a proto-Michelangelesque hero, saw fit to characterize Nanni di Banco (one hundred fifty years after the fact) as Donatello's lackluster follower: "persona alquanto tardetta" (not too bright).[29] Vasari's comic tale about Nanni being unable to fit the four statues of the *Quattro Coronati* into their single niche at Orsanmichele and Donatello's ingenious solution seem to derive directly from the tone of "The Fat Woodcarver," especially since Donatello and his *garzoni* end up having a good laugh (and a good dinner) at Nanni's expense.[30] According to the legends, both Grasso and Nanni lacked that special combination of forethought and afterthought that can be summed up in one word: perspective. Vasari's biased characterization of Nanni di Banco as a foil for Donatello is a notion that several modern scholars have attempted to redress.[31] The origins of this bias are to be found in Vasari's historical schema, in which Donatello is the spiritual "grandfather" of Michelangelo. But the comic mode of telling the story is rooted in the mentality and reality of the world of "The Fat Woodcarver."

Indeed, Manetti's novella unfolds in the charged atmosphere of precisely the place where Nanni di Banco

worked on a daily basis, namely the partly constructed cathedral of Santa Maria del Fiore, and its chapels, tribunes, *ad hoc* workshops, and surrounding piazza. The Baptistry of San Giovanni, Santa Maria del Fiore, and the piazza ("Il Paradiso") between them served as a central public forum and meeting place for the city of Florence, as well as a constant hub of activity for architects, sculptors, and purveyors of materials. When, for instance, Manetti has Brunelleschi and Donatello take Grasso aside to further their ingenious hoax, they go to the choir of the cathedral to carry on their mocking conversation.[32] Significantly, of course, the unfinished cathedral of 1409 was the site of their future artistic triumphs, including Brunelleschi's cupola and Donatello's *Prophets* for the campanile, as well as the site of their present *tour-de-force* of practical joking. Nanni di Banco lived in this ambience, and it is important to emphasize that the cathedral of Santa Maria del Fiore and its secular construction agency, the Opera del Duomo, was the setting for Nanni's lifework, for his own sculpture as well as major interactions (collaborations and competitions) with the protagonists Donatello and Brunelleschi. The Opera del Duomo served as a springboard for Nanni di Banco's guild leadership and civic honors, as well as for his personal identity and prosperity. When Grasso the woodcarver needs time and place to reflect upon his mistaken identity, he finds his solace in walking around in Santa Maria del Fiore, not for a transformative spiritual experience, but rather as the "real" public site of his work and society, a place of professional affirmation.[33] And so it was for Nanni di Banco.

A potential interface between the story of "The Fat Woodcarver" and the life and times of Nanni di Banco creates humus for further historical interpretation. In 1409, the year of the novella, Nanni was fresh from having produced the heroic *Isaiah* (cat. 1-4), a figure that was set up as an exemplar and challenged by Donatello's marble *David* (fig. 91).[34] These statues were intended to stand free atop the tribune buttresses of the cathedral, and although they never actually played that role, the idea of a standing Herculean youth — a "homo magnus et albus" (white giant) — lived on in the Florentine imagination to culminate in Michelangelo's *David* of 1504. In fact, thirty-three days after the completion of Nanni's *Isaiah*, on 17 January 1408/9 (after four days of uninterrupted snowfall), a heroic snowman was modeled in Piazza San Michele Berteldi (presently San Gaetano). Bartolommeo del Corazza described it in his

diary as a particularly good-looking figure, a "Hercules" two braccia in height.[35] It is tempting to wonder who made this noteworthy snow *Hercules* (a precedent, incidentally, for Michelangelo's legendary snowman by eighty-six years). Filippo Brunelleschi lived his entire life in the Piazza San Michele Berteldi, and according to the *novella del Grasso*, Brunelleschi was back in Florence from Rome in the winter of 1409, hobnobbing with his artisan and patrician friends. In the same ironic spirit found in the text of "The Fat Woodcarver," perhaps Brunelleschi himself responded to Nanni di Banco's brand new white marble *Isaiah* by creating a competitive counterpart in snow. Certainly Donatello and Brunelleschi experimented freely with "white giants" in various materials including terracotta for the cathedral tribunes in the years that followed.[36] My attribution of a long-since melted snowman to Brunelleschi stretches all the limits of interpretation and may have nothing whatsoever to do with Florentine public sculpture of the more permanent kind. But, like the story of Grasso, the episode of the 1409 snowman *Hercules* discloses a modicum of what a cultural anthropologist might call "local knowledge," namely a Florentine preoccupation with making and viewing Herculean figures, be they permanent or ephemeral, in the first decade of the fifteenth century.[37]

The art and architecture of Santa Maria del Fiore was generated by a system of carefully selected committees and of artists placed in public competition with one another. A carefully wrought procedure of competition, consultation, and consensus ensured high-quality results in this important domain of public patronage.[38] At Santa Maria del Fiore in 1409, Nanni and Donatello were in competition again, working on the Evangelists *Saint Luke* (cat. 1-5) and *Saint John* (fig. 97) for the cathedral facade, together with Niccolò Lamberti, who was assigned the *Saint Mark*. As per custom, the sculptors were set up in *ad hoc* studios located in the chapels of the cathedral.[39] Bernardo Ciuffagni joined the competition with a *Saint Matthew*, and chapel-workshops were eventually closed under lock and key to keep out the inevitable stream of casual kibbitzers and critics.[40] Rivalry was the name of the game; and Antonio Manetti himself, as well as denigrating Ghiberti at every possible turn in his biography of Brunelleschi, cast Donatello's understanding of Brunelleschi's architectural principles in serious doubt.[41] Art-historical writing has placed a premium on the nature of artistic competition in the Florentine Renaissance, with the most famous example being the contest of 1401 for the

Baptistry doors. At a distance of nearly six centuries, this contest is seen to have set the tone for all of Renaissance art, giving Ghiberti the means to develop a repertoire of advanced pictorial sculpture, and setting Brunelleschi free to transform the theory and practice of architecture.[42] In this vein, Nanni di Banco and Donatello have been envisioned as keen rivals during the first and second decade of the century. But consensus in the cathedral bureaucracy was as important to innovation as was competition, and there is evidence of friendship and collegiality among Brunelleschi, Donatello, and Nanni di Banco in the cathedral works.[43]

It is recorded, for instance, that Nanni di Banco was Donatello's guarantor to the Opera for advance payments on the series of *Prophets* for the Campanile: he guaranteed ten gold florins in March of 1415/16, and twenty gold florins in 1418, surely a gesture of trust if not friendship.[44] And in 1419 the triumvirate of Brunelleschi, Donatello, and Nanni di Banco were paid a total of forty-five gold florins for the preparation of a large, scale model of the cupola made in brick without the use of armature.[45] Four months later Nanni di Banco and Donatello took part in an Opera del Duomo committee (minus Brunelleschi) to evaluate and advise on Brunelleschi's design for the cupola. It is significant that another member of that particular advisory committee was a noted jurist and humanist, Giovanni di Gherardo da Prato, who believed in promoting the exchange of ideas among men of diverse trades and intellectual disciplines and served the Opera as an esteemed counselor.[46] The picture of the Opera del Duomo that emerges is one of a coterie of artisans and wool merchants united in the visionary and pragmatic endeavors of public works.

Nanni di Banco can be placed firmly in the social world of the novella of the Grasso, in the locus of the Opera del Duomo together with Brunelleschi, Donatello, and their friends. Nanni's life and works took place in a city-state fresh from triumph over the despotic efforts of the Milanese under Giangaleazzo Visconti; in a republican oligarchy controlled by the Albizzi family, who dominated the wool guild and therefore the Opera del Duomo. Again, the pretext for the story of the Grasso is a kind of Sunday-evening dinner club composed of artisans and men of letters, who would get together to engage in dynamic exchanges having to do with professional projects as well as pleasurable chatter.[47] These meetings have been described as the Florentine — and exclusively male — version of the French "salon."[48] Women, children, workers, and peasants were never part of the social, intellectual, or political equations that drove the visible forms in the city-state.[49] Men from different strata of society — but only those men who were entitled and enfranchised — were the dramatis personae who supped together, from merchant literati such as Tommaso de' Pecori to artist-craftsmen such as Brunelleschi, Donatello, and Grasso. The cast of characters in Manetti's novella also includes Giovanni di Francesco Rucellai and an unnamed jurist, "known no less for his literary than for his legal fame," presumably identifiable with Coluccio Salutati, Giovanni di Gherardo da Prato, or someone of that ilk.[50] In the social world described by Antonio Manetti, which was precisely the social milieu of Nanni di Banco, there was plenty of room for a free exchange of ideas among artisans, engineers, jurists, and men of letters in casual meetings as well as in governmental or professional settings. What they apparently had in common was their intellect, ingenuity, good humor, practical abilities, and competitive edginess. Not least, however, these qualities were presumed to have signaled the acceptance of the best and the brightest guildsmen into the Florentine *reggimento*, or high government councils, a point that is strongly emphasized by Manetti right from the start.[51] It is therefore appropriate to turn to the civic life of Antonio di Banco and his son, Nanni di Banco, and to inquire into the content of Nanni's works in this respect. We shall see in the following chapter that Nanni di Banco's public sculpture postulates the corporate ethos and Ciceronian *amicitia* endorsed by the members of the Florentine government under the Albizzi regime.

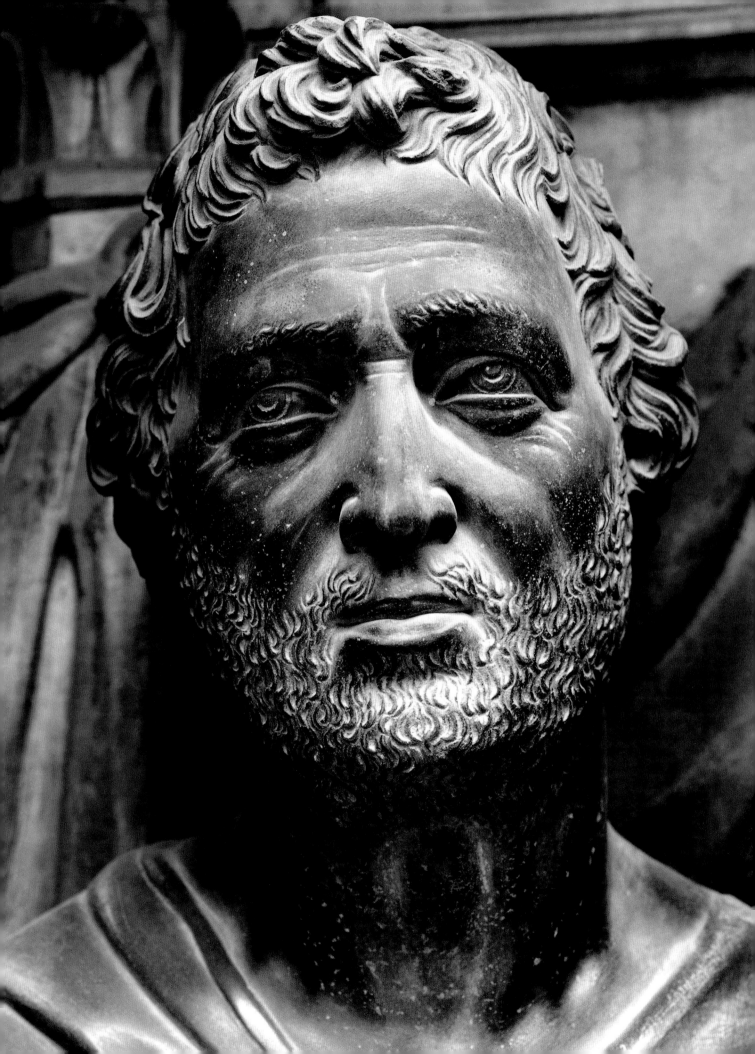

2 . PUBLIC LIFE AND CIVIC WORKS

As a Florentine citizen he obtained many offices in his Patria, and because in these and in all his other affairs he conducted himself as a just and reasonable man, he was much loved.

—*Giorgio Vasari*

In the historiography of Florence, the period between about 1390 to 1433 has been styled as a kind of "golden age," when the commitment of solid citizens paralleled that of the finest statesmen of Roman antiquity. The projected self-image of the Florentine oligarchy-as-meritocracy was stated bluntly by the banker-statesman Cristofano Spini in 1408: "Everyone who deserves to belong to it, belongs to it."[1] It was during this time that Antonio di Banco and his son, Nanni di Banco, entered the Florentine political arena — a family endeavor that culminated in Nanni's appointment to the major councils of the regime.

Nanni di Banco chose a life of civic engagement, entering the public sphere through the position established by his family and himself in the stonemasons' guild.[2] The way into public life was prepared for him by his family, particularly by his father, Antonio, who achieved distinction both as artisan and supervisor within the workshop of the cathedral.

Antonio di Banco first matriculated to the guild of stonemasons with the title of *magister*, in 1372.[3] Antonio was to enjoy a long and distinguished career in the workshop of Santa Maria del Fiore, serving within the infrastructure of that complex as mason, stone carver, contractor, planner,

and eventually as chief foreman, or *capomaestro*. From the very earliest recorded phase of his career Antonio appeared not only as a wage-earning artisan, but also as a contractor through the wholesale purveyance of building materials. As early as January 1374/75 in partnership with Michele di Giovanni and Tommaso di Matteo, he was paid for deliveries of "black marbles" (actually the familiar dark green marble quarried at Monte Ferrato near Prato) to the Operai of the cathedral.[4] Not limiting himself to outside contracting, however, Antonio was listed on the payrolls for stonemasonry (1376) together with his father and his uncle, Banco and Agostino di Falco, and such masters as Lorenzo di Filippo.[5] During the 1390s—the decade in which Nanni probably contributed the precocious little *Hercules* (cat. 1-1) to the lower left reveal of the Porta della Mandorla — Antonio's name appeared on the cathedral payrolls alongside such prominent masters of the Porta della Mandorla as Giovanni d'Ambrogio, Lorenzo di Filippo (at that time *capomaestro*), and Niccolò Lamberti.[6] In the first decade of the quattrocento Antonio continued to provide the Opera with different types of stones and piecework for various purposes, such as the cathedral floor, waterspouts, window frames, and so forth.[7] During this time Antonio was also occupied with the production of the archivolt friezes of

Nanni di Banco, *Quattro Santi Coronati* (cat. 1-6, detail), ca. 1409–16/17. Marble. Orsanmichele, Florence

the Porta della Mandorla, a project for which Nanni di Banco carved the keystone *Man of Sorrows* now in the cathedral museum (cat. 1-2).[8] Antonio continued to work as a stone carver, while the wholesale contracting of prepared stones, besides contributing to his personal prosperity, may have served to advance his social standing in an emphatically mercantile society. The contracting transactions no doubt brought Antonio into economic contact with the cathedral trustees, or *Operai*, who were merchants themselves and members of the city's strongest corporation, the Arte della Lana (wool guild). Not that he lacked contact with this group of men as a respected stonemason: in 1407, for instance, Antonio was selected for a committee to supervise the exterior decoration of the northwest choir tribune under the leadership of *capomaestro* Giovanni d'Ambrogio.[9] By this time Antonio di Banco, his father Banco di Falco, his uncle Agostino di Falco, and his in-laws the Succhielli had been part of a core group of masters in the cathedral workshop for some fifty years. In envisioning the social relationship of Antonio to his employers, it must be remembered that the Opera del Duomo was a secular governmental department operated by the wool guild, and that the cathedral trustees were therefore among the most powerful men in Florentine government.[10] It was under the auspices of the committee of 1407 that Nanni di Banco carved an *Atlante* for the northwest tribune window (cat. 1-3).[11] But even more significantly for the history of art, Nanni di Banco was assigned the statue of *Isaiah* to stand free on a buttress of the tribune in January 1407/8 in partnership with his father, Antonio. The *Isaiah* served as the designated model for Donatello's marble *David* and was therefore the ultimate progenitor for the consequent history of Florentine Hercules and David statues that followed, including Michelangelo's *David* of 1504, itself an extension of the tribune buttress project.[12]

In 1412 and 1413 Antonio di Banco, apparently acting as his own agent, provided stones for the doors and a window of Orsanmichele to the Captains of Orsanmichele, a group of civic officers.[13] These sales coincided with Nanni di Banco's activity at Orsanmichele as he finished the *Saint Philip* for the shoemakers' guild (cat. 1-7). Nanni was also in the midst of producing the *Quattro Coronati* for his own guild of stonemasons at this time, a commission that was probably given to Nanni under the consulate of his father Antonio in the spring of 1409.[14]

Antonio di Banco was a prominent member of the guild of stonemasons and woodworkers (Arte di Maestri di pietra e legname). He was elected consul seven times, beginning in January 1394/95, and for the last time in May 1415, overlapping his term as *capomaestro* of the cathedral.[15] Although the stonemasons' guild was the largest of all the Florentine guilds in terms of total membership, the consulate was always garnered from an elite core. In order to qualify for the office of consul, a man had to be "scrutinized" by the oligarchy of guildsmen already in control. Then, the actual sortition (*tratta*) of name-slips from prepared bags was overseen by the merchants' court (*mercanzia*). Eligibility for office in the stonemasons' guild therefore depended upon the approval of the established elite rather than any kind of democratic "voting" by the rank and file. If a guildsman succeeded in obtaining the office of consul, it meant that he had already achieved a certain status. And the prestige of becoming a guild consul was linked with his direct access to the greater arena of participation in the politics of the city-state. The guild system acted as a tight filter for the eligibilities that were so urgently desired by citizens like Gregorio Dati, the silk merchant and chronicler whose one great personal aim was to be *veduto* (pass scrutiny) for the major councils.[16]

The wool guild named Antonio di Banco *capomaestro* of the Opera of Santa Maria del Fiore in December 1413: his tenure began on the first of January 1413/14, and was ended by his death in May 1415.[17] As *capomaestro*, Antonio entered the most productive phase of his administrative career. Under his direction the second tribune was begun, and in the same period, his son Nanni di Banco was commissioned the *Assumption of the Virgin* that would eventually give the Porta della Mandorla its name.[18] During this time Antonio shared decisions with the cathedral trustees: in planning the new tribune in August 1414, for example, Antonio worked closely with none other than Antonio di Tedice degli Albizzi, a leading figure in the Albizzi-controlled district (*gonfalone*) of Chiave.[19]

Antonio di Banco's professional accomplishments afforded him not only the means but also the incentive to enter the government of the Florentine Republic. The aspiration to public office would have been for Antonio, as it was for many Florentine citizens, not dictated so much by a desire for the opportunity to exercise real power in the political arena, as by the wish to demonstrate and extend the prestige that he and his family had gained within the city.

We may now look back in time to see how Antonio's

entrance into the governing councils of Florentine society paralleled his career as a stonemason. On 17 April 1391 Antonio di Banco had been nominated by the *gonfaloniere* of his residential district Chiave to be scrutinized for eligibility to the Priorate of the Signoria. Had he passed scrutiny successfully, he would have become eligible to serve on any of the three major councils, that is, the executive branch of Florentine government, or the Tre Maggiori, which comprised the Priors of the Signoria and the two colleges known as the Sedici Gonfalonieri di Compagnia (Sixteen Standard Bearers) and the Dodici Buonuomini (Twelve Good Men). As it was, Antonio received only fifty-three votes, which were too few to succeed.[20] It was first in the sortition of January 1403/4 (and by now Antonio had been working in the Opera del Duomo for more than thirty years) that he was chosen as a representative to the Council of the Commune, one of the two large legislative (voting) bodies of the Florentine government (*Comune* and Popolo), for the standard term of four months.[21] Although by this time he had been consul of his guild twice, and although Florentine government required that each *gonfalone* be represented by a given number of artisans, it was still no small achievement for a minor guildsman to have passed scrutiny by the oligarchy of the few families — notably the Albizzi — who had tight control of Chiave. This was because the legislative as well as the executive councils were, even in the most "populist" of times, dominated by patricians of the merchant class. It must not have been purely coincidental to Antonio's civic career that the Albizzi, as well as being a dominant force in politics, loomed large in the wool guild, which in turn controlled the Opera del Duomo, itself an arm of the Commune. In any case, although he had not been made eligible for the Tre Maggiori (Priorate), Antonio made his entrée by serving on the Council of the Commune. Following his term in 1403/4, there was a long lapse before Antonio's name was extracted from the electoral pouches again.

In 1411 Antonio di Banco, along with his son Nanni di Banco, was again scrutinized for the Priorate. Neither father nor son was among those chosen, although this time Antonio received a relatively high number of votes: seventy-seven to Nanni's forty-three.[22] Antonio's name was drawn for another term on the Council of the Commune in September 1412.[23] A little more than a year after that term expired, he became *capomaestro* of the Opera del Duomo and was therefore disqualified from holding public office.[24] In

any case, Antonio's name does not appear to have been drawn again, and he died an old man as *capomaestro* on 22 May 1415. Characteristically enough, he died on cathedral business, while on a journey to inspect forests owned by the Opera del Duomo in the Florentine *contado* (countryside).[25]

Antonio di Banco's ascent to prominence in the fields of stonemasonry and architectural administration progressed slowly and deliberately. Political activity was an honor that commenced fairly late in his career and remained on a modest level, the legislative councils of the *Comune* and Popolo being governmental bodies of relatively easy access. But, having been guild consul seven times, and finally ending his career as *capomaestro* of the Opera del Duomo, Antonio di Banco could also boast of having served on the Council of the Commune together with some of the most distinguished and influential leaders of his *gonfalone*, themselves among the premier statesmen of Florence.[26]

Following closely upon his father's recent terms, Nanni di Banco was first elected to the consulate of his guild in January 1411/12, while during the year 1411 (Florentine calendar) he and his father had been scrutinized and rejected for the high executive offices of Florence.[27] In terms of Nanni's artistic work, these events took place while he was involved in the production of the *Saint Luke Evangelist* for the cathedral facade, and the *Saint Philip* and *Quattro Coronati* tabernacles for Orsanmichele.[28] At the end of April 1414 (possibly as the result of a popularizing electoral reform of 1412), Nanni's name was drawn for public office: he was appointed to the minor executive post of *podestà* of Montagna Fiorentina, a "first-class" *podesteria*. Beginning 22 August Nanni di Banco would reside at Castel San Niccolò (fig. 7), which was located in the Casentine Valley near the more famous castle at Poppi.[29] On 1 May he was re-elected guild consul for the months of May through August.[30] There was apparently no legal prohibition against holding guild office and public office at once, and Nanni di Banco was prepared to absorb the responsibilities of guild business in Florence, public duties at Castel San Niccolò, and major artistic production, namely the *Quattro Coronati* for his own guild, which was underway at the time. Indeed, in the very midst of these public commitments (19 June 1414) Nanni was given the commission for the *Assumption of the Virgin* at the cathedral, while his father held the office of *capomaestro*.[31] Nanni's name was drawn again in October 1414 and January 1414/15 for the *podesterie* of Tizzana and Bug-

Fig. 7. Castel San Niccolò, Montagna Fiorentina

giano respectively, but he was disqualified for both because of having recently held appointment to that office in Montagna Fiorentina.[32] After his father's death — during the progress of the *Assumption* relief and while still at work on the *Quattro Coronati* — he was made *podestà* of the Florentine dominion of Castelfranco di Sopra for six months beginning July 1416; and as soon as that term ended he became guild consul, beginning January 1416/17.[33] Exactly one year later, in January 1417/18, he was elected guild consul again.[34] These appointments were held while Nanni was finishing the *Quattro Coronati*, working at full tilt on the *Assumption*, and beginning the *Saint Eligius* ensemble for the blacksmiths' guild at Orsanmichele (cat. 1–10).[35]

In May 1419 the Operai of the cathedral paid Nanni di Banco for two carved reliefs with the arms of their own wool guild (the *Agnus Dei*) which were to be part of a sculptural complex for the facade of the papal apartments at Santa Maria Novella (cat. 1–11).[36] The facade of the papal residence (inside the Chiostro Grande of Santa Maria Novella) is no longer intact, but it probably looked some-

thing like a more grandiose version of the facade of the guild hall of the second-hand dealers *(rigattieri),* the memory of which is conserved in a drawing by Emilio Burci (fig. 59). In order to create a sculptural frontispiece for the papal residence, a melange of heraldic elements was parceled out by the Opera del Duomo to prominent stonemasons such as Nanni di Piero del Ticcio; Pippo di Cristofano called "Cerbio," and Andrea di Nofri.[37] The most familiar component of the facade program, of course, was Donatello's *Marzocco* (fig. 58), which originally stood at the base of a grand outdoor staircase designed by Lorenzo Ghiberti. Meanwhile, it seems that no wool-guild related assignment was too trivial for Nanni di Banco: that summer he carved four more *Agnus Dei* reliefs (this time commissioned by the Arte della Lana directly) for some farmhouses beyond the Porta Pisana that had been bequeathed to that guild.[38] The following September he was once again elected consul of the guild of stonemasons.[39]

The period of Nanni di Banco's most intense civic engagement overlapped his work on the *Saint Eligius* tabernacle at Orsanmichele (ca. 1417–21) and his greatest activity in the production of the *Assumption of the Virgin,* which took place around 1417/18 through 1419. On 12 September 1419 Nanni di Banco's name was drawn and he was seated without obstacle as a member of the Twelve Good Men, or Dodici Buonuomini.[40] The Dodici included three men from each of the four quarters of the city; as one of the two colleges they had considerable authority, advising the Signoria (the supreme executive consisting of eight Priors and the *primus inter pares* Gonfaloniere di Giustizia) on all matters of policy and the ultimate selection of officials. With this appointment Nanni moved into the ranks of the *veduti,* or the men whose name-tags had been extracted from bags for the councils of the Tre Maggiori once having passed scrutiny for this level. The *veduti* and *seduti* (*seduti* simply meaning those who were drawn and seated without disqualification) formed the most privileged stratum of society during the regime of 1382 to 1433, especially in the years after 1411. The *seduti* for the three major councils made up the effective inner circle of Florentine government, or the *reggimento* as we perceive it today. Since the results of scrutinies and the contents of the sortition bags were secret, it was only when a candidate was *veduto,* or had his name-tag pulled for office, that he knew he had passed scrutiny for the Priorate. Although the social prestige of such an advancement for Nanni should be emphasized over

and against the possibility of actual power in the determination of internal or external state policy, a modicum of that was certainly present.[41]

Because Florentine government required that the councils be composed of minor as well as major guildsmen, the presence of artisans in the *reggimento* was not a novelty. Nevertheless, for a manual worker, as sculptors in marble were then considered, to enter the Tre Maggiori as a "new man" represented a significant enhancement of that man's community status. Indeed, *gente nuova* (new men) included any of those lower guildsmen, be they shopkeepers or artisans, who were newly arrived to participation in the regime as well as new major guildsmen who lacked extensive family connections.[42] Nanni's well-known contemporary, the chronicler Gregorio Dati, himself a member of the major guild of Por Santa Maria (silk guild), voiced the importance of the fact that he had finally passed scrutiny for the Tre Maggiori: Dati recorded the satisfaction it brought him, and the benefits for his personal prosperity and that of his family.[43] Dati had previously failed (together with Antonio and Nanni di Banco) in the scrutiny of 1411, having received only forty votes.[44]

Members of the colleges (although they did not actually live in the Palazzo della Signoria as the Priors did) were probably involved with some kind of governmental activity on nearly a daily basis. The same week that he was appointed, 15 September 1419, Nanni di Banco, listed among those privileged to walk in the city after curfew and to bear arms, was entrusted with granting that privilege to another citizen from his quarter, a certain "Blasius Laurentii, spetarius."[45] The following day, as representative of the Dodici, Nanni appeared at the Palazzo della Signoria along with one of the Sedici Gonfalonieri to consider an authorization for the citizen Matteo di Agnolo Malatesta's request for eligibility to hold public office; and nine days later he was called in again on similar business.[46] On the occasion of this last summons to the Signoria, 25 September 1419, his name was paired with that of "Dominus Laurentiis Ridolfi gonfalonierus." Lorenzo Ridolfi, a distinguished lawyer and statesman, was one of the leading civic humanists of his day: he advocated a popularly based government, and taking Republican Rome as his model, he introduced *exempla* from ancient history and literature to the practical functioning of government in Florence.[47] It is somehow germane to this discussion that Ridolfi, like Antonio and Nanni di Banco, was to have a strong professional connection with the Opera del Duomo: he served as legal counsel for the wool guild in their negotiations with Rome for direct control of the cathedral administration in 1426.[48] The paired names of Ridolfi and Nanni di Banco in September 1419 cannot reveal the extent of casual intellectual contact between a stonemason creating public sculpture and members of the humanist elite: we will never know what they said to each other on the way in and out of the council halls.[49] This small fact, however, embedded as it is in relevant knowledge of the period, does confirm that civic life could link artists and humanists on a level in which their duties as equals served a common republican ideal.

Toward the end of 1419 Brunelleschi, Nanni di Banco, and Donatello, working as a team of three, were paid forty-five gold florins for having constructed, some time before, a brick scale model of Brunelleschi's "chupola grande" (great dome).[50] On the second day of the Florentine new year, 27 March 1420, Nanni di Banco was one of a committee of four men, one from each quarter, who assembled to approve the statutes of the *podesteria* of Valdambra.[51] Five days later, on 1 April 1420, he again received a payment relevant to the cupola, this time as part of an *ad hoc* committee gathered to give advice on the design of the cupola. This cupola committee was headed by Giovanni di Gherardo da Prato, a humanist intellectual who more or less shared the vantage point of literati such as Leonardo Bruni.[52] Nanni's alternation of civic and guild activities with sculptural work and project-planning in the sphere of Santa Maria del Fiore is plainly reminiscent of the pattern established by his father, Antonio di Banco.

Nearly a year later, on 16 January 1420/21, Nanni di Banco was appointed to the Consiglio del Dugento (Council of Two Hundred), a large but deliberately elitist organization that was created expressly to be at one with the ruling group of the Albizzi-dominated regime. The councils of Two Hundred and "131" had been created in 1411 as legislative groups to supersede the voting power of the councils of the *Comune* and Popolo in the making of foreign and military policy.[53] Less than a month into his six-month term on the Two Hundred, on 9 February 1421, Giovanni d'Antonio, known as Nanni di Banco, wrote his will in favor of his wife, and died a few days later.[54]

If Filippo Brunelleschi, as it has been suggested, used his participation in government as a lever to help persuade the wool guildsmen of the Opera del Duomo to accept his controversial plans for the cupola, Nanni di Banco would

Fig. 8. Ambrogio di Baldese and Smeraldo di Giovanni,
Santi Coronati, 1403. Mural painting. Orsanmichele, Florence

overtly civic nature of the *Quattro Coronati* at Orsanmichele, a work that clearly advocated and celebrated the corporate practices and ideals described above.

The outdoor tabernacle at Orsanmichele dedicated to the *Quattro Santi Coronati*, patron saints of the stonemasons and carpenters, is a signal work for the beginning of the Florentine Renaissance.[57] The sculptured ensemble combines a pondered interpretation of classical models with a specific representation of the empirical present, qualities which have brought scholars to recognize a new humanism in Nanni di Banco's vision. His treatment of the subject gives little attention to the complicated legend of the Roman martyrs who chose death rather than carve a cult image of the god Aesculapius. The martyred *coronati* painted on the interior of the pier of Orsanmichele in 1403 by Ambrogio di Baldese and Smeraldo di Giovanni hold up the tools of their trade as if they were the instruments of Christ's Passion, and their souls are escorted to heaven by angels (figs. 8, 102, 103); but the only overtly Christian element in Nanni's ensemble is the Blessing Christ in the uppermost zone.

The four men stand in grave but harmonious conversation; three of them are dressed in togas and wear Roman sandals (fig. 9). The figure on the extreme right is clearly derived from an orator such as one from the Temple of Fortune at Pompeii (fig. 10). Here the Roman orator is adapted to a group of figures, thus lending the ancient rhetorical type a new intimacy and naturalism. The four saints display neither saintly attributes nor symbols of martyrdom. The socle relief, which the artist might well have taken as an appropriate space and medium for narrating the legend, instead shows *muratori*, *lastraiuoli*, and *scarpellatori* (masons, carvers, and sculptors) at work fifteenth-century style, in contemporary dress, with the sculptor at the right completing the image of a wingless, nude boy or pagan-style putto (fig. 11).

Critics have time and again characterized the group of statues as evoking the image of four Roman senators or philosophers in rational, restrained debate as opposed to zealous martyrs of the Christian age.[58] It has likewise been observed that the circle of "republican Romans" consequently brings forth an ideal image of the actual Florentine counterpart: merchant or artisan guild consuls, or dedicated representatives to the communal government.[59] The *Quattro Coronati* group appears to stand as a concrete affirmation of the corporate republican ideals maintained by merchant-class and artisan-class guild members in Florence.[60]

have had no such need.[55] The *Assumption* at Santa Maria del Fiore, his last and most ambitious work, was underway by the time Nanni joined the ranks of the Tre Maggiori. Furthermore, it had been commissioned under his father's direction as *capomaestro*. For certain commissions, filiation within a trade may have carried more weight than did political patronage *per se*. Far from using civic involvement as a means to artistic realizations, the public rank attained by both Antonio and Nanni seems to have been a result of their prominence within the working orbit of the Opera del Duomo and in the stonemasons' guild, which was directly linked to that Albizzi-driven agency. Recognition of his sculptural projects may have even enhanced Nanni's eligibility for high office. We have seen that Cristofano Spini viewed government participation as a meritocracy; the same belief was stated more eloquently twenty years later (1428) by Leonardo Bruni: "Equal liberty exists for all. . . . The hope of winning public honors and ascending is the same for all, provided they possess industry and natural gifts, and live a serious-minded and respected way of life."[56]

Beyond a simple causal relationship, however, there does exist a rapport between Nanni's civic life and his artistic production. This integration is demonstrated by the

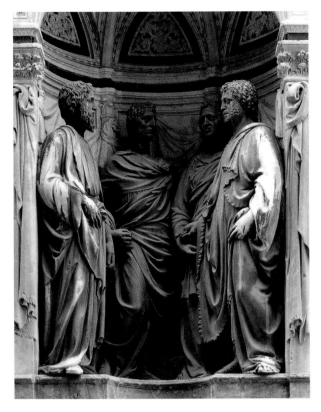

Fig. 9. Nanni di Banco, *Quattro Santi Coronati* (cat. 1-6, detail), ca. 1409–16/17. Marble. Orsanmichele, Florence

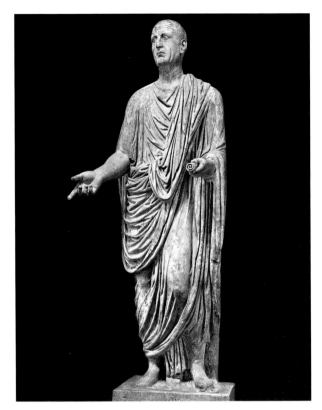

Fig. 10. *Orator* from the Temple of Fortuna Augusta, Pompeii, ca. 50 B.C. Marble, height 73¾ in. (187 cm). Museo Archeologico Nazionale, Naples

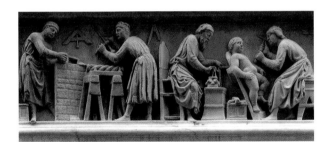

Fig. 11. Nanni di Banco, socle relief for *Quattro Santi Coronati* (cat. 1-6, detail), ca. 1409–16/17. Marble. Orsanmichele, Florence

That a work of visual art plays a role just as active in the historical process as any written text or social agency is particularly relevant to the issues of public sculpture at hand here.[61] Like the merchant-class humanists who through classical examples called forth the ideals of the republican state, emphasizing the responsibility of the committed citizen, Nanni di Banco based his work on classical Roman sculpture, introducing a new naturalism and setting the classicizing group against a relief descriptive of the quotidian work of the Florentine artisan. Just as Leonardo Bruni used classical models to extol Florentine republicanism in his civic humanist writings, Nanni di Banco used ancient models to advance the same corporate ethos.[62] Besides physically juxtaposing the implicit Graeco-Roman ideal of the four statues with the descriptive Florentine "vernacular" of the workshop scene below, Nanni di Banco integrated the actual with the ideal in his approach to the interpretation of forms.[63] His use of classical principles in the four standing figures transcends a purely archaeological imitation: he brought to the subject an accurate observation of the way men stand and converse. This empirical naturalism determines the meaning of the work, bringing the "semicircle of senators" into the Florentine present. The

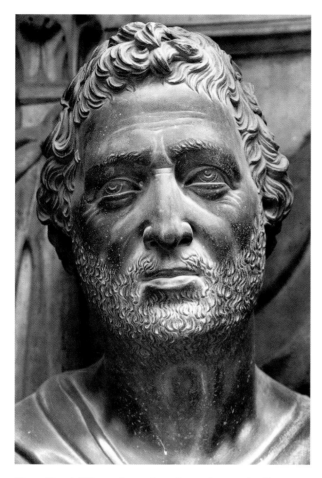

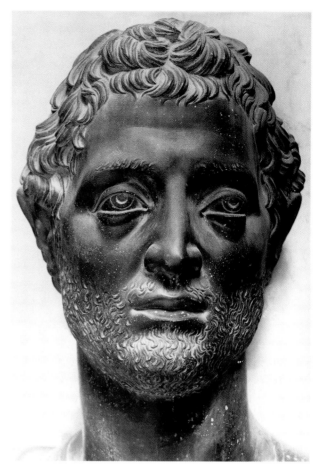

Fig. 12. Nanni di Banco, *Quattro Santi Coronati* (cat. 1-6, detail), ca. 1409–16/17. Marble. Orsanmichele, Florence

Fig. 13. Nanni di Banco, *Quattro Santi Coronati* (cat. 1-6, detail), ca. 1409–16/17. Marble. Orsanmichele, Florence

situation of the ensemble enhances its insertion into "present" time because of the direct rapport with the city street. Furthermore, the statues no longer adhere to the medieval formula of patriarchal inscrutability. In fact, we are meant to identify rather closely with them: the head of Nanni's "middle-aged saint" (fig. 12), for example, communicates a certain imperfection and anxiety, and shows the passage of time measurable in terms of human experience. Realism, of course, is no more neutral or involuntary than classicism, and here those modalities are tightly interwoven to represent the proverbially self-described "wise men and good citizens" of the Florentine Commune.[64]

The *Quattro Coronati* is a profoundly self-referential work, as finely nuanced and persuasive as any verbal oration or text. This begins with the nature of the commission: Nanni di Banco, who belonged to the elite of the commissioning guild was himself an influential member of the corporate patron body. And this tabernacle, more than any other at Orsanmichele, is a work not only commissioned by

a guild, but it is also about that guild: its subject deals with the building trade, the craft of stonecarving, and the art of figurative sculpture — Nanni's trade and that of his family. The socle relief illustrates the various tasks conducted by *muratori*, *lastraiuoli*, and *scarpellatori*, in an agency such as the Opera del Duomo. The group of four standing *Coronati* has been interpreted as an open reference to the camaraderie and dignity of the four consuls of the stonemasons' guild, an observation which becomes all the more pointed when we consider that already by 1411 Nanni's father, Antonio di Banco, had served as guild consul four times (of a total of seven in his lifetime), and that during one term (January through March 1410/11) Antonio was consul together with Nanni's maternal uncle, Jacopo di Niccolò Succhielli, and that Nanni himself would be elected consul, first in 1412 and then five other times.[65] In the *Quattro Coronati* the question of autobiography rubs inevitably close to that of social history, since the sculptor together with his forebears and family members (including Banco di Falco, Agostino di

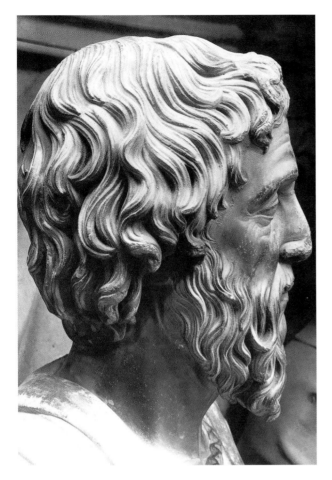

Fig. 14. Nanni di Banco, *Quattro Santi Coronati* (cat. 1-6, detail), ca. 1409–16/17. Marble. Orsanmichele, Florence

under discussion, we must ask: what was the nature of the actual points of conjuncture between humanists and artists in early quattrocento Florence? How did economic and social history interact with the making of art and vice versa? How consciously could Nanni di Banco have fused the loftiest ideals of Florentine civic life — ideals known to us through the voices of patrician humanists in Latin letters — with the activities of his own manual trade, and conceptualized these ideas on behalf of the guild of stonemasons? Did artists and humanists have a mutual recognition of their parallel *all'antica* strategies of representation? Nanni di Banco's civic life addresses these questions. Nanni's biography and family history show him to have been a person wholly integrated with the ideals and practices of his native society. His guild activity and public engagement, which put him in direct contact with such "civic humanist" statesmen as Giovanni di Gherardo da Prato and Lorenzo Ridolfi, reveal that the devotion to guild and *patria* expressed in the *Quattro Coronati* was an integral aspect of the sculptor's own life.

The doings of his father (Antonio di Banco) and uncle (Jacopo di Niccolò Succhielli) buttressed Nanni di Banco's own civic aspirations and success. The pattern of guild, civic, and cathedral activity initiated by Antonio di Banco was followed by Nanni on a greater and more synthetic scale. In addition to his own imposing body of public sculpture, Nanni's name was linked with those of Filippo Brunelleschi (in architecture) and Lorenzo Ridolfi (in government) in the same year. Nanni di Banco had fulfilled an early Renaissance ideal, the visualization of which is so deeply fathomed in his *Quattro Coronati*.

Public art was essential to the self-representation of the Renaissance city, and in Florence the republic spoke most eloquently through the language of sculpture. As such, the *Quattro Coronati* is a quintessential self-representation of civic responsibility and consensus in Renaissance Florence.

Falco, Jacopo di Niccolò Succhielli, and Antonio di Banco di Falco) were, or had been, major figures in the commissioning group and in the subjects portrayed in the tabernacle ensemble. In the older art-historical literature, scholars had gone so far as to identify the "youngest" of the saints (fig. 13) as a self-portrait and the "eldest" (fig. 14) as a portrait of Antonio di Banco.[66] Portrait hunting in Renaissance art can be an empty and anachronistic venture, and (especially in light of the "portraits" by Fra Angelico and Vasari) it is not likely that Nanni meant to portray himself in the young *coronato*. However, some interpretive speculation about contemporary portrait references (Antonio di Banco?) in the group may be entertained, especially since Antonio di Banco was presumably one of the four guild consuls who assigned this monument to Nanni di Banco, and died (*capomaestro* and guild consul) in 1415 when the *Quattro Coronati* was underway.

Indeed, if the social history of art is to do more than place a backdrop of "historical context" behind the work

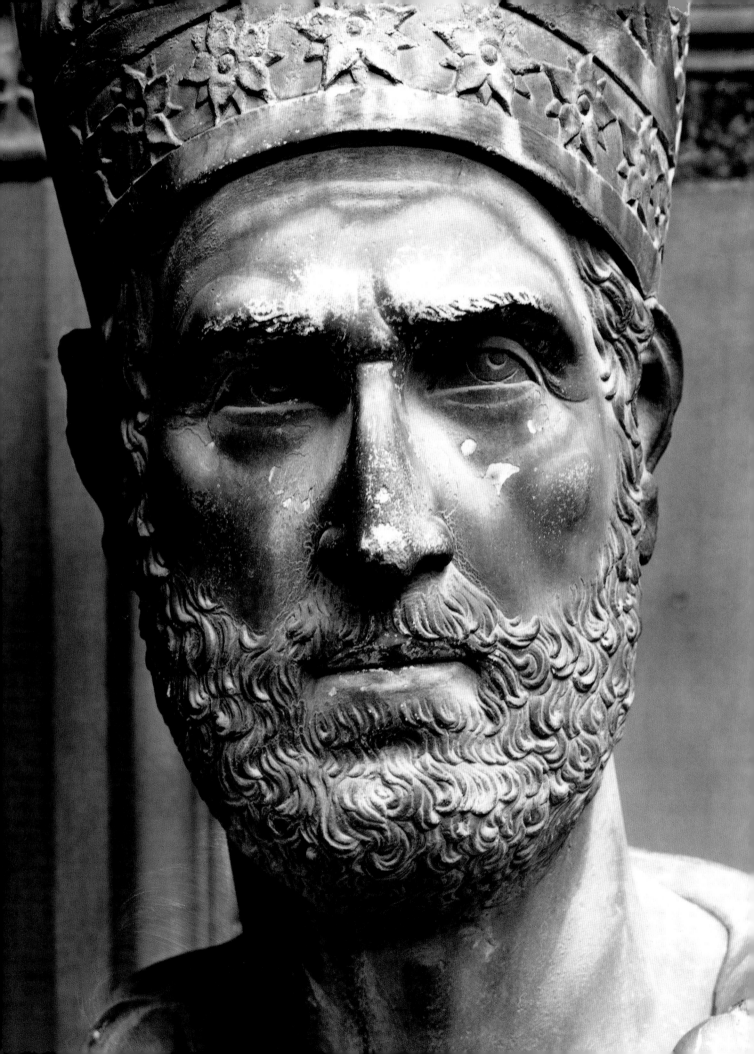

3 . THE CLASSICAL TRADITION: NANNI DI BANCO AND DONATELLO

IN ESSENCE WE ARE DESCENDED FROM OUR ANCIENT ROMAN FATHERS;
WE HAVE SHOWN THIS IN VIRTUE AND IN SUBSTANCE.

—*Giovanni di Pagolo Morelli*

NANNI DI BANCO is frequently characterized as the artist whose sculpture bridged the trecento "gothic" style and the revival of classical forms that was to ignite the true Renaissance in quattrocento Florence. Indeed, a startling discontinuity is apparent between Nanni di Banco's two major works, the *Quattro Coronati* at Orsanmichele (cat. 1-6) and the *Assumption of the Virgin* at the Porta della Mandorla (cat. 1-12). Whereas the *Quattro Coronati* ensemble is notoriously down-to-earth, concrete, measured, and classical, the *Assumption* could be described in terms of lyricism, spirituality, and flight. The content of these images may be best studied in terms of formal gravity and transcendence: each is composed in such a way that formal vocabulary constructs specific meaning appropriate to its subject and site.[1] If the *Quattro Coronati* is a humanist oration extolling a masculine, guild-driven, republican ethos, the *Assumption* is a specifically Florentine hymn to the feminine ideal of the Virgin Mary. In other words, the basic form of each work (oration versus hymn might be one useful metaphor) differs according to its sacro-civic function. The art-historical literature, however, has tended to represent this formal schism as one of artistic personality rather

than meaning, and has envisioned the intellect of Nanni di Banco as divided in two between a boundless enthusiasm for classicism on one side of the spectrum and an intense nostalgia for "gothic" traditions at the other. If intellectual trends could be packaged into discrete one-hundred-year units, Nanni would have had, as it were, one foot in each century. But this historically over-determined idea of Nanni's career is ultimately misleading, and has led scholars to assign such works as the fascinating *Annunciation* group in the Museo dell'Opera del Duomo (cat. 11-6) to Nanni di Banco simply because the pair of statues was perceived as the work of a "progressive," classicizing artist still "rooted" in the trecento. (The truth is that even a casual examination of the *Annunciation* figures shows that they bear little visual resemblance to Nanni di Banco's known works, and that the attribution is an academic convenience.)[2] In order for Nanni di Banco's artistic personality and art-historical role to be refined, each work need be considered on its own terms, according to how form produces meaning. The predominantly lyrical vocabulary of forms used in the *Assumption of the Virgin* will be analyzed specifically in chapter 5. The present chapter will explore Nanni di Banco's relationship with Graeco-Roman art.

Nanni di Banco may have visited Rome around 1409 or

Nanni di Banco, *Saint Eligius* (cat. 1-10, detail), ca. 1417–21. Marble. Orsanmichele, Florence

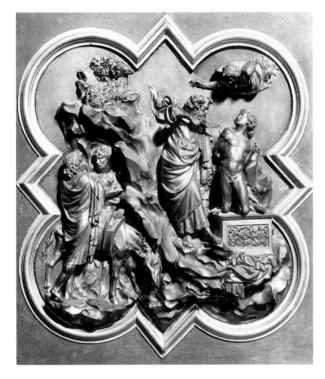

Fig. 15. Lorenzo Ghiberti, *Abraham and Isaac*, 1401. Gilded bronze, 17 ¾ x 15 in. (45 x 38 cm). Museo Nazionale del Bargello, Florence

comprehensive naturalism. In sculptural terms, Nanni's interpretation of ancient art was shaped considerably by local tradition, that is, the works of his medieval predecessors in Florence and Pisa. The catalogues of this study enumerate individual ancient and medieval sources for various works. Here I will discuss three *all'antica* themes of Nanni di Banco's art: first, that of the heroic youth; second, that of Roman portraits as sources for the rendition of the male head; and third, the question of the manifestation of ancient literary sources, such as Cicero's treatise *On the Orator* or Pliny's *Natural History*, in Nanni's works.

The classicizing male figure as interpreted in sculpture by Nanni di Banco, Ghiberti, and Donatello set the tone for the favored subjects, forms, and mediums of the Italian Renaissance. A familiar touchstone is Ghiberti's nude *Isaac* in the competition relief of 1401, which has been described as the first Renaissance figure to combine classicism and naturalism to a new end (fig. 15).[4] Around the turn of the quattrocento Nanni di Banco participated in the development of an idealized, heroic, youthful man in contrapposto—a type that was strongly rooted in the Graeco-Roman tradition from the sculpture of Polyclitus, Praxiteles, and Lysippus through the bronze and marble nudes of the later Roman empire. Nanni's works in this vein include the *Hercules* relief of ca. 1395 (cat. 1-1), the *Atlante* of around 1407–8 (cat. 1-3), the *Man of Sorrows* of 1407–9 (cat. 1-2), and most importantly, the *Isaiah* of 1408 (cat. 1-4). The young apostle *Saint Philip* at Orsanmichele of 1410–12 (cat. 1-7) is also a product of the idealizing, heroic aspect of Nanni's sculpture.[5]

The precocious *Hercules* relief in the lower left reveal of the Porta della Mandorla, which is here attributed to Nanni di Banco, is small in size but monumental in scope (fig. 16). The most poignant *locus classicus* for the cycle of *Hercules* reliefs of the Porta della Mandorla is found in a pilaster of the Severan Basilica at Leptis Magna, where the hero's story unfolds in vegetally framed modules (fig. 17).[6] Whether there was a similar frieze close enough to Florence to serve as a proper "model" is not known. Krautheimer offered a compelling prototype for the present *Hercules* figure, namely a third-century Roman relief with a nude *Apollo* standing in symmetrically curving acanthus leaves, one of a set of four pilasters that was present on the interior facade of Old Saint Peter's, Rome.[7] Since the same basic design module was used for all the reveal friezes of the Porta della Mandorla's "first campaign" of decoration, the Saint Peter's model would have to have been transmitted by means of a template

1410, if not earlier, where he would have had abundant contact with antiquities of all kinds.[3] There is no record that he did travel to Rome, but aside from his responsibilities in a family business based in Florence, there is no reason to envision Nanni as less cosmopolitan than Brunelleschi or Donatello in this regard. We simply do not know. But whether or not he ever visited Rome, Nanni di Banco's interpretation of the antique was formed primarily by his experience as a Florentine. Nanni's participation in humanist circles has been discussed in the first two chapters, where it emerged that his interaction with the literati may have been constant and deep. At this early point in the Renaissance, however, little or no distinction was made by humanist connoisseurs among ancient objects of diverse epochs or places; and in any case, Nanni di Banco's approach to ancient sculptural models tended to be synthetic and inclusive, rather than categorically archaeological or historicist. Conceptual references to the art of antiquity may have been present in Nanni's work to some extent, but his classicism was for the most part applied rather than theoretical. Passages from models as diverse as Republican tradesmen's funerary reliefs, orator statues, portraits of citizens, late Imperial portrait heads, and various sarcophagi were incorporated into his works *ad libertas*, as means to expressing a

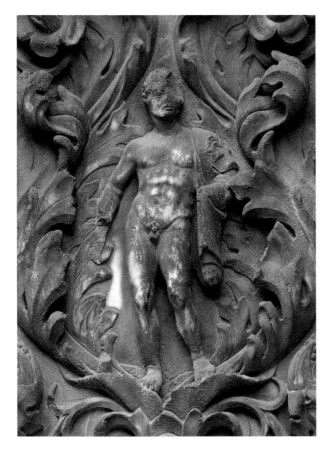

Fig. 16. Nanni di Banco, *Hercules* (cat. 1-1, detail), ca. 1395. Marble. Porta della Mandorla, Santa Maria del Fiore, Florence

Fig. 17. *Labors of Hercules*, A.D. 203. Marble pilaster. Severan Basilica, Leptis Magna

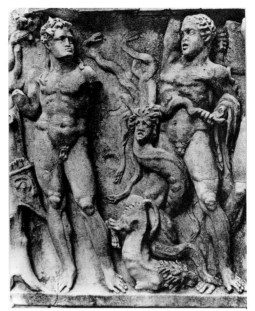

Fig. 18. Labors of Hercules sarcophagus (detail), 2nd century after Christ. Marble. Boboli Gardens, Florence

(drawing) provided by *capomaestro* Lorenzo di Filippo or (less likely) by one of the merchant Operai on a planning council around 1391.[8] It is not known whether Florentine stonemasons such as Lorenzo di Filippo had occasion to travel to Rome on a regular basis. If antique designs similar to the *Apollo* relief or the Leptis Magna *Hercules* frieze were used as direct matrices for any parts of the Porta della Mandorla friezes, which were group projects, there may well have been comparable examples closer to hand.

As it was, the ubiquity and variety of Roman sarcophagi throughout Italy made them the most important ancient resource for medieval and early Renaissance artists, providing extensive menus of individual figure types and details.[9] Sculptors in Nanni di Banco's immediate circle at the Opera del Duomo were said to be particular connoisseurs of Roman sarcophagi: in an anecdote of 1407 passed on by Vasari, Filippo Brunelleschi walked all the way to Cortona on the spur of the moment to see a second-century battle sarcophagus recommended by Donatello in a parish church there.[10] Ancient sarcophagi were abundant in Tuscany throughout the later Middle Ages, and the size and scale of their relief decoration was eminently suitable for adaptation by individual artists in group efforts such as the friezes of a portal. It is very likely that the Porta della Mandorla *Hercules* was studied from an example such as the beardless nude hero of the second-century *Labors of Hercules* sarcophagus (fig. 18) now in the lower Boboli Gardens

near Porta Romana. An influence of this kind is particularly evident in the energetic modeling of muscles and of large, heavy facial features of the *Hercules* on the northeast portal.[11] The Porta della Mandorla *Hercules* (like its antique counterpart in the Boboli) is conceived in such a manner that the figure strives outward from the slab: there is a muscularity in the sculptural concept as well as in the heroic subject that would remain a constant feature of Nanni di Banco's relief sculpture.

A few steps to the left of the Porta della Mandorla at Santa Maria del Fiore, a nude, winged, console *Atlante* by Nanni di Banco (cat. 1-3) supports a tribune window with preternatural muscularity. Nanni di Banco's *Atlante* belongs to the *all'antica* tradition of the classical putto, which found its fullest development in Renaissance art of the sixteenth century. Nanni's putto *Atlante* is one of the earliest developed examples of its kind, and therefore of consequence for the history of Renaissance sculpture. The *Atlante* is distinguished by a herculean energy that allows the figure to assume a weight-bearing role in contrapposto, and to resist the force of the architecture he "supports": his engaged arm reiterates the ninety-degree angle of the bracket, with hands braced at the hip, and the torso and thighs tensed forward, so that the knees form another right angle in solid as well as plane space, as if the figure were to complete the rectangular block from which it was carved. These heroic qualities are particularly evident as against the console *atlanti* made by Jacopo di Piero Guidi for the window of the southeast tribune about a decade earlier (fig. 89). In fact, Nanni's *Atlante* reads as a "correction" of the earlier model.[12] The bracing of this figure's heels against the window bracket is repeated in the left leg of the putto from the socle relief of the *Quattro Coronati* at Orsanmichele, itself a statue of a statue. Both of Nanni di Banco's putti deal with a proto-Michelangelesque theme: that of freeing the figure from the block of stone of which it is carved.[13] As the *Atlante* pushes up at the shoulders to support weight, the socle putto arches out as if to free himself (with the help of the sculptor) from the slab. Such a rendition of the Roman putto, most commonly found in third-century sarcophagus reliefs, could have been inspired by heroic images of the baby Caligula, small portable bronze putti, or oft-copied ensembles such as the famous *Boy with a Goose* at the Capitoline Museum. But we also feel the presence of prototypes such as Labors of Hercules sarcophagi in the adultlike strength of the *Atlante*'s chest and arms.

Fig. 19. Andrea Pisano, *Hercules and Cacus*, 1334–37. Marble, 32 ¾ x 27 ⅛ in. (83 x 69 cm). Museo dell'Opera del Duomo, Florence

Nanni di Banco's *Man of Sorrows* (cat. 1-2) on the Porta della Mandorla is related to the earlier *Hercules* of the same portal in terms of a strong projection of the chest, and heavy, forcefully modeled limbs. The heroically muscular shoulders, torso, and arms are portrayed *all'antica* in organic, naturalistic terms, and brought forth in very high relief — almost in the round. This is the earliest Florentine *Man of Sorrows* to depart from the type exemplified by Giovanni di Balduccio's *Pietà* from above the Porta dei Canonici, which features an elongated head, schematized hair and beard, and an essentially flat, rectangular formation of the torso and arms. Christ's powerful but heavy arms may well have been inspired by the Graeco-Roman "dead hero" type, most likely known to Nanni through the various battle sarcophagi that were so commonly spread throughout the peninsula. Indeed, such a fragment of an Orestes sarcophagus was present in the Florentine cathedral complex throughout the centuries.[14] Leon Battista Alberti later recommended that artists study a Meleager relief: "They praise a 'historia' in Rome, in which the dead Meleager is being carried away [. . .] in the dead man [all the limbs and members] hang loose; hands, fingers, neck, all droop inertly down, all combine together to represent death."[15]

Notwithstanding the multitude of resources present in sarcophagus reliefs, it is important to establish that the Porta

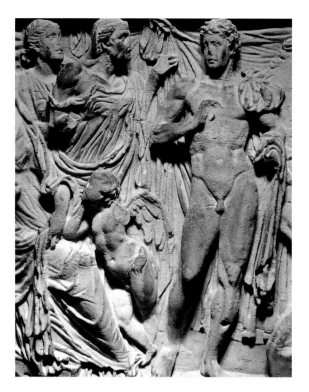

Fig. 20. Nicola Pisano, *Fortitude as Daniel* (detail of pulpit), 1262. Marble. Baptistry, Pisa

Fig. 21. *Hippolytus* (detail of Phaedra sarcophagus), late 2nd century after Christ. Marble, ca. 37 x 96 in. (94 x 243 cm). Camposanto, Pisa

della Mandorla *Hercules* and *Man of Sorrows* belong to an enduring Tuscan classical tradition that was fundamental to Nanni di Banco's artistic formation; and any identification of individual antique models must be cast in this light. Had Nanni di Banco come upon a Labors of Hercules, or a Meleager sarcophagus as fresh inspiration, he would have been primed to integrate them at the cathedral portal according to specific aspects of a medieval tradition in the sculpture of Florence and Pisa. As was the rule for most of Nanni di Banco's relief sculpture, the Porta della Mandorla *Hercules* also acknowledges close study of the antique as mediated by Andrea Pisano's panels from the Florentine Campanile: it follows the *Hercules and Cacus* panel (fig. 19) in several details, such as Hercules's forearm draped with a lion skin.[16]

An early attention to Pisan sculpture was crucial for the development of a monumental *all'antica* style in Florence, and it is clear that Nanni di Banco traveled to Pisa with some frequency throughout his life, as did many Florentine sculptors and stonemasons. Pisa, with its wealth of antiquities as well as Romanesque and trecento works, must have been a kind of "museum" for young Florentine sculptors of Nanni's generation who were attracted to monumental forms such as those they knew in the works of Arnolfo di Cambio on the facade of their own cathedral.[17]

The fame of Nicola Pisano and the Pisan cathedral complex was alive in the late trecento and early quattrocento, and, according to the *Commentaries* of Lorenzo Ghiberti, the most respected Italian sculptors were the "old masters" of the Pisan school: Nicola, Giovanni, and Andrea Pisano.[18]

The primary source of white marble for Florence was Carrara, where the stones were quarried; they were then transported down the Arno to Florence by way of Pisa. As a contractor of marbles Antonio di Banco dealt with the Carrara-based quarrier Maffiolo di Giovanni da Como.[19] Antonio di Banco had been a purveyor of stones since the 1370s, and he traveled to Pisa and Carrara with Nanni to acquire marbles, prepare piecework, and conduct business.[20] Nanni would presumably have accompanied his father frequently during the period of his apprenticeship, contributing to the manufacture of piecework and transportation of marbles, so that acquaintance with the Pisan masters would have constituted an early phase of his education.

At the Pisan Baptistry, Nicola Pisano's *Fortitude as Daniel* of 1262, which itself bears a strong connection to late Roman and early Christian prototypes, stood as a particularly strong representation of the youthful Herculean *all'antica* type (fig. 20).[21] The *Daniel* together with the famous nude *Hippolytus* from the Phaedra sarcophagus at the Cam-

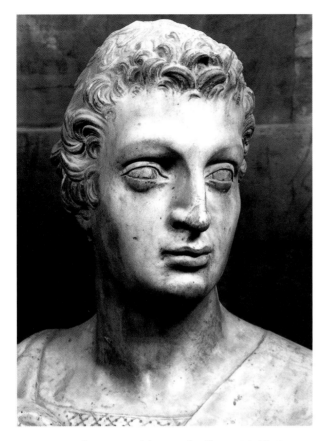

Fig. 22. Nanni di Banco, *Isaiah* (cat. 1-4, detail), 1408. Marble. Santa Maria del Fiore, Florence

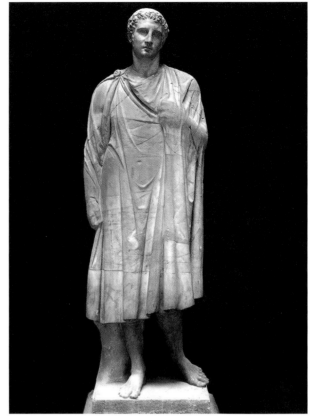

Fig. 23. *Composite Statue of a Youth*. Marble pastiche, height 75 ⅝ in. (192 cm). Casa Buonarroti, Florence

posanto in Pisa (fig. 21) served as strong precedents for Nanni's late-trecento *Hercules* and for the more securely attributed *Isaiah* of 1408.[22] Nicola's *Daniel* also served as an important prototype for the iconographic polyvalences associated with Hercules-Fortitude-David figures in Florentine art, a concept that burgeoned in Nanni's work with the portrayal of the prophet *Isaiah* and the apostle *Philip* as heroic youths *all'antica*.

Nanni di Banco had ample opportunity to study Nicola Pisano's *Daniel*, and, if closer documentation were needed, Antonio di Banco's payments for stones during 1407 indicate that Nanni was likely to have been to Pisa just prior to carving the *Isaiah*.[23] The weighty, squarish type of the head, facial features, and throat of the *Isaiah*, along with the large muscular shoulders, arms, and chest, and the overdevelopment of the relaxed leg reveal close observation of Nicola Pisano's interpretation of the antique. The formation of the head and neck of the *Isaiah* (especially the nose, mouth, chin, and jawline) deliberately revives techniques peculiar to Nicola Pisano's vision of Roman antiquity. Like the *Hercules* of the Porta della Mandorla, there is

no question that the *Isaiah*, too, was informed by the observation of ancient nude figures such as the Hercules from the Boboli Labors of Hercules sarcophagus. The *Isaiah*, like Nanni's relief *Man of Sorrows* of the same time, demonstrates an outspoken concern for the articulation of muscles in the chest and limbs, which must have been studied from Nicola Pisano's *Daniel* and from ancient nudes, which were primarily accessible to Nanni through sarcophagi such as the Phaedra and Labors of Hercules. Beneath his swirling gothic costume, the *Isaiah* is a beardless young hero in the classical mode.

We have already seen (chapter 1) that the visual impact of Nanni di Banco's *Isaiah* prompted a change of thinking about sculpture in Florence. It is clear that upon the creation of Nanni's *Isaiah* in 1408, the program of twelve prophets to surmount the tribune buttresses of the cathedral was tacitly changed, by patrons and sculptors alike, to the idea of a series of heroes *all'antica*, a project that may have inspired Brunelleschi's *Hercules* snowman of 1409, and eventually culminated in Michelangelo's *David* of 1504. The *Prophet* cycle, instead, was quickly shifted back to the Campanile niches,

where Donatello continued Andrea Pisano's *Prophet and Sibyl* statues, creating a series of soul-searching figures, including the *Beardless Prophet*, the *Jeremiah*, and the *Zuccone*.

The head of Donatello's marble *David*, which was made in competition with the *Isaiah*, is carved with the stylized refinement that typified the so-called International Gothic style: hard, almond-shaped eyes and a delicate nose and mouth are centered in a small, smooth, oval face (fig. 91). Nanni's *Isaiah*, on the other hand, already searches for a different type of adolescent masculinity — one that pushes the modeling of facial features to expression without any sort of courtly restraint. The eyes are swollen within deeply recessed sockets; square jaw and cheeks are fully projected with bone structure, muscle, and flesh; the plasticity of these heavyset features is enhanced by a deep undercutting and a subtle asymmetry of modeling throughout (fig. 22). Apropos the cultural trajectory of this heroic style, it is revealing that over the years the *Isaiah* had erroneously come to be thought of as an actual portrait of the humanist scholar Gianozzo Manetti.[24]

The *Hercules, Isaiah,* and *Saint Philip* were unusual for their idealized youthful faces as well as their classically inspired postures. In addition to having studied Pisan models and ancient sarcophagi, Nanni di Banco probably had access to at least one life-size, three-dimensional head of *Apollo*, most likely a Roman copy of a Greek original, such as one presently conserved in a composite statue at the Casa Buonarroti (fig. 23). Nanni's application of this *Apollo* type is present in the facial structure and hair of the *Isaiah*. The Apollonian ideal is interpreted with particular loveliness in the *Saint Philip* at Orsanmichele, where the (once gilded) hair of the youth is fashioned in massive tendrils *all'antica*, the skin of his face and gaze of his eyes are untroubled, and his full lips are parted in speech (fig. 24). Whereas the connection of *Saint Philip*'s gaze to the urban scene and his speaking mouth work in harmonious accord with the naturalizing torsion of the entire sculptured organism, the artist's primary concern here was not the pursuit of verism — at least not the kind of verism that was expressed in the *Coronati* or the *Saint Luke* — but rather the demonstration of a particular aesthetic of ideal youth that was learned from ancient sculpture. The smooth, uniformly hard surface of the skin aspires to the organic unity that is a distinctive trait of antique portraiture of the Antinoüs type.[25] Busts of Antinoüs, such as the one now in Palazzo Pitti (fig. 25), were commonly available to early Renaissance sculptors, as

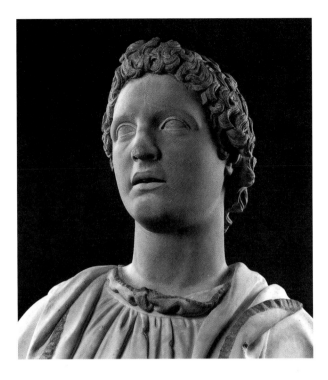

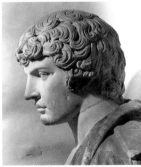

Fig. 24. Nanni di Banco, *Saint Philip* (cat. 1-7, detail after restoration of 1989), ca. 1410–12. Marble. Orsanmichele, Florence

Fig. 25. *Portrait of Antinoüs* (detail), 2nd century after Christ. Marble, entire bust height 37 ¾ in. (96 cm). Palazzo Pitti, Florence

we know from the Antinoüs head in Pisa, which was recarved around 1410 (cat. 11-14). The features of the *Saint Philip* are modeled in a broad, summarizing manner to emphasize the unified volume of the head rather than individualized details of the surface. Unlike the heads of the *Coronati*, individual features are not contrasted one against another; linear textures are not inscribed into the surface; remembered details are not added as eclectic parts of a whole. Instead Nanni di Banco has struck what historians of ancient art identify as a distinctively Graeco-Roman harmony of form and color between face and head.[26] Even the coiffeur seems to consist of a single modeled mass that maintains its own plastic volume — a form composed of

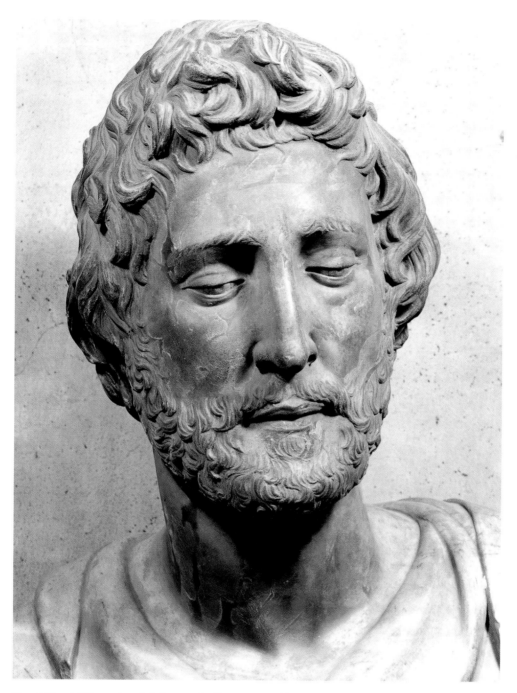

Fig. 26. Nanni di Banco, *Saint Luke* (cat. 1-5, detail), 1412/13. Marble. Museo dell'Opera del Duomo, Florence

fictive matter as substantive as the flesh of the face. The type of model consulted for the head of the *Saint Philip* may have been a Roman copy of a Greek original in the style of Scopas. Nanni's carving, however, in spite of the fleshy cheeks, tall columnar neck, articulation of the chin with strong indentation under the full lower lip, and semi-open mouth, never really gives way to the Lysippian softness that characterizes the carving of the *Buonarroti Youth* and other pagan works like it. Nor does it take on the whistfully nar-

cissistic mood of the Pitti *Antinoüs*. In the *Saint Philip*, the dreamy, somewhat absent countenances of certain classical prototypes of idealized youth are replaced by a crispness indicating psychological presence: this is apparent, for example, in the incision of the irises and pupils, in the firm articulation of the lower eyelids, and even in the visible presence of teeth. The quality of psychological interaction brings back the idea (chapter 2) that in Nanni's oeuvre the ideal of invincible, unblemished youth was countered by an

equally important current of verism. This verism (a term coined to describe a particular quality of Roman Republican portraits) was also nourished in Nanni's work by the study of ancient heads.[27]

Nanni di Banco began the study of individualized physiognomic personality through a deeply integrated awareness of nature, human psychology, and ancient models.[28] The head of Nanni di Banco's Evangelist *Saint Luke* for the cathedral facade, for instance, announced an unprecedented fusion of classicism and realism in this aspect of Florentine art (fig. 26). The pose of the head, which is freed from the confines of a masking, patriarchal beard, creates a naturalistic equipoise in both physical and psychological terms. The exposed columnar neck turns slightly toward the raised left shoulder with the head itself tilted up and the eyelids correspondingly lowered: these features counterbalance one another naturalistically, as though the spine, head, and eyelids were apprehended in a fleeting moment. Saint Luke's semiclosed eyes, lowered in natural equilibrium with the upward tilt of the head, express potential for lifelike mobility—a kind of quiet contrapposto of the face.

In this phase of Nanni's career as a figurative sculptor, his development is inextricably interbraided with that of Donatello. Nevertheless, the two sculptors had distinctly different visions. It is in the Evangelists *Saint Luke* (1408–13) (cat. 1-5) and *Saint John* (1409–15) (fig. 27) that the contrasting approaches of Nanni and Donatello to the human head are first articulated. Sacred revelation is the subject of Donatello's statue, whereas a study of human comprehension is the main concern of Nanni's work, which was completed a full two years earlier. Donatello's interpretation of the *Saint John* is the more conventional approach, as it emphasizes the ecclesiastical-symbolic presence of the Evangelist in which we are confronted with a bearded, unknowable figure of indefinably advanced age and heroic virility. In this way, Donatello's *Saint John* possesses a conventional *terribilità* as imagined through the centuries of Western art for the representation of Zeus, Moses, and God the Eternal Father.[29] Nanni's *Saint Luke*, instead, belongs to the world of human emotions and human knowledge. The traditional patriarchal beard is stripped away again (as it was in the *Hercules, Isaiah,* and *Saint Philip*), this time to reveal the features not of a heroic youth but of an intelligent middle-aged man. Short curls of beard describe, rather than mask the contours of the face. The introspective gaze contained in the upward tilt of the head,

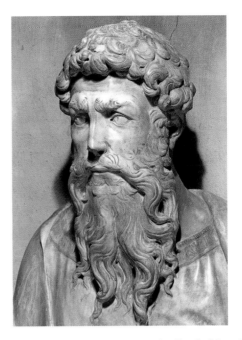

Fig. 27. Donatello, *Saint John Evangelist* (detail of fig. 97), 1415. Marble. Museo dell'Opera del Duomo, Florence

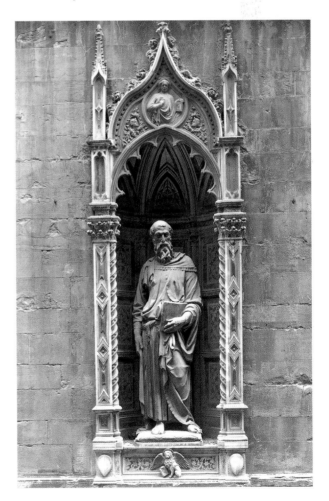

Fig. 28. Donatello, *Saint Mark*, 1411–13. Marble, height 93 in. (236 cm). Orsanmichele, Florence

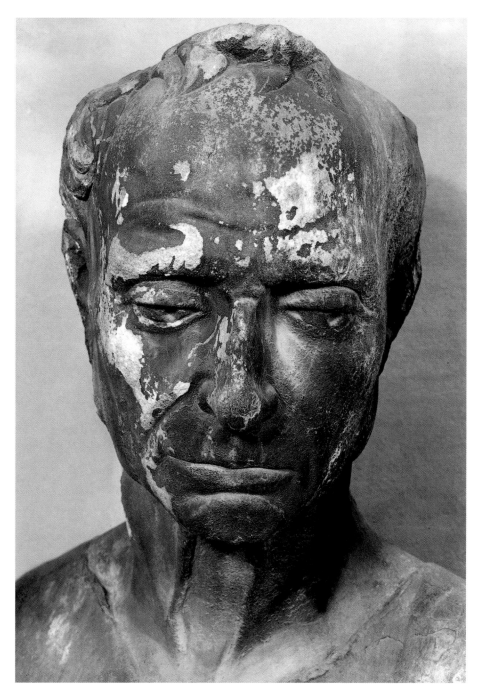

Fig. 29. Donatello, *Beardless Prophet* (detail), ca. 1416–18. Marble. Museo dell'Opera del Duomo, Florence

downward cast of the eyes, and subtle modulations of the surface of the face absorbs, rather than distances, the beholder. With the *Saint Luke* the inscrutable visionary type is replaced with a carefully studied normative realism: we are meant to be in the presence of a self-conscious individual personality.[30]

At Orsanmichele, a comparison similar to that of the Evangelists *Luke* and *John* can be made between Donatello's standing *Saint Mark* (fig. 28) made for the guild of second-hand dealers *(rigattieri)* and Nanni's *Quattro Coronati*. The head of Donatello's *Saint Mark* belongs to the same type as that of the *Saint John Evangelist*: a long forked beard creates a distracting mask that joins, as if in relief, the head to the torso. Although less remote from earthly cares than the Evangelist *Saint John*, the *Saint Mark* is in no way identifiable with the tradesman or merchant in the street below.[31] Nanni di Banco in the *Quattro Coronati*, on the other hand, has created four distinctly individual — even idiosyncratic

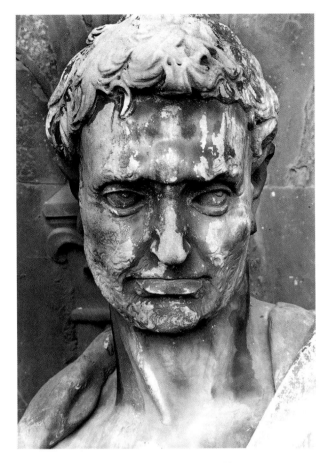

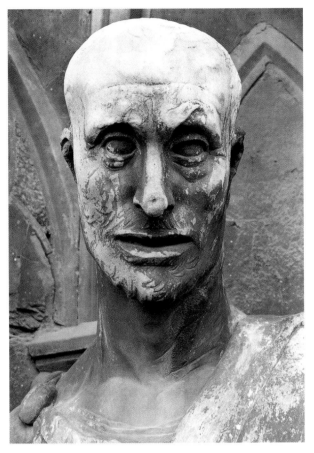

Fig. 30. Donatello, *Jeremiah* (detail), ca. 1427. Marble.
Museo dell'Opera del Duomo, Florence

Fig. 31. Donatello, *Lo Zuccone* (detail), ca. 1423. Marble.
Museo dell'Opera del Duomo, Florence

— characters, no one of which adheres to a preestablished conventional type. An important essay toward verism is undertaken in the head of the third saint from the left (fig. 12), which was probably carved soon after the *Saint Luke*. Here, a short beard reveals the tendons of the neck and defines the contours of the face. The weight of flesh in cheeks and nose is disposed imperfectly, and this is reflected in the organic modulation of the skin. Heavy wrinkles in the upper and lower eyelids are naturalistically uneven, as is the projection of the brow. Nanni's figures show the effects of time: whereas Donatello's *Saint Mark* (like his *Saint John*) is charged with a superhuman intensity of energy, the faces of the *Quattro Coronati* are quite literalistically imprinted with signs of physical and mental fatigue. If the *Saint Mark* is a being of unfathomable age, the head of Nanni's saint communicates a passage of time measurable in terms of human biological experience.

Although the two artists had set out with radically different intentions in carving the heads of monumental statues, it did not take long for Donatello to comprehend the

potential of Nanni di Banco's vision.[32] When Nanni died in 1421, Donatello had already embarked upon the series of new *Prophets* for the Campanile of the cathedral. The *Prophets* were first begun around 1416–18, and their production would extend into the 1430s.[33] Donatello's perception of Nanni's verism surfaces in the *Prophet* series, especially in the so-called *Beardless Prophet* (fig. 29), the *Jeremiah* (fig. 30), and the figure known as *Lo Zuccone* (fig. 31). It has already been mentioned that Nanni di Banco was Donatello's guarantor to the Opera del Duomo for two payments related to this series of statues, and the interface between competition and consensus is in this instance quite tangible in visual terms as well.[34] The *Jeremiah* has long been admired for its veristic characterization of an earthbound man, earning it the nickname "Il Popolano." During the sixteenth century a legend declared that the head of the *Jeremiah* was a portrait likeness of Francesco Soderini, archenemy of the Medici family.[35] The "portrait-ness" of this head was reaffirmed in the nineteenth century, when it (along with the *Zuccone*) was fashioned into a plaster bust *all'antica* to be apprehended

Fig. 32. *Bust of Donatello's "Jeremiah"* 19th century. Plaster, height ca. 12 in. (31 cm). Istituto Statale dell'Arte, Gipsoteca, Florence

Fig. 33. Cast from the death mask of Filippo Brunelleschi, 1446. White stucco. Museo dell'Opera del Duomo, Florence

eye-to-eye (fig. 32).[36] The short stubbly beard introduced by Nanni di Banco at least a decade earlier has been adopted in the *Jeremiah* to reveal the tendons of a strained neck and enormous tension in the set of the jaw and the mouth. Here, the obsessive energy that we know from the *Saint John* and the *Saint Mark* has been specified according to Nanni's precepts, and what emerges is a human being capable of anxiety and aggression.[37] A number of stories sprang up around the *Zuccone*. The most believable one, supposedly garnered firsthand from a workshop assistant, claims that when Donatello was carving the figure he would gaze up at its face and say, "Speak! Speak or may the bloody dysentery take you!"[38] The anecdote suggests not only that the statue could have come alive if endowed with the power of speech; but also that it was already so human as to be vulnerable to a "blood-and-guts" physical disease. The speaking lips, protruding Adam's apple, and short beard were devices first introduced in Nanni di Banco's statues: the *Saint Luke*, the *Saint Philip*, the two right-hand *Coronati*, and the *Saint Eligius*. In the *Zuccone* these features have been reworked so dramatically that the aging neck, broad mouth, and imposing cranium are left, as it were, naked, to reveal physical and spiritual pain.[39]

Donatello came closest to the spirit of Nanni's verism in the *Beardless Prophet*: it is as though quite fresh from the experience of the *Saint Luke* and the *Quattro Coronati*, Donatello produced a synthetically superior version of the *testa virile* as it had been set forth by Nanni, and the organic naturalism is here tuned not to the neurotic humanity of the *Zuccone*, but to the more affirmative gravity first stated by Nanni di Banco himself. Donatello rendered the image of a self-conscious human individual, whose countenance registers the actual and universal experiences of growth, maturity, sickness, and decay, with extraordinary sympathy. It is therefore somehow appropriate that Giulia Brunetti, with a stroke of wit and imagination, proposed this head to be a "portrait" of Filippo Brunelleschi, for the *Beardless Prophet*, not unlike Nanni di Banco's *Saint Luke*, meets us with the startling immediacy and complexity of a real man.[40]

Although the *Beardless Prophet* was probably not intended as a portrait of Brunelleschi or any other living person, the very notion brings to mind Brunelleschi's death mask (fig. 33), and the possible role of death masks in producing sacred art in the earliest years of the fifteenth century. The few surviving death masks from the fourteenth and fifteenth centuries indicate that even if these casts were

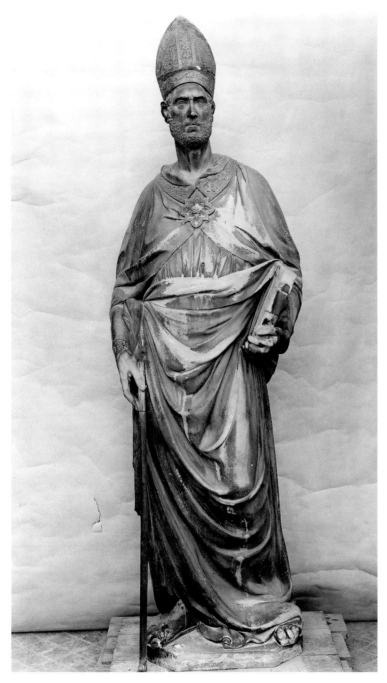

Fig. 34. Nanni di Banco, *Saint Eligius* (cat. 1-10), ca. 1417–21. Marble, height 90 in. (228 cm). Orsanmichele, Florence

used as models for Christian, nonportrait sculpture, a great deal of interpretation would have been needed to transform the visages from being absent to being hyperpresent and psychologically interactive as they are in the works of Nanni di Banco and Donatello.[41]

As stated at the beginning of the chapter, critics have largely neglected Nanni di Banco's experimental ventures, and instead much has been made of the idea that his works express an unresolved compromise between a lingering gothic taste and a supposedly indiscriminate enthusiasm for classical models. An instance of dissonance between gothic and classic is particularly present in one of Nanni di Banco's works, the statue of *Saint Eligius* at Orsanmichele (fig. 34). In the figure of *Saint Eligius*, a French bishop saint, the *all'antica* contrapposto pose itself is securely resolved: the original pastoral staff would have visually reinforced the engagement of the figure's right leg, and an elegant, unified, diagonal sweep of drapery falls persuasively from the supporting hip all around the free leg and foot; the shoulders, arms, and chest pull back or project forth, respectively,

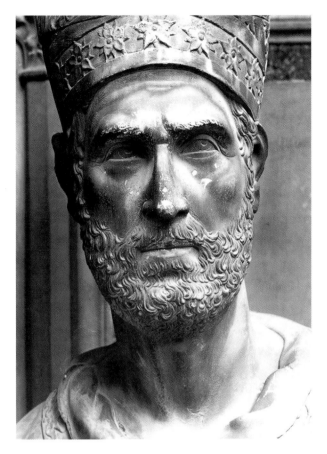 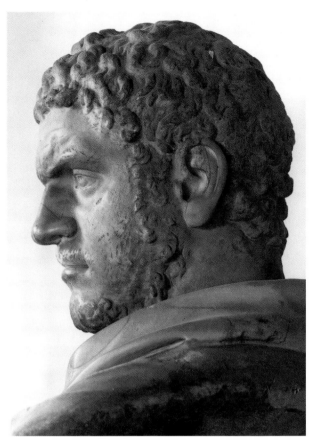

Fig. 35. Nanni di Banco, *Saint Eligius* (cat. 1-10, detail), ca. 1417–21. Marble. Orsanmichele, Florence

Fig. 36. *Portrait of Caracalla*, ca. A.D. 212. Marble, height ca. 13 in. (33 cm). Palazzo Pitti, Florence

in accordance with the central axis of the spine. Eligius's costume, however, consists of the necessary episcopal vestments conflated with classicizing draperies. Although his cloak is secured at the collar with a splendid Gothic quatrefoil brooch, the lower part of Eligius's cloak wraps around the body as if it wanted to become a variation of the diagonally draped togas of the *Quattro Coronati*. Nanni di Banco's Bishop of Noyon is shod in classical sandals and wears no gloves. This composite costume style accents the verticality of the figure, giving him an apparently high-waisted, long-legged contrapposto, which adds to his predominant verticality in the niche (cat. 1-10). What is most startling about the *Saint Eligius* statue is that he greets the public as a Christian (French) cleric with the head of a Roman emperor (fig. 35). Under the weight of an enormous gothic miter, the head of *Saint Eligius*, with its knitted brow and intensely focused gaze, is clearly modeled on a portrait like that of Caracalla (fig. 36). Here in the *Saint Eligius* the facial expression is translated with regard to the ancient model as more serious than angry, and more benign than *terribile*. (We shall see that Donatello would take the oppo-

site attack in his *Prophets* for the Campanile, endowing his Renaissance adaptations of ancient emperor portraits, such as the *Jeremiah*, with qualities of hostility, anguish, and fear.)

Nanni di Banco's *Saint Eligius*, perhaps his most problematic work, in all its sculptural strengths and compromises, may have been inspired by conglomerate statues in which ancient heads were inserted into medieval gothic bodies. From an early date cathedral workshops found it an economical (and aesthetically satisfying) practice to incorporate ancient figurative *spoglie* into Christian monuments. Ancient figures were reused by sculptors like Arnolfo di Cambio in Rome and Orvieto, and it may be that ancient heads were attached to contemporary statues in fourteenth-century Florence. Lack of documentation leaves the issue open to speculation. It would be interesting, however, to imagine the custom of transposed heads having been brought to the Florentine cathedral by way of Arnolfo, with classical heads on Christian bodies serving as precedents for works like the *Saint Eligius*. One plausible prototype may be an *Apostle* (Musée du Louvre, Paris) whose ultimate provenance was the facade of Santa Maria del

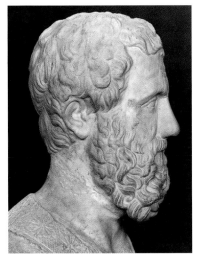

Fig. 38. Detail of fig. 37

Fig. 37. *Composite Statue of Apostle* from Santa Maria del Fiore, 14th-century pastiche. Marble, 73 in. (185 cm). Musée du Louvre, Paris

Fiore (figs. 37, 38).[42] The *Apostle* consists quite literally of an ancient head set into the body of a fourteenth-century statue — one of several such figures from the Florentine Duomo facade. This statue (together with the others, including a now headless bishop sometimes attributed to Giovanni d'Ambrogio) may have already been a pastiche when it stood on the cathedral facade, as early as the 1390s; and the body may even have been carved expressly to be joined with the ancient head.[43] Such composites would then not only have been the purely material precursors, but also the conceptual models, for works like the *Saint Eligius*. In the Florentine Opera del Duomo some statues were created with deliberately prepared sockets for the insertion of separate heads and hands.[44] By the fifteenth century, it seems that heads were transposed somewhat freely according to the taste and preference of the Operai: in an episode of April 1420, for example, Nanni di Bartolo was asked to complete a statue left unfinished by Bernardo Ciuffagni; he was to remove the head carved by Ciuffagni and replace it with a new one.[45] The sort of composite statue that would have featured a head *all'antica* (if not a genuinely ancient one) on the body of a "gothic" saint may have served as a conscious or subliminal model for works like the *Saint Eligius*. For the development of *all'antica* verism in the sculpture of Nanni di Banco, then, one must turn to the issue of the reception of Roman portrait heads by early-fifteenth-century sculptors and their public audiences.

It had long been assumed — as stated by Vasari and before him by Antonio Manetti — that Brunelleschi was the principal mentor to have guided the young Donatello

Fig. 39. *Portrait of a Citizen*, 1st century B.C. Marble, height 14½ in. (37 cm). Vatican Museums, Vatican City

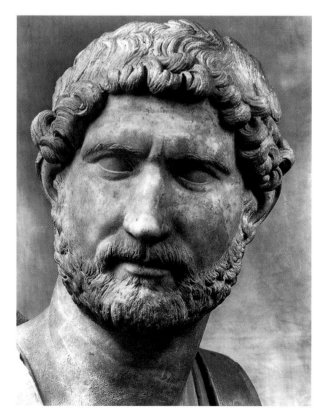

Fig. 40. *Portrait of Hadrian*, ca. A.D. 130. Marble, height 11⅝ in. (29.5 cm). Museo Capitolino, Rome

to an awareness of classical antiquity.[46] One envisions Brunelleschi and Donatello journeying to Rome together as early as 1402, to discover in the classical ruins of that neglected city architectural and sculptural elements such as those that would appear recombined by Donatello in works such as his niche for the Parte Guelfa at Orsanmichele and his Cantoria for the cathedral.[47] Nanni di Banco's critical fortunes, on the other hand, as initiated by Vasari, have characterized him either as a maladroit follower of Donatello, or at best as a slavish academic copyist of cold Roman stones. But we have seen that Nanni di Banco was the first Florentine artist to demonstrate such a concrete interpretation of antique heads, and it is clear that Nanni opened the way for Donatello to use Roman portraits in figural sculpture such as the Campanile *Prophets*.[48] Donatello's *Beardless Prophet* has antecedents in the "warts-and-all" portraits of Republican Rome, such as the *Portrait of a Citizen* (fig. 39). Donatello assimilated and wholly transformed such sources to the image of a remarkably sentient being, with an emotional depth unknown it its Republican models. Likewise the *Jeremiah* is vastly different from the busts of Caracalla that must have served as models; and the *Zuccone* defies the identification of any *locus classicus* at all.

What was Nanni di Banco's relationship to the ancient sources he drew upon for his own sculptured heads? Instead of the arid archaeologist that textbook clichés sometimes claim Nanni to be — a sculptor who stood behind "the moral weight of archaeological accuracy"—he emerges as an artist who was able to wholly transform classical examples through interpretation.[49] The *Saint Luke* invokes the sensuous momentary charm of the portraiture of the Trajanic-Hadrianic age, as in a portrait of Hadrian at the Capitoline Museum in Rome (fig. 40). But at the same time *Saint Luke* possesses a sustained psychological depth that precludes it from having been a mere "version" of any other single work of art. A scrutiny of ancient counterparts shows that whereas the *Saint Luke* recalls images of Hadrian in the texture of the beard and hair, and in the generally intelligent, withdrawn mood of the eyes and facial posture, no single plausible "model" need be extrapolated from among the known Roman portraits of the first or second centuries. In this respect, the heads of the *Quattro Coronati* and *Saint Eligius* are as synthetic and self-sustaining as that of the *Saint Luke*. The bearded statue at the outer left of the group of *Coronati*, the "oldest" of the saints (fig. 14), has a vaguely Aurelian or Antonine air, yet it is not to be identified with any one par-

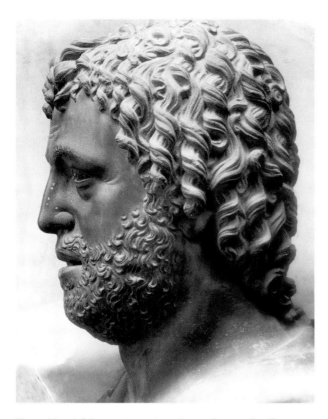

Fig. 41. Nanni di Banco, *Quattro Santi Coronati* (cat. 1-6, detail), ca. 1409–16/17. Marble. Orsanmichele, Florence

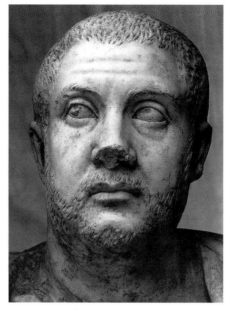

Fig. 42. *Portrait of Balbinus* (detail of figure on sarcophagus lid), A.D. 238. Marble. Catacomb of Praetextatus, Rome

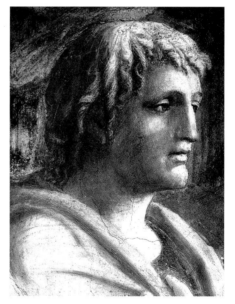

Fig. 43. Masaccio, *Tribute Money* (detail of Saint John Evangelist), 1424–28. Fresco. Santa Maria del Carmine, Florence

ticular portrait of Marcus Aurelius. The speaking saint at the outer right of the group, with its corkscrew curls, heavy jowls, and close-cropped beard (fig. 41) can be related in certain of its details to third-century Imperial sculpture, such as portraits of Balbinus (fig. 42).[50] When placed next to such portraits, however, the head of Nanni's saint communicates a warmer, more sympathetic, even humorous, presentation of a personality than was ever to be found in the portraits of rulers or ancestors produced in antiquity. One way to think about this work is to imagine that Nanni di Banco's figure, which is not a portrait, has transformed the emperor-type (Balbinus or Gallienus) into a credible image of "The Fat Woodcarver" of Antonio Manetti's chronicle, who was also a member of the patron guild of *Maestri*. When Masaccio interpreted this statue as *Saint John Evangelist* in his fresco at the Brancacci Chapel, he revised Nanni's sculptured example, smoothing over the eccentric idiosyncracies toward a less local, more idealized and transcendental characterization (fig. 43).[51] The second saint from the left, the "youngest" of the *Quattro Coronati* (fig. 13), has a strong affinity with the early Republican called *Lucius Junius Brutus* at the Palazzo dei Conservatori in Rome, even to the extent that it is carved with a somewhat metallic hardness to the surface (fig. 44).

This closeness may reveal direct visual observation of a work like the *Brutus*, or, as a product of Nanni's imagination with an *ad hoc* mixture of influences from various kinds of Roman portraits, the saint may have simply ended up resembling the *Brutus* in kind.[52]

The "middle-aged" saint (second from the viewer's right) may be taken as a paradigm of Nanni di Banco's

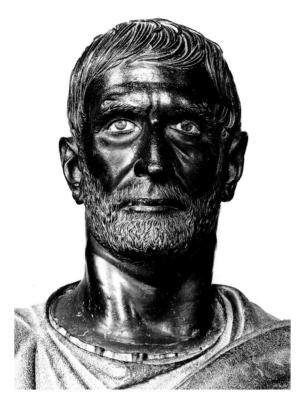

Fig. 44. *Portrait of Lucius Junius Brutus*, 3rd–1st century B.C. Bronze, height 16 ½ in. (32 cm). Museo Capitolino, Rome

verism (fig. 12): its explicit visualization of aging and human fragility recalls the spirit of certain third-century Imperial portraits such as the head of *Decius* (fig. 45). A small bronze head identified as *Trebonianus Gallus* now in the Archaeological Museum of Florence is particularly striking — in its creased forehead, inscribed eyebrows, incised beard, and naturalistic set of the mouth — as a typological antecedent for this "middle-aged" saint in the *Quattro Coronati* (fig. 46). It has been proposed that Nanni's choice of ancient models rested on the concept of historicity, with the four saints portrayed as they might have looked at the end of the third century under the reign of Diocletian.[53] Although this theory would fit neatly with some of the ancient models cited here, it is unlikely that this sort of historicity had a place among sculptors and even their most sophisticated public so early in the fifteenth century. Rather, ancient heads were savored for their venerability and skillful naturalism.

What sort of material or intellectual scenario can be constructed with regard to the reception of antique portraits in the earliest years of the Renaissance? Roman sarcophagi, coins, and gems were preserved as tombs and treasures throughout the Middle Ages in Tuscany, but it is not clear whether three-dimensional portrait-heads — which may have never lost the overtones of pagan idolatry, their original function being ruler worship or ancestor worship — were available in significant numbers outside Rome. The little we do know about the state of antiquarianism in Florence around the turn of the century suggests that not only coins and gems, but also fragments of sculpture and architecture were of interest to merchants and intellectuals of the patron class, and that such objects were valued by practicing artisans as well. Both groups imported objects from Rome, so that portrait busts (whether or not they were an imported rarity) would have been admired by artists and humanists alike.[54] Indeed, the recarved *Antinoüs* head in Pisa (cat. 11-14) together with the example of the Florentine composite *Apostle* in Paris (figs. 37, 38) indicate that there was little resistance to portraits of mortals or deities as long as they were reused in Christian contexts, not unlike the sarcophagi that routinely became altars and tombs.

The extent to which the artists and the humanists had separate criteria for their reception of ancient sculpture has been long debated: one assumption is that intellectuals collected ancient fragments to gather historical information whereas artists were primarily interested in using them to further their essays in naturalistic representation.[55] Working under the premise that art and the capacity to understand it are made in the same shop, however, it appears that the claims of perceptual differences between artisans and their most sophisticated audience have been somewhat exaggerated. There may have been little need for a "rapprochement" between artists and their humanist patrons since ancient sculpture, particularly ancient portraits, were appreciated for their naturalism as well as their *romanitas*.[56] After all, Alberti wrote the *Breve compendium de compenda statua* around 1430 in Rome, probably under the personal influence of Donatello, a literary-artisan collaboration *par excellence*.[57] Moreover, there is no evidence that the Italian humanists systematically consulted busts or coins for archaeological erudition until well into the sixteenth century; rather, their appreciation of antique sculpture in the early fifteenth century must have been very much in tune with that of the artists.[58] In fact, it seems that the aesthetic and historical worth of ancient specimens was vetted by the artists, and in later decades, after Nanni di Banco's death, Donatello was called upon to advise the most serious Florentine antiquarians, such as Niccolò Niccoli and Poggio Bracciolini, in the appraisal of individual pieces of ancient

sculpture. Poggio Bracciolini wrote to Niccolò Niccoli from the papal court at Rome that he had acquired something that he would send home to Florence, which Donatello had seen and praised.[59] Poggio said that he had his bedroom furnished with marble heads of which "one is elegant and intact; the others have had their noses broken off, but still they will delight a good artist."[60] He expressed interest in commemorative portraits in marble and bronze not so much as indices of historical fact, but rather because "they represent even the emotions of the soul so that a thing which can feel neither pain nor joy looks to you as if it laughed or mourned."[61] This particular *ekphrasis* could be applied to any of the sacred figures invented by Nanni or Donatello during the first three decades of the fifteenth century in Florence.

In short, artisan and humanist collectors probably owned portable objects such as the *Trebonianus Gallus* and consulted them freely without classifying the historical subject or date of the portrait. The best source for extrapolating an interface between artists and humanists in the reception of antique sculpture may, once again, be found in the writings of Antonio Manetti, who declared that Filippo Brunelleschi made many trips from Florence to Rome during the first decade of the fifteenth century, and that each time he returned to Florence his findings and ideas were eagerly received.[62] In "The Fat Woodcarver" Manetti specified that in the winter of 1409 Brunelleschi was back in Florence from Rome and shared a supper at the hearth of the merchant Tommaso de' Pecori with the proverbial group of ingenious artisans.[63] Supposing Brunelleschi had brought back antique portraits from Rome to show at such soirées, the artists and merchant savants would have established new common ground precisely through their admiration and discussion of these objects. Because of its portability, the *Trebonianus Gallus* can be proposed as the type of image that had a strong impact on the historical, as well as the visual, imagination: it would have been easy to muse over such an object in private or in company. If an object like the small bronze *Trebonianus Gallus* were handed around at a dinner party, artists and their potential audiences would quite literally have been educated together. As such, Florentine sculpture would have had a visually educated audience, primed to appreciate (and possibly even to expect) the reinterpretation of ancient portraits in public religious art. Nanni di Banco was one of the *pesci nuovi* (bright young innovators) to have frequented such circles,

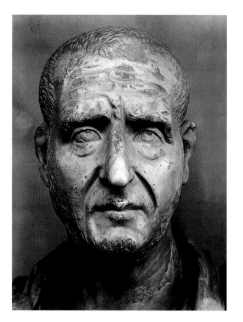

Fig. 45. *Portrait of Decius*, A.D. 241–59. Marble, height 11 ¾ in. (29.5 cm). Museo Capitolino, Rome

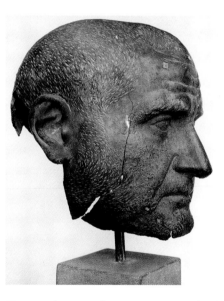

Fig. 46. *Trebonianus Gallus*, A.D. 251–53. Bronze, height 10 ⅝ in. (27 cm). Museo Archeologico, Florence

participating in conversations among artisans, humanists, and merchants, who put a premium on almost all traces of Graeco-Roman civilization.[64] Whether or not Nanni traveled to Rome during the first decade of the fifteenth century as did Brunelleschi and Donatello, his awareness of veristic ancient portraits was heightened around 1409 and expressed throughout his career.[65] His innovations had a momentous impact upon his younger colleague Donatello and the painters and sculptors who followed them in the Florentine tradition.

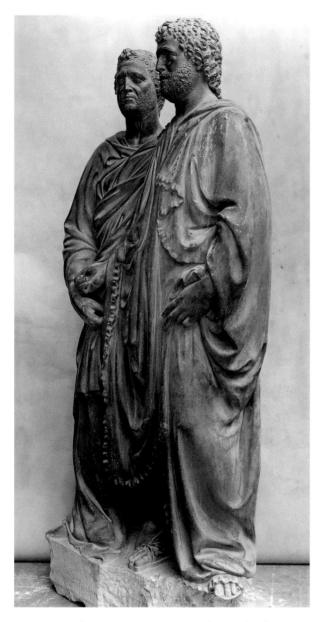

Fig. 47. Nanni di Banco, *Quattro Santi Coronati* (cat. 1-6, detail), ca. 1409–16/17. Marble, height ca. 72 in. (183 cm). Orsanmichele, Florence

The extent to which Nanni may have been prompted, supported, or lionized by the writings and orations of humanist literati is one of the most perplexing, if fascinating, factors in his classicism. The humanists were guided by sculptors in their sensory apprehension of ancient art, and they participated together according to a unifying ethos in the civic participation in the councils of the republic. However, the humanists' promulgation and interpretation of ancient written texts may or may not have directly fueled the classicism of public art.

The two right-hand figures of Nanni di Banco's *Quattro Coronati*, which are carved from the same stone, may con-

tain deliberate allusions to ancient texts that were known in the first decade of fifteenth-century Florence, and can be taken as a paradigm of this query (fig. 47). Whereas references to antique sculpture are easy to recognize in early Renaissance art, any self-conscious allusion to specific Latin letters is open to speculation. The rhetorical gesture of the saint at the outer right, whose mouth (like that of the *Saint Philip*) is open in speech, is visually derived from a Roman orator type, as exemplified by statues presently in the Boboli Gardens (fig. 48) and in Naples (fig. 10). Incorporating his sources freely, Nanni blended the oratorical gesture as seen in the orator type with that of the *dextrarum iunctio* formula from Roman sepulchral sculpture. The hand of the third saint rests on the shoulder of the speaker as in the funerary portrait of husband and wife called *The Gratidii* at the Vatican (fig. 49).[66] Unlike the typical Roman Republican funerary portraits of husband and wife, however, the poses of Nanni di Banco's interconnected figures express a fully psychological, rather than merely symbolic, solidarity.

To the twentieth-century viewer, the relation between the two connected statues in the *Quattro Coronati* suggests a kind of Renaissance visual synthesis of Cicero's treatise *On the Orator* and his related writings on friendship and public life.[67] The oratory gesture of the "speaking saint" even matches choreographic advice given by Cicero's follower, Quintilian, whose full-length *Institutio Oratoria* was discovered and transcribed by Poggio Bracciolini in 1416.[68] Quintilian recommended that in an accomplished speaker, "the arm will be thrown out in a stately sidelong sweep and the words will, as it were, expand in unison with the gesture."[69] During the later Middle Ages and early Renaissance, such visually specific ideas must have been more readily apprehended in Roman sculpture than in Latin texts. It seems unlikely that Nanni di Banco would have literally applied the verbatim instructions of Cicero or Quintilian in the composition of his speaking figures; nevertheless, an educated audience would have recognized the oratorical *romanitas* in a figure such as the "speaking saint."

In terms of written texts, it is more likely that ideas advanced by the ancients could have been known to Nanni di Banco by way of the work of Coluccio Salutati or Leonardo Bruni.[70] The virtues of intellectual friendship and the representation of group consensus by a single speaker are Ciceronian motifs that were consciously reiterated by the Florentine chancellor Coluccio Salutati, who praised the value of oratory and maintained that the best things in life

Fig. 48. *Orator*, ca. 50 B.C. Marble, height ca. 75 in. (190 cm). Boboli Gardens, Florence

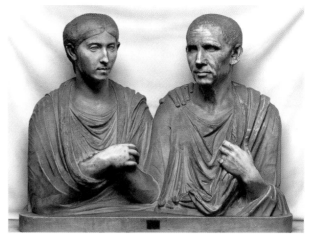

Fig. 49. *Funerary Portrait of Husband and Wife (The Gratidii)*, 13 B.C.–A.D. 5. Marble, height 26 ¾ in. (68 cm.). Vatican Museums, Vatican City

were friendship and duty to patria.[71] Whether in turn Nanni di Banco would have deliberately alluded to the literary works of Salutati or Bruni (much less to those of Quintilian or Cicero) is far from certain.[72] But we do know that in the fifteenth century (as in antiquity) these ideas were also available by way of that most perishable medium, public speech. In addition to social conversations of the Tommaso de' Pecori "supper-club" type, Nanni surely heard the rhetoric of Salutati and Bruni quoted and summarized in the council-halls of the Palazzo della Signoria.

Ekphrastic descriptions of ancient works of art, on the other hand, were common currency among humanists *and* artists. Ekphrastic *topoi*, being easily summarized and recalled, surely had an oral as well as a written tradition. Pliny the Elder's comments on art were known throughout the Middle Ages in Italy and were important for the theoretical writings of Ghiberti and Alberti.[73] In the *Natural*

History, Pliny extolled the device of figure-groups carved from a single block, naming the sculptors Lysias, Apollonius, Tauriskos, and Arkesilaos as masters of that achievement. Above all, he praised what he called "a work superior to all the pictures and bronzes of the world," the *Laocoön* group. He went on to say that "from one block of stone" (*ex uno lapide*) the illustrious artists from Rhodes (Hagesander, Polydoros, and Athanodoros), after taking counsel together, carved the Laocoön, his sons, and the wondrous coils of snakes.[74]

The expression "ex uno lapide" was a rhetorical *amplificatio* invented by Pliny to appeal to the popular imagination; and in any case the *Laocoön* group could not be seen, admired, or envisioned in the fifteenth century as it was still underground, its location totally unknown. The visual impact of the *Laocoön* itself became important after its excavation in Rome in 1505; here we are still dealing with a literary trope.[75] Nevertheless, Nanni's carving of two figures from the same block may well have been a conceit that was consciously intended to rival the ancients as known from this literary source. Such a device, illustrating the maximum degree of skill in the sculptor's craft, as well as a solidarity of counsel among sculptors, would have found its ideal rhetorical place in a work of art that was made to honor the Florentine guild of stone carvers.

4 . PUBLIC SCULPTURE AND
CEREMONIAL SPACE

THE CELEBRATIONS WERE MAGNIFICENT, AND OUR HIGH SPIRITS GREW
THROUGHOUT THE DAY.

—*Giovanni di Pagolo Morelli*

SCULPTURE, ARCHITECTURE, and urban space worked together to shape everyday life and public ceremony. Since prayer, ceremony, and procession were the forms that ensured survival, they were at the heart of the self-image of Florence and its inhabitants.[1] Nanni di Banco's commissions for public sculpture at Orsanmichele, the papal apartments, and the cathedral of Santa Maria del Fiore, were all site specific. This chapter will be dedicated to exploring the ways in which Nanni's sculpture was constructed and received in terms of functioning urban space and public ceremony. Two sites will come under focus: the *Saint Philip* tabernacle at Orsanmichele and the facade of the papal residence at Santa Maria Novella.

The series of fourteen outdoor tabernacles at the church of Orsanmichele is the most celebrated example of guild patronage in Italian art. Each niche houses the statue of a patron saint of a particular guild, representing an individual commission within a greater civic plan. Orsanmichele itself is a point of urban focus in its situation between Santa Maria del Fiore to the north and the Palazzo della Signoria to the south (fig. 50). If urban geography

Fig. 50. Ferdinando Ruggeri, *Map of Florence*, 1731. Enlarged detail from Mori and Boffito 1973. Orsanmichele is located to the lower right of the Piazza del Granduca and is labeled "S. Michele in Orto"

were a determinant of social significance, the nature of Orsanmichele and its decoration would seem to have been defined by its location midway between the city's religious and governmental seats. A reciprocal sacred and mercantile purpose determined the function and decorative forms at Orsanmichele for several centuries.

In 1285 the Florentine Commune replaced the convent church of Orto San Michele with an open hall for the buying and selling of grain. An image of the Virgin on one of the pilasters began to work miracles, and a confraternity of Laudesi assembled there in 1292, all the while coexisting with the municipal grain hall. A new loggia, the *palatium Orti S. Michaelis*, was built in 1337, and Orcagna's magnificent indoor tabernacle of the Virgin—virtually a temple within a temple — was produced following the plague years, between 1352 and 1359.[2] In the 1380s Orsanmichele became the hall church that stands today, but even after the loggia was enclosed to transform the market into a church, the upper two stories were used as silos for public grain storage. Meanwhile, in 1339 the guild of Por Santa Maria (silk guild), together with the confraternity of Laudesi (who were largely controlled by the Parte Guelfa), had ruled that the city's guilds (categorized at the time as to major, middle, and minor guilds) were to decorate the pilasters with

Public Sculpture and Ceremonial Space 47

tabernacles containing pictures or statues of their respective patron saints. All of the saints' annual feast days would be celebrated with masses and processions, so that there would be a kind of living calendar of sacro-civic rites surrounding the building.[3] The celebrations focused around the outdoor tabernacles would thus complement the practices of the cult of the Virgin Mary (Laudesi) on the inside of the church. The Arte della Lana had installed a statue by 1340, and the guild of Medici e Speziali installed their *Madonna della Rosa* tabernacle in 1399. But action on the other commissions languished (despite some plans made by the guilds of Por Santa Maria and Calimala) for more than sixty years. This period (ca. 1350–1410) was given over to the execution of the interior mural cycles of Orsanmichele. Within the interior mural scheme, the surfaces of individual piers and pilasters were used to depict patron saints of the city and the guilds with panel polyptychs or fresco, so that, for instance, the *Santi Coronati* mural by Ambrogio di Baldese and Smeraldo di Giovanni (fig. 8) was painted on the interior of the same compound pier that was to receive Nanni di Banco's ensemble on the exterior of the church.[4]

In the first decade of the fifteenth century great sculptural activity issued from initiatives taken by the confraternity of Orsanmichele, the Signoria, and the individual guilds. In 1402 the captains of the confraternity dispensed funds to construct an empty niche for whichever guild could come up with a statue first; and in 1406 the Signoria of the Commune decreed that each guild had ten years to install a statue. If a statue failed to appear within that time the guild would forfeit patronage rights to the *pilastro*, which could then be claimed by another organization. Statues commissioned to Nanni di Banco, Ghiberti, and Donatello appeared in quick succession along with works by other respected masters, a total of twelve ensembles between around 1395 and 1428. In less than two decades, Orsanmichele became a veritable forum of monumental sculpture that was unique in Italy. Because of a new attention to empiricism and classical principles, writ large in the tabernacle statues by Nanni di Banco, Ghiberti, and Donatello, these works are traditionally recognized by art historians as being among the first significant monuments of the Renaissance, signaling a "radically un-medieval image of man."[5] This standpoint is generally accepted here, as discussed in chapters 2 and 3.

The recent "art-in-context" historiography of the Orsanmichele statues is particularly interesting. Writing in the 1960s, Frederick Hartt envisioned the rapid commissions and progressive styles of the works following the notices of 1402 and 1406 to have been a direct response to an extended political crisis of the time.[6] More specifically, he perceived of the classicizing treatment of the male figure at Orsanmichele as a unified, fully conceptualized act of "civic humanism"—an affirmation of public ideals in the face of a series of Florentine wars against despotism. The signal event was the sudden death of Giangaleazzo Visconti of Milan in 1402.[7] Giangaleazzo died of plague just as his Milanese forces were preparing to seize Florence: Florentine liberty was rescued, and Tuscany was freed of Milanese troops and the Visconti threat for the first time in ten years. Hartt imagined an unspoken intellectual alliance between artists and guildsmen with their gathered energies blossoming in an unprecedented classicism as a direct response to urgent political events.

Hartt's idea that a democratic regime turned to humanist precepts (in the form of Graeco-Roman sculpture) in order to celebrate the dignity of the republic in the face of a tyrannical threat, is a proposal that has been much revised and refined during the past three decades.[8] But his article "Art and Freedom in Quattrocento Florence" of 1964 has remained the jumping-off point for many an inquiry, including several of the issues taken up in earlier chapters of this book. In fact, one might modify Hartt's argument by adding that in 1406, the same year in which the Signoria insisted that the guilds fulfill their obligations at Orsanmichele, Florence conquered Pisa, an event that signaled the final collapse of one of Italy's great maritime republics and raised Florence to a power of the first rank.[9] The acquisition of Pisa not only furthered the Mediterranean trade interests of Florentine merchants, whose prosperity had been in a relative state of decline; it also facilitated the acquisition of white marble from Carrara.[10] The availability of good stones should not be discounted as a factor in getting the series of tabernacle commissions underway. But it may be relevant in a more overarching way that the first action the Florentines took in Pisa was to squash the Pisan guilds: they were made subject to Florentine guilds by heavy taxation and forbidden to enforce their own regulations. Pisan guilds associated with the textile trades suffered most of all at the hands of their Florentine counterparts.[11] Although war had been expensive, the taking of Pisa boosted Florentine merchant-class prosperity, and general Florentine wealth was increased considerably.[12]

Giovanni di Pagolo Morelli, for instance, noted a strengthening of morale during the festivities after the conquest: "The celebrations were magnificent and our high spirits grew throughout the day."[13] The conquest of the Pisan guilds must have given the Florentine government and guildsmen a special attitude of self-congratulation, and it may have contributed to the enthusiasm with which they undertook to represent themselves *all'antica* in public space at Orsanmichele.

Looking back retrospectively at the progression of the Orsanmichele statues with their increasing demonstration of naturalistic and classical forms, one is tempted to see the works in remarkably secular terms. But in fact the function of the tabernacles was a traditional, religious one. Each tabernacle was a locus of public devotion and not merely the visual symbol of the guild's protector. On the feast of the *Quattro Santi Coronati* (8 November), for instance, the four consuls of the stonemasons' guild, accompanied by as many guildsmen as possible, made an offering at Nanni di Banco's tabernacle at Orsanmichele (fig. 1); they would hear mass together and then drink and feast, the guild budget providing for candles, trumpeters, and food.[14] The same was true of the blacksmiths at Nanni's *Saint Eligius* tabernacle, the bankers at Ghiberti's *Saint Matthew*, the armor makers at Donatello's *Saint George* tabernacle, and so forth. After the tabernacle of *Saint Peter* for the butchers' guild was completed in 1412, the Compagnia di Orsanmichele gave the guild a gift of wax (for candles) and a fir tree (for garlands) to celebrate Saint Peter's day on 29 June.[15]

Of the early quattrocento statues at Orsanmichele, Nanni di Banco's *Saint Philip* for the shoemakers' guild was designed for a particularly elegant interaction with city life. Within the ritual dynamics of worship and civic celebration, as well as the patterns of everyday production and commerce, the *Saint Philip* ensemble, through the classicizing device of contrapposto, engaged in a dialogue with the living city.

The reinvention of classical contrapposto in quattrocento Italy permitted artists an unprecedented eloquence in public sculpture. A sculptured human figure in expressive processes of tension and resolution communicates according to the body's own self-referential configuration, gathering meaning from a dialectical relationship with its social and physical site. With the development of contrapposto, the civic impact of sculpture was enhanced as three-dimensional figures were able to engage in a visual dialogue with their urban setting. One of the earliest and most poignant examples of this phenomenon in Florence was Nanni di Banco's *Saint Philip*, which is located in the second niche from the east on the north side of Orsanmichele (cat. 1-7).

New forms and mediums in Renaissance art sometimes sparked singular innovations in expression. Just as Jan van Eyck (the supposed inventor of oil paint) created the proverbial language of "light as form and symbol," or as developments in linear perspective contributed to a new symbolism of time and space in narrative fresco painting, Nanni di Banco, one of the first sculptors to "discover" contrapposto, used it as an effective symbolic form at Orsanmichele.[16] In the *Saint Philip*, contrapposto allows the statue to interact with the greater city-space, with a continuum of human activity existing beyond the confines of the statue's niche. The internal dynamics of the work—namely anatomical torsion and contrapposto—permit an orientation of the whole ensemble to the east (toward the present via Calzaiuoli) that is by no means accidental.[17] Through a persuasive application of contrapposto principles, the statue made for the guild of Calzolai laid claim through its gaze to a congruous segment of the urban scene, including the "piazza" between Orsanmichele and Santa Anna, where the shoemakers sold their wares, and to a major processional route of Florence, which ran from the cathedral to the Palazzo della Signoria. Saint Philip's directed gaze is not an *unicum* among the statues at Orsanmichele, but as the "first" such use of contrapposto, it was packed with meaning; the subsequent statues more or less followed the formal convention established by Nanni di Banco.

At first glance, the *Saint Philip* appears to be a rather cool, "academic" work of art: the sculptor has minimized iconographic information and suppressed surface details in favor of an exposition of the ponderation of weights in the figure's stance. Yet, as in Nanni di Banco's *Quattro Coronati*, the relationship of the statue to the niche forms a sculptural picture.[18] The pictorial focus of the *Saint Philip* tabernacle is the figure's own vertical center of balance. Nanni has activated the composition by moving the supporting pedestal (inscribed S. PHILIPPUS. AP), from which the statue rises, to a position left of center, that is, to the viewer's left of the central axis of the architecture.[19] In this way the two-dimensional contour of the statue and the frontal view of the niche interact in equilibrium.[20] All the internal and external coordinates are measured (quite literally underscored) by the relationship of the putto at the center of the acanthus frieze in the socle to the twelve semi-gothic letters

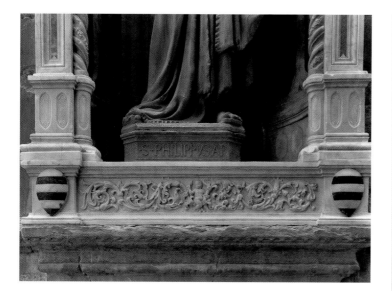

Fig. 51. Nanni di Banco, *Saint Philip* (cat. 1-7, detail), 1410–12. Marble. Orsanmichele, Florence

Fig. 52. Francesco Pieraccini, *Diagram of Nanni di Banco's "Saint Philip,"* 19th century. Engraving. Location unknown

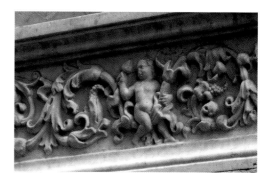

Fig. 54. Nanni di Banco, socle relief for *Saint Philip* (cat. 1-7, detail), ca. 1410–12. Marble. Orsanmichele, Florence

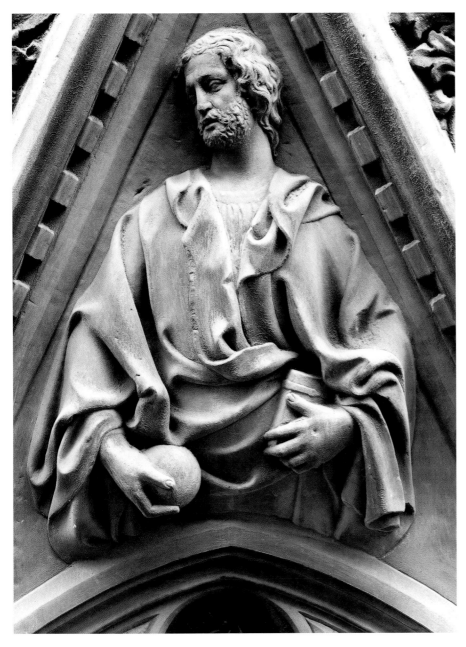

Fig. 53. Nanni di Banco, *Saint Philip* (cat. 1-7, detail), ca. 1410–12. Marble. Orsanmichele, Florence

inscribed on the face of the asymmetrically placed plinth (fig. 51). The off-center position of the plinth emphasizes the vertical axis of Philip's body within the tabernacle: the imaginary plumb line from his nose to the inside of his weight-bearing foot is located close to the center of the architectural projection and is indicated by the putto that bisects the socle frieze. These diagrammatic elements are orchestrated to emphasize the torsion with which the saint's attention is turned away from his engaged leg toward the east (fig. 52 and cat. 1-7). Such a deliberate orientation is emphasized by the relief bust of Christ the Redeemer (or

the Eternal Father) in the gable: his head is rendered between three-quarter and profile view, and he gazes down at the street below (fig. 53). Even the tiny nude putto straddling the socle frieze — he, too, turns away from a distinctly engaged leg — mimics the attitude of Christ and Saint Philip as he looks playfully over his shoulder toward the *corso* (fig. 54).

The *Saint Philip*'s attention to the east must have been understood as a symbolic attention, or even benediction, in the direction of the general prosperity — possibly even the specific guild enterprise — he was entreated to protect. The

Fig. 55. Dragon Helmet Crest, ca. 1410. Leather, height ca. 10 in. (25.5 cm). Museo Bardini, Florence

ensemble addresses a nexus of urban processional and mercantile activity, including the north-south artery currently known as the "via Calzaiuoli."[21] As an important processional and commercial street, running from the cathedral to the Palazzo della Signoria, the via Calzaiuoli was enlarged during the 1390s; it was further widened and named ("Calzaiuoli"—for the stocking makers) in the nineteenth century.[22] Throughout the fifteenth century the street had no official name: it was a crowded, prosperous thoroughfare sometimes referred to as the Corso degli Adimari (or simply the "Corso") for the northern tract of street where the Adimari family had their palaces. The section of street in front of Orsanmichele was known as the "piazza" of Orsanmichele, and before the street was widened this area did have the character of a piazza, with the facade of Orsanmichele facing that of Santa Anna across the square.[23]

Makers of leather heraldry, decorations, and accessories, including shoes, were designated in the fourteenth and fifteenth centuries as *calzolai* and *pianellai*; they belonged to the guild of Calzolai, which had its meeting hall behind the Loggia dei Lanzi.[24] Although the prevailing historical impression has been that particular trades were grouped

together by neighborhood to enforce guild surveillance, the actual disposition of shops in medieval and Renaissance Florence must have been somewhat more random and subject to flux.[25] The trecento chronicler Giovanni Villani declared that there were so many shoe sellers in town that he couldn't even estimate their number.[26] Then as now these shops were dispersed around the entire city from the Mercato Vecchio to Porta Romana.[27] But it comes as little surprise that the *calzolai* had constituted an especially visible presence in and around the north-south *corso* since medieval times. Contemporary documents testify to the presence of several shops of *pianellai* and *calzolai* in the Corso degli Adimari and in front of Orsanmichele since the middle of the fourteenth century.[28]

The combined ingenuity of different kinds of artisans served a common aesthetic in early-fifteenth-century Florence. Shoemakers made more than just shoes, and since this chapter will also touch upon Florentine customs of theatrical public procession, it is pertinent to note that a special mercantile cooperation between shoemakers *(calzolai)* and painters *(dipintori)* was operative in the *corso* near Orsanmichele, where various workshops produced painted leather paraphernalia for liturgical, military, and parade use.[29] For example, the artisan Calvano di Cristofano was a painter by training, inscribed in the guild of the Medici e Speziali in 1397 and in the Company of Saint Luke in 1419; but Calvano apparently decorated many objects of leather because by April 1421 he was inscribed in the guild of Calzolai, where he is listed as "Calvano di Cristofano di Salvi dipintore e pianellaio" (painter and slipper-maker).[30] The ceremonial regalia made by craftsmen such as Calvano di Cristofano were an especially imaginative and vital kind of public art, as can be seen, for example, in one of the few such surviving objects, a ceremonial dragon-shaped helmet crest now in the Museo Bardini (fig. 55).[31]

In any case, the original statutes of the guild of Calzolai indicates that shoemakers would typically set up their ready-made shoes, slippers, and belts for sale in the "piazza" of Orsanmichele; and the guild had to forbid its members to sell shoes in the piazza of Orsanmichele on Sundays, feast days (excepting those holy days dedicated to the Virgin Mary), and Saturdays after vespers.[32] With the turn of his body and gaze in space, the protector saint of the *calzolai* was capable of daily interaction with the shoemakers as he surveyed the industry of the guild.

Fig. 57. Antonio di Piero del Vagliente and Michelozzo, *Standing Saint Philip* (finial figure from Reliquary of Saint Philip), ca. 1420. Museo dell'Opera del Duomo, Florence

Fig. 56. Nanni di Banco, *Saint Philip* (cat. 1-7), ca. 1410–12. Marble, height 75 in. (191 cm). Orsanmichele, Florence

The niche figures at Orsanmichele served not only as visual representations of the guilds' protector saints, but also as the physical focuses of collective prayer: all of the patron saints' feast days were observed with masses, banquets, processions, and offerings at the tabernacles. The constitution of the Calzolai required a procession to the tabernacle on the morning of Saint Philip's day; and appropriate funds were set aside in their budget for the usual candles, pipers, trumpeters, and banquet.[33] Guild ritual, then (in addition to workshop practice and the display of goods), came under the comprehensive gaze of Nanni di Banco's *Saint Philip* (fig. 56).[34]

But Florentine ceremonies honoring the apostle Philip were not limited to those presented by the shoemakers' guild. Among the most celebrated relics possessed by the city of Florence was the arm of Saint Philip, which was paraded, together with the head of Saint Zenobius and other sacred objects, on most of the important feast days and during civic ceremonies honoring anniversaries of diplomatic triumphs and victories at war.[35] Nanni di Banco's *Saint Philip* turns toward the central processional artery of the city, and the reliquary containing the arm of Saint Philip, housed in the Baptistry, was frequently carried from Santa Maria del Fiore to the Palazzo della Signoria. In this way Nanni di Banco's *Saint Philip* paid homage to his own relic and therefore to the Florentine patria on behalf

of the Calzolai through the turn of his attention to the corso degli Adimari.

Indeed, the association between relic and statue remained strong: in 1425 a new reliquary for the arm of Saint Philip was made by Antonio di Piero del Vagliente under the design of Michelozzo.[36] The reliquary is a masterpiece of micro-architecture, complete with a cupola and buttress figures after the fashion of the Duomo; the crowning figure of Saint Philip, presumably made by Michelozzo himself, is modeled after the figure of Nanni di Banco's statue at Orsanmichele (fig. 57).

At Orsanmichele Nanni produced major sculptural ensembles on behalf of "middle-guild" corporate patrons, which secured him fame in posterity. But throughout his career Nanni di Banco still worked primarily as an artisan, accepting commissions for stonemasonry as they arrived. For the facade of the papal residence, for instance, he contributed two relatively modest relief panels to a larger program that was orchestrated by a committee of cathedral Operai. Whereas Orsanmichele had a long and complex history of architecture, images, and rites, the facade of the papal apartments was decorated *ad hoc* because of a particular historical event — namely the election of Oddo Colonna as Pope Martin V. The papal residence no longer exists at Santa Maria Novella, the articulation of the facade has been demolished, and of the two *Agnus Dei* panels Nanni made for the facade, one remains *in situ* in a good state of conservation (cat. I-II).

A reconstruction of the facade decoration and the attendant public ceremony in the Chiostro Grande, however, finds Nanni di Banco to have been an active participant (and witness) in the creation and reception of the material culture associated with the presence of the pope in Florence. The papal residence, built to accommodate Martin V, was situated in the upper story of the western wing of the Chiostro Grande (main cloister) at Santa Maria Novella. An ensemble of escutcheons including the arms of the Popolo, the *Comune*, the Parte Guelfa, the arms of the Roman Church, and the family arms of the Colonna—this group flanked by Nanni's panels for the wool guild at either side—were arranged at second-story level on the west interior facade of the cloister. On this inward-facing side of the wing, a central portal with a freestanding stairway led directly from the Sala Magna (audience hall) to the Chiostro Grande, allowing the pope passage into the convent, from where he could then proceed through the

Fig. 58. Donatello, *Marzocco*, 1418–20. Macigno, height 53⅜ in. (135.5 cm). Museo Nazionale del Bargello, Florence

Chiostro Verde into the great Dominican church.[37] The freestanding staircase designed by Lorenzo Ghiberti led to a portal with an elaborately carved lintel at second-story level which opened onto the audience hall. Ghiberti's stairway commenced below on ground level with an ovoid *scudo* with the red lily of the Commune, supported by Donatello's *Marzocco* (fig. 58). All the escutcheons were probably painted and gilded; and it is likely that the facade was also decorated with draped textiles, garlands, and so forth, although no precise documentation of such ephemera remains.

The history of the Florentine papal residence finds its origins in the history of the Roman Church. Oddo Colonna, son of one of the great baronial families of Rome, was elected pope at the Council of Constance, 11 November 1417, taking the name Martin V. This event ended the thirty-nine-year Great Schism during which the clerical hierarchy and temporal power of the papacy had disintegrated. Rome, now a squalid, depopulated city with churches, roads, and bridges in disrepair, had long fallen to the factional struggles of powerful families. The territory

of the papal state was torn asunder by the fighting of individual *signori* and *condottieri* such as Braccio da Montone, known as Fortebraccio.[38] Latin Europe suffered from a weak and divided papacy: the last Italian claimant to the tiara before Colonna's election was Baldassare Coscia, described by the ambiguous inscription on his tomb (supposedly ordered by Cosimo de' Medici) in the Florentine Baptistry as "Johannes quondam papa XXIII."[39] Oddo Colonna had to virtually reinvent the papal state in order to restore authority and establish himself in the Holy City.

Colonna left Constance on 16 May 1418 and made his way through Lombardy to central Italy where the patrimony of the Holy See was controlled by the warlord Fortebraccio; diplomatic endeavors en route therefore delayed his arrival in Rome until September 1420.[40] Meanwhile, the pope resided at Mantua from October 1418 to February 1418/19; he then moved to Florence for a year and a half while statesmen such as Leonardo Bruni aided him in negotiations with Fortebraccio, and the mercantile community supported his papacy with the abundant financial resources of the republic.[41]

On the first of January 1418/19 a Florentine embassy was sent to Mantua to invite Martin V to Florence.[42] Later that month (25 January) a government *provvisione* declared that the secular hospice that had existed at the Dominican convent of Santa Maria Novella for a century be rebuilt to accommodate the pope and his entourage.[43] The rebuilding project was entrusted to the Opera of Santa Maria del Fiore with a budget of 1,500 florins: the Operai began deliberations immediately, and decoration continued for almost the entire duration of the pope's stay.[44]

At the time of Pope Martin's visit the idea of a papal residence in Florence was unique and new, and therefore gave rise to the potential for an innovative design. Nevertheless, the carefully calculated arrangement of *stemmi* was conservative and local, essentially an aggrandized version of several other decorated civic facades in Florence. Although it was located on an interior wall of the main cloister of the Dominican convent, the effect of the decorated facade of the papal apartments was purely heraldic and civic, as befitting, say, the facade of a mercantile guild hall facing a public square. Although no traces of polychrome are visible today, the reliefs were probably painted as they were at the guild hall of the Rigattieri, where a similar arrangement of escutcheons on the facade were carved by Andrea di Nofri and painted by Lorenzo di Piero (fig. 59).[45] Since, as far as

Fig. 59. Emilio Burci, *Guild Hall of the Rigattieri and Linaiuoli*, 1841. Pen and ink on paper, 9 ⅞ x 8 ¼ in. (25 x 21 cm). Gabinetto di Disegni e Stampe degli Uffizi, Florence, 1034 P.

we know, not a single element of religious figurative art or narration was planned for the facade of the papal residence, this project can be identified as one of the few real examples of the "secularization" of a sacred place, here with an essentially conservative civic message and design.[46] The facade decoration had a distinct political iconography, laying claim to the papal residence at the Dominican convent as a Florentine civic property financed by the wool guild.

Nanni di Banco's *Agnus Dei* reliefs were made to be received in the expanded contextual setting of ceremonial display. In fifteenth-century Florence, decoration of a heraldic or ceremonial nature played a vital part in such occasions as the visit of Pope Martin V. Colonna's presence in Florence therefore prompted a flurry of patronage on the part of the papal court and the Florentine Republic. Descriptions of objects and festivities that embellished the pope's stay have a courtly tone, more evocative of the world as described by an artist like Gentile da Fabriano than the more austere, sober vision typically associated with the art of Nanni di Banco. Yet Nanni's *Agnus Dei* reliefs at Santa

Maria Novella constituted a part of the material spectacle centered around the papal court in Florence.[47] Despite the Marxist (Antalian) distinction between "courtly" and "civic" art, there seemed to be little conflict between heraldic ("court") decoration and "middle-class rationalism" in public representation.[48] Heraldry was produced and consumed by the same ruling group that steered the republican government and commissioned the most "progressive" works of classicizing public sculpture. These corporate patrons—including, for example, protagonists such as Leonardo Bruni, Lorenzo Ridolfi, Giovanni di Bicci de' Medici, Pier Paolo Petriboni, and vocal "new men" such as Bartolommeo del Corazza, and Nanni di Banco himself—participated directly in the events that were enacted through emblematic decoration and splendid ritual gifts.

Upon Martin V's arrival in Florence the city exploded in a demonstration of expensive courtly display and diplomatic gift-giving that lasted for a full eighteen months. Bartolommeo del Corazza, who was a contemporary and peer of Nanni di Banco, recorded the events surrounding the pope's visit in his diary.[49] Corazza (like "Grasso" the Fat Woodcarver) shared Nanni di Banco's culture and can to some extent serve as a social analogue for Nanni: as a prosperous vintner he, like Nanni, had risen through the ranks of the tradesmen's guild network. It is likely that any public event witnessed from 1418 through 1420 by Bartolommeo del Corazza would have been known to Nanni, and that when Bartolommeo was among a group of Florentine citizens — he was apparently an eyewitness to most of the events described in his diary — Nanni, who had a particularly strong civic profile during these years, would also have been present.

Bartolommeo del Corazza tells us that when the pope arrived at San Salvi on 24 February 1418/19 the captains of the Parte Guelfa met him with a white horse decked out in a red velvet blanket emblazoned with the Guelph emblem and a bridle covered in crimson and fitted with the Colonna arms in gilded silver and enamels.[50] When the Priors of the Signoria met him two days later at the Porta San Gallo they raised a gold brocade baldachin lined with furs above his head, from which were hung magnificent draperies with the arms of the Colonna and the Roman Church.[51] The continuing procession included the display of reliquaries, banners, maces, candelabra, garlands, a spray of silver coins, and carpets laid out on specially built platforms outside the cathedral.[52] Gifts from the Florentine Signoria to Colonna

Fig. 60. Donatello, miter from *Saint Louis of Toulouse*, 1425. Bronze and enamel. Museo dell'Opera di Santa Croce, Florence

included wine, capons, hares, pigeons, marzipan cakes, and even "messer Antonio loro buffone" (Sir Antonio, their poet-jester).[53] In return Martin V gave the Florentine people a branch of nine roses made of gold and sapphire.[54] At Christmas the ambassador from Vienna presented the pope with a large beaver-skin hat with ermine hangings, and a gilded silver sword and scabbard, all of which Colonna wore throughout the next morning until it was time to say mass.[55] Amidst this display of objects, confections, and gestures, an artist no less distinguished than Lorenzo Ghiberti was hired to design a miter and morse for Pope Martin V.[56] Although Ghiberti's creations are lost, an echo of their form may be visible in fictive decorations (ironically made of more permanent materials) such as the enamel-decorated miter and the staff held by Donatello's *Saint Louis of Toulouse* made for the Parte Guelfa in 1425 (fig. 60). When the warlord Fortebraccio arrived for negotiations, he, in his turn, treated the public to lavish displays of jousting.[57] Throughout the pope's sojourn there, the city of Florence witnessed the exchange of ambassadorial gifts as rare and

precious as a living lion: "un bellissimo leone."[58] Colonna's departure was marked with as much festivity and decoration as his arrival; his last request was that a member of his court who had murdered a Florentine butcher be pardoned, and the Florentine government granted his wish.[59]

Nanni di Banco, as a frequently elected guild consul and office-holding citizen, would, like Bartolommeo del Corazza, have participated in this scene, for which his two *Agnus Dei* reliefs served as a part of the official frontispiece of the pope's residence. The project for the ensemble of the *scudi* was already deliberated by 8 February 1418/19.[60] When Colonna arrived on 26 February, Nanni was likely to have been among the "great concourse of noble citizens" who received him at Porta San Gallo and accompanied him to the Duomo and Santa Maria Novella.[61] Nanni di Banco was paid for the *Agnus Dei* reliefs on 10 May; so they may have been begun by Palm Sunday, 9 April.[62] That day, Nanni was probably among the "secolari cittadini" (together with Bartolommeo del Corazza) to have received the olive branch from Martin V at Santa Maria Novella.[63] During the following months the series of the relief panels was finished—part of the expanded program of spectacle surrounding the pope's arrival. During Martin V's residence in Florence, Nanni di Banco sat on major government councils, having been elected to the Dodici Buonuomini in September 1419.[64] Although the records of the *Consulte e pratiche* are missing for that year, we may imagine that Nanni heard serious debates regarding papal appeals during his term on the Dodici.[65] On the less onerous side, we do know that during Nanni's term on the Dodici the Florentine legislature designated many gold florins to buy wine, fat chickens, confections, and other delicacies for the pope's relatives when they came to visit.[66] When Oddo Colonna departed in pomp and honor on 9 September 1420, accompanied by Lorenzo Ridolfi, Palla Strozzi, Giovanni di Bicci de' Medici, and others, Nanni di Banco would have doubtless been part of the "great group of invited citizens" who witnessed the procession.[67]

All in all, the unifying reign of Martin V was an important stimulus for architecture and art. Colonna, besides undertaking an urbanistic restoration of Rome, discovered Gentile da Fabriano and Pisanello in the north of Italy, and Masolino in Florence, and had them follow his court down the peninsula to Rome.[68] His sojourn in Florence gave rise to works by Ghiberti, Donatello, and Nanni di Banco, as well as numerous other artists and artisans who participated in the decoration of the papal residence and the production of ceremonial accoutrements. Of the many permanent and ephemeral decorations created to mark the diplomatic display shown to the papacy by the Florentine Republic, Donatello's *Marzocco* and Nanni's *Agnus Dei* remain, thus holding a special place in the history of Florentine civic patronage.

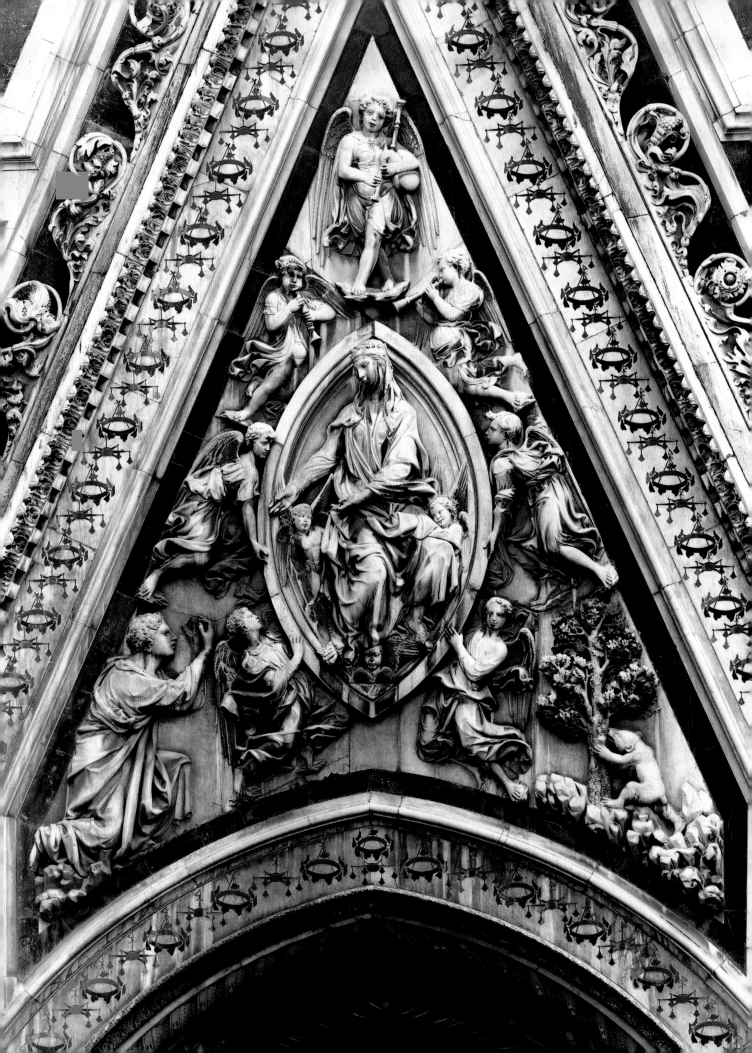

5 . THE "ASSUMPTION" OF THE PORTA DELLA MANDORLA: TRADITION AND INNOVATION

THIS IS THE "ISTORIA" IN RELIEF REPRESENTING THE ASSUMPTION OF THE VIRGIN MARY THAT IS SEEN ABOVE THE PORTAL OF THE CATHEDRAL OF FLORENCE WHICH LOOKS TOWARD THE CHURCH OF SANTISSIMA ANNUNZIATA.

—*Filippo Baldinucci*

NANNI DI BANCO'S great relief sculpture, *The Assumption of the Virgin* is located in the steep triangular frontispiece above the Porta della Mandorla (cat. 1-12). A monumentally graceful figure of the Virgin seated within an elegant almond-shaped nimbus rises to heaven, surrounded by festive, flying, music-making angels. Saint Thomas the apostle kneels in the left corner of the triangle to receive the sash of the ascendant Virgin, and a bear scrambling up a rocky landscape toward an oak tree closes the composition in the right corner (fig. 61). The *Assumption* is a work that is carefully integrated into the fabric of the preexisting sculptural program of the cathedral; and in many ways it is an organic extension of that program. At the same time, however, the *Assumption* is striking for its qualities of Albertian pictoriality *ante litteram*, and was admired by artists for its compositional sophistication well into the sixteenth century. This chapter will explore the ways in which traditional mariological texts and sculptural types are presented in innovative visual terms in Nanni di Banco's *Assumption*.

In the sculptural decoration of traditional Gothic cathedrals, images tend to be aligned in the architectural

Fig. 61. Nanni di Banco, *Assumption of the Virgin* (cat. 1-12), 1414–22. Marble. Santa Maria del Fiore, Florence

matrix as if in a cosmic diagram, so that narrative content is often cryptic or oblique. Nanni di Banco's *Assumption of the Virgin* at Santa Maria del Fiore, instead, is constructed as a self-contained narrative picture.[1] This fact sets the frontispiece of the Porta della Mandorla apart from the reveal friezes below, which are to be read as a kind of architectural marginalia. As in the margins of medieval manuscript pages, these inhabited scrolls tend to enjoy an iconography in the flux of becoming rather than an elaborately planned state of being.[2] Their content is decidedly civic, but also fanciful and inventive for its own sake, and meanings seem to have emerged by accident as well as design.[3] Whereas the archivolt and lower friezes are necessarily savored best in a close view of individual passages, the gable zone (front, center, and above) is read from the street as a pictorial whole, displaying a major episode in sacred history, the bodily transport of the Virgin Mary to heaven and the handing of her sash to Saint Thomas as proof of that fact.

In a formal analysis, the *Assumption* could be described in terms of lyricism, spirituality, and flight — traits that might sometimes be considered anticlassical.[4] Twentieth-century art historians have characterized these lyrical elements of the *Assumption* as a last resort to gothic forms, calling the work a "retreat towards a distinctly gothic man-

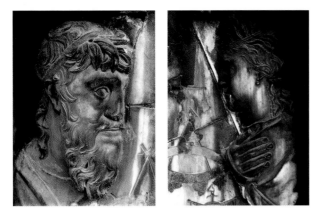

Fig. 62. Donatello, *Solomon* (cat. 1-12, detail), 1422. Marble, height 25¼ in. (64 cm). Santa Maria del Fiore, Florence

Fig. 63. Donatello, *Sheba (or Esther)* (cat. 1-12, detail), 1422. Marble, height 25¼ in. (64 cm). Santa Maria del Fiore, Florence

ner," or a symptom that "the tide of classicism had already begun to recede."[5] Giorgio Vasari, however, who cared deeply about evolutionary progress in the arts, considered the *Assumption* so advanced that he was reluctant to associate it with Nanni di Banco (whom he consistently represented as something of a dullard), giving the relief to Jacopo della Quercia and stating that it was still studied by mid-sixteenth-century artists as a marvelously inspiring composition.[6] Vasari's contemporary G. B. Gelli praised the work for its beauty and *varietà*, maintaining the traditional attribution to Nanni, which was eventually vindicated by cathedral documents.[7]

The *Assumption* relief is planted firmly in the local culture of Florence, and even the sculptural tradition of the cathedral itself, with unsevered roots in medieval mariological texts. The doctrine of the corporeal Assumption of Mary to heaven (which became dogma only in 1950) was already widely diffused by the time Jacopo da Voragine wrote the *Golden Legend*.[8] The idea of the bodily Assumption was developed together with the growth of the cult of the Virgin and the interfacing worldview of Franciscan naturalism.[9]

But the iconography of the Madonna della Cintola also had a specifically Tuscan tradition, which was linked with devotion to the *sacra cintola* at Prato.[10] Numerous manuscript copies of an anonymous vernacular "Leggenda della Cintola" were disseminated in the Florentine territory during the later trecento, together with the *Golden Legend* and other oral and written sources of this kind, which presented the Assumption in tangibly human terms.[11] Such sacred legends were woven from hymns, sermons, and writ-

ings which had evolved over the course of the centuries, so that an ancient and profound theological base supported the Tuscan devotional context.

The unmediated joy expressed in Nanni di Banco's interpretation of the *Assumption* comes of a long tradition. Because it was believed that the earliest Church fathers (Saint Jerome) declared that the Virgin was elevated "above the choirs of angels," this image was perpetuated in all the literature, music, and figurative art concerning the Assumption.[12] The chorus of festive musical angels surrounding the Virgin is the most common visual element in images of the Assumption, and was part of the liturgy in Florence and elsewhere: "Maria is assumed into heaven; angels rejoice in chorus praising the Lord, alleluja."[13]

The iconographic program of the *Assumption* of the Porta della Mandorla must have been outlined in detail by the Operai and *capomaestro*, however, because after Nanni di Banco's death, Donatello was called in to complete the work with heads of prophets inserted below the two lower corners of the external frieze (figs. 62, 63).[14] These relief busts, which are scarcely visible from the ground, but apparently indispensible to the iconographic scheme, represent two characters from the Hebrew Bible, probably among those cited in the medieval literature on the Assumption of the Virgin, but specified in cathedral documents only as "prophets."[15] Among all biblical texts, the Song of Solomon had a central role in Christian thought on the Assumption.[16] This focus turned on the phrase "Who is this who ascends?" Therefore the crowned patriarchal figure under the left corner of the frontispiece may represent King Solomon. If the head at the right represents a woman, as some art historians have suggested, it may then be identified as Esther or the Queen of Sheba.[17] In the literature of the Assumption, especially in the sermons of Franciscans such as Saint Bonaventure and of Matteo d'Acquasparta (the latter was a particularly important figure in Florentine religious thought), Esther was invoked as a prefiguration of Mary Queen of Heaven.[18] In a similar vein, an alternative might be that the female head represents the Queen of Sheba, who was figured in the Middle Ages as a prototype for the Church, or Ecclesia as the seat of wisdom, *sedes sapientiae*.[19] Furthermore, the Song of Songs was frequently interpreted as prefiguring the union of Christ and the Church. The Christian view saw the Queen of Sheba, the perfect companion of Solomon and a vehicle of wisdom, as mystically comparable to Maria, the Bride of Christ.[20]

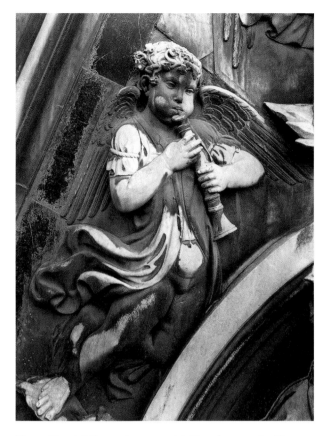

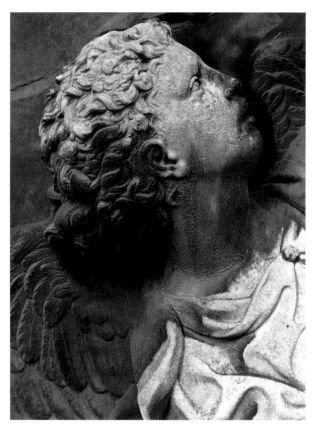

Fig. 64. Nanni di Banco, *Assumption of the Virgin* (cat. 1-12, detail), 1414–22. Marble. Santa Maria del Fiore, Florence

Fig. 65. Nanni di Banco, *Assumption of the Virgin* (cat. 1-12, detail), 1414–22. Marble. Santa Maria del Fiore, Florence

A metal lily in the Virgin's left hand, which was so easily read as the *giglio fiorentino* in all its visual and linguistic polyvalences, had a Marian significance dating back to the writings of Saint Ambrose, who resided in Florence briefly during the fourth century.[21] In the seventh century Ildefonso of Toledo cited the Canticle in his sermons on the Assumption of the Virgin (VII, 2): "Your belly is as a heap of wheat, surrounded with lilies"; and he referred to the risen Virgin as "virgin blessed among daughters like a lily among thorns."[22] In devotional writings of the thirteenth century, Maria Regina was lauded as "angelic lily" and "celestial flower."[23] Vernacular Assumption legends of the trecento continued this trend, declaring that "The angels sang the song that says, 'as the lily is above the thorn, so my friend is above all other women.'"[24]

Two of the musical angels wear tendrils of amaranth woven into their hair (figs. 64, 65). The amaranth vine had been a symbol of immortality since pagan antiquity, and its meaning carried over into Christian art as an allusion to the Resurrection of Christ and victory over death, as is seen in a fifth-century ivory in Milan depicting the sepulcher of

Christ (fig. 66). In a more local example, Donatello's victorious *David* of 1408–9 is crowned with amaranth wreathes (fig. 91).[25] As a flower that never wilts, amaranth also became the symbol of the body of the Virgin Mary in late medieval hymnology.[26] Here, the interwoven crowns of amaranth serve to elaborate the central themes of the immortality and incorruptibility of the body of the Virgin, and of the eternity of her reign in Paradise.

One of the most intriguing features of Nanni di Banco's *Assumption* is the polychrome *intarsia* ribbon surrounding the interior composition, which depicts a chain of hanging candelabra seen in perspective from below. These candelabra, alternating in type, demonstrate a precocious *tour de force* of Renaissance principles of linear perspective executed in stonemasonry. Light and lamps are an important feature of Marian iconography, so the suspended candelabra are not gratuitous to the scene. For the iconography of the clusters of candelabra, we may turn once again to the earliest writings on the Assumption, which characterized the Assumed Virgin as "Maria illuminatrix."[27] Sacred literature used the metaphor of light to refer to the risen Virgin,

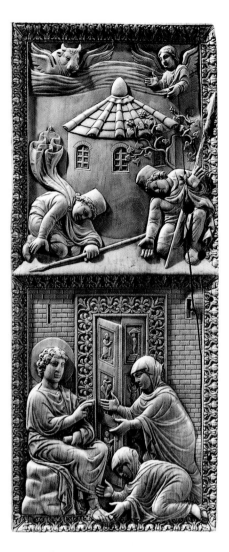

Fig. 66. *Holy Women at Christ's Tomb* (panel from a diptych), ca. 400. Ivory, 14 ½ x 5 ⅜ in. (37 x 13.5 cm). Museo Nazionale di Castello Sforzesco, Milan

and homilies and sermons on the Assumption repeated and reinterpreted the phrase from the Song of Solomon, as well as referring to other scriptures, such as the Psalms.[28] The idea seems to have begun with the pseudo-Jerome who invoked the Canticle: "Who is this who ascends like the dawn, as beautiful as the moon, as splendid as the sun, as awe-inspiring as camps of ordered soldiers?"[29] The same writer, invoking the psalmist David wrote: "As the moon and our lamp, she was illuminated by the Lord and was herself illuminatrix of the world, according to this prophecy, 'How you illuminate my lamp, Oh Lord!' Behold, Maria was the light of wisdom."[30] A homily by Paulus Warnefridus (eighth century) pronounced that there were "two great luminaries who ascended from mankind . . . Jesus and Maria," thus pairing the Assumption of the Virgin with the Ascension of

Christ.[31] The image of the Assumed Virgin as the splendid light of divine wisdom was developed and amplified throughout the later Middle Ages in a stream of texts from the sermons of Saint Bernard of Clairvaux, to the writings of Saint Bonaventure, to the sermons on the Assumption by Matteo d'Acquasparta, and Dante's *Paradiso*. Bernard of Clairvaux was the most authoritative voice on the glorification of the Virgin; and it is important to recognize the great Bernardian influence on the Florentine tradition from Dante forward. In his rich profusion of texts on the Assumption, Saint Bernard used many images of lamps and candelabra, with profound references to the Hebrew Bible, especially to the Canticle. In his first sermon on the Assumption Saint Bernard declared: "Now [that she has risen] the heavenly patria shines with more vivid splendor, illuminated by the light of this virginal lamp."[32] And building upon the Song of Solomon: "That most brilliant lamp, the glorious Virgin, was a marvel of light, even for the angels, and made them exclaim: 'But who is this who rises like the dawn, as beautiful as the moon, as resplendent as the sun?'."[33] Nowhere is Saint Bernard's imagery of "Maria illuminatrix" more extensively interpreted than in the *De Assumptione B. V. Mariae* (1287–89) by Matteo d'Acquasparta. Since Acquasparta was bishop of Florence at the time of the dedication of Santa Maria del Fiore and the composition of the Divine Comedy, his writings must have been particularly formative in the shaping of Florentine mariology.[34] In Florence, Saint Bernard's and Acquasparta's devotional imagery fed into the language of Dante, who in his most mystical vein, in the poetry of the *Paradiso*, configured the Virgin Mary as "viva stella" (living star) and the light of wisdom.[35]

Saint Anthony of Padua's reflections on the Virgin Mary may also be pertinent here. In his observation that the Gospels report only six occasions upon which the Virgin Mary spoke, Saint Anthony compared her words to the six branches of a candelabra, as well as the six leaves of a lily, and the six steps that lead to the throne of Solomon.[36] All three of these themes are clearly present in the tympanum, where Solomon, the lily, and the chandeliers are interwoven into a unique Marian program.

In terms of traditional theology, then, the candelabra are iconographically proper to the Assumption scene. But here, through their rendition in perspective space, the Porta della Mandorla becomes a virtual "porta lucis," a portal of light, as the Virgin herself was commonly called in contemporary poetry and hymns.[37]

If we move inward from the general and universal to a more specific and local meaning, it becomes apparent that Nanni di Banco's *Assumption* is a specifically Florentine manifestation of the Virgin Mary. The ascending Virgin originally held a metallic lily and offered a silk and gold-threaded sash to Saint Thomas.[38] Notwithstanding their disappearance over the course of the centuries, these added "accessories" were important elements of the original composition. The lily, like the gilded lilies that the Florentines carried in their civic processions, functioned as an emblem of the city as well as a symbol of the incorruptibility of the Virgin in body and spirit.[39] And the sash was a simulacrum of the *sacra cintola* conserved at Prato, promising a numinous power associated with the original relic.[40] Since Prato had been annexed by the Florentines in 1351, the *sacra cintola* itself had become a *de facto* possession of the Florentine Republic.[41]

In April of 1412 the Priors of the Florentine Signoria had publically reconfirmed the dedication of the cathedral to Santa Maria del Fiore and declared that a statue of the Virgin Mary holding a lily in her hands was to be installed at the summit of the west facade of the Duomo.[42] This figure was apparently never realized, and we can assume that it was substituted conceptually by Nanni's *Assumption* relief, which was commissioned in 1414. In the poetry and visual art of the "dolce stil novo," Florence had come to be personified as a beloved woman, with Marian allusions integrated through the symbolism of the lily.[43] The prayers of the first Laudesi at Orsanmichele called the Virgin Mary "aulente giglio" (fragrant lily), as in a love song.[44] And a civic poem of the trecento described Florence as "nostra donna" (our Lady), the precious "amata" (beloved) of the Priors and councilmen.[45] Analogous transpositions of Maria-Florentia-Firenze are found in the figurative art of the trecento, such as the altarpiece of Santa Maria del Fiore by Bernardo Daddi, which stood on the main altar of the cathedral (fig. 67), and in a miniature of the famous *Carmina Regia* by Convenevole da Prato, where a personification of Florence rising from her fleur-de-lis throne has the typical characteristics of a Virgin Annunciate.[46] The Virgin of the Porta della Mandorla, then, represented a poetic, richly evolved personification of "Santa Maria del Fiore." The display of the lily and the *cintola*, integrated into the scene of the *Assumption of the Virgin* like trophies, underscored and embellished the civic overtones of this work in its predominantly public setting — Santa Maria del Fiore ascendant and triumphant.

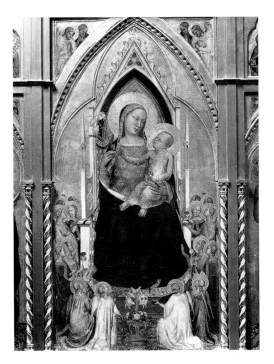

Fig. 67. Bernardo Daddi, *Santa Maria del Fiore Altarpiece* (central panel), ca. 1340. Tempera on panel, 65 x 33 ½ in. (165 x 85 cm). Galleria degli Uffizi, Florence

Fig. 68. Andrea Orcagna, *Dormition and Assumption of the Virgin* (Tabernacle of the Virgin), 1359. Marble and mosaic. Orsanmichele, Florence

Fig. 69. Agnolo Gaddi, *Assumption of the Virgin* (detail), 1392–95. Fresco. Cappella della Cintola, Cathedral of Prato

With this specifically civic meaning of the ensemble recognized, it is important to remember that when the frontispiece of the Porta della Mandorla was assigned to Nanni di Banco, a strong sculptural tradition had already been established in Tuscany, and that the Florentine cathedral itself was already encrusted with various images from the life of the Virgin. It is clear that the compositional structure of the tympanum was inspired by local prototypes, the most obvious and important one being the *Dormition and Assumption* relief by Andrea Orcagna on the Tabernacle of the Virgin at Orsanmichele (fig. 68), a work that Nanni quite obviously set out to rival and surpass.[47] Another important model (less frequently acknowledged in the literature) was the recently completed fresco by Agnolo Gaddi in the Chapel of the Cintola at Prato (fig. 69).

All the people directly involved with the production of the Porta della Mandorla *Assumption* — the *capomaestro*, the commissioning wool guildsmen, and the clergy, as well as the sculptor and his assistants — were profoundly aware of the preexisting Marian sculptural program, which was, of course, in place around the cathedral exterior at the time. Indeed, the sculptural decoration of the cathedral paralleled the family history of Nanni di Banco, whose grandfather, great-uncles, uncles, and father all served as masters in the Opera del Duomo.[48] In 1414 Nanni's father, the *capomaestro* Antonio di Banco, secured this commission for the frontispiece for his son; and let us not forget that Nanni had begun his own artistic career at the cathedral with the prophet *Isaiah* which was destined for one of the buttresses, and then with the monumental *Saint Luke* for the facade.

The existing sculpture was an imposing, if not encyclopedic, account of the life of the Virgin. Above the portals of the west facade, Arnolfo di Cambio had installed the Nativity of Christ, the Virgin in Majesty, and the *Dormitio Virginis*.[49] Statues of Gabriel and Mary of the Annunciation were situated in lateral niches above the southwest door, or Porta del Campanile.[50] Most striking, perhaps, is the fact that the lunette above the Porta dei Canonici accommodated Niccolò Lamberti's *Madonna della Rosa* (fig. 70), a composition inspired by one of Dante's figurations of the Virgin Mary (*Par.* XXIII: 73): "Here is the rose in which the divine Word / was made flesh: here are the lilies / whose fragrance led humankind to the righteous way." In fact, the decoration of the Porta della Mandorla was initiated in the trecento as a symmetrical counterpart to the Porta dei Canonici; and it is no mere coincidence that the lily held by Nanni's Assunta rhymed in a poetic, even Dantesque, sense with the rose held by the Madonna of the Porta dei Canonici. Nor is it merely by chance that the typological source for Nanni di Banco's figure of the ascendant Virgin was the fourteenth-century *Annunciate* from the Porta del Campanile, who wears a *cintola* modeled on the relic conserved at Prato (fig. 71).[51]

Among the "site-referential" images incorporated into Nanni di Banco's *Assumption* relief is the band of "real"-looking candelabra, which recall church furnishings of the time.[52] It is even possible that the frieze of chandeliers had a specific local allusion to the festive lamps illuminated at the cathedral for the feasts of the Purification and Assumption of the Virgin. During the first century of the history of Santa Maria del Fiore, the official feast day was changed from the feast of Santa Reparata to that of the Nativity of the Virgin, and finally to Annunciation Day (25 March), which was the first day of the Florentine calendar year.[53] In their deliberations of 1412 the Priors of the Signoria reiterated that the Annunciation be celebrated as the principal feast of the cathedral.[54] But the redeclaration of this custom was short-lived because on 19 February 1416/17 the Servites from the church of Santissima Annunziata petitioned the Commune requesting that the Annunciation be kept as the official feast exclusively at their own church, and that the cathedral choose another feast day from the Marian calendar.[55] Due to a long-standing nexus of Guelfism that tied the *reggimento* to the Florentine Servite church, the Priors deliberated in favor of the wealthy and influential order, stating that the principal feast of the cathedral be

Fig. 70. Niccolò Lamberti, *Madonna della Rosa and Angels*, 1402. Marble. Porta dei Canonici, Santa Maria del Fiore, Florence

Fig. 71. *Virgin Annunciate* from Porta del Campanile (photographed *in situ*), 14th century. Marble, height ca. 59 in. (150 cm). Museo dell'Opera del Duomo, Florence

changed to the Purification of the Virgin (2 February) beginning with the following year.[56] Therefore the Purification, which in Tuscany was popularly known as "Santa Maria Candelaia," was incorporated into the cult and iconography of Santa Maria del Fiore.[57] It was a celebration in which the benediction of candles and a procession of lighted candles had a fundamental liturgical role.[58] The actual production of the tympanum, which for the most part took place between 1417 and 1420, followed closely upon the choice of the "Candelaia" (Candelora) as the principal festivity of the cathedral of Florence. The choice of a candelabra frieze may reveal an acknowledgment of change in the liturgical calendar. It is significant that during the major period of work on the frontispiece (1417–20), Nanni di Banco himself served his *patria* on the major councils of the Signoria, as well as having an influential presence inside the Opera del Duomo.[59]

The feasts of the Purification and Assumption were closely linked in the Florentine idea of the glorification of the Virgin. It was precisely in order not to contradict the fourteenth-century iconography of the Assumption, that the "Purification" had to be considered a perpetual condition of the Virgin Mary, whose body was not subject to corruption or decay. Tuscan religious observance required that on the feast of "Santa Maria Candelaia" the faithful carry lighted candles in procession precisely to prove that the Virgin Mother did *not* need ritual purification insofar as she was perpetually "most pure and resplendent with light."[60] Saint Bonaventure, who was one of the major Franciscan proponents of the corporeal Assumption of

Mary, had already presented the Virgin of the Purification as "stella purificante celeste" (purifying star of the heavens) rather than human biological mother *post partum* purified at the temple.[61] This was an idea followed by Matteo d'Acquasparta in the later thirteenth century.[62] Indeed, the prayers at the blessing of the candles declare: "Once the obscurity of this world has passed, we may attain the perpetual light of heaven."[63] By means of the iconography of light, then, the Madonna of the Purification became confluent with that of the Assumption in the sacred imagination of the time and place.[64] Therefore it is not unlikely that the chandeliers of Nanni di Banco's intarsia frieze allude to the actual lamps and candelabra used at the cathedral to celebrate the Purification, whether they were to decorate the church (interior or exterior) or to be carried as processional apparatuses. It is no coincidence that in his time as bishop of Florence, Saint Antoninus was particularly devoted to celebrating the Purification as a feast of

Fig. 72. Nanni di Banco, *Assumption of the Virgin* (cat. 1-12, detail), 1414–22. Marble. Santa Maria del Fiore, Florence

Fig. 73. Nanni di Banco, *Assumption of the Virgin* (cat. 1-12, detail), 1414–22. Marble. Santa Maria del Fiore, Florence

"Maria illuminatrix."[65] At Santa Maria del Fiore the liturgical chants of Purification Day (in choral books made after 1417) included the following *incipit*: "Ave Maris Stella Dei Mater" (Hail Star of the Sea, Mother of God), "Post partum virgo inviolata" (Virgin inviolate after giving birth), and "Lumen ad Revelationem gentium" (Light of Revelation to Humankind).[66] The image of Maria Purificatrix fused with that of the Assunta through the iconography of light took particularly strong root in Tuscany — a solution that may have found its first truly Renaissance iconography in Nanni di Banco's *Assumption* at the Porta della Mandorla.

Nanni di Banco's *Assumption* appears to have had a strong impact on Leon Battista Alberti's concept of *istoria* as codified in his treatise *On Painting*. As we shall see, fifteenth-century beholders of the *Assumption* (including Alberti himself) were primed for the reception of this composition through their experience of sacred drama, in much the same way that Alberti was touched by that genre in his formulation of pictorial theory. That a work of sculpture like the *Assumption* seems to have presaged Alberti's lessons

to painters with an uncanny accuracy should not be surprising, because even as Leon Battista Alberti's writings encouraged artists to compose in a certain way, his theories were necessarily drawn from images that he knew firsthand.[67] Since Renaissance art theory involved visualization, it was based upon existing figurative culture; and all of Alberti's pictorial experience contributed to the synthetic formulations he presented in the *De pictura* of 1435. In fifteenth-century Florence, painting and sculpture were regarded as a single discipline; for Alberti they were "cognate arts."[68] And Alberti recommended that painters practice drawing from "elegant and singular" examples of relief sculpture rather than imitating other paintings.[69]

Whether or not Alberti first visited Florence in 1428, when the ban on his family was lifted, he definitely arrived in 1434 with the papal entourage of Eugenius IV.[70] At that time Masaccio's fresco cycle at the Carmine was complete, Donatello and Luca della Robbia were at work on the Cantorie, and Ghiberti's panels for the east Baptistry door were also in progress. The Porta della Mandorla would have loomed large, both literally and figuratively, in the world of

Florentine pictorial art. Public sculpture was a part of everyday life, and the presence of this sculptured image was exceptionally well attended. The background was painted blue and the figures were highlighted with gold leaf, presumably on the embroidery of their garments, and their wings and hair.[71] And, as mentioned above, accessories such as the metallic lily, and elaborate sashes provided for Assumption day (to simulate the relic of the *sacra cintola* conserved in the cathedral of Prato) were added to the sculptural complex.[72]

All of the side portals of the cathedral were decorated with tricolored marble inlay. But whereas the frontispieces of the other portals, such as the Porta del Campanile, emphasized two-dimensional pattern-work, that expectation was reversed at the Porta della Mandorla. Here the polychrome *intarsia* perforates the picture plane to describe a chain of hanging lamps in exquisite mathematical perspective.[73] I have already suggested that if these objects seem to have been drawn "from life," it may be because they were modeled on the actual lamps with which the Florentines illuminated their liturgical celebrations. In fact the three dimensions of the candelabra are rendered using contrasting colors to describe the changing planes, a method that Alberti would recommend in the first book of his treatise *On Painting*.

Just as the chandelier pattern registers the perspective of complex objects seen from below, the relief sculpture contained within the steep outlined triangle is a startlingly pictorial composition. Although by no means an Albertian "view through a window," its pictorial and narrative wholeness, and its considerations of human perception and response, do set it apart from earlier monumental stone sculpture in Florence.

Compared to its most obvious prototype, Orcagna's tabernacle relief at Orsanmichele, Nanni's *Assumption* is psychologically alive, structured with a dynamic network of figure types, poses, and interconnecting gazes. The structure of the *Assumption* must have been extraordinarily interesting to Alberti in his formulation of pictorial tension between *compositione* and *varietà*, whereby economically disposed, more or less symmetrical groupings accommodated diverse figures in space.[74]

Alberti's counsel that each figure within a picture should be distinguished as physiologically and affectively individual may have been stimulated by the range of attitudes in the *Assumption*.[75] Within each pair, the angels differ

Fig. 74. Nanni di Banco, *Assumption of the Virgin* (cat. 1-12, detail), 1414–22. Marble. Santa Maria del Fiore, Florence

in somatic type, as do their actions in three-dimensional space. Alberti advocated that an artist not repeat the same pose in any of the figures in a single composition, and he advised to "let some be naked, and let others stand around who are halfway between the two, part clothed and part naked," much as Nanni di Banco did with the pair of shawm players at the top of the mandorla (figs. 64, 72).[76] Vertical ascent is suggested by the sharp back-wings of the two cherubim flanking the Virgin inside the mandorla; but whereas the placement of their wings is symmetrical, the spatial and affective expressions of these infants create a study in contrasts between active and passive attitudes. One cherub comes forth while the other retreats, smiling, in response to the handing of the *cintola* (fig. 73). The depiction of various states of mind in reaction to the same sacred event demonstrates the observation of human cognition, a principle so famously applied (after Alberti) in Leonardo's unfinished *Nativity* and his *Last Supper*. In the case of the tangible reception of the Virgin's *cintola* by Saint Thomas, human cognizance of a divine mystery—Mary's bodily translation to heaven—is at the heart of the subject.

Fig. 75. Follower of Guido da Siena, *Stigmatization of Saint Francis* (panel from the diptych of Santa Chiara), ca. 1280. Tempera on panel, height ca. 25 ¼ in. (64 cm). Pinacoteca, Siena

Fig. 76. School of Guido da Siena, *Stigmatization of Saint Francis* (panel from the diptych of Beato Andrea Gallerani), ca. 1270. Tempera on panel, height ca. 26 ⅜ in. (67 cm). Pinacoteca, Siena

Fig. 77. Andrea Pisano, *Adam and Eve in the Wilderness*, 1334–37. Marble, 32 ¾ x 27 ⅛ in. (83 x 69 cm). Museo dell'Opera del Duomo, Florence

According to Alberti the "copiousness and variety" within a single composition should include a mixture of human character-types and animals.[77] In pictorial terms, the bear scrambling up a rocky terrain toward an oak tree in the *Assumption* represents the wilderness of the Valley of Josaphat, from which the Virgin ascended (fig. 74). It is important to remember that the bear has a representational (pictorial) value to at least the same extent that he may have symbolic or emblematic value in Nanni di Banco's relief. This is why I have chosen to discuss it in terms of *istoria* rather than as a commonly established symbol in Marian iconography, which it was not.

Bears and rocks were particular descriptive features of the wilderness in European art. Similar scenes of bears getting fruit from trees were used to describe the remoteness of Monte della Verna, where Saint Francis received the stigmata. This is seen in a group of panel paintings from the circle of Guido da Siena (figs. 75, 76) now in the Pinacoteca of Siena.[78] In Tuscany, the Assumption of the Virgin and the Stigmatization of Saint Francis were conceived of as parallel events. Saint Francis and the Virgin Mary were both types of Christ, and they sometimes paired each other in representation since their respective fates echoed the Crucifixion and Ascension of Christ.[79]

Alberti may well have been looking at this landscape segment when he wrote that "we should depict well, not only the human figure, but also the horse, the dog, and all other living creatures [so that] variety and abundance . . . will not be lacking in our works."[80] Bears and oak groves were common enough features of the outlying Florentine countryside in the time of Nanni di Banco and Alberti.[81] Here in the landscape passage of the *Assumption*, the mimetic carving of rocks, branches, bark, and fur add to the scientific description of nature and therefore to the sensory intrigue of the whole sculptural picture.

In fifteenth-century art, interpretation frequently leads out from the realized possibilities of naturalistic description to more cosmic, philosophical issues. Wilderness is an important component of the Assumption of the Virgin because it is here that Mary consummates her role as a second Eve. The Solomonic phrase, "Who is this who ascends from the desert?" provided the basis for the traditional medieval image of contrast between the exile of Eve to the wilderness for her fatal transgression and the Virgin's ultimate physical transcendence from that earthly desert to celestial Paradise.[82]

Throughout his career Nanni di Banco adapted pictorial material from Andrea Pisano's repertoire on the Campanile. Nanni's bear in the gable zone corresponds to the desert of human sorrow as configured in a bear eating fruit from a tree in the panel by Andrea Pisano (fig. 77), where Adam and Eve are expelled from earthly paradise into the valley of tears from which Mary would finally rise as humanity's new representative.[83] Images of wilderness also refer to the state of original sin, or the human condition outside Baptism. In the *Baptism of the Neophytes* relief, for instance, on the Florentine baptismal font of around 1370, the background is a wood populated by a stag, a lion, and a bear (fig. 78); and the theme of the wilderness as sin is continued in the relief panels of the *Altar of Saint John Baptist*, such as *Saint John Baptist Preaching*. Deeply embedded in all of these images is Dante's concept of the dark wood in which dangerous beasts roam according to animal instinct.[84] In a sense, this wilderness of the bear is the "landscape-opposite" of the *hortus conclusus*, or enclosed garden, that stood for the ever-protected condition of the Virgin. The bear as the essence of wilderness has a long tradition from ancient animism in Europe through twentieth-century thought.[85] In a recent essay about the forests of northwest Montana, Ian Frazier declared: "Bears don't simply imply wilderness — bears are wilderness — bears are one of the places in the world where big mysteries run close to the surface."[86] This observation, ahistorical as it may be, rings especially true in Nanni di Banco's *Assumption of the Virgin*.

In the Christian cosmology, bears were equated with gluttony, anger, and lust — presumably a continuation of their identity as *incubi* and *succubi* which had originated in pagan folklore.[87] According to medieval medical thought, bears were associated with excessive libido, human bestiality, and even demonic intervention in the human conception of monsters.[88] Throughout the later Middle Ages, bears were characterized as exemplifying the sins of lust for physical gratification, or *luxuria*.[89] Well into the sixteenth century bears remained symbols of unchastity or Luxuria, as she is personified in a sixteenth-century woodcut by Cornelius Anthonisz (fig. 79). The sinister (if slightly polyvalent) symbolism of the bear accentuates the doctrinal issue that was at stake here in the *Assumption*, namely the incorruptibility of the Virgin in body as well as spirit. In terms of visual symmetry, the bear's physical appetite is counterposed by the more rational, spiritual desires of Saint Thomas, who lifts his gaze and hands to the ascendant Vir-

Fig. 78. *Baptism of the Neophytes* (detail of baptismal font), ca. 1370. Marble. San Giovanni, Florence

Fig. 79. Cornelius Anthonisz, *Personification of Luxuria*, 1546. Woodcut, 8 ¼ x 4 in. (21 x 10 cm). The Metropolitan Museum of Art, Gift of Harry G. Friedman, 1961. Original inscription "Oncusheit" (Unchastity) altered to read "Cusheit" (Chastity)

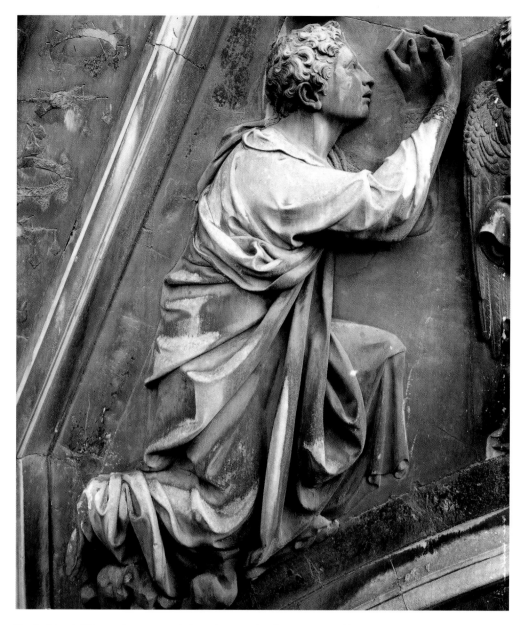

Fig. 80. Nanni di Banco, *Assumption of the Virgin* (cat. 1-12, detail), 1414–22. Marble. Santa Maria del Fiore, Florence

gin crying, "Dammi un segno" (give me a sign).[90]

The gaze of the Virgin, whose body is a veritable *figura serpentinata*, is directed down to Saint Thomas, to whom she hands her precious sash as material proof of her Assumption (fig. 80). There is no question that her turn from left to right accords with an established semiotic left-right logic in European art.[91] But in terms of what cultural anthropologists might call "local knowledge," this torsion corresponds to a specific vector of urban space.[92] Nanni di Banco's *Assumption* was known throughout the quattrocento as the Virgin of the "door of the Servites," or of the "door that leads to Santissima Annunziata."[93] The application of

an elaborate contrapposto allows this figure to turn to her right in the direction of the Santissima Annunziata, which was one of the most venerated and opulent Marian sanctuaries in Europe as well as an extremely wealthy stronghold of Guelph power in the city of Florence (figs. 2, 81). As in the *Saint Philip* statue at Orsanmichele, experimentation with torsion and contrapposto allowed the sculptured figure to be site-specific according to a seemingly inevitable relationship with the surrounding city.[94]

I have already mentioned that the Servite church was an agency strong enough to have denied the cathedral the right to have Annunciation Day as its major feast, and

Fig. 81. Nanni di Banco, *Assumption of the Virgin* (cat. 1-12, detail), 1414–22. Marble. Santa Maria del Fiore, Florence

legally appropriated Annunciation Day for its own exclusive rites. From its foundation in the thirteenth century, the cult had strong links with the patrician Florentine families, and eventually with the Parte Guelfa, which even housed its secret archive in the sacristy there. Annunciation Day was celebrated at Santissima Annunziata with great ceremony, including the presence of the Twelve Buonuomini, the Sixteen Gonfalonieri, and the Priors of the Signoria.[95]

Here the Virgin herself turns and gestures toward the church of the important order of Servants of Mary (Servites). If a company of government officials were to proceed from the cathedral to Santissima Annunziata, they would pass the Virgin of the mandorla, who would serve as a processional marker, showing the way. From the standpoint of the person coming from the Servite church, she may appear to gather pilgrims and citizens into the precinct of the cathedral, itself newly rededicated (1412) to the Virgin Mary as Santa Maria del Fiore.[96]

Leon Battista Alberti advanced the proverbial idea that in a successful *istoria* "the movements of the soul are made known through the movements of the body"; and he favored "movements . . . that are directed upwards into the air."[97] As late as 1568 Vasari declared that the flying angels of the Porta della Mandorla were unsurpassed in the his-

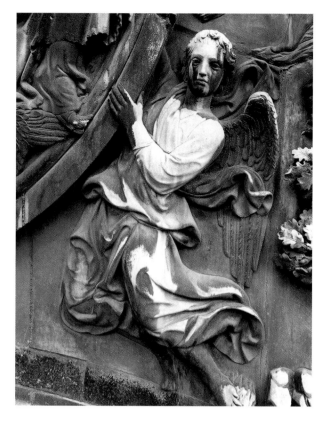

Fig. 82. Nanni di Banco, *Assumption of the Virgin* (cat. 1-12, detail), 1414–22. Marble. Santa Maria del Fiore, Florence

tory of art, a critical evaluation that was heartily seconded by H. W. Janson four hundred years later.[98] This "naturalism" in flying human forms would surely have interested Alberti, who commented extensively on the rendition of drapery in an *istoria* and wanted the fabric of garments to look like it was moved by the random effects of breezes and wind.[99] The animation of the Virgin's draperies here results from her simultaneous ascendance and torsion, the rotation of her posture enhancing the effect of an upward motion (helicopter-like), and of a rapidly increasing distance between herself and Saint Thomas.[100]

At the Porta della Mandorla the coherence of the angelic chorus is structured according to a circuit of interacting gazes, which ultimately connect with the beholder through the steady outward gaze of the lower right-hand angel (fig. 82).[101] In Albertian terms this angel is precisely the commentator who "tells the spectators what is going on, and either beckons them with his hand to look . . . or by his gestures invites you to laugh or weep with them."[102] It has been shown that the device of outward-gazing angels who serve as a psychological link between the representation and the spectator was developed with great subtlety in

post-Albertian paintings, such as Piero della Francesca's *Baptism of Christ*.[103] Such intermediary figures had a significant parallel in the theatrical *festaiuolo* of Florentine sacred drama, that is, an angel who remained on stage to mediate between the spectacle and audience.[104]

The *mise en acte* of paraliturgical drama has been used as a model to contextualize the experience of fifteenth-century painting, and it can likewise be brought to enrich our apprehension of public sculpture such as the *Assumption*, as well as the Albertian concept of *istoria*.[105] All these genres can be considered reifications rather than abstractions, and all were confluent in the shaping of a sensuous apprehension of the sacred in the visual culture of Renaissance Florence.[106]

Performance is by nature an ephemeral art form, but some early Renaissance *sacre rappresentazioni* in Florence have been described by Franco Sacchetti (ca. 1390), Pier Paolo Petriboni (1422), Bishop Abraham of Souzdal (1439), Giusto d'Anghiari (1482), and Giorgio Vasari in his lives of Brunelleschi and the *ingeniere* (inventor) Cecca (1568).[107] The scenic apparatuses (*ingegni*) of these plays and their effects have been fairly difficult for modern scholars to reconstruct, and several dispiriting drawings have been published in the art historical literature.[108] Architectural historians have typically concentrated on the literal reconstruction of the mechanical causes of these *ingegni* rather than the visual effects they produced, which must have been far more interesting and pertinent to the visual culture of the time. Scholars have depended heavily on the sketch of Brunelleschi's mandorla as reconfigured in the notebook of Buonaccorso Ghiberti.[109] Even from a strictly architectural, archaeological point of view, however, one can hardly imagine Filippo Brunelleschi cramming a human figure into a constrictive, capsule-like mandorla — especially when he had a model like the harmoniously solid, capacious, beveled mandorla in Nanni di Banco's relief before his eyes every day of his life at the cathedral.

In any case, we can generalize enough from several accounts to say that sacred drama was primarily visual and illusionistic in its impact, and that it seems to have centered upon a choreography of thrilling ascents and descents between heaven and earth, accompanied by colorful props and spectacular lighting effects. The Russian bishop, Abraham of Souzdal, was astonished not only by the performances themselves, which he considered amazing, but by the intensity with which they were received. He wrote that at Santissima Annunziata large crowds of people waited in

absolute silence, all eyes fixed upon the spot where the representation was to take place.[110]

The spectacles themselves must have been worth the bated breath with which they were awaited. Audiences were treated to a particularly tactile apprehension of the sacred in representation. One Annunciation, for example, featured a heaven full of swirling figures and flickering lights. A moving mandorla (ascending and descending on hidden pulleys) contained a fifteen-year-old boy dressed as Gabriel, and boys of a variety of ages dressed as putti and angels accompanied his flight. These angels wore gilded wings and had their hair arranged in tangled gilded skeins.[111] Another such play (at Santissima Annunziata) featured God the Father enthroned high in the heavens surrounded by hundreds of burning lamps that revolved continuously and by wreathes of musical angels playing flutes, cymbals, and zithers as Gabriel flew through the air singing his greeting to the Virgin.[112]

From all that we can gather, an enactment of the Assumption of the Virgin was performed at least once a year in the choir end of Santa Maria del Carmine from the late fourteenth century forward.[113] Pier Paolo Petriboni noted in his diary that on 21 May 1422 a spectacular Ascension play was performed at the Carmine, and that simulations of all episodes in the life of the Virgin, Mary Magdalene, and the Twelve Apostles were performed there as well, with various *ingegni* and many candles surrounding the ascending *nuvole* (clouds).[114] Petriboni's comments conform to a description by Giusto d'Anghiari of an "Assumption of the Virgin" performed at Santa Maria del Carmine in 1480 in which the Madonna rose to paradise and handed her sash down to Saint Thomas.[115] These sources indicate a continuous tradition of Assumption dramas performed at the Carmine and possibly elsewhere in Florence throughout the fifteenth century.

Whereas Franco Sachetti had joked about the slowness with which Christ ascended at the Carmine in the late Trecento, production techniques became more sophisticated during the first decades of the quattrocento.[116] The installation of an enormous stone iconostasis (about 28 feet high and 140 feet long) in 1422 provided an excellent new platform at the Carmine, and it was presumably here that Brunelleschi first worked out his theatrical *ingegni* as witnessed by Petriboni that same year.[117] So it seems that even as Nanni di Banco was completing the *Assumption* relief before his death in 1421, Brunelleschi was planning dramatic representations of the same sacred event.

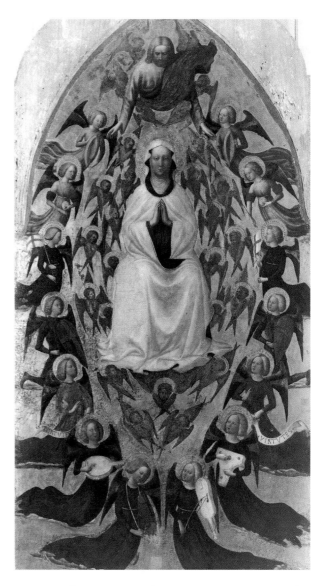

Fig. 83. Masolino, *Assumption of the Virgin*, 1423–25. Tempera on panel, 56 ¾ x 29 ⅞ in. (144 x 76 cm). Museo Nazionale di Capodimonte, Naples

Representations of the Assumption (put together by Brunelleschi together with other artisans at the Carmine) included a constructed mountain landscape (which was also used for the Ascension of Christ), and a rising mandorla with a boy dressed as the Virgin Mary seated inside. It seems that symmetrical pairs of iron branches projected from the mandorla structure like rays, and it was on these perches that the ranks of angels were arranged. At the end of each rod was a child dressed as an angel, strapped in from behind so that he could sing, dance, genuflect, and play music without falling. The branches supported little platforms covered with cotton wool to imitate clouds, so that the angels of heaven would rise with the mandorla.[118]

There were also (fictive?) angels in concentric "bouquets" in the firmament high above. The "heavens" were illuminated with intricate candelabra, which apparently turned like pinwheels to a splendid effect.[119]

For an Ascension play performed at the Carmine in 1425 a painter no less prestigious than Masolino made the clouds, applied blue paint and gold leaf, and created figures of flying angels, while the blacksmith Lionardo da Rigo fashioned chandeliers to hang beside and below the ascending *nuvola*.[120] The bouquets of gilded angels by Masolino in the *Assumption* panel of the *Colonna Altarpiece* (fig. 83) become particularly vivid in the context of the angels Masolino made for the Florentine *sacre rappresentazioni* of Ascensions and Assumptions.[121]

The Porta della Mandorla *Assumption* clearly has strong analogies with the material features of performed sacred representations. Among these are the clusters of suspended chandeliers that turned to create flickering stars, angels standing on *nuvole* that branched out from a rather architectonic mandorla, gilded wings and hair of the angels, hand-held accessories such as metallic lilies and luxurious textile sashes, the playing of diverse musical instruments, and even a mediating *festaiuolo*. To say that reciprocal allusions between paraliturgical representation and public sculpture would have enlivened the reception of both genres in the mind's eye of a fifteenth-century beholder is probably an understatement.

Arriving in Florence when he did, Leon Battista Alberti the scholar immediately became a practical theorist. He was a theorist who recommended — with typically Florentine pragmatism — that the artist, rather than study abstract mathematical texts, should seek concrete visual knowledge, or what he called "a more sensate wisdom."[122] Since Alberti's imagination was shaped by various modes of representation including painting, public sculpture, and liturgical drama, the idea of *pictura*, or pictorial composition, was not limited to painting *per se*.[123] Diverse art forms quickened and deepened one another's effect in the landscape of the material world and in the sacred imagination of Florentines. Alberti was nothing if not a keen observer, and the basis of his *istoria* exists in a confluence of visual practices.

The unfinished cathedral of Santa Maria del Fiore stood at the epicenter of Florentine public life — an enormous work in progress that as such was a paradigm of the city's collective imagination as well as a regular meeting place for ingenious artisans and intellectuals.[124] The way

forms produced meaning there, in large-scale pictorial projects such as Nanni di Banco's *Assumption*, as well as in statuary and architecture, had an immeasurable impact on the formulation of the theory and practice of Renaissance art.

Notes

INTRODUCTION

1. Gutwirth 1989, 1:31–32.

CHAPTER ONE

1. Vasari-Milanesi 2:161.

2. Docs. 5, 6, 7, 102. The prosperity of the family can be evaluated by a casual comparison of the forced loan taxes paid with those of other residents of the same *gonfalone*: e.g., docs. 11, 22, 27, 28, 39, 102; for Prestanze, see Molho 1968, 406.

3. Docs. 1–6, 16–18, 20, 21, 23–25.

4. Docs. 18, 29, 30, 32, 33, 37, 41–43, 54, 57, 60, 61.

5. Docs. 9, 114, 116, 168–71, 178; Nanni di Banco's cousin, Maso di Jacopo Succhielli was named *capomaestro* of the cathedral on 22 March 1451/52: Saalman 1980, doc. no. 337.

6. Condivi 1823, 3–4.

7. Wundram 1969, 261; for arguments regarding the date of Nanni di Banco's birth, see Bergstein 1987b, 6–32.

8. Docs. 9, 168, 169.

9. *Statuta* 1415, 2:793–94. See Bergstein 1987b, 6–32; Wundram 1969, 261; Herlihy and Klapish-Zuber 1978, 411; Trexler 1980, 11; Kent 1975, 609–10.

10. Wulff 1913 and Vaccarino 1950.

11. Billi 1891, 323.

12. Anonimo Gaddiano 1893, 3–6, 74–75.

13. Vasari-Ricci 1:245–47.

14. Gelli 1896, 61.

15. Vasari-Milanesi 2:164.

16. Vasari-Milanesi 2:507.

17. Gilbert 1967, 16–20.

18. Kreytenberg 1972, 5–32; Ladis 1992, 297–301.

19. The Alberti were readmitted to Florence from exile in 1428, and Leon Battista probably visited Florence before he arrived with the papal court in 1434; Alberti 1972, 108.

20. Doc. 48. As the Florentine year began on 25 March, dates falling into the period between 1 January and 25 March of any year are marked according to both Florentine and modern usage, e.g., 2 February 1404/5. His father had matriculated at about thirty-two after four years of marriage: doc. 10.

21. Cat. 1-6, doc. 72.

22. Chapter 2.

23. Docs. 160, 161.

24. Antonio Manetti: Martines 1994, passim.

25. Martines 1994, 254.

26. Manetti 1991, xv–xvi.

27. Docs. 168, 170.

28. Martines 1994, 219.

29. Vasari-Milanesi 2:162–64.

30. Vasari-Milanesi 2:163.

31. Brunetti 1930; Middeldorf 1936; Grassi 1951, 32; Janson 1963; Wundram 1969.

32. Martines 1994, 203.

33. Martines 1994, 196–97, 233.

34. Cat. 1-4.

35. Corazza 1894, 246.

36. Docs. 78, 82, 84, 86, 89, 93.

37. Geertz 1983.

38. Haines 1989, 91, 125.

39. Cat. 1-5.

40. Cat. 1-5.

41. Manetti 1970, 53, 108.

42. Mustari 1975, 317–37; Hartt 1987, 154, 167–69.

43. Haines 1989, 91, 125, passim.

44. Docs. 124, 134.

45. Doc. 155.

46. Doc. 158; Brucker 1969, 217–18.

47. Martines 1994, 213.

48. Brucker 1969, 217–18.

49. Gutwirth 1989, 179.

50. Martines 1994, 180, 227.

51. Martines 1994, 171–72.

CHAPTER TWO

1. Brucker 1977, 300.

2. Bergstein 1987a, 55–82.

3. Doc. 10.

4. Docs. 12–15.

5. Docs. 16, 18.

6. Cat. 1-1; docs. 30, 33.

7. Docs. 58–60.

8. Cat. 1-2; docs. 52, 54, 61.

9. Doc. 56.

10. See Zervas 1979, 634; Brucker 1977, 270.

11. Cat. 1-3.

12. Docs. 63, 64.

13. Docs. 98, 101.

14. Cats. 1-6, 1-7; doc. 72.

15. Docs. 31, 44, 51, 72, 85, 99, 114.

16. Goldthwaite 1980, 273–75, 284–86; Najemy 1982, 11; Dati 1869, 71–73.

17. Docs. 103, 104, 107, 116, 118, 119.

18. Docs. 108–10; cat. 1-12.

19. Doc. 109; Kent 1982, 55.

20. Doc. 26; for the scrutiny system see Rubinstein 1966, 4–5 and Najemy 1982, 263–300.

21. Doc. 46; *Statuta 1415*, 2:659–61.

22. Doc. 87.

23. Doc. 95.

24. Doc. 103; *Statuta 1415*, 2:783.

25. Docs. 115, 119.

26. Antonio served on the Council of the Commune for Chiave along with members of the Albizzi, Ammanati, and Arrighi families (e.g., 1 January 1403/4, ASF, Tratte 147, c. 182v). Others, including Chiarissimo di Bernardo Chiarissimi and Giovanni di Bicci de' Medici served on the councils that same year (Tratte 147, passim, under the rubric "Chiave").

27. Docs. 87, 88.

28. Cats. 1-5, 1-6, 1-7.

29. Doc. 105; Brucker 1977, 335–36, 411 n. 69; Repetti 1839, 3:264.

30. Doc. 106.

31. Doc. 108.

32. Docs. 111, 112.

33. Docs. 126, 129.

34. Doc. 132.

35. Cats. 1-6, 1-10, 1-12.

36. Docs. 139, 140.

37. Docs. 138–41, 144, 146; cat. 1-11.

38. Docs. 142, 145, 147; cat. 1-11.

39. Doc. 148.

40. Doc. 149.

41. For Florentine electoral politics see Brucker 1962, 59; Rubinstein 1966, 37, 117; Molho 1968, 401–20; Kent 1975, 578–84; Brucker 1977, 248–318; Najemy 1982, 299–300.

42. See Kent 1975, 581–84, 615–16.

43. Dati 1869, 71–73.

44. ASF, Tratte 45, c. 13v, cited by Brucker 1977, 257.

45. Doc. 150.

46. Docs. 151, 152.

47. Martines 1968, 392, 428, 483.

48. Saalman 1980, doc. no. 231-1.

49. See Krautheimer 1956, 294–305.

50. Doc. 155.

51. Doc. 157.

52. Doc. 158; for Giovanni di Gherardo da Prato, see Baron 1966, 332–37.

53. Doc. 159; Rubinstein 1966, 69, 117.

54. Docs. 159–61. More than six years after his death, Nanni's name was finally drawn for the Priorate of the Signoria in 1427: Docs. 172, 173.

55. Cf. Zervas 1979, 630–38.

56. Bruni *Oratio funebris* for Nanni Strozzi (Baron 1966, 556).

57. Cat. 1-6.

58. Planiscig 1946, 34; Weise 1953, 6; Hartt 1964, 120, 128.

59. Seymour 1966, 63; Horster 1987, 59–79.

60. Hartt 1964, 120–21, 123–28; followed by Martines 1979, 251–54. Antal (1948, 305) considered the ensemble a full expression of "upper-middle-class classicism."

61. Bryson 1994, XVII–XVIII.

62. The term "civic humanism" was coined by Baron in 1955; see Buck 1971, XXXI–LVIII, and Hay 1971, XI–XXIX.

63. Brucker (1969, 214) interpreted the civic humanist writings of Leonardo Bruni in terms of a reconciliation of the "Florentine vernacular" of the guild-based republic with the "Graeco-Roman ideal" of Latin letters.

64. Morelli 1956, 209.

65. For Antonio di Banco and Jacopo di Niccolò Succhielli serving as guild consuls during the same period, see ASF, Arte dei Maestri di pietra e legname 2, 1 January 1410/11, cc. 19r, 70r. For Jacopo di Niccolò Succhielli as guild consul, see ASF, ibid., 1 September 1391, c. 2v; 1 January 1401/2, cc. 11r, 62r; 1 May 1404, cc. 13r, 63v; 1 January 1406/7, cc. 15v, 66v; 1 May 1409, cc. 17v, 69r; 1 September 1412, cc. 20r, 71v; 22 May 1415, c. 22r, in which he substitutes Antonio di Banco; 1 January 1418/19, c. 26v; 1 September 1420, c. 28r; 1 September 1422, c. 29v; 1 January 1424/25, c. 31r; 1 January 1426/27, cc. 35r, 86r (dies during this term).

66. Cf. Planiscig 1946, 33; Vaccarino 1950, 39.

CHAPTER THREE

1. See Davis 1974, 142–59.

2. Cat. 11-6.

3. Wundram 1969, 145–46.

4. Olson 1992, 42.

5. See cats. 1-4, 1-7.

6. Kleiner 1992, 343.

7. Krautheimer 1956, 278–81.

8. Mustari 1975, 191.

9. Bober and Rubinstein 1986, 31–40.

10. Vasari-Milanesi 2:340; Bober and Rubinstein 1986, 31, 41.

11. See Coffin-Hanson 1977, 120.

12. Kreytenberg 1979a, 37.

13. Einem 1962, 68–79; Kreytenberg 1972, 26–28; Bergstein 1989, 82–88.

14. Becherucci and Brunetti 1969, 1: cat. no. 1-1.

15. Alberti 1972, 75; Bober and Rubinstein 1986, 143–47.

16. Moskowitz 1978, 61–62, Moskowitz 1986, 112; Hessert 1991, 34–43.

17. Seymour 1961, 207–26.

18. Ghiberti 1974, 45–47.

19. See doc. 91; Rodolico 1965, 247; Klapisch-Zuber 1969, 79–94.

20. Doc. 96.

21. Angiola 1977, 1–27.

22. For Nicola Pisano and the Phaedra sarcophagus, cat. 11-14.

23. Docs. 57–59.

24. See cat. 1-4.

25. Bianchi-Bandinelli 1946, 2–3.

26. Ibid.

27. For verism see Richter 1969, 117–30.

28. Bergstein 1986, 7–11.

29. Janson 1957, 15–16; Weise 1968, 107–13.

30. Bergstein 1986, 8–11; White 1989, 170–72.

31. Rosenauer 1974, 29.

32. See Reymond 1897–98, 1:24.

33. Becherucci and Brunetti 1969, 1: cat. nos. 125, 163, 164.

34. See chapter 1 and docs. 124, 134.

35. Janson 1957, 35; the *Zuccone* was likewise known as a portrait of Giovanni di Barduccio Cherichini.

36. Bernardini 1985, XLVII–LIV, 406–7, and cat. nos. 7, 8.

37. See Castelfranco 1963, 23–33.

38. Gelli and Vasari quoted by Janson 1957, 35.

39. Rose (1981, 31–41) identified the statue as the bald prophet Elisha.

40. Brunetti 1980, 273–77.

41. Marek 1989, 263.

42. Beaulieu 1957, cat. no. 578.

43. Rathe 1910, 108–14; Greenhalgh 1989, 214.

44. Mustari 1975, 297–99.

45. Poggi-Haines 1: doc. nos. 235, 241.

46. See Vasari-Milanesi 2:337–38; Manetti 1970, 52–56.

47. Levey 1967, 149–50.

48. Vasari-Milanesi 2:162–64; Janson 1968, 93.

49. Cf. Avery 1970, 59.

50. See Nicholson 1942, 92.

51. Bellosi 1966, 5; Parronchi 1980, 31; Cole 1980, 161–62; Beck 1981, 31; Kreytenberg 1986, 11–20.

52. Haskell and Penny 1981, 163, cat. no. 14.

53. Pope-Hennessy 1993, 31.

54. See Krautheimer 1956, 296–97; Janson 1961, 299; Weiss 1969, 1–59; Holmes 1969, 20–22.

55. For contrasting views see Holmes 1969, XIX, versus Krautheimer 1956, 294, 299–300; for the relations between literary and sensory experiences see Gadol 1965, 29–55.

56. Cf. Krautheimer 1956, 305.

57. Janson 1961, 299.

58. Haskell 1993, 13–25, 26–79.

59. Krautheimer 1956, 303.

60. Ibid.

61. Ibid., 303–4.

62. Manetti 1970, 62.

63. See chapter 1.

64. Manetti 1976, 3.

65. Wundram (1969, 145–46) proposed a trip to Rome in 1409 or early 1410.

66. Herzner 1973b, 89–93.

67. Cicero 1967, 167–79.

68. Johnson 1997, 167.

69. Quintilian 1968, 4:289, and passim.

70. Baron 1966, 225–69.

71. Witt 1983, 68–75, 343–45.

72. Marek (1989, 265, 271) cited the "eloquentia quaedam corporis" of Quintilian's *Institutio Oratoria* as an ideal that was attempted in the *Quattro Coronati.*

73. Alberti 1972, 55–57, 69; Krautheimer 1956, 306–14.

74. Sellers 1968, 208–9.

75. Sellers 1968, 206 n. 1; Hibbard 1974, 89–90.

Chapter Four

1. Gutwirth 1989, 1:32–33.

2. Zervas 1996, 1:79–98.

3. Ibid., 181–207.

4. For the paintings, Zervas 1996, 1:493–570.

5. Janson 1966, 82.

6. Hartt 1964, 114–31.

7. For the term "civic humanism," see Baron 1966, Buck 1971, Hay 1971.

8. See Zervas 1996, 1:182–87.

9. Mallett 1968, 403.

10. Becker 1968, 115–17; Poggi-Haines 1: doc. no. 164.

11. Mallett 1968, 404, 420–21.

12. Baron 1966, 364–65; Goldthwaite 1980, 31.

13. Morelli 1956, 472.

14. Goldthwaite 1980, 266–67

15. Zervas 1996, 1:621–22.

16. Meiss 1970; Andrews 1996.

17. Cat. 1-7. Summers 1977, 336–61; Bergstein 1992, 10–16.

18. For pictoriality of the Orsanmichele niches: Rosenauer 1975, 15–20; Poeschke 1980, 21; Poeschke 1989, 145–54; Maginnis and Ladis 1994–95, 41–54.

19. Vaccarino 1950, 35; and reproduced engraving by Francesco Pieraccini reproduced in Kunsthistorisches Institut von Florenz, Fototeca no. 113301 (fig. 52)

20. Cf. Wundram 1969, 117.

21. See Johnson 1994, 108–9.

22. Carocci 1889, 17–75; Fanelli 1973, 97–99, 121, 376; Zervas 1989, 101–7, 172–76.

23. Procacci 1960, 3.

24. For unpublished documentation on the Calzolai see ASF, Notizie dell'Arte dei Calzolai; ASF, Arte dei Calzolai 1 bis, 1, 2, 3, and 4. See Notizie dell'Arte dei Calzolai, c. nn: "Si matricolono in essa i Calzolai, zoccolai, cintai, pianellai, collettai, ciabattini." For the designation of tradesmen as *calzolai* and *pianellai*, see ASF, Arte dei Calzolai 2, 3, and 4.

25. Gandi 1928, 14.

26. Villani 1857, 1:117.

27. Gandi 1928, 14 n. 1. For notations regarding the locations of shops of *calzolai* see ASF, Arte dei Calzolai 3 and 4.

28. ASF, Arte dei Calzolai 4, c. 2v, Calvano di Cristofano di Salvi; c. 11v, Antonio di Bartolino; c. 12r, Antonio di Charbone di Ceccho with his brother Fruosino di Charbone; c. 12r, Credi di Simone di Credi; passim. Other *calzolai* known to have operated in the limited area of the Corso degli Adimari include Arrigho di Corso.

29. Procacci 1960, passim.

30. Procacci 1960, 21 n. 89; ASF, Arte dei Calzolai 4, c. 2v.

31. Lensi 1925–26, 181.

32. ASF, Arte dei Calzolai 1 bis, c. 1r, under the rubric of the first of the statutes to be preserved: "De non vendendo laborerium die festivo in platea sanctis michaelis in orto, item xii"; summarized in Italian under the rubric "Frammenti d'antico statuto dei Calzolai"; see ASF, Notizie dell'Arte dei Calzolai, cc. nn.

33. ASF, Notizie dell'Arte dei Calzolai, c. nn.

34. Goldthwaite 1980, 266–67.

35. Anonimo Fiorentino 1986, 73, 99, 141, 212.

36. Natali 1996, 18–21.

37. Cat. 1-11. Entry to the apartments from the city was provided by a staircase on the (so-named) via della Scala.

38. Pastor 1944, 1:219–23; Partner 1958, 17–42; Brucker 1977, 421–22; Christiansen 1982, 55–56.

39. Holmes 1968, 376; Lightbown 1980, 1:24–51.

40. Partner 1958, 17–42.

41. Brucker 1977, 421–25.

42. Ibid., 421.

43. Cat. 1-11.

44. Ibid.

45. Ibid.

46. Cf. Trexler 1973, 125–44.

47. BNF, Petriboni-Rinaldi, c. 99.

48. Cf. Antal 1948, 1–9, 305–6.

49. Corazza 1894, 233–39. Nanni and Bartolommeo were peers in terms of age and social status: Bartolommeo matriculated to the vintners' guild in 1404, Nanni to the stonemasons in 1405; each served as guild consul repeatedly, each with his own father among the electors; each eventually distinguished himself in government service.

50. Corazza 1894, 256.

51. Ibid.

52. BNF, Petriboni-Rinaldi, c. 98v; Corazza 1894, 258.

53. Corazza 1894, 258.

54. BNF, Petriboni-Rinaldi, c. 99 r–v; Corazza 1894, 258.

55. Corazza 1894, 265.

56. Krautheimer 1956, 405, digest no. 64.

57. Bulli 1935, 3–4.

58. BNF, Petriboni-Rinaldi, cc. 101r–102r.

59. Corazza 1894, 271–73.

60. Doc. 138.

61. Corazza 1894, 257; BNF, Petriboni-Rinaldi, c. 98v.

62. Doc. 139.

63. Corazza 1894, 259.

64. Doc. 149.

65. Brucker 1977, 422.

66. BNF, Petriboni-Rinaldi, c. 100v.

67. Corazza 1894, 271–72.

68. Beck 1970, 20–22, 24, 27; Christiansen 1982, 17–18.

Chapter Five

1. Cat. 1-12.

2. Camille 1992, 9.

3. Cf. Himmelmann 1985, 228–47; Hessert 1991, 40; Gatti 1992, 29–41.

4. Bergstein 1991, 673–719.

5. Antal 1948, 306; Pope-Hennessy 1955, 53; Avery 1970, 60.

6. Vasari-Ricci 1:236–37, 247; Vasari-Milanesi 2:115.

7. Gelli 1896, 59–61.

8. Voragine 1924, 3:977–1002.

9. Sinding 1903, passim.

10. Grassi 1995, 23–39; Lessanutti 1996, 141–61.

11. Gatti 1992, 45–57 and "Leggenda della Cintola," redaction of 1427, Appendix 6, pp. 235–38.

12. Pseudo-Jerome, in Conrad of Saxony 1904, 91.

13. "Assunta est Maria in coelum, gaudent Angeli collandantes benedicunt Dominum, alleluja" (Rossi 1940, 11). For the liturgy of the Assumption at the cathedral of Florence, see the following codices at AOSMF: A.3.n.55, fols. 19v–22r; F.6.n.32, fols. 71r–75v; S.14, fols. 10r–112r; H.8.n.45, fols. 128v–131r; 3. Lettera C., fol. 10v. Citations brought to my attention by Marica Tacconi.

14. See Cat. 1-12.

15. Doc. 166. As an apocryphal story, the Assumption of the Virgin was ratified in the early Middle Ages by phrases taken from prophets including Moses, Solomon, David, Isaiah, Enoch, Elijah, and Daniel. See Ildelfonso, Bishop of Toledo, Sermon VI on the Assumption: "Haec ist illa virgo gloriosa, cuius ineffabile longe ante et figuris legalibus et prophetarum oraculis praenuntibitur" (Migne 1844–66, 96: col. 264).

16. A Marian association with the Song of Solomon was strongly rooted in the art of the Mediterranean world, as seen in the *Coronation of the Virgin* mosaic at Santa Maria Maggiore in Rome (Jacopo Torriti, 1292–95) which bears the following inscriptions: "Veni electa mea et ponam in te thronum meam," "Maria Virgo assumpta est ad ethereum thalamum in quo Rex Regum stellato sedet solio," and "Exaltata est sancta Dei genitrix super choros angelorum ad caelestia regna."

17. Cf. Janson 1957, 43.

18. Bonaventure 1938, 265–67. Matteo d'Acquasparta 1962, 193, and see Angiola 1977, 18–19.

19. Watson 1974, 116–17; Angiola 1978, 245–48.

20. See Krautheimer 1956, 117–80; Wright (1994, 395–441) has proposed that Dufay's motet "Nuper Rosarum Flores," composed for the consecration of the Duomo in 1436, was structurally based on the proportions of the Temple of Solomon.

21. Ambrose, in Migne, 1844–66, 16: cols. 289–91.

22. "Et venter tuus acervus tritici, vallatus liliis"; "virgo sancta inter filias, ac si lilium inter spinas." See Migne 1844–66, 96: cols. 240, 246, 412.

23. Conrad of Saxony 1904, 169–70.

24. "Gli angeli cantavano che cantico che dice, 'come el giglio è sopra la spina, così l'amicha mia è sopra tutte le donne'" (Gatti 1992, 235–38).

25. Eisler 1961, 86.

26. Marracchi 1694, 34.

27. Pseudo-Jerome in Migne 1844–66, 30: col. 134; Augustine in ibid. 40: col. 1146.

28. Paulus Warnefridus in Migne 1844–66, 95: cols. 1494–96; Petris Cellensis in ibid. 202: cols. 850–65; Stephen of Tournai in ibid. 211: cols. 245–47; Pope Innocent III in ibid. 221: col. 578 and passim; Bonaventure 1938, 277; "Leggenda della Cintola," in Gatti 1992.

29. "Quae est ista quae ascendit quasi aurora consurgens pulchra ut luna, electa ut sol, terribilis ut castorum, acies ordinata?" (Migne 1844–66, 40: col. 134).

30. "Ipsa namque luna et lucerna nostra illuminata fuit a Domino et illuminatrix fuit mundo, iuxta illus propheticum, 'Quaniam tu illuminas lucernam meam Domine!' Ecce, si Maria fuit lumina sapientiae" (ibid.).

31. "Duo magna luminaria ex hominibus assumpta . . . Jesum et Mariam" (Migne 1844–66, 95: col. 1496).

32. Pelikan 1996, 206; Bernard 1980, 193.

33. Bernard 1980, 208.

34. Matteo d'Acquasparta 1962, 147, 167, 190, 203, 206–7, 209, 254, 256, 258–59, 263, 266–67.

35. *Par.* XXIII: 21–22. The dedication of the cathedral to Santa Maria del Fiore (8 September 1296) coincided with Dante's first participation in Florentine government as a member of the Consiglio del Cento from May to September 1296 (Chiminez 1960, 385–451); regarding Dante and Bernard of Clairvaux, see Manselli 1970, 601–5; Dal Prà 1990, 29–88.

36. Rohr 1948, 76; regarding the Assumption, Adam of Saint Victor wrote: "Tu thronus es Salomonis, cui nullus par in thronis, Arte vel materia; Ebur candens castitatis, Presignans mysteria" (in Fleury 1878, 1:270).

37. Marracchi 1694, 380–81.

38. Cat. 1-12; docs. 164, 167, 176. See Poggi-Haines 1: doc. nos. 389, 392, 396–98.

39. Bergstein 1991, 675–87.

40. Lessanutti 1996, 200, 208.

41. Cassidy 1988, 174–80.

42. Bergstein 1991, 675–87.

43. Moseley 1916, passim; Weinstein 1968, 15–44.

44. Bargellini 1969, 22.

45. RIC, Ms. Riccardiano no. 683, M. Iv. 33, rubrica XI: "Canzone in lode della Signoria di Firenze: Canzone morale fatta a Commendatione de' Signori priori e del gonfaloniere della giustizia e de' Gonfalonieri di Chompagnia e de' dodici buoni huomini loro collegi deputati al governo della gloriosa città di Firenze," cc. 194v–198r, discussed in Bergstein 1991, 687–88.

46. For the Pala di San Pancrazio and the personification of Florence in BNF, Convenevole da Prato, fol. 13, see Bergstein 1991.

47. A 14th-century relief by Niccolò di Cecco di Mercia in Prato used the same format.

48. See chapter 1.

49. Christian 1989, 72–103.

50. Kreytenberg 1995, 83.

51. See Neri-Lusanna 1996, 29; Kreytenberg (1995, 83), attributes this statue to a pupil of Giovanni di Balduccio. For the woven structure of the *cintola* at Prato, Schoenholzer-Nichols 1995, 79–81.

52. Anson 1948, 106–7; Moroni 1841, 7:206–10.

53. Bergstein 1991, 673–75.

54. Guasti 1887, doc. no. 465.

55. Guasti 1887, doc. no. 476; Benvenuti 1994, 290.

56. Assumption Day was presumably excluded as a choice, since from the 14th century onward, it was celebrated by the Florentines with primary rites held in the annexed city of Prato; the clergy of Santa Maria del Fiore apparently possessed the key to the Pratese reliquary of the *cintola*.

57. Voragine 1924, 1:311–29.

58. The night of the Candelora was evolved from an ancient tradition in Italy, linked to the expiation feast of Amburbiale, which was celebrated with the procession of lamps and torches carried by women in pagan Rome as the feast of Demeter and Persephone, and of Februa mother of Mars. According to Pope Innocent III and Bishop Federico of Pisa, the pagan observance in Rome was practiced throughout the 13th century notwithstanding the fact that Pope Sergio I (687–701) had Christianized the custom to honor the Virgin Mary. For the derivation of the Purification from pagan festivals see Campana 1933, 1:297–302; for the theological fortunes of the feast day from antiquity through 1965, Righetti 1969, 2:115–20.

59. Bergstein 1987a, 65; cat. 1-12.

60. "Purissima e splendente, tutta riluce" (Voragine 1924, 1:311–29); and see Davidsohn 1956–68, 3:124.

61. Bonaventure 1938, 278: "Virgo gloriosa est maris stella purificans."

62. Matteo d'Acquasparta 1962, 217–18.

63. "Passata l'oscurità di questo mondo, possiamo pervenire alla luce perpetua in cielo" (Eisenhofer 1940, 110).

64. The idea of the Virgin of the Purification as a purifying light was diffused in the sacred poetry of the trecento, and the metaphor of the flower was also applied to the Purification, as in a manuscript in Bamberg (Ed. IV. 6): Mone 1964, 2: hymn nos. 421, 493, and hymn nos. 419–30.

65. Antoninus 1681, 4: chap. 33, "In purificatione beatae Mariae & de multiplici lumine"; 4: chap. 34, "In purificatione b. Maraie. Sermonibus de ratione numeri variatione purificationis & de interpraetatione nominis."

66. AOSMF, (Antiphonary) Codex N. n. 6, fols. 124v–125r, 161v–169r; (Gradual) Codex F6 n. 32, fols. 13r–20v; (Gradual) Codex S. n. 14,

fols. 23r–37v. Citations brought to my attention by Marica Tacconi.

67. Holmes 1969, XVIII–XIX.

68. Pope-Hennessy 1993, 316.

69. Alberti 1976, 94–95.

70. Gadol 1969, 5; Alberti 1976, 13.

71. Poggi-Haines 1: doc. nos. 396–98.

72. Ibid., doc. nos. 389, 392.

73. Del Bravo 1977, 768–69.

74. Baxandall 1972, 137.

75. Alberti 1972, 78–79.

76. Ibid., 78–81.

77. Ibid., 82–83, 76–77.

78. Cat. 1-12; Torriti 1980, 35–40; Getty inv. no. 86. PB. 490.

79. Blume 1983, 91–92; Hueck 1976, 268. The scenes were set up as a pair, for instance, on the choir facade of Santa Croce, left and right of the main altar. It may be significant that Saint Francis received the stigmata on 14 September (Elevation of the Cross) during a fast that he began on Assumption Day (15 August).

80. Alberti 1972, 102–3.

81. Morelli (1956, 92) described wildlife and woods of the Mugello.

82. Among many examples: Augustine, in Migne 1844–66, 40: col. 1144; Saint Peter Damian, in ibid. 144: cols. 719–22; Bernard of Clairvaux, in ibid. 183: col. 425; Martin of Lièges, in ibid. 209: cols. 22–23; Conrad of Saxony 1904, 164; Matteo d'Acquasparta 1962, 281–83; Voragine 1924, 3:982.

83. See Janson 1963, 98–107.

84. *Par.* I:1. The *Divine Comedy* was recited in public places, e.g., in 1412 at Orsanmichele (Zervas 1996, 1:186).

85. Bergstein 1987b, 394–403, 418–20.

86. Frazier 1987, 119–50.

87. Bertini 1985, 1045.

88. Jacquart and Thomasett 1988, 162–68.

89. For one example among many, Luca di Bitonto 1985, 185, 196: "Quidam, enim, corpori innituntur per voluptatem. De quibus Amos (V): 'Quod si fugiet vir a facie leonis id est a peccato superbie sed occurrit ei ursus scilicet peccatum luxurie.' Ursus enim super omnia mel diliget, et ingreditur domum descendendo ad curiositatem carnis, et innititur manu super pariete confidendo robori et iuventuti sue et mordeat eum coluber, scilicet dyabolus animam eius rapiendo ex improviso." "Luxuriam desiccavit in incarnatione, quia de virgine conceptus et natus." See further Bergstein 1987b, 394–403.

90. "Leggenda della Cintola," in Gatti 1992, 237. For alternative iconographic readings cf. ibid., 58–68; Emison 1992, 381–87; in cat. 1-12.

91. Gaffron 1950, 312–30.

92. As the term is used by Geertz 1983.

93. Cat. 1-12.

94. Chapter 4.

95. Petrucci 1992, 5–6; Benvenuti 1994, 290.

96. Bergstein 1991, 673–75.

97. Janson 1963, 102–3.

98. Ibid., 103–7.

99. Alberti 1972, 86–87.

100. Wundram 1969, 96–97. "I should like all the movements I spoke of to appear in hair: let it twist around as if to tie itself in a knot, and wave upwards in the air like flames; let it weave beneath other hair, and sometimes lift on one side and another" (Alberti 1972, 86–87). In the lower left angel of the *Assumption* we see the hair "wave in the air like flames" and the strands intertwine with tendrils of amaranth wreathes, a feature that would be continued by Luca della Robbia in his Cantoria.

101. Janson 1963, 98–107; Wundram 1969, 160.

102. Alberti 1972, 82–83.

103. Baxandall 1972, 72–75.

104. Ibid.

105. Francastel 1965, 211–38; Francastel 1967, 68–72.

106. See Trexler 1972, 9–10; Ladis 1986, 581–96; Verdon 1990, 8–20.

107. Franco Sacchetti 1946, Novella 72, 160; BNF, Petriboni-Rinaldi, c. 107r; Souzdal and Vasari in Molinari 1961, 35–48. For the choice of the word "performance" in this context see Battisti 1980, 403–4.

108. Blumenthal 1967, 20–31.

109. BNF, Buonaccorso Ghiberti, c. 115r–115v.

110. Abraham of Souzdal, in D'Ancona 1891, 1:246–53.

111. Vasari-Milanesi 2:375–78.

112. D'Ancona 1891, 1:246–48.

113. Vasari-Milanesi 3:195–204; Trexler (1980, 454–75) cites Giusto d'Anghiari, c. 136r, 1480 May 14: "Si fece al Carmine una Rappresentazione della Vergine Maria quando ella si andò in Paradiso e diede la sua cintola a sancto Tommaso." Sacchetti describes an enactment of the Ascension at the Carmine in the late trecento, and it is probable that the Assumption was performed as well.

114. Pochat 1978, 233; BNF, Petriboni-Rinaldi, c. 107r.

115. BNF, Giusto d'Anghiari, c. 136r.

116. Sachetti 1946, Novella 72, 160.

117. See Fabbri 1975, cat. no. 1-18.

118. For the *nuvola* in paraliturgical theater and processional representations see Damisch 1972, 91–114.

119. Vasari-Milanesi 3:195–204.

120. Pochat 1978, 232.

121. Joannides 1993, 414–22, cat. no. 23.

122. Alberti 1976, 19.

123. Poeschke 1993, 28.

124. See Martines 1994, 213–41.

Catalogue of Works

The Catalogue of Works is divided into two sections: (I) Authentic Works and (II) Rejected Attributions. Entries for authentic works are arranged chronologically; entries for rejected attributions are arranged alphabetically according to location. Works listed in the catalogue are referred to throughout the text as "cat.": for example "cat. II-5." Documents digested in the Register of Documents are signalled with the abbreviation "doc."

Dimensions are given as height alone, or with height preceding width.

Whereas the Catalogue of Authentic Works (cat. I) attempts to be as complete as possible in terms of information and argumentation, the Catalogue of Rejected Attributions (cat. II) gives basic information and discussion of each work only insofar as it relates to the accepted oeuvre of Nanni di Banco.

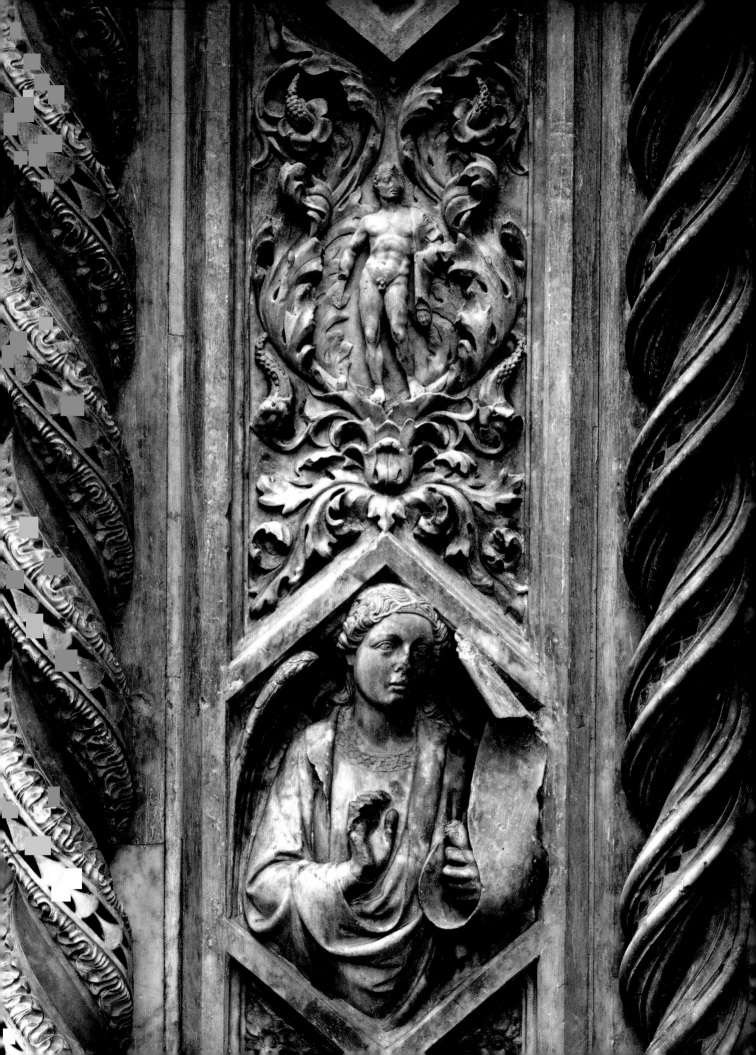

1.1 *Hercules and Blessing Angel*

ca. 1395
Marble, height of segment ca. 37 ½ in. (95 cm)
Santa Maria del Fiore, Florence

Located on the lowest section of the northeast door (Porta della Mandorla) of Santa Maria del Fiore, two half-length "Blessing Angels" in hexagonal frames hold scrolls. Between them, in a passage of acanthus foliage, stands a nude "Hercules" holding a lion skin. The "Hercules" is in relatively poor condition, lacking the upper left quadrant of the figure's face and the lower portion of the figure's right arm which was presumably braced on a club, the bottom stump of which is still visible in the lower section of acanthus stem. The reveal friezes are generally corroded and blackened from exposure to pollutants (1999).

ATTRIBUTION AND DATING

The portal's earliest decoration was derived from local fourteenth-century precedents, such as the busts of scroll-bearing prophets in quatrefoils at the Loggia del Bigallo, and the rinceaux of classicizing grotesqueries in the frame and reveals of the Porta dei Canonici on the south side of the cathedral for which the Porta della Mandorla was planned as a symmetrical counterpart (Kreytenberg 1995). At the Porta della Mandorla, the keystone of the lintel is a hexagonal cartouche with God the Father blessing; the lintel and jambs continue in rinceaux where putti, angels, and mythological vignettes (such as three of the labors of Hercules in the lower half of the inner jamb) populate the foliage. The reveals, or *sguanci*, contain half-length, scroll-bearing angels in hexagonal frames. These angels alternate with passages of acanthus foliage which enframe small nude figures of classicizing taste. These reveal friezes at the Porta della Mandorla have attracted special attention from art historians: although the angels continue an established tradition, several of the figures in both the left and right reveals transcend local precedents in their comprehension of the standing nude. Scholars beginning with Krautheimer (1956) and Seymour (1959) have suggested that a new kind of attention was paid to ancient models here and that this "proto-Renaissance" activity prepared the way for the classical focus developed by the next generation of sculptors who worked in the first decades of the quattrocento.

Since the reveal friezes are interesting for individual figures rather than as a whole, the attribution of parts to various artists has given rise to several intricate hypotheses. The standard approach to riddles of authorship (which are especially problematic in the figured reveals of the lower zone) is to separate artists' hands according to the physical division of blocks of stone, and to assign these physical segments to the sculptors named in the deliberations at the outset of the project. A series of deliberations and payments of the Operai, presumably documenting the decoration of the Porta della Mandorla, were coordinated and

Fig. 84. Porta della Mandorla (detail of outer friezes), Santa Maria del Fiore, Florence

published by Poggi in his analysis of the "first" and "second" campaigns. The so-called first campaign of the Porta della Mandorla, 1391–97, directed by *capomaestro* Lorenzo di Filippo, produced the lintel, jambs, and figured reveals of the lower section (fig. 5). The outermost reveals of the jambs (fig. 84) may well have been part of the tympanum project (cat. 1-12). In 1391, at the outset of the first campaign, it was stated that individual sculptors be assigned blocks of marble to be carved according to a single design conceived by Lorenzo di Filippo (Poggi-Haines 1: doc. no. 348). Poggi (ibid., 1909) identified subsequent payment documents with the actual sections of stone in the lower portal decoration, an assumption upon which most subsequent scholarship rests. Kauffmann (1926) proceeded with Poggi's method, coordinating discrete sections with documents, attributing sections to hands in a systematic way. Kauffmann's approach has been followed by most later scholars. The first modern writers to undertake attributions, including Semper (1890), Cavallucci (1881), Schmarsow (1887), and Wulff (1909, 1913), worked without Poggi's systematization of documents; and Wulff, even after

Poggi's contribution, envisioned a single campaign (lower reveals and archivolt friezes) unfolding in the first decade of the quattrocento (1402–8), a possibility which is even now not to be ruled out. At times purely visual criteria have indicated attributions to artists not named in Poggi's documentary framework, which is in any case problematic owing to missing records.

Briefly summarized, the ten segments of stone composing the lintel and jambs, or *stipiti*, have been accepted (since Kauffmann's study of 1926) as the work in part of Giovanni d'Ambrogio and in part of Piero di Giovanni Tedesco (with the blessing Deity also by Piero), dated by Kauffmann according to corresponding payments to 1391–95 (1926). The seven blocks of stone that constitute the figured reveal friezes have been variously distributed among four carvers mentioned in relation to *sguanci* from 1392 to 1397: Giovanni d'Ambrogio; Jacopo di Piero Guidi; Piero di Giovanni Tedesco; and Niccolò Lamberti. Most scholars since Kauffmann (1926) are agreed in assigning the second and third angels in hexagons from the top of the left *sguancio*, along with the putto playing bagpipes between them, to Piero di Giovanni Tedesco; the second and third angels of the right *sguancio*, along with figurines from the first, second, and third acanthus intervals, are given to Jacopo di Piero Guidi. Kauffmann (1926) ascribed the remaining parts of the left reveal, namely the uppermost module with its angel and nude *Apollo* (fig. 85) and lowermost section with two angels and *Hercules*, to Giovanni d'Ambrogio; and those on the right (uppermost hexagon, foliage, and lowest two hexagons with *Abundance* between them) to Niccolò Lamberti. The attributions of these parts to Giovanni and Niccolò were accepted and expounded upon by Wundram (1960, 1962, 1969), who was followed by Kreytenberg (1972, 1995), Goldner (1978), and Schulz (1986), but challenged by Brunetti (1951, 1952), Seymour (1959), and Gordon (1968). Artists such as Jacopo della Quercia, Lorenzo di Giovanni d'Ambrogio, and Nanni di Banco (none of whom are mentioned in the documents) have been introduced as younger, more progressive hands, possibly working as assistants to the more established masters mentioned above. Brunetti (1951, 1952) gave the uppermost and lowermost sections of the left reveal to Jacopo della Quercia as a pupil of Giovanni d'Ambrogio. Seymour (1959, 1966) assigned the lower left reveal to Niccolò Lamberti and the upper left reveal to Lorenzo di Giovanni d'Ambrogio working under his father. Gordon (1968) attributed the *Hercules* alone from the lower

Fig. 85. Porta della Mandorla (detail of upper left reveal), Santa Maria del Fiore, Florence

left reveal to Lorenzo di Giovanni d'Ambrogio, carved by Lorenzo within the segment of stone produced in his father's shop. Beck (1991) considered Giovanni d'Ambrogio and Lorenzo di Giovanni the best candidates for authorship of the *Hercules*.

A recurring theme in the literature both before and after Poggi's work was the association of Nanni di Banco with the first campaign of the Porta della Mandorla. Although Nanni is not mentioned in the documents associated with the first campaign, the older (pre-Poggian) criticism had suggested his participation in the reveal friezes. Semper (1890, 1875), who envisioned one sweeping campaign, supposed that Antonio and Nanni di Banco and Niccolò Lamberti were responsible for the figured reveals, as well as the outermost posts, decorated with lilies and lions' heads. Schmarsow (1887) claimed the entire reveal decoration for Antonio and Nanni di Banco, after having been begun and subsequently abandoned by Niccolò Lamberti. Wulff (1909) retained for Nanni, of the many parts assigned to him by Schmarsow (1887), three figures — *Abundance*, *Prudence*, and *Hercules* — and the angel busts from the top and bottom left reveal sections. Despite Poggi's intervening research, Wulff kept to this opinion in his monograph of 1913. Poggi's particular grouping of documents (along with a mistaken belief that Nanni was born as late as 1390) negated the possibility of his activity here for most subsequent authors such as Brunetti (1947) and Seymour (1959). Nanni di Banco's activity in the first campaign of the Porta della Mandorla will be reappraised in the following paragraphs.

Nanni di Banco was probably a young stone carver at the time the lower zone of the Porta della Mandorla was made, and although his name does not appear in documents associated with this phase of decoration, we may nevertheless seek his activity there insofar as his father was firmly entrenched in the cathedral shop during that decade: Antonio's name occurs repeatedly in payments of the 1390s next to the names of sculptors known to have worked in the first campaign. From 1394 to 1398 Antonio was occupied in producing carved architectural members for the Opera: consoles, frames, "brackets for a pilaster," and so forth (see docs. 29, 30, 32–33, 37). Since Antonio was already a consul of the stonemasons' guild by 1394 (doc. 31), he must have received commissions for choice projects. If we suppose that the twisted colonnettes with intarsia work and scrolled acanthus colonnettes were created around the time of the jambs and figured reveals, we may presume that Antonio participated in their manufacture, especially since he received payments for ornamentation during the years 1394–98. He may also have taken part in the production of the figured reveal friezes with the help of his son, Nanni. In a document of 1406 (doc. 52), Antonio is referred to as "Antonio Banchi magistro qui laboravit in et super portam ecclesie . . . per quam itur ad ecclesiam Servorum Sancte Marie," indicating that he had done work on the upper and lower zones of the Porta della Mandorla, be it of a figurative or a decorative nature (Herzner 1973b).

The segment of stone constituting the lower left reveal of the Porta della Mandorla, which comprises two scroll-bearing angels and a figure of "Fortitude" personified by *Hercules*, is dated by most experts to around 1395 and can be inserted into Nanni di Banco's career. Reading back from Nanni di Banco's later recognized oeuvre, the nude *Hercules* emerges as a youthful work on the basis of concept and style.

Some modern critics have attempted to isolate a group of fine works of unknown date and authorship around the

Hercules (see Krautheimer 1956 and Seymour 1959). Most frequently and wrongly connected to the Hercules is the Annunciation group from the Museo dell'Opera del Duomo (cat. 11-6). The following scholars have seen the Hercules and Annunciation as the work of a single artist: Schmarsow 1887; Wulff 1913; Kauffman 1926; Grassi 1951; Toesca 1951; Brunetti 1952; Wundram 1960; Gordon 1968; Kreytenberg 1972; Cardini 1978. This so-called "Hercules Master" has been identified with sculptors as diverse as Giovanni d'Ambrogio, Lorenzo di Giovanni d'Ambrogio, Antonio di Banco, Jacopo della Quercia, Jacopo di Piero Guidi, Niccolò Lamberti, and Nanni di Banco. But the Hercules-Annunciation connection is simply an attempt to resolve two puzzles by tying them together, and in this present study, all notions of a "Hercules Master," around whom various works have been grouped, will be put aside.

The Hercules has been seen correctly as a precedent for the Isaiah (cat. 1-4) and the youngest saint of the Quattro Coronati group (cat. 1-6) (Schmarsow 1887, 1889; Wulff 1909, 1913; Brunetti 1947; and Toesca 1951). The figure anticipates the physical and spiritual type of Nanni's later statues and is consistent with his approach to relief carving. Mutatis mutandis, the Hercules seems to predict Nanni's (over life-sized, clothed, freestanding) Isaiah of 1408 (cat. 1-4), which repeats the position of the limbs and emphases of weights. The turn of the head away from the direction of the body and the highly plastic modeling of the youthful face, with fleshy protrusion of eyelids and lips — even the direction of the gaze — seem to anticipate the Isaiah. Similarly repeated are the position of neck and shoulders, the exaggerated definition of the chest, forced recession of the waist under the rib cage, and shot-hip contrapposto with an engaged right leg. In both the Hercules and the Isaiah there exists a certain tension in the position of the arms, resulting from a motion whereby the shoulders are lifted and held back. In both figures the bulk of the weight curves forward in an "S" from the left shoulder to the right hip, thus overstating the projection of the chest and breaking the weight-bearing side.

The Hercules prefaces the Isaiah, too, in that it appears to have risen from a study of Nicola Pisano's Daniel at Pisa (fig. 20). In each figure the squarish face with heavy lips seems derived from Nicola Pisano's vocabulary, itself so close to later Roman and Early Christian models (Angiola 1977). Nanni di Banco broke the pattern of the gothic patriarchal type throughout his career, and the Hercules may

be the first instance of this tendency. In this respect, Nanni's Hercules departs from its closest iconographic predecessors, namely the Labors of Hercules vignettes from the lower half of the inner jamb of the Porta della Mandorla (carved by Piero di Giovanni Tedesco) and Andrea Pisano's Hercules and Cacus of ca. 1335 for the Campanile. (For Andrea Pisano's Hercules and Cacus relief, see Becherucci and Brunetti 1969, Kreytenberg 1984, and Moskowitz 1986.) The Porta della Mandorla Hercules follows Andrea Pisano's Hercules in several details. Although the right arm of the present figure is broken, we can still see that the arm, shoulders, and torso are conceived in a manner similar to Andrea's relief; the passage of the figure's left forearm draped with a lion skin is derived from the Campanile relief as well (Kauffmann 1926; Moskowitz 1978; Hessert 1991). In turn, the draped arm in Andrea's relief is a motif traceable to the Hippolytus in Pisa (fig. 21) and Nicola Pisano's Daniel. Despite the ruined condition of the supporting leg in Andrea's Hercules, it is obvious that Nanni's Hercules stands in a similarly conceived contrapposto. It is significant that Nanni would subsequently refer to the Campanile panels in later works. The present Hercules is more convincing than that of Andrea Pisano, though, because not only are the free and engaged legs more persuasively differentiated, but the feet are naturalistically foreshortened. These technical refinements may have been observed from the Apollo of 1393 at the top section of the same reveal (fig. 85) which is generally attributed to Giovanni d'Ambrogio.

The carving technique of the Hercules and surrounding spray of acanthus leaves is stylistically consonant with Nanni's mature relief works. The figure is projected from the ground in the manner of the full figures in the socle reliefs at Orsanmichele. The highly plastic modeling of face and hair would be continued in figures such as the blacksmith's apprentice in the Saint Eligius relief (cat. 1-10). The acanthus design, which conforms to a pattern repeated in all sections of the sguanci, may be perceived as relatively static and flat, lacking the nervous energy of the foliage, for example, in the socle zone of the Saint Philip niche (cat. 1-7). The Saint Philip acanthus is much more independent of its ground in a two-dimensional as well as three-dimensional sense; its agitated composition shows the brio of a virtuoso carver. But in the passage of foliation in the Hercules panel, the pods are already carved with round, beadlike seeds that create a vibrant chiaroscuro color, and the stems twist and reverse direction freely.

The busts of angels in hexagonal frames above and below the *Hercules* of the lower left reveal are not instantly or dramatically identifiable with Nanni di Banco's known style. Nevertheless, the lower *Blessing Angel* has a startlingly direct gaze, as well as a pervasive lack of smoothness — a struggle with anatomy in the cramped posture of the blessing hand, the turn of the head in space, and the placement of the tiara low on the angel's brow — that indicates the effort of a younger artist, and one attuned to a monumental direction. This openness in coming to terms with the construction of anatomical forms remains an undisguised characteristic of Nanni's early work. And the broad planes of the angel's face, formation of eyes and nose, and particularly the composition and carving of the lips and chin anticipate the sentient countenance of the *Saint Philip*. An irregularity and denial of hard edges in the carving of the *Blessing Angel's* hair, as against the tighter coiffeurs of the other angels in the reveal decoration, approach the naturalism and largeness of the hair of the *Isaiah* and *Saint Philip*.

Although part of the same panel, the *Pointing Angel* above *Hercules* is less individual in all respects than the *Blessing Angel* below. With its curving neck, narrower torso, oval face, dimpled chin, and tighter coiffeur, the upper angel is composed of a more standard vocabulary of forms: it is less searching and carries less conviction. A mutation (and qualitative difference) in style between the two angels in the lower left reveal has been acknowledged by Seymour (1959), who gave both angels to Niccolò Lamberti, and Kreytenberg (1972), who saw them both as by Giovanni d'Ambrogio. Seymour and Kreytenberg considered the upper angel the later or more integrated version of the two, whereas Brunetti (1952) saw the lower angel as more advanced. But if not carved by the same hand, the two angels were made to follow the same matrix: this is evident in the placement of scroll and wings in the frame, the arrangement of the sleeves of the left hands, the position of the right elbows, and the strands of hair that fall on the shoulders. The lower left reveal was probably a collaborative work, with Nanni di Banco responsible for the *Hercules* and the *Blessing Angel*.

I would propose that the lower section of the left reveal was a production of Antonio di Banco's shop — a collaboration between father and son — and that the work was made under the artistic aegis of Giovanni d'Ambrogio. The *Hercules* in its searching monumentality reflects the more accomplished *Apollo*, and the *Pointing Angel* (Antonio di Banco?) appears to be a derivative and clumsy attempt

toward the manner of Giovanni d'Ambrogio's infinitely more graceful angel in the upper reveal. The *Pointing Angel* provides a stylistic precedent for the angels from the left half of the archivolt frieze (second campaign, 1406–9), which in this study are cautiously attributed to Antonio di Banco (cat. 1-2).

DOCUMENTATION

Docs. 29, 30, 32, 33, 37, 40.

For further pertinent documentation, Poggi-Haines 1:LXVIII–LXX, doc. nos. 348–59.

BIBLIOGRAPHY

Semper 1890, 26–31; Semper 1875, 53–61; Cavallucci 1881, 106; Schmarsow 1887, 143–53; Wulff 1909, 28; Poggi-Haines 1:LXVIII–LXX; Wulff 1913, 115–41; Kauffmann 1926, 216–35; Brunetti 1947, 218; Brunetti 1951, 3–17; Grassi 1951, 20–21; Toesca 1951, 358–60; Brunetti 1952, 119–26; Krautheimer 1956, 278–81; Paatz 1952–56, 3:87–89; Seymour 1959, 1–17; Wundram 1960, 109–25; Seymour 1963a, 207–26; Wundram 1962, 94–104; Seymour 1966, 33–45; Gordon 1968, 4–8, 11–33; Wundram 1968, 208; Becherucci and Brunetti 1969, 1, 23–27, 255–58; Wundram 1969, 84–85, 163–67; Avery 1970, 54; Kreytenberg 1972, 5–11, 25–32; Herzner 1973b, 74–82; Mustari 1975, 191; Angiola 1977, 15–16; Coffin-Hanson 1977, 120; Cardini 1978, 44–46; Goldner 1978, 13–14; Moskowitz 1978, 61–62, 163; Poeschke 1980, 18; Kreytenberg 1984, 67, 99; Moskowitz 1986, 112; Schulz 1986, 13; Beck 1991, 1:194–95; Hessert 1991, 34–43; Gatti 1992, 29–41, 90–102; Ladis 1992, 297–301; Witt 1994, 177–78; Kreytenberg 1995, 88–145.

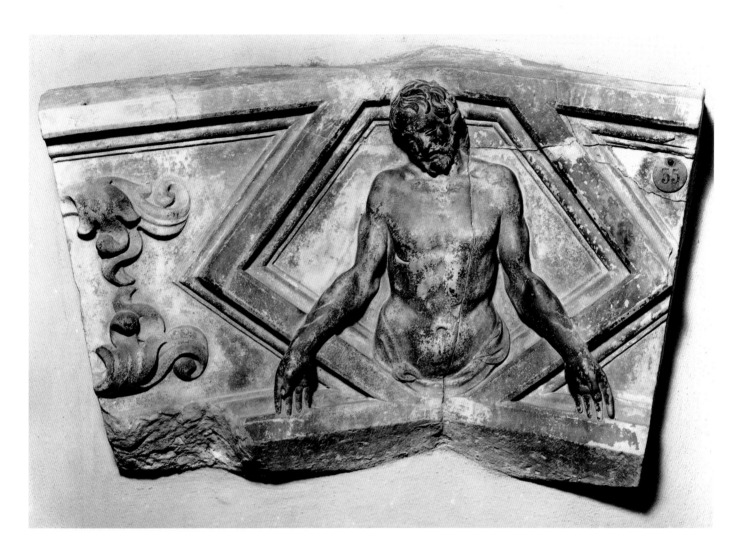

1.2 *Man of Sorrows*

1407–9
Marble, 16 ½ x 26 in. (42 x 66 cm)
Museo dell'Opera del Duomo, Florence

A three-quarter-length Christ as the Man of Sorrows, framed by a beveled pentagonal cartouche, decorates the former keystone of the archivolt of the Porta della Mandorla. The Porta della Mandorla underwent extensive restoration under the direction of Emilio de Fabris in 1869–71, at which point five sections of the archivolt — two angels and acanthus figurines from the right frieze, the keystone "Man of Sorrows" relief, and various fragments of columniation — entered the storerooms of the Opera del Duomo, having been replaced by freehand copies outside. They were installed in the Museo dell'Opera del Duomo in 1886 (Franceschini 1886; Elenco 1887; Becherucci and Brunetti 1969). The work is in a relatively poor state of conservation.

ATTRIBUTION AND DATING

It has long been recognized that the sculptor of the *Man of Sorrows* sought a naturalism that was absent in the lateral friezes of the archivolt. The "second campaign" of decoration of the Porta della Mandorla, 1404–9, led by Giovanni d'Ambrogio, produced the keystone and *sguanci* of the archivolt zone. Payment documents for the so-called second campaign name Antonio di Banco, Nanni di Banco, and Niccolò Lamberti (docs. 52–54, 57, 61, 62, 65, 73). The archivolt friezes have been juggled among the three; and some experts have seen the presence of Nanni di Bartolo or Donatello in parts. The Operai of the Duomo deliberated to complete

the decoration of the northeast portal in December 1404, and a new campaign of work was begun under the direction of Giovanni d'Ambrogio (doc. 47). It appears that Antonio di Banco had a substantial part in this campaign, working together with his son Nanni, who matriculated to the guild in February 1404/5 (doc. 48). Nanni di Banco is mentioned for the first time in cathedral documents in this phase of decoration, 1406–8 (doc. 54). According to Poggi's systematization of documents, the project in question was the archivolt zone of the portal, and the work was divided into equal (or nearly equal) parts between the Banco father and son, on the one hand, and Niccolò Lamberti, on the other, with Niccolò possibly acting as coordinator (docs. 52–54, 61, 62, 65, 73). Payments to these artists apparently refer to the upper archivolt reveal friezes, which are composed of busts of angels alternating with a populated acanthus rinceau, an interior twisted column sprinkled with rhomboids of darker marble described as "mandorle" (doc. 61), an outer twisted column similarly encrusted, and an outermost band of foliation; and payments may include the production of the frieze of the lunette frame — vegetal rinceaux with some nude figurines — as well.

If we bear in mind that records for the year 1405 and early 1406 are entirely missing, the documentary picture may

be sketched as follows. In October 1406 Antonio di Banco is paid twenty florins for work done "in et super portam ecclesie" (doc. 52), although the archivolt zone is not specified per se. On the following 29 November Niccolò Lamberti is paid fifteen florins for work on the "arcum figuratum pro porta" (doc. 53). On 18 March 1406/7 Antonio and Nanni di Banco, called "magistris scarpelli," are paid seven florins for some unspecified work (doc. 54). In June 1407 Antonio is appointed to a committee to supervise the decoration of the northern choir tribune (doc. 56). Antonio continues to work for the cathedral through summer and autumn of 1407, providing various stones and finished decoration for projects other than that of the archivolt of the northeast portal (docs. 57–60). More than one full year after the "arcum figuratum" was first mentioned, an entry of 31 December 1407 (doc. 61) names Antonio and Nanni di Banco and Niccolò Lamberti for the production of various — apparently equal and identical — parts, which were to be installed above the jambs ("super stupitem") of the northeast door: a leaf-textured marble frame to go under the column of the "second arch"; segments of reveal frieze with "compassi angelorum" and figured foliation; twisted columniation "cum mandorlis" with a foliated frame; a frame "cum mandorlis itus a rossette"; and a segment of twisted column, encrusted and foliated. In January 1407/8 it is deliberated that a mason named Pace be responsible "pro murando arcum ianue" (doc. 62). On this same occasion Niccolò and Antonio, the latter together with his son, each receive twenty-five florins. Less than two weeks later, the *Isaiah* would be commissioned from "manu Antonii Banchi et Johannes eius filii" (doc. 63), a work that apparently occupied Nanni alone until its date of completion in December 1408. During this period, around 1407–8, Niccolò Lamberti and Nanni di Banco probably produced the *Console Atlanti* for the window to the immediate left of the northeast portal (cat. 1-3).

But the story of the archivolt continued throughout the year 1408. A complication arose on 5 May 1408 when Niccolò Lamberti received an ultimatum from the Operai that if he did not correct his work on the "fogliaminum et sex compassum cum dimidio et vitis et aliis ornamentis" by June to conform to *capomaestro* Giovanni d'Ambrogio's original plan, he would be fined twenty-five florins (doc. 65). That all six sections and all the bands of decoration are mentioned indicates that Niccolò may have been responsible for supervising or coordinating the production of the entire archivolt according to instructions or iconographic requirements

given him by the *capomaestro*. No further mention of this issue is reflected; on 11 September Niccolò was paid ten florins and then twenty more florins on 19 December 1408 (doc. 65, and see Poggi-Haines 1: doc. nos. 367–69). In the context of larger sculptural events in the Opera del Duomo, this last payment was made on the same day that three of the four Evangelists for the cathedral facade were commissioned to Niccolò, Donatello, and Nanni di Banco (doc. 71). In a badly damaged, partly illegible document of 4 February 1408/9 (doc. 73), Antonio di Banco (Nanni not mentioned) and Niccolò Lamberti are paid various sums "pro resto laborerii porte per quam itur versus ecclesiam s. marie servorum," presumably concluding the second campaign.

As in the lower zones of the portal, the extent to which the archivolt was restored before 1869 is unknown. But the poor condition of the pieces in the museum indicates that the archivolt may have been particularly damaged, either by weather (such as the lightning fulminations that sent debris flying in the direction of the via dei Servi in the fifteenth and sixteenth centuries), erosion from dripping water, stress, or other circumstances (see Guasti 1857; Lungo 1900; Saalman 1980). Guasti quoted a text dated 5 April 1492: ". . . de la porta va alla nunziata ne la via ne chade più di venti pezzi di marmo chome botte e barili grosi fichoronsi in terra due braccia e drento. . . ." Broken parts were not left in ruins, and we know from Richa (1754–62) that during his own time repairs were frequent; he spoke of ". . . un arsenale di marmiche vi si conservano per le frequenti occorranze di reparazioni da farsi quasi ogni dì alla gran fabbrica della Cattedrale. . . ." (See also Giusti 1996.) Therefore any appraisal of style must consider the possibility of prior restorations in parts of the archivolt. Such a cautious approach is particularly appropriate for the left frieze, which, besides having been (suspiciously?) sound and pristine relative to the keystone and right frieze in 1869, is also the most problematic section of the archivolt in terms of style.

True to the situation indicated by the documents, it does appear that two separate masters or workshops divided the archivolt decoration almost equally, because the hexagons with angels and rinceaux with nudes on the left have a wholly different character and morphology from those on the right, with a third hand present in the keystone. The attribution of parts among the three artists who worked here — Niccolò Lamberti, Antonio di Banco, and Nanni di Banco — is in no way clear, though, and the proposed combinations and permutations for the separation of hands are

as numerous as the critics who have undertaken to write about this problem.

There has been little consensus: each of the archivolt frieze sides has been given variously to Niccolò, Antonio, or Nanni; the keystone *Man of Sorrows* (which is nowhere specifically described in the documents) has been variously attributed to Niccolò Lamberti, Nanni di Banco, Nanni di Bartolo, and Donatello. Semper (1875) considered all six of the archivolt angels the work of Nanni and Antonio di Banco; Rossi (1891) ascribed the right side to Niccolò Lamberti and the left to Antonio and Nanni; Poggi (1909) saw the influence of Niccolò for the entire archivolt zone, as had Pachaly (1907). Wulff (1913) believed the left to be by Nanni alone and the right by Niccolò. Kauffmann (1926) gave the left reveal and lunette frame to Niccolò and corresponding parts on the right to Antonio and Nanni, with the main pieces of the right archivolt by Nanni and the decorative rinceau passages by Antonio; Kauffmann was followed by Planiscig (1934, 1946) and Vaccarino (1950), who identified the hand of Antonio di Banco in two of the heads of angels in the museum.

Meanwhile, Brunetti (1934), on the basis of stylistic analysis, had given the left archivolt to Nanni di Bartolo and the right to Niccolò Lamberti. Grassi (1951) gave the right side to Nanni and Antonio and the left to Niccolò. Swarzenski (1951), admitting the nearly impossible nature of the problem, said that the left side was "probably by the Bancos." Wundram (1961) maintained that since Antonio was not a figurative sculptor, the left archivolt should be given to Nanni alone, and the right to Niccolò Lamberti, maintaining this opinion in subsequent publications (1962, 1969). Phillips (1964) gave the right archivolt to Nanni and the left to Niccolò. Kreytenberg (1972) followed Wundram regarding the archivolts, and concerned himself with the much-neglected lunette frame, giving the left half of it to Giovanni d'Ambrogio and the right to Donatello. Herzner (1973b, 1979a) believed the left archivolt frieze to be by Niccolò Lamberti and the right by Antonio di Banco. Goldner (1978) held to Wundram's analysis of the two sides of the archivolt. Schulz (1986) asserted that Niccolò Lamberti contributed the right archivolt, with the left archivolt and keystone carved by Antonio di Banco and his son Nanni.

The *Man of Sorrows* was credited to Nanni di Bartolo by Becherucci and Brunetti (1969), who also gave him the left side of the archivolt. Lisner, on the basis of the interpretation of published documents and certain stylistic analogies

with the wooden *Crucifix* at Santa Croce (cat. 11-10), gave the keystone relief to Donatello, ca. 1408 (1962, 1968, 1970). But stylistic and anatomical differences are such that the *Man of Sorrows* may be kept entirely separate from the Santa Croce *Crucifix* (cat. 11-10). The attribution to Donatello, however, was followed by: Castelfranco 1963; Seymour 1966 (with reservation); Bellosi 1977; Goldner 1978; Martini 1978. Wundram (1961) and Phillips (1964) attributed the *Man of Sorrows* to an "unidentifiable master" outside those mentioned in the documentation of the archivolt zone. Only Semper (1875) and Fiocco (1927–28) have given the piece to Niccolò Lamberti. The following authors have ascribed the keystone *Man of Sorrows* relief to Nanni di Banco: Schmarsow 1887; Wulff 1913; Kauffman 1926; Planiscig 1934; Vaccarino 1950; Herzner 1973b, 1979a; Parronchi 1976, 1980; Schulz 1986.

Because of the dilemma about the separation of hands here, much has been made of the fact that the overall design was by Giovanni d'Ambrogio, therefore suppressing the individual "signature" styles of participating carvers (Vaccarino 1950). But there is no reason why the presence of the *capomaestro* should be felt any more strongly here than elsewhere. The passage that was corrected by Niccolò Lamberti in 1408 at the request of the Operai is not identifiable: the sections of the right archivolt are now dismembered and quite ruined; and in any case, the objectionable part was presumably fixed. Scholars have pointed to the asymmetry of the keystone block as a possible result of Niccolò's deviance in carving the frieze (Kauffmann 1926; Herzner 1973b). Surely Niccolò's error was one of measurement or state of finish, rather than "interpretation" or "style" (Seymour 1959; Goldner 1978).

What role did Nanni di Banco play in the creation of the archivolt? There is no obvious correspondence between the ensemble and its presumed documentation. Even in the purely literal context of the documents, Nanni is mentioned only in March 1406/7 (for work not named) and in connection with the northeast door only in December 1407 and January 1407/8, each of these times together with his father. The nature of Nanni's participation is therefore open to visual investigation.

The *Man of Sorrows* is accepted here as a work by Nanni di Banco. The right archivolt frieze (now fragmentary) is correctly given to Niccolò Lamberti by Schulz (1986), and the left archivolt frieze may possibly be by Antonio di Banco.

The right archivolt frieze fits comfortably in the oeuvre of Niccolò Lamberti: the angels (figs. 86, 87) are carved with

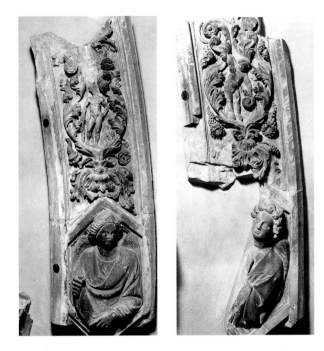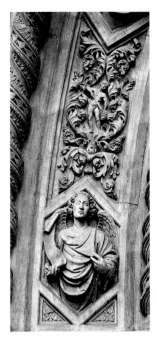

Figs. 86, 87. Fragments of right archivolt frieze from Porta della Mandorla with Hercules and Angel, 1408/9. Marble, height 45 in. (114 cm). Museo dell'Opera del Duomo, Florence

Fig. 88. Porta della Mandorla (detail of left archivolt frieze), Santa Maria del Fiore, Florence

a hard planarity, surface tension, and linear stylization typical of Niccolò's manner. Coiffeur and wings are crisp and schematized; the formation of narrow eyes and lips, and the treatment of chin, throat, and hair all correspond with that of Niccolò's *Madonna della Rosa* from the Porta dei Canonici and its flanking left-hand angel (fig. 70). Moreover, the nude *Putto Stabbing a Snail* (fig. 87) is a precedent for the executioner in the socle relief of Niccolò's *Saint James* relief at Orsanmichele, which is generally attributed to Niccolò's shop, possibly to his son Piero (see cat. 11-8). This detail, therefore, opens the suggestion of the participation of Niccolò's young son, Piero, in the archivolt frieze: the semidraped putto would not have been outside his ken. Piero might also have carved the rather inexpert nude Hercules with a club (the so-called Cain). Piero di Niccolò is first mentioned in a payment document of 1410, where he is described as "giovane" together with another of Niccolò's assistants named Vittorio di Giovanni (Procacci 1928). Goldner (1978) estimated Piero's date of birth as ca. 1393 on the basis that he was called "giovane" in 1410, and declared that in 1410 he would have been too young to have been responsible for any kind of artistic work beyond "cleaning and polishing." I see no reason to exclude the possibility that Piero was carving by 1410 and even earlier, bringing him into play as his father's assistant in the archivolt friezes of the Porta della Mandorla.

If not by Piero, then the nude figurines in the right archivolt could be by some other helper, such as Vittorio di Giovanni. (Vittorio might be the same stonemason who is described in cathedral documents of 1410 as fully mature: "vectorius Nannis scarpellator populi s. Michaelis Berteldi de Florentia" [Poggi-Haines 1: doc. nos. 187, 191].) Whereas the right archivolt frieze is identifiable as a product of Niccolò Lamberti's shop with the angels by his own hand, the authorship of the archivolt on the left (fig. 88) is a more difficult question. An attribution to Nanni di Banco (carving on behalf of his father's enterprise as he apparently did in the *Isaiah*) may be excluded for stylistic reasons: the forms composing the angels' heads are too soft, smooth, and rounded; the dimpled chins, undulating curls, and elongated faces with mannered down-curving eye sockets all take on a stylization that is foreign to the frank, rather literal vocabulary used by Nanni whenever he approached the subject of the human head. Of the figurines from the left archivolt, neither the turbaned "Hercules" nor the nude looking back over his shoulder is identifiable with Nanni di Banco's known relief style: the former is too smoothly and pictorially modeled; the stance of the latter is too awkward and mincing.

The formation of the torsos of the three left archivolt angels, in which a long narrow chest is projected forth in swinging tubular folds of drapery, however, does resemble

that of the upper angel of the lower left reveal, which is here tentatively attributed to Antonio di Banco. Apropos this stylistic similarity, it may be appropriate to invoke *(mutatis mutandis)* Herzner's (1973b) argument that Antonio di Banco (active from 1368 to his death in 1415) was a practicing figurative sculptor. Whereas Wundram (1961, 1969) had hypothesized that Antonio worked only as a project administrator and purveyor of stones, Herzner (1973b) has pointed out that Antonio is mentioned in the archivolt documents as "scarpellatore" and "lastraiuolis," and was paid ten florins *pro braccia*, just as was Niccolò Lamberti. A contract of 1407/8 (doc. 63) assigned the figure of a prophet *Isaiah* to "manu antonii banchi et eius filii. . . ." And Antonio served as *capomaestro* of the cathedral from 1413/14 to 1415: *capomaestri* were almost always stone sculptors, reponsible for providing *modini*, *esempi*, and *disegni* according to which the architectural decoration was made (Mustari 1975). Furthermore the purveyance of materials and quarrying of marbles was a profitable activity, frequently carried out by figure carvers as accomplished as Niccolò Lamberti, who provided marbles for the Opera del Duomo and for the Linaiuoli *Saint Mark* at Orsanmichele (Poggi-Haines 1: doc. nos. 162, 164; Janson 1957). Since Antonio's hand is completely unknown, the possibility of his authorship for the left archivolt frieze must not be discarded, especially in light of such strong documentary evidence. Although the soft, florid carving style may conflict with what we envision Antonio's hand to have been ("gothic" or "archaic") based on a supposed biological relationship with his son's work, the question of identifying any of the work from Antonio's long, productive career should be kept open. A corporate effort between father and son in the left archivolt, in which Antonio had the dominant part, including the nude figurines, is possible. And the idea of a later restoration, taking place anywhere from around 1410 to 1868, is not to be excluded.

Several experts have attributed the keystone relief to a progressive "third hand," and according to the documentary evidence presented above, a likely candidate for this third master is Nanni di Banco. Although no payment exists for a specifically individuated "keystone" or "Christ," the irregular shape of the block may indicate that it was cut to measure after the lateral sections of the archivolt were made, i.e., after the Opera's ultimatum to Niccolò Lamberti in 1408 (Herzner 1973b) but before the balances due on the ensemble were paid in February 1408/9. Because Nanni's name appears with his father's in two payments concerning the archivolt frieze (and

one payment for unnamed work during the campaign), we know that some of the abstract decoration for the archivolt (probably about half of it) came from the Banco shop. If Niccolò Lamberti supervised the making of the entire archivolt zone, as it appears, then he and Nanni were working together as colleagues during this entire time, 1404–6. The keystone, uneven in shape so as to compensate for disparity between the two sides, may have been delegated to Nanni by Niccolò after the ultimatum of 5 May, to complete the program of sculpture designed for the Porta della Mandorla by Giovanni d'Ambrogio.

The *Man of Sorrows* should be retained for Nanni di Banco and should be fitted into his oeuvre around the time of the *Atlante* (cat. 1-3) and the *Isaiah* (cat. 1-4), between 1407 and 1409, a chronology verified by the dates yielded in Poggi's documentary history of the archivolt zone. The relief is of a kind with the other works identified here as Nanni's early productions. A hyper-vigorous modeling of the thickly proportioned, heavy limbs is related to Nanni's approach to anatomy in the *Atlante* and the *Isaiah*. It is also pertinent that both Lisner and Janson saw a connection between the keystone relief and the *Hercules* from the lower left reveal, which is here attributed to Nanni di Banco (cat. 1-1).

DOCUMENTATION

Docs. 52–54, 57, 61–63, 65, 73.

BIBLIOGRAPHY

Richa 1754–62, 6:79; Guasti 1857, 204–5, 208; Semper 1875, 61; Franceschini 1886, 365–66; "Elenco" 1887, cat. no. 8; Schmarsow 1887, 151; Rossi 1891, cat. no. 8; Lungo 1900, 145; Poggi 1904, cat. no. 8; Pachaly 1907, 37; Poggi-Haines 1:LXII; Wulff 1913, 140; Kauffmann 1926, 228–33; Fiocco 1927–28, 292, 299; Procacci 1928, 307; Planiscig 1934, 437; Brunetti 1934, 262–72; Planiscig 1946, 15–17, 52; Brunetti 1947, 217; Vaccarino 1950, 25–26; Grassi 1951, 30–31; Swarzenski 1951, 92; Brunetti 1957, 4; Janson 1957, 16–17; Seymour 1959, 13–17; Wundram 1961, 23–32; Lisner 1962, 65–66; Wundram 1962, 92; Castelfranco 1963, 90; Phillips 1964, 63–66; Seymour 1966, 52; Lisner 1968, 126–27; Becherucci and Brunetti 1969, 1:24–25, 258–60, cat. nos. 112–14; Wundram 1969, 81–84; Lisner 1970, 55–56; Kreytenberg 1972, 23–26; Herzner 1973b, 75–81; Mustari 1975, 123, 191; Parronchi 1976, 50–55; Bellosi 1977, 165–66; Goldner 1978, 11–18, 92–94; Martini 1978, 214–16; Herzner 1979a, 28; Parronchi 1980, 52–54; Saalman 1980, 145; Schulz 1986, 13; Kreytenberg 1995, 79; Giusti 1996, 71–82.

1.3 *Console Atlanti*

Niccolò Lamberti and Nanni di Banco
ca. 1407–8
Pietra forte, height of each figure ca. 13¾ in. (35 cm)
Santa Maria del Fiore, Florence

Two nude, winged putti serve as decorative console "atlanti" under the west window of the north tribune of the cathedral, to the immediate left of the Porta della Mandorla. In the right-hand console (B) there is a flow of real space, where the figure is completely detached from the corbel, between the containing bracket and the figure. The putto turns his head to look across the breadth of the window at his companion (A), whose face is tilted up in an alert gaze fixed straight ahead; both heads are free from the constraints of the architecture. The figures are dirty and corroded from exposure and from pollutants carried by rainwater, their actual state (1999) being considerably less pristine than the photographs here indicate.

ATTRIBUTION AND DATING

As the north tribune was constructed between 1401 and 1408, the console decoration can be dated to the end of that campaign, ca. 1407–8 (Paatz 1952–56; Kreytenberg 1972). Kreytenberg (1972) attributed the right-hand figure (B) to Giovanni d'Ambrogio. The attribution of the *Atlanti* to Niccolò Lamberti (A) and Nanni di Banco (B) was introduced by Bergstein (1989).

Cat. 1-3A. Niccolò Lamberti, *Atlante*

Cat. 1-3B. Nanni di Banco, *Atlante*

Predecessors to these putti are a pair of *atlanti* beneath a southeast tribune window of the cathedral, attributed by Kreytenberg (1979a) to Jacopo di Piero Guidi (fig. 89). The present *Atlanti* are close in date to Jacopo della Quercia's garland-bearing putti on the tomb of Ilaria del Carretto at Lucca. Kosegarten (1968) believed that the *Atlanti* influenced Quercia's putti for the Ilaria tomb, which in her study is dated "after 1406–7."

Although they conform to a unifying design, the two figures were clearly made by different sculptors. In the right-hand putto (B) the engaged arm reiterates the ninety-degree angle of the bracket: his hand is braced at the hip, and the torso and thighs are tensed forward, so that the knees form another right angle in solid as well as plane space, as if the figure were to complete the rectangular block from which the entire unit was carved (Kreytenberg 1972). The *Atlante* at the left (A), situated in the curve of his own wings, simply crouches — hips thrust back, hand on knee, and legs tucked under. This figure has a more even surface as well as a more relaxed posture: thick arms and legs and broad, planar chest are encased in a tight skin; the face, lifted straight out from under the cornice, is carved in a simple and clear manner with the edges of eyelids, lips, and nostrils creating outlines against the hard surface; hair

Fig. 89. Attributed to Jacopo di Piero Guidi, *Atlante*, ca. 1380. Southeast tribune, Santa Maria del Fiore, Florence

and wings are rendered in symmetrical patterns, thus adding bilateral emphasis to the frontal posture.

The artist who carved the *Atlante* at the right (B) appears to have struggled as much with the plastic expression of individual features as he did with the invention of a weight-bearing posture: the turned head has a rich, unruly coiffeur and swollen eyelids, cheeks, and lips; the stress of the chest is brought out by an exaggeration of the pectoral muscles and of the area where the waist folds into the rib cage; and the chubby legs are creased in rolls of fat. Here the wings mesh with the scrolled surface of the corbel, which is itself carved in a dense texture of feathers, creating an imaginative variation on the typical corbel decoration — the scroll of acanthus leaves — that was used for many of the cathedral windows. It seems a deliberately cunning alternative to the schematic, if elegant, single-arc treatment of the pendant angel's wings. Indeed, although the figures were evidently produced as a pair, the *Atlante* at the right (B), with its greater involvement in texture, more plastic exploration of head and body, and ingenious expression of a weight-bearing posture, seems to have been created as if

in direct response to the one at the left (A). That he turns his head toward the somewhat more conservative counterpart suggests the relationship of master and pupil. The authors of the *Atlanti* are to be found among sculptors active in the workshop of the Duomo around 1407–8, presumably an older, established hand (A) next to a younger or simply more experimental colleague (B), here identified as Niccolò Lamberti and Nanni di Banco respectively.

The sculptor of the more conservative *Atlante* (A) can be identified on stylistic grounds as Niccolò Lamberti. The putto appears to have been carved by the same hand that made the Christ Child held by the *Madonna della Rosa* of the Porta dei Canonici on the other side of the Duomo (fig. 90). Niccolò produced the *Madonna della Rosa* for the tympanum of the southeast portal around 1402 (Brunetti 1957; Wundram 1962). Goldner (1978) considered the Madonna and Child a collaboration between Niccolò Lamberti and Lorenzo di Giovanni d'Ambrogio but still gave the head of Christ to Niccolò alone. Comparison of the console *Atlante* with Lamberti's Christ Child reveals a nearly identical treatment of the two heads: hair is disposed in a symmetry of carefully incised strands, with a flat bilateral pate winging out into clusters of curls around the ears; eyes are hard-edged, rounded almonds with little plasticity; facial structure is broad, smooth, and planar; lips are carved with linear edges, the upper lip turned down at the ends. In each case the neck meets the chest in a pronounced line. The torsos of both the console *Atlante* and the Christ Child are encased in a smooth, planar skin, and the treatment of chest muscles is similar, despite the fact that the torso and limbs are rendered more energetically in the *Atlante*.

Another signature feature to be found in Niccolò Lamberti's console *Atlante* is the schematic diamond crisscross pattern of the wings, which is close to that of the patches of cloud beneath the two angels in the tympanum of the Porta dei Canonici (fig. 70); Niccolò used the same technique to describe the clouds in the gable relief of the *Saint Luke* (fig. 110) at Orsanmichele, and he would repeat it in the clouds and feathers in the gable panel of his *Saint James* niche there (cat. II-8).

The new energy in the balance of volumes in Niccolò's console *Atlante* is likely due to the influence of the more dynamic sculptor working at his side, namely Nanni di Banco. The wingless putto by Nanni in the socle relief of the niche of the *Quattro Coronati* (cat. I-6) is similar in structure and texture to the *Atlante* at the right of the tribune win-

Fig. 90. Niccolò Lamberti, *Madonna della Rosa* (detail of fig. 70), 1402. Marble. Santa Maria del Fiore, Florence

dow (B). Each head demonstrates a highly plastic coiffeur, soft, swollen eyelids, broad nose, broad lips, and fleshy sinuses and cheeks. In each case the neck joins the spine in a naturalistic, telescoping manner. The right arm and the structure and placement of the right hand at the hip of the putto at Orsanmichele are almost identical to the composition of the right arm and hand of Nanni's window console. Similarly, the bracing of the figure's heels against the window bracket is a gesture repeated in the left leg of the *Quattro Coronati* putto (Einem 1962). Certain features of the console *Atlante* appear to have been refined in the later, relief version, where, for instance, the elements of the face and head are more cohesive, the individual features less exaggerated (both pieces are considerably weathered); the creases of flesh in the legs are fewer and bolder, displaying a more secure understanding of anatomy. In the course of Nanni's oeuvre, the window *Atlante* precedes the *Quattro Coronati* putto in the same way that the *Isaiah* of 1408 (cat. 1-4) relates to the full-scale statues that followed it. The console *Atlante* and the *Isaiah* share the slightly disturbing characteristic of an overly vigorous modeling of individual parts: a highly plastic treat-

ment of hair, which covers the ears; exaggerated eyebrows and eye sockets and swollen lower lids; not least, the two figures share a forced projection of the chest and hips. These uncomfortable traits were to become absorbed into a more integrated vision as Nanni achieved a deeper understanding of anatomical balance. Still, the same semivegetal hairstyle, swollen facial features, and densely feathered wings reappear in the left-hand shawm player in the gable of the Porta della Mandorla, Nanni's last composition.

Nanni di Banco was active in the Opera del Duomo around 1406–7, apparently working side by side with his father, Antonio, under whose trust he contributed the *Man of Sorrows* and the *Isaiah*. It is relevant that Antonio di Banco was a member of the committee appointed 2 June 1407 to supervise the decoration of the north tribune of the cathedral (doc. 56) where Antonio and Nanni worked as partners throughout their lives — and especially in these years — so it was natural that Nanni play a part in the decoration of the tribune exterior. The following slip of the pen is curious, although not necessarily pertinent to either of the winged console *Atlanti*: a payment of 31 October 1410 by the Opera del Duomo to Nanni di Banco includes a canceled notation regarding "two angels" (doc. 83).

DOCUMENTATION

Docs. 56, 83.

BIBLIOGRAPHY

Paatz 1952–56, 3:332, 454 n. 87; Brunetti 1957, 9–10; Einem 1962, 68–79; Wundram 1962, 108–9, 112–13; Kosegarten 1968, 247–48, 258; Kreytenberg 1972, 26–28, 30, 32; Lisner 1977, 111–82; Goldner 1978, 29–30; Kreytenberg 1979a, 34–44; Kreytenberg 1980, 275–82; Bergstein 1989, 82–88.

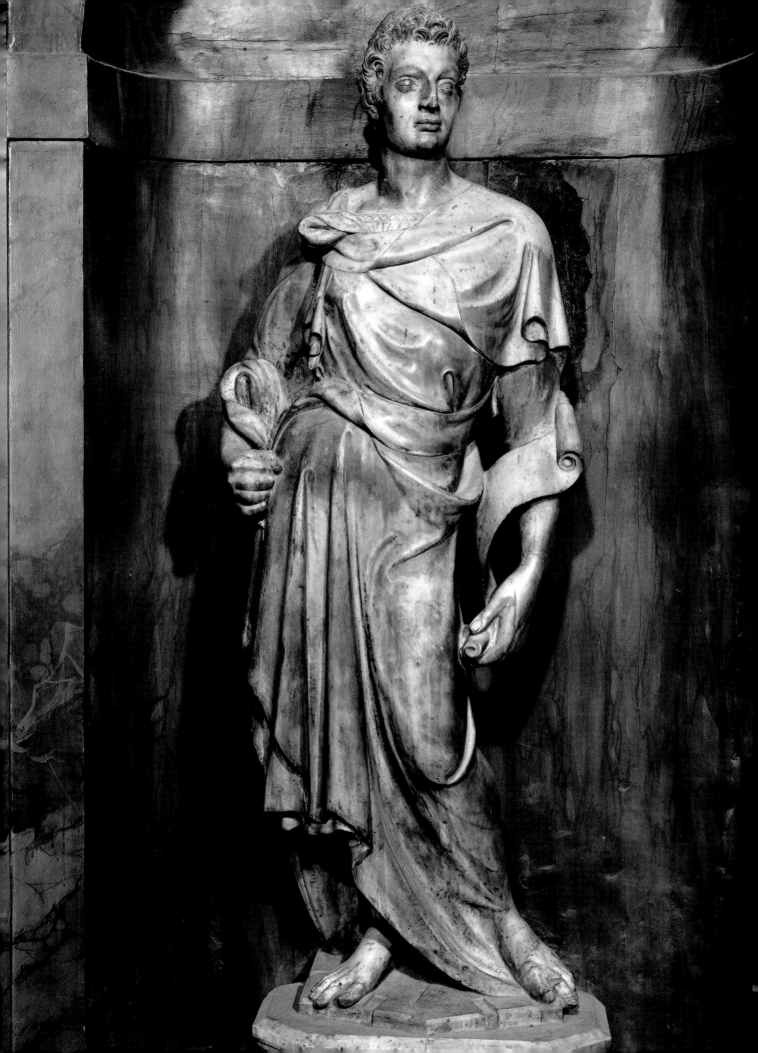

1.4 *Isaiah*

1408
Marble, height ca. 75 in. (190 cm)
Santa Maria del Fiore, Florence

The statue is located in the interior right side aisle of Santa Maria del Fiore. It is in fairly good condition; the nose has been broken and repaired.

ATTRIBUTION AND DATING

When the northwest tribune of the cathedral was completed in 1407/8, the Operai proceeded to plan the decoration of the *sproni*, or buttresses, with freestanding, life-size statues of prophets. Although not a common feature of Tuscan architecture, a design of this sort had apparently been envisioned for decades, as in the model of the Duomo depicted by Andrea da Firenze (ca. 1375) at Santa Maria Novella (Seymour 1967a). The commission for the first of the twelve prophets, a marble *Isaiah*, which was to establish a working precedent for the other eleven figures, was given to Antonio di Banco and his son Nanni on 24 January 1407/8 (doc. 63). It is hardly surprising that the Bancos were delegated the first buttress figure, given that Antonio was a member of the supervisory committee for the tribune (doc. 56), and that he and Nanni were providing decoration for the adjacent Porta della Mandorla. Less than a month after the Bancos received the commission for the *Isaiah*, a second figure, a "David profete," was assigned to Donatello (doc. 64). This deliberation, 20 February 1407/8, stated that the

David was to be carved in the same way and under the same conditions as the one being made by "Johanne Antonii Banchi." In December 1408 Antonio was given the sum of eighty-five florins in final payment for a marble figure "facte per Johannes eius filium" (doc. 69). Donatello received sundry advances in payment for a marble figure throughout the year 1408–9 (docs. 67, 70, 75), and in June 1409 it was deliberated that Donatello have a total of one hundred florins for "quodam profeta" and was rendered the balance of thirty-six florins (doc. 76). In the space of seventeen months, a prophet *Isaiah* was made by Nanni di Banco, with a corresponding *David* by Donatello, both destined to decorate the tribune buttresses as part of a series of twelve. Although no specific document survives regarding the installation of the statues, about two weeks after Donatello finished the *David*, the officials decided that a statue of a prophet that had been placed above the tribune be taken down (doc. 78); it is therefore inferred that one of the two buttress figures, probably Nanni's *Isaiah*, had been put in place and then removed for reasons not stated (Lányi 1935, 1936; Janson 1957). Sometime during the following year, a campaign for a giant figure, also intended for a buttress above the northwest tribune, went into effect (docs. 82, 84, 86, 89, 91–93, 123; see Poggi-Haines 1: doc. nos.

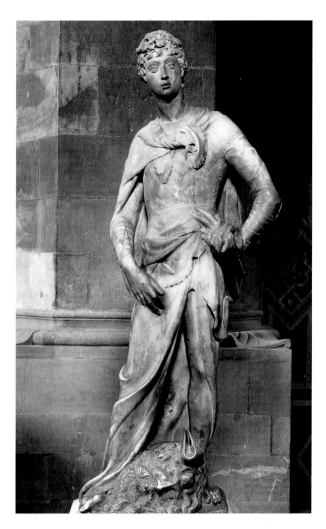

Fig. 91. Donatello, *David*, 1409. Marble, height 75 ¼ in. (191 cm). Museo Nazionale del Bargello, Florence

414–21; Stang 1962; Seymour 1967a, 1967b). In 1412 Donatello himself is mentioned in connection with the project for this colossal figure, called "Giesuè" (*Joshua*). Whereas Nanni seems to have dropped out of the project for the buttress figures, Donatello was to remain involved, experimenting with new concepts and materials (docs. 92, 93, 123). Scholars beginning with Poggi (1909) and Lányi (1936) have concluded that, since the *Joshua* differed from the *Isaiah* and *David* primarily in terms of material and size, the original marble prophet had proved inadequate in scale and was therefore replaced with at least one "giant" made of affordable, workable material.

After considerable trial-and-error restoration, a white-washed "homo magnus" was completed by Donatello. It presumably remained in place on a buttress facing the via dei Servi through the middle of the eighteenth century (possibly with companions and/or replacements), as is

chronicled by diaries, cathedral records, and prints. References to Donatello's "homo magnus" occur in writings of the fifteenth and sixteenth centuries (Janson 1964), as well as in prints such as those by Israel Silvestre (mid-seventeenth century) and G. Zocchi (mid-eighteenth century) (see Seymour 1967a). This *Homo Magnus*, which must have had an enormously theatrical presence in its particular setting, has disappeared. Seymour (1967a) recounted that Wolfgang Lotz told him in conversation that some large stucco figures, which looked like those in the eighteenth-century prints, were still in storage in the cathedral.

In the intervening centuries, the original "twin" marble figures by Nanni di Banco and Donatello, discarded as they were from the buttress program, had separate destinies. Donatello's marble *David* was stored at the Opera del Duomo until July 1416, when the *Provvisore* officially conceded the statue to the Priors of the Signoria to be installed in the Palazzo della Signoria, at which point it appears that Donatello and his assistants made minor alterations to prepare the statue for its new collocation (docs. 125, 127, 128).

Donatello had received an advance of fifty florins on 12 August 1412 to be credited toward his *Saint John Evangelist* and a "David profete" (doc. 94). As this sum was never applied to the *Saint John*, Janson (1957, 1972) concluded that the payment was for revisions made on the *David* of 1408–9, possibly already in anticipation of its transfer to the Palazzo della Signoria. Wundram (1969) considered the document evidence that an entirely new marble *David* was in progress. Raghna and Nic Stang (1962) associated the document with either a model or a second "gigante" for the new series of colossal buttress figures. My alternative interpretation for this payment, which is connected neither with a commissioning deliberation nor with a deliberation appraising the total value of a new *David*, is that fifty florins were given Donatello as a partial payment for the *Joshua*, which was appraised at the price of 128 florins the exact same day, and for which he had received only fifty florins in advance, on 27 July 1412 (doc. 92). This would mean that the scribe simply made a mistake, substituting the word "David" for "Joshua" — an understandable error, since the terracotta *Joshua* was indeed a replacement for the original marble *David*. Given this hypothesis, the issues of major recarving of the Bargello *David*, or the presence of a new marble *David* of 1412, may be dismissed.

The *David* of 1409 is documented in the Palazzo della Signoria throughout the sixteenth century; it apparently

entered the Uffizi sometime in the eighteenth century and is traditionally identified as the marble *David* at the Bargello (fig. 91), where it would have been moved in the 1870s. Not only does the Bargello *David* fit perfectly into Donatello's oeuvre as a kind of "younger brother" to the *Saint George* of 1416, but it closely approximates the height of 3¼ *braccia* as stipulated in the instructions of 1408; it also shows evidence of some partial recarving or adaptations (Lányi 1936; Janson 1957), thereby fitting all the specifications set forth in the documentary history.

Nanni di Banco's *Isaiah*, on the other hand, undocumented and unidentified after 1409, remained at large until 1935, when Lányi persuasively demonstrated it to be the so-called *Daniele*/"*Gianozzo Manetti*" in the nave of the cathedral to the right of the entrance, a figure taken indoors from the cathedral's demolished facade in 1587 (Lányi 1935, 1936, 1937). Prior to Lányi's research, this statue, which stands in one of Ammannati's wooden niches along with the other Apostles in the nave, carried a legendary attribution to Donatello, known as his "Daniele" which early sources (Billi, Vasari, Borghini) mentioned as standing on the cathedral facade. The present statue *(Isaiah)*, nicknamed "Gianozzo Manetti," was identified as Donatello's "Daniele" by Richa (1754–62) and was given to Donatello by Semper (1875), Schubring (1907), who called it Donatello's *Joshua*, Cruttwell (1911), and Wulff (1932). Cavallucci (1873, 1881) was unclear as to which statue bore the features of Gianozzo Manetti: either an "Ezekial" by Nanni di Banco or a "Joshua" by Ciuffagni. The *Isaiah* was ascribed to Nanni di Bartolo by Poggi (1909) and to Ciuffagni by Bode (1926), who called it a "Joshua" finished by Nanni di Bartolo in 1417, a notion followed by Schottmüller (1912). Becherucci (1931) and Brunetti (1934) considered the *Isaiah* a figure begun by Nanni di Bartolo in 1424 and finished by Ciuffagni in 1427.

The first positive association of the present statue with Nanni di Banco's buttress figure was given by Cavallucci (1881). Schmarsow (1889) originally followed Semper (1875) in giving the statue (or at least its head) to Donatello but later (1887) hinted at an attribution to Nanni di Banco. Tschudi (1887) was the only one of these older writers to declare that the nave statue displayed an affinity with the "youngest" saint in Nanni di Banco's *Quattro Coronati* group (fig. 92), and tentatively proposed it as his buttress statue, the *Isaiah* of 1408.

The present statue, here identified as Nanni di Banco's

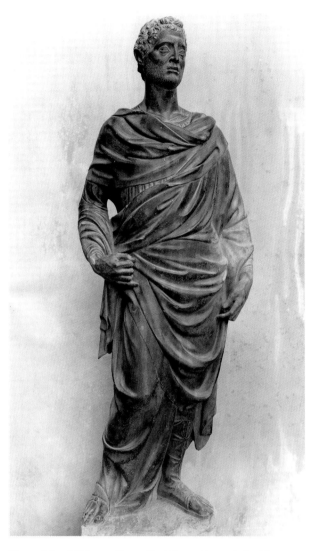

Fig. 92. Nanni di Banco, *Quattro Santi Coronati* (cat. 1-6, detail), ca. 1409–16/17. Marble. Orsanmichele, Florence

Isaiah, seems to resemble the figure in Bernardo Poccetti's drawing, which stands on the second tier to the right of the central door between two columns of a projected pilaster, very likely the statue ascribed to Donatello by the Anonimo Gaddiano "in della facciata fra due colonne è la figura di Daniello" and described by Albertini as "uno che si piegha." This figure would in any case have been among the statues described in the *Diario del Settimanni* of 1587 (quoted by Poggi 1909) as the "principali santi" from the facade, those figures that "demostravono le effigie di uomini illustri di quei tempi," i.e., a statue of "Daniele" that bore the features of the humanist scholar Gianozzo Manetti. It was surely one of the four statues brought indoors to complete a series of Apostles in the nave (Poggi 1909). The fact that the present figure inspired the pose of a small finial prophet

by Tommaso di Lorenzo Ghiberti on the Silver Altar of San Giovanni is evidence that the *Isaiah* was still visible (probably on the cathedral facade) toward the middle of the fifteenth century (cf. Greenhalgh 1982).

Lányi's definitive identification of the nave statue (traceable to the Duomo complex from pre-1445 to the present) as Nanni di Banco's lost *Isaiah* (1935, 1936) was immediately endorsed by Middeldorf (1936). Lányi's methodical analysis is as follows. He first observed that the height of the statue, which from this point on shall be referred to as the *Isaiah*, corresponds, like the Bargello *David*, to the specified height of 3¼ *braccia*. The plan of the statue's base corresponds with that of the buttresses, and, what is more revealing, the indentations made for clamps and screws in the base show that at one time it had been secured from below to let the statue stand free. These same markings in the base served as evidence for Lányi that the *Isaiah* and not the *David* was the statue to have been erected above the tribune and then removed shortly after its installation. From a formal point of view, the *Isaiah* reveals itself as the exemplar for certain of the *David*'s peculiarities: a correspondence between the two figures is manifested in their contrapposto, where the free and engaged members of one mirror those of the other; only the heads and gentle torsion of the shoulders move in the same direction — this presumably motivated by their planned orientation toward the body of the cathedral. Lányi went on to analyze the figure morphologically and conceptually in terms of Nanni di Banco's oeuvre; he concluded that whereas the *David* was transferred to the Palazzo della Signoria, the *Isaiah* was placed on the cathedral facade. Most experts have followed Lányi in his identification of the present statue as Nanni di Banco's *Isaiah*, including Middeldorf (1936), Planiscig (1946), Paatz (1952), Krautheimer (1956), Stang (1962), Phillips (1964), Seymour (1966), Rosenauer (1993), and Hirst (1994). Wundram, however, following an idea introduced by Kauffmann (1936), has argued at length that the present statue is actually Donatello's buttress figure of "David" of 1408–9, identifying the so-called *Campanile Prophet* (cat. 11-4) as Nanni di Banco's *Isaiah*, and the Bargello *David* as a separate work by Donatello begun in 1412 (Wundram 1968, 1969). Wundram's argument, which is summarized here apropos the *Campanile Prophet* (cat. 11-4), was intended to instigate a reappraisal of the artistic give-and-take between Nanni di Banco and Donatello in the first decade of the quattrocento. Wundram's theory was accepted by Herzner (1973a, 1973b, 1978) but has been vigorously rejected by most other scholars, including Lisner (1967), Gaborit (1970), Brunetti (1969, 1974), Poeschke (1971, 1980, 1993), Janson (1972), Rosenauer (1974, 1993), Parronchi (1980), and Hirst (1994). A summary of the various art-historical discussions around these statues is published by Rosenauer (1993). Pope-Hennessy (1993) maintained the identification of the present statue as the *Isaiah* by Nanni di Banco (as he had in 1955) but suggested that the *Campanile Prophet* (cat. 11-4) was in fact the 1408–9 "David" by Donatello, a proposal soundly and effectively rejected by Hirst (1994).

In terms of the large visual issues, Donatello's Bargello *David* and Nanni di Banco's *Isaiah* clearly belong together as a pair: not only is one the symmetrical reflection of the other in terms of contrapposto, and in the corresponding distribution of drapery at the shoulder, waist, and legs, but each portrays a biblical prophet as an adolescent, thereby suggesting that one statue served as the thematic exemplar for the other. The *Isaiah* is out of character with Donatello's entire varied oeuvre, and the carving of the head is especially incompatible with that of the Bargello *David* despite any and all possible "compensation" for distant viewing, and even allowing for an interval of three to seven years. The *Isaiah*, on the other hand, is very closely related to the "youngest" saint (1409–12) of Nanni di Banco's *Quattro Coronati* (fig. 92), in terms of the spiritual and morphological composition of the head and the formation and ponderation of the entire figure. This has been recognized by Brunetti (1968) among others. The relationship between these two statues constitutes one of the most obvious connections in Nanni di Banco's work, and cannot be dismissed (cf. Herzner 1978) as an intense reflection of an earlier figure by Donatello resurfacing in the *Quattro Coronati*. The method of carving, particularly the simplified carving of hands and feet, the fascination with plastic expression of hair, and the experimental, vigorous, almost uncomfortable realism in the physiognomy of the head, were clearly continued in Nanni's subsequent documented works, such as the *Saint Luke*, the *Saint Philip*, and the *Quattro Coronati*. A fleshy pronunciation of eyes, nose, mouth, and throat, with deep undercutting and varied modulation of the surface skin (so different from the crisp, refined, almost effeminate stylization of the Bargello *David*) links the *Isaiah* with the *Quattro Coronati*. Finally, suffice it to say that an inevitable equation exists between the *Isaiah* and the Bargello *David*:

just as the *David* is a kind of "younger brother" to Donatello's *Saint George*, the *Isaiah* precedes Nanni's *Quattro Coronati* in terms of both ontogeny and phylogeny.

The *Isaiah* "facte per Johannem" is the first full statue that we know to be by Nanni di Banco. By virtue of its historical position as the first freestanding statue known to have been made by Nanni or Donatello, the *Isaiah* represents a point of departure for the monumental Florentine figure sculpture to follow. A simultaneous presence of "gothic" and classicizing features in the *Isaiah* has defined the critics' response to the work, at times producing confused or contradictory theories about its conception. Whereas Janson (1972) compared its pose to that of a slightly earlier miniature painting of Saint Paul by the Boucicaut Master, suggesting that they come from a common source (a source possibly located in French goldsmiths' work, manuscripts, or ivories), Greenhalgh (1982) saw the *Isaiah* as directly derived from an antique gem of Apollo (known also to Ghiberti) that later entered the Medici collections. These improbable speculations aside, other scholars (Planiscig 1946; Vaccarino 1950; Grassi 1951; Pope-Hennessy 1955; Phillips 1964; Seymour 1966) have found the statue to be composed in an unresolved collision of two distinct trends, with the revival of classical models straining against the momentum of the "International Gothic" style. I believe the apparent contradiction stems from a number of local and individual forces, the same traditions and impulses that influenced Nanni's sculpture throughout his career and that consequently shaped the history of Florentine monumental sculpture.

The traditions apparent in the *Isaiah* may be identified by proceeding, as it were, from the surface to the core, as follows: the "International Gothic" style; the tradition of Pisan sculpture; the study of Roman antiquities; and the most prominent factor of all, namely the local collective impulse to create a "Hercules/Fortitude" hero. The *Isaiah*, monumental not only in scale but also in size, a statue conceived to stand free from the constraints of architecture in the open air, and high above the street life of the via dei Servi, reflects, as it were, *in grande* certain idioms of the contemporaneously prized gothic style. In tracing a source for the exaggerated contrapposto, clinging and arabesquing drapery, and animated ribbon-reverse activity of drapery and scroll, one need not sort through numbers of portable French ivories or Northern manuscripts for a "model" but rather turn to the contemporary works of the stonecarver

Niccolò Lamberti and the goldsmith Lorenzo Ghiberti. Nanni had worked beside Niccolò Lamberti on the archivolt and jamb reveals of the Porta della Mandorla (cats. 1-1, 1-2) and on the two caryatid *Atlanti* of the adjacent window (cat. 1-3). By the time Niccolò and Nanni were at work on the seated Evangelists for the cathedral facade, along with Donatello and Bernardo Ciuffagni, the prevailing mode had changed direction sufficiently so that Nanni could confidently present the Operai with a strong exploratory realism, departing from the trecentesque conception perpetuated by Niccolò. In 1408–9, however, Niccolò was the greatest proponent of the predominant gothic taste in the ambit of Florentine monumental stone carving. Shortly before the *Isaiah* was commissioned, Niccolò Lamberti had completed two large figures that stand in a swaying shot-hip pose animated by multiple, sharply defined, swinging curves of drapery, which emphasize the separation of the torso from the hips: the *Madonna della Rosa* of the Porta dei Canonici (1402) and the *Saint Luke* from Orsanmichele (1406, Bargello). In the *Isaiah* such a gothic sway is simplified and forced into a precocious "would-be" contrapposto. The stylistic ambience defined by Niccolò Lamberti provides the physical context within which the *Isaiah* would have stood in the cathedral complex, and there was indeed a developmental sympathy between the two artists. Still, virtually all the immediately earlier statues in Florence were more restrained, less vigorous, than the *Isaiah*, a figure whose every aspect demonstrates an unprecedented boldness of pose and largeness of scale.

It is just this apparent largeness, the issue of scale itself, that leads the observer to local examples of the particular International taste that is "blown up" in the *Isaiah*. Nanni di Banco's statue monumentalizes a figure style — and especially a drapery construction — that is best known in the panels of Lorenzo Ghiberti's North Doors, which may themselves contain reflections of French or German goldsmiths' work (for Ghiberti and "Master Gusmin" see Krautheimer 1956) and find a close counterpart in the painted figures of Lorenzo Monaco. The *Isaiah* subsequently served as a model for Jacopo della Quercia's *Apostle* at San Martino at Lucca (List-Freytag 1986). It is slightly ironic that the figure of *Isaiah* was quoted by Tommaso di Lorenzo Ghiberti in a finial figure of the *Silver Altar* dossal around mid-century, because it is precisely the goldsmiths' aesthetic, apparent in Lorenzo Ghiberti's early reliefs, that the *Isaiah* itself expanded to monumental size.

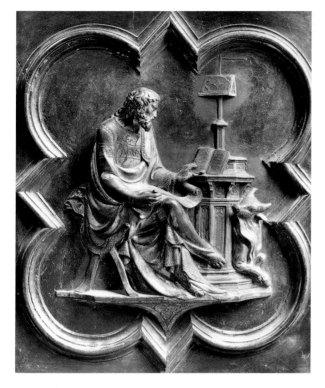

Fig. 93. Lorenzo Ghiberti, *Saint Luke*, 1407–13. Bronze, 15 ¼ x 15 ¼ in. (39 x 39 cm). North Doors, San Giovanni, Florence

Fig. 94. Lorenzo Ghiberti, *Baptism of Christ*, ca. 1404–7/8. Bronze, 15 ¼ x 15 ¼ in. (39 x 39 cm). North Doors, San Giovanni, Florence

One Ghibertian parallel (if not exemplar) for the *Isaiah* might be the seated *Saint Luke* (1407–13) from the north doors of the Baptistry (fig. 93). Here, the most conspicuous trait in common with the *Isaiah* is the soft draping of the saint's garment around his crossed right leg, which creates a sort of "wet drapery" effect like that used to articulate *Isaiah*'s relaxed (left) leg. In each case the drapery falls in a graceful arc of its own, and at the same time it is plastered down to reveal the anatomy of the leg, the construction of kneecap and shinbone, and the musculature of the calf. A single loop of folded drapery encircles *Saint Luke*'s torso just as a single reversing sash of drapery defines the waist of the *Isaiah*. In each case the scroll behaves with an animated ribbonlike life of its own. The stance of the *Isaiah* can be related to the lyrical, pictorial modeler's approach to drapery in Ghiberti's *Virgin Annunciate*, *Adoring Magus*, and *Baptizing Saint John* (fig. 94), all of which, according to Krautheimer (1956), were probably visible in the Ghiberti shop from about 1404 to 1407/8. Other lost and forgotten wax models in various stages of experimentation were probably made available to artists by Ghiberti during the same time. Ghiberti himself stated that he helped "many painters, sculptors, and masons to attain honor by furnishing them with models in wax and clay" and that "those who had to execute figures over life-size were given rules and the correct method for making them" (Krautheimer 1956). During the designing and carving of the *Isaiah*, Ghiberti's shop was frequented by stonecarvers such as Ciuffagni and Donatello, and around this time Ghiberti's own interest in the "International Gothic" style was seriously launched. It is therefore not surprising that Nanni di Banco, although exclusively a stonecarver, was exposed to this milieu and chose to drape his *Isaiah* in fashionable Ghibertian clothing. But Nanni's orientation as a stonecarver, and the requirement that the buttress figure be large and freestanding, determined the ultimate form and corresponding content of the statue: his *Isaiah*, therefore, looks vastly different from Ghiberti's own full-size *Saint John the Baptist* made for the Calimala guild at Orsanmichele in 1414/15. Unlike Ghiberti's *Baptist*, where the pattern of drapery folds seems to screen the figure behind it, it is just the soft, animated, stylized quality of the *Isaiah*'s garb that sets off his heroic scale, proportions, and intent. The drapery is at times independent of and extraneous to the body, as where the short cloak ties off elegantly, and where the sash bubbles up in a gratuitous loop at the hip behind his right hand in answer to the freely curling

scroll at the other side. But in other passages the soft fabric reveals a strong, vigorously counterposed body. A powerful chest (prefacing that of Donatello's *Saint Mark* at Orsanmichele) is tangible behind the simple, clinging folds of the mantle; the engaged leg is emphasized by large fluting, with the lower part of the leg uncovered. The free leg, although it still stands on its own drapery, is revealed through the drapery, which folds under the knee for emphasis; even the ankle bone is as clearly articulated through the drapery as it would be had the statue been nude.

A phylogenic and morphological prototype for the *Isaiah* is found in the *Hercules* figure of the lower left reveal of the Porta della Mandorla, which is here attributed to Nanni di Banco. The *Hercules* and the *Isaiah* have a common source in Nicola Pisano's *Daniel* in the Pisan Baptistry. It is certainly from the Pisan matrix that the *Isaiah* evolved and not, as Phillips (1964) proposed, from fourth-century monumental sculpture such as the colossal head of Constantine in Rome. Whereas Nanni may or may not have traveled to Rome, it is quite sure that he visited Pisa repeatedly and became familiar with the heroic monumental current that had characterized medieval or "proto-Renaissance" stonecarving there.

Although the *Isaiah* was removed from the buttress only shortly after its installation there, it nevertheless did fulfill its role as exemplar. This is demonstrated by the critical fortunes of the *Isaiah*, which emphasize the figure's heroic aspect: it has been named or associated with the personalities Daniel, David, Joshua, Fortitude, and Hercules. As discussed above, during the time that the statue stood on the cathedral facade (and even after having been moved into the nave), it was known as "Daniele." The white terracotta colossus *Joshua* designed by Donatello in 1410 (presumably the figure finished in 1412) was an alternative and sequel to the *Isaiah*. This insistence on the identification of the *Isaiah* not as a prophet, but rather as a biblical hero, has persisted through time: in the twentieth century Lisner, who always accepted the *Isaiah* as a secure work by Nanni di Banco, believed that the present statue actually did represent a "Joshua": the document of its commission (doc. 63) names the figure "Ysaie" which Lisner (1974) considered a slip of the pen for "Giesuè" or "Josua." The statue's associations with the hero David are much more obvious. Donatello's pendant tribune figure was a heroic young *David* made "cum modis et condictionibus factis cum Johanne" (doc. 64). Agostino di Duccio was assigned a marble *David* for

the cathedral tribune in 1464, and from the same block of stone, the *David* of Michelangelo was originally intended to continue the same program of tribune figures begun with the *Isaiah* (Seymour 1967a, 1967b). The pagan hero associated with the *Isaiah* was Hercules: in 1415, in the immediate wake of *Isaiah*'s installation on the buttress, Donatello and Brunelleschi made a gilded stone model of a figure "per ruova e mostra delle figure grandi che s'anno a fare in su gli sproni" (doc. 123), which in 1449 came to be known as the "primo Erchole di macignio choperto di pionbo" (Poggi-Haines 1: doc. no. 429). A colossal terracotta *Hercules* was commissioned in 1463 of Agostino di Duccio for the buttresses, possibly based on Donatello's model and made under his direction (Poggi-Haines 1: doc. no. 437). The close relationship between the *Isaiah* and the *Hercules* from the lower left reveal of the Porta della Mandorla has already been mentioned, and the Hercules imagery from the jambs and archivolt gives Hercules a long history in the sphere of the Florentine cathedral (see Hessert 1991, Witt 1994).

DOCUMENTATION

Docs. 56, 63, 64, 66, 67, 69, 70, 75, 76, 78.

BIBLIOGRAPHY

Richa 1754–62, 6:35, 119, 121; Cavallucci 1873, 21; Semper 1875, 129–30, 268; Cavallucci 1881, 108, 252–53; Schmarsow 1887, 150 n.1; Tschudi 1887, 6; Schmarsow 1889, no. 12, 5; Semper 1890, 1–70; Reymond 1897–98, 1:90; Schubring 1907, 19:13; Poggi-Haines 1: doc. nos. 414–21; Cruttwell 1911, 24; Schottmüller 1912, 17; Bode 1926, 5–6; Becherucci 1931, 507; Wulff 1932; Brunetti 1934, 258–66, 271 n. 11; Lányi 1935, 248–50; Lányi 1936, 150–78; Middeldorf 1936, 585; Lányi 1937, 128; Planiscig 1946, 12, 13, 20; Vaccarino 1950, 27–28; Grassi 1951, 31; Swarzenski 1951, 95; Paatz 1952–56, 3:394; Pope-Hennessy 1955, 219; Krautheimer 1956, 7, 62–67, 76, 83, 122–23, 207, 231, 309, 353–57; Janson 1957, 4; Stang 1962, 119–21; Janson 1964, 131–38; Phillips 1964, 64–65; Bellosi 1966, 1; Seymour 1966, 52–53; Lisner 1967, 79; Seymour 1967a, 98; Seymour 1967b, 27–32; Brunetti 1968 277–82; Wundram 1968, passim; Becherucci and Brunetti 1969, 1:265–66, cat. no. 123; Wundram 1969, passim; Gaborit 1970, 88–89; Poeschke 1971, 10–23; Janson 1972, 546–50; Herzner 1973a, 1–28; Herzner 1973b, 81–82; Rosenauer 1974, 28–30; Lisner 1974, 323–43; Goldner 1974, 222–23; Herzner 1978, 44–58, 62 n. 47; Poeschke 1980, 100; Parronchi 1980, 67; Greenhalgh 1982, 14–15; List-Freytag 1986, 39–43; Hessert 1991, passim; Rosenauer 1993, cat. nos. 1, 80; Pope-Hennessy 1993, 17–19; Hirst 1994, 843–44; Witt 1994, 177–78.

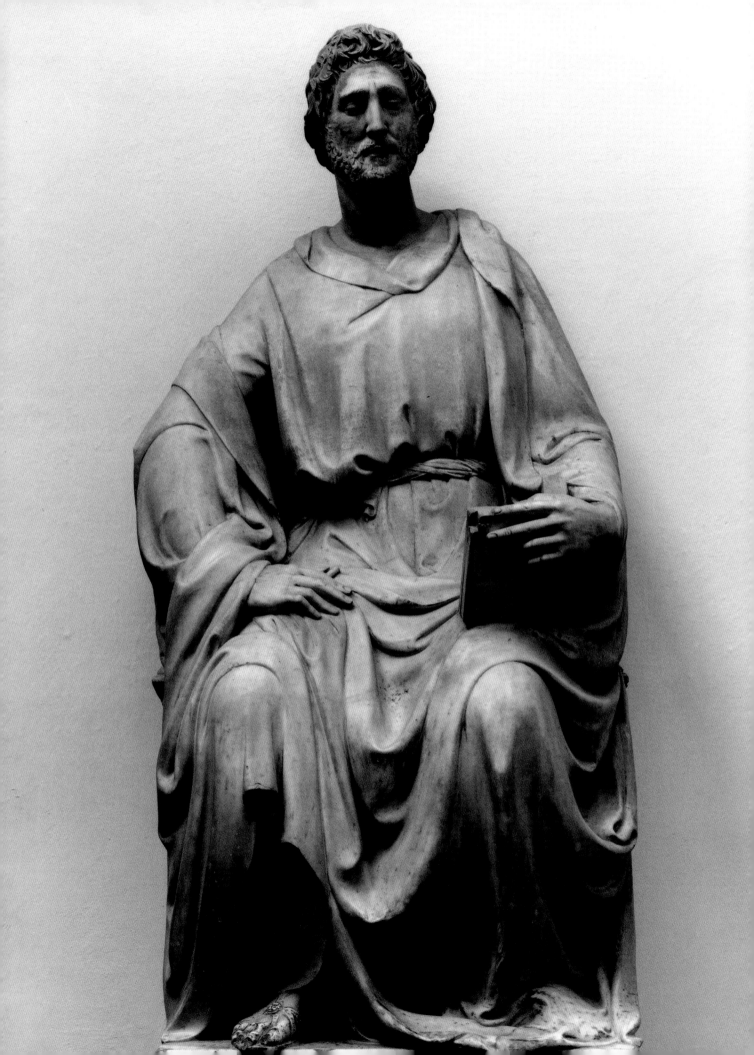

1.5 *Saint Luke Evangelist*

1412/13
Carrara marble, 78 ¾ x 34 ¼ in. (200 x 87 cm)
Museo dell'Opera del Duomo, Florence

The statue is in good condition but lacks the tips of three toes and the corner of the book.

ATTRIBUTION AND DATING

Nanni di Banco's *Saint Luke* is innovative in the composition of a monumental seated figure and in the observed realism in the human head. These qualities, substantiated by the statue's documented authenticity and date, designate the work as a landmark in early Renaissance sculpture as well as the touchstone of Nanni di Banco's career. The ensemble of four Evangelists for the cathedral facade, to which the *Saint Luke* belonged, is an unusually well-documented project, traceable from the acquisition of the raw marbles in 1405–7 to the eventual installation of the figures in the Museo dell'Opera del Duomo after the Second World War.

By spring of 1405 the Evangelists were planned; stones were quarried and blocked at Carrara by Niccolò Lamberti and Lorenzo di Giovanni d'Ambrogio in June of that year (doc. 49). War with Pisa had prevented the Florentines from transporting the *bozze* to Florence from Pisa where they languished for at least a year (doc. 50). In December 1408 three of the four Evangelists were finally assigned to Niccolò Lamberti, Donatello, and Nanni di Banco, with the provision that whoever was to carve the superior figure would be awarded the contract for the fourth statue (doc. 71). The terms of the commission itself, therefore, ask that Nanni enter into competition with Niccolò and Donatello, just as he had done with the console *Atlanti* (cat. 1-3) and the buttress figure *Isaiah* (cat. 1-4). There is no reason to accept Seymour's statement (1966) that Niccolò Lamberti and Lorenzo di Giovanni d'Ambrogio were originally to have shared the commission for all four figures: Niccolò and Lorenzo were simply responsible for procuring the stones, just as Niccolò was later to provide the block that the Linaiuoli would consign to Donatello for their *Saint Mark* at Orsanmichele (see Janson 1957). The Operai did change their plans, however, when on 29 May 1410 they abandoned the incentive clause established two years earlier and gave the contract for the fourth Evangelist, *Saint Matthew*, to Bernardo Ciuffagni (doc. 79).

Nanni di Banco received his first payment toward a statue specified as *Saint Luke* on 12 June 1410 (doc. 80), one month after the deliberation that the chapels in which the Evangelists were being carved be closed under lock and key (doc. 81). The closing of the work spaces is reiterated 24 January 1414/15 when eight denari were spent on a new key for Donatello's chapel (Poggi-Haines 1: doc. no. 210). Seymour's idea that the three artists closed their areas to pre-

Fig. 95. Bernardo Poccetti, *Facade of Santa Maria del Fiore*, 1587. Pen and ink on paper applied to canvas, 39 ¾ x 22 ¾ in. (101 x 58 cm). Museo dell'Opera del Duomo, Florence

vent Bernardo Ciuffagni from "sniffing about the cubicles in search of ideas" (1966) is probably overly imaginative. Nanni di Banco received further payments on 31 October 1410 (doc. 83) and 8 June 1412 (doc. 90); the balance was paid 16 February 1412/13 when the work was completed (doc. 100). On the date of the second entry, 31 October 1410 (doc. 83), a canceled notation regarding "two angels" suggests that Nanni may have been providing other figures for the cathedral or related buildings at this time, perhaps in *concorso* with other sculptors, such as Ciuffagni, who was paid thirty florins for "unius angeli longitudinis duorum brachiorum" on 30 June 1410 (Poggi-Haines 1: doc. no. 185). The odd sum total of 137 florins and 1 lira (docs. 80, 83, 90, 100) indicates that some of the payment documents for the *Saint Luke* are missing, including the deliberation that would have quoted the estimated total value of the statue; the Evangelists produced by Lamberti, Ciuffagni, and Donatello were appraised at 130, 150, and 160 gold florins respectively (Becherucci and Brunetti 1969). Such missing documents may have contained further references to the "angels" or other works.

Nanni was the first of the four sculptors to present the

Operai with a finished Evangelist statue, 16 February 1412/13: Lamberti completed his *Saint Mark* on 18 March 1414/15, and Ciuffagni and Donatello (after some serious urging on the part of officials) delivered the *Saint Matthew* and *Saint John* on 8 October 1415, the date of the installation of the group on the facade (Poggi-Haines 1: doc. nos. 213–15, 220). Because the *Saint Luke* was finished more than two full years in advance of the others — it is significant that the *Saint Luke* was already completed when the majority of payments for Donatello's *Saint John* had just begun — Nanni di Banco was once again in the position of providing a challenging exemplar for a series of works of public sculpture.

The four statues were placed in niches that flanked the central portal in pairs. The first notice of their collocation is in 1415 (Poggi-Haines 1: doc. no. 220), when Ciuffagni and Donatello's statues are described as "missa (. . .) in facie anteriore supradicte ecclesie" and "posta al lato alla porta di mezzo di santa Maria del Fiore." Later drawings and paintings, such as Bernardo Poccetti's well-known six-teenth-century drawing (fig. 95), show the Evangelists placed in classicizing scallop-shell niches, which appear to have been similar to the one depicted in Ghiberti's *Christ Among the Doctors* from the North Baptistry Doors. The niches, which no longer exist, except in pictorial representa-tion, have been analyzed by Rosenauer (1978), who suggests that niches with seated figures may have been planned in the fourteenth century under Arnolfo di Cambio, and that their actual design may have been by Lorenzo Ghiberti. Reymond (1905) had also proposed Ghiberti as the designer, pointing to similarities with the *Saint Matthew* niche at Orsanmichele (fig. 96). Scholars have also men-tioned Brunelleschi as a candidate (Kalusok 1996). The sev-eral preserved drawings and paintings of the intact cathedral facade with the Evangelist statues in place, along with the descriptions from various written sources, have generated some discussion about the original arrangement of the four figures. The visual material includes, in addition to the Poccetti drawing, an anonymous miniature of 1471 depicting the Consecration by Eugenius IV in 1436, con-served at the Biblioteca Laurenziana, Poccetti's fresco at San Marco showing the entrance of Saint Antoninus into the cathedral, and a painted panel of a *cassone* now conserved at the Bargello (Rosenauer 1978; Munman 1980). All these images give generic, freely handled descriptions of seated figures in niches; none seeks to portray the works with any

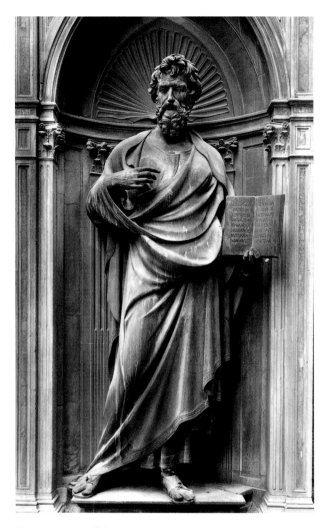

Fig. 96. Lorenzo Ghiberti, *Saint Matthew*, 1419–22. Bronze statue in marble niche, height 106 ¼ in. (270 cm). Orsanmichele, Florence

individualizing specificity. Whereas the Poccetti drawing was probably made to document the facade before its demolition, the other renditions served as background in narrative paintings. In any case, although the shape and style of the niches are presented with some consistency, the inconsistency between these pictures in terms of relative beard lengths, arm positions, and postures of the individual statues prevents us from taking any one for a definitive reference-picture. The written sources (Antonio Billi, Anonimo Gaddiano, G. B. Gelli, and Vasari) locate the *Saint Luke* as having been one of the two statues on the north side of the central portal; the Anonimo Gaddiano was the most specific, stating that the *Saint Luke* "è quello accanto la porta del mezo verso i Legnaiuoli" (Legnaiuoli meaning the modern via Martelli). Brunetti (1969) was correct in observing that if the Poccetti drawing were to be trusted, then the beardless-looking figure to the immediate left of

the portal must be the *Saint Luke*. Munman's study (1980) remains unstable because he depended upon the accuracy of Poccetti's drawing for evidence as well as positing the northernmost statue to be Nanni di Banco's *Saint Luke*. Because Poccetti's statue on the extreme left looks nothing like the *Saint Luke*, Munman then proposed that none of the original figures was in the northern niche when Poccetti's drawing was made, but rather that the niche was occupied by an anonymous substitute which would subsequently disappear entirely from the precinct of the cathedral. To the extent that a reconstruction of the ensemble is possible at all, the conclusions of Paatz (1952–56), Seymour (1966), Janson (1963), and Goldner (1978) are more plausible in assuming that Nanni and Donatello's statues flanked the door left and right respectively, with Ciuffagni's *Saint Matthew* at the extreme left and Lamberti's *Saint Mark*, in the act of writing, at the outer right.

With regard to the attribution of the present *Saint Luke* to Nanni di Banco, sixteenth-century writers, including the Anonimo Gaddiano, Antonio Billi, G. B. Gelli, and Giorgio Vasari, corroborate documentary and pictorial evidence, citing Nanni di Banco as the sculptor of "uno dei quattro vangelisti che sono nella facciata" (Anonimo Gaddiano). After the demolition of the facade in 1587, the Evangelists were brought indoors, and on 1 February 1589 they were settled in chapels of the east tribune (Poggi-Haines). In 1904 they were moved to the right side-aisle, and after the Second World War they entered the Museo dell'Opera del Duomo (Janson 1957; cf. Becherucci and Brunetti 1969).

Because none of the four Evangelists displays identifying attributes, they are assigned to the artists specified in the documents on the basis of style — except the *Saint Mark*, which is signed "Opus Nicholai" between the brackets on the lower part of the base. For three centuries the statues were housed in the tribune chapels in inadequate light: so shadowed was their environment that Lamberti's signature on the *Saint Mark* was completely overlooked and Nanni's *Saint Luke* was taken by Follini and Rastrelli (1790) to be Donatello's *Saint John* "con l'aquila." Semper (1875) must have been thinking of Nanni's *Saint Luke* when he alluded to the smiling mouth and simple draperies of Donatello's *Saint John*. Bode identified Nanni's figure correctly in his 1884 edition of Burckhardt's *Cicerone*. And from 1904, when the figures were moved into the lighted nave, scholars have unanimously agreed upon their respective identities, all of which demonstrate the signature styles of

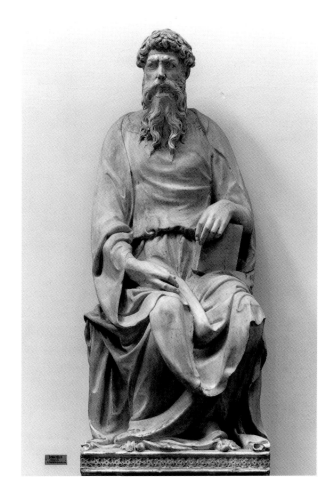

Fig. 97. Donatello, *Saint John Evangelist*, 1415. Marble, height 82 ⅝ in. (210 cm). Museo dell'Opera del Duomo, Florence

(1966) states that "Donatello's *Saint John* looks gothic in comparison with the blunted squaring off of the *Saint Luke*." Avery (1970) called the *Saint Luke* "extroverted," whereas Wundram (1969) considered the gaze of the *Saint Luke* "introverted as compared to the *Saint John*." Even Brunetti's (1951) playful remark, "they are lined up like four professors at a lecture and the only one not dozing off is Donatello's *Saint John*," is evaluative rather than informative. Goldner (1978), Marek (1989), and White (1989) have been more observant and less judgmental in their evaluations of the Evangelists, discussing the relative qualities of one statue without disparaging those of the other. Still, the Evangelists need to be studied as a group.

Seymour (1966) offered a good analysis of the problems faced by the sculptors in creating seated figures, where three primary planes — upper body, lap, and knees-to-feet — must be contrasted, and where the problem of depicting potential movement through contrapposto must be undertaken in a posture that is by nature one of repose. Because the statues were carved from slabs designed to be placed in shallow niches, they are to be examined primarily from a frontal point of view.

Let us take the statues outside their chronological order. Donatello created potential movement in the *Saint John* (fig. 97) by a system of graphic contrasts, namely the construction of a shallow zigzagging of the orientation of the figure in space, and an animated contrast in the behavior of draperies from one part of the body to the other. The head and gaze are aimed to the statue's right, away from the center of balance in the opposite direction from the lap, knees, legs, and feet, which are likewise fully turned to the statue's left. The chest twists slightly in the direction of the saint's mental attention, and both arms are at rest. The engaged side of the body is the statue's left, with the weight-bearing lower leg and the forearm (propped on a book) emphatically uncovered. The drapery covering *Saint John*'s torso is plastered down in the soft, "wet drapery" style of the *Saint Mark* at Orsanmichele (fig. 28) to show musculature and torsion, whereas the figure's lower drapery is irrationally substantive and animated into large, violent contours, which at once conceal and dramatize the sideways turn of the knees. The whole statue is organized in a triangular composition culminating in the head, with spatial recession angling from left-to-right and right-to-left, thus adding the illusory depth of relief space, or pictorial space, to the actual depth demanded by the planes of the seated

their respective sculptors (Becherucci and Brunetti 1969).

It is widely accepted that the destiny of Florentine art was largely determined with Nanni di Banco's *Saint Luke* and Donatello's *Saint John* (fig. 97). But the stylistic analysis of these two works has remained deterministic, with each scholar contributing his or her own critical bias in an aesthetic ranking of the statues in terms of "gothic" versus "progressive" qualities in the manner of a Wölfflinian system of comparison and contrast. Comments typical of the art-historical literature claim that "second best [to Donatello] is Nanni's *Saint Luke*" (Planiscig 1946), or "the whole [of Donatello's *Saint John*] is out of proportion and unharmonious . . . vulgar," whereas "the most elegantly sandaled foot [of *Saint Luke*] is that of an aristocrat" (Vaccarino 1950). According to Pope-Hennessy (1955), "Donatello's *Saint John* is the creation of a more forcible and independent artist, and it is in this work, and not the *Saint Luke*, that a Renaissance style is predicted," whereas Bellosi

statue. The entire torso, arms, head, and beard are elongated in Donatello's Evangelist. This elongation of the upper body was probably intended not so much as an optical "corrective" for viewing from below, but rather as a device that contributed to the pyramidal quality of the whole design: it set off the upper part in contrast to its weighty support, which consists of the bench, lap, legs, and base, which together constitute a rectangular (squarish) block swathed in grandiose draperies. Nineteenth- and twentieth-century art historians who have held to an "optical compensation" theory in the works of Donatello, based on their interpretation of some passages of Vasari, include Crowe and Cavalcaselle (1864), Kauffmann (1936), Seymour (1966), Wundram (1969), Goldner (1978), and Munman (1985). But surely Janson (1957, 1972) was correct in this case when he pointed out that the lengthened torso projects an enduring medieval convention in the construction of monumental figure sculpture, rather than the Renaissance rediscovery of a Vitruvian optical system. The effect is equally powerful.

Niccolò Lamberti's *Saint Mark Evangelist* is one of that artist's most excellent and representative works. It, too, is a triangular composition; not counterposed, the *Saint Mark* is turned slightly toward his right, with a steady gaze that leads to the raised right hand, which originally held a metal pen. The body slopes down in a mild slouch that creates a pyramidal plane from narrow shoulders and chest to protruding abdomen, to the gradually wider incline of lap and knees. Lamberti's hard symmetrical hair, and beard patterns, and liquid articulation of reversing arabesquing drapery are tours-de-force of the "International Gothic" taste; and Lamberti's is the only statue of the four in which the drapery spills down freely over the socle relief as if by pure chance. In this sense Niccolò's *Saint Mark* is stylistically comparable with Brunelleschi's seated *Apostle* from the silver altar at Pistoia (see Gai 1986). Bernardo Ciuffagni's *Saint Matthew* is indeed the most eclectic of the four Evangelists, apparently synthesizing elements from the others. Ciuffagni, perhaps the most ardent of Florentine "Donatellists" (Wundram 1969), produced results that were frequently static and dispiriting for the modern viewer. Nevertheless, the Operai valued Ciuffagni's *Saint Matthew* at 150 florins, whereas Lamberti's *Saint Mark* fetched only 130 florins.

The compositional structure of Nanni di Banco's *Saint Luke*, compared with the dynamic torsion of Donatello's *Saint John* or the fluid triangularity of Lamberti's *Saint Mark*, is intended as an open investigation of the seated figure in an organically unified, or "closed," contrapposto. The nature of a seated pose is expressed in the *Saint Luke* in the counterbalance of each of its parts — from the eyelids to the soles of its feet. Nanni's statue is conceived in a far more frontal manner than the statues by Donatello or Lamberti, and it is more deeply carved than Donatello's figure, making greater use of real space and far less of fictive or pictorial space. Kalusok's (1996) reconstruction of the *Saint Luke* in its niche demonstrates that it was the widest of the Evangelists relative to its niche space, almost impinging upon the niche wall at the viewer's right. In Nanni's *Saint Luke* the torso and neck stabilize the figure in depth: the figure is given a massive, tall neck that emphasizes the fact that the spine is pulled back and the chest and face project out from the center of balance. This way the arms are able to play an active, if somewhat clumsy, part in the contrapposto configuration. The saint's right hand, posted on the flank of his engaged right leg, is emphasized by means of the many small folds of drapery radiating from the pressure of the palm and fingers. His left shoulder, raised in counterbalance, pulls the tunic taut from the waist on that side, while at the other side the drapery material is slack, overflowing the sash at his waist. The *Saint Luke* is the only Evangelist statue in which one arm is free from the upper body: its akimbo position, besides demonstrating naturalistic weight and stress, eschews the triangularity that dominates the solutions of the other sculptors. A certain awkwardness in the position of the elbow gives the arm a slightly unresolved, rubbery quality. Poeschke (1989) proposed that the akimbo arm was a "remake" of Donatello's marble *David*, and that the propping of the book in the saint's forward hand was a response to Donatello's *Saint Mark* at Orsanmichele, which would then have to have been almost finished in the summer of 1412. The width of the torso of *Saint Luke* is enhanced by the relative freedom of the statue's left arm as well. The engaged leg is brought forward of the relaxed leg, with the knee raised and the foot itself drawn back, its sole planted on the floor of the base to bear the weight; this arrangement reappears in Donatello's *Saint John*, where it is turned on a diagonal in space to a dramatic effect. The uniformly soft drapery in the *Saint Luke* (unlike the alternately "wet" and "starched" drapery solution to be chosen by Donatello) is consistent in its formation of broad, smooth folds, which

Fig. 98. Antonio del Pollaiuolo, Reliquary Cross of Saint John Baptist (detail), 1457–68. Silver. Museo dell'Opera del Duomo, Florence

size seated bronze *Saint Peter Blessing*, whose legs in contrapposto, sandaled feet, and depth in space might have informed the *Saint Luke*. It could be argued that just as Masaccio turned back to the principles of Giotto's art, Nanni to a great extent recognized his own aims in the works of Arnolfo. Jacopo della Quercia's *Ferrara Madonna*, rather than having a direct relationship (be it of derivation or inspiration) with Nanni's art, as claimed by Pope-Hennessy (1955), may simply share a common affinity for the ideals of Arnolfo di Cambio (see Beck 1991). But Nanni di Banco's *Saint Luke* did become a model for the works of subsequent Florentine sculptors. Luca della Robbia had the *Saint Luke* in mind when he worked on the terracotta Apostles for the Pazzi Chapel (Pope-Hennessy 1980); and Antonio Pollaiuolo's seated *Saint John the Baptist* from the silver reliquary cross of San Giovanni (fig. 98) clearly derives from the *Saint Luke*.

DOCUMENTATION

Docs. 49, 50, 71, 79–81, 83, 90, 100.

SOURCES

1516–30, Antonio Billi: "Nanni di Antonio di Bancho . . . fecie . . . nella facciata dinanzi di decta chiesa al lato della porta del mezo, verso i Legnaiuoli uno de' quattro evangelisti et altri acanto."

ca. 1537–42, Anonimo Gaddiano: to Nanni di Banco: "anchora nella facciata dinanzj di detta chiesa uno de 4 evangelistij, che è quello acanto la porta del mezo verso i legnaiuoli."

1550, Vasari: "Nella faccia di Santa Maria del Fiore è di sua mano uno Evangelista de la banda sinistra entrando in chiesa, a la porta del mezzo."

ca. 1550–63, G. B. Gelli: to Nanni di Banco: "uno di que' 4 vangelisti che sono nella facciata di santa Maria del Fiore. Ci è quello [. . .] in mezo la porta del mezo di verso i legnaiuoli."

1568, Vasari: "nella faccia di s. maria del Fiore e di mano del medesimo [Nanni di Banco] dalla banda sinistra entrando in chiesa per la porta del mezzo uno evangelista che, secondo que' tempi, è ragionevole figura."

BIBLIOGRAPHY

Follini and Rastrelli 1790, 233; Crowe and Cavalcaselle, 1864, 2:280; Semper 1875, 69–72; Bode and Fabriczy 1884, 346; Reymond 1897–98, 2:24; Reymond 1905, 171–82; Poggi-Haines 1:XXXV–XXXVIII; Sirèn 1914, 438–61; Kauffmann 1936, 15; Middeldorf 1940, 18–20; Planiscig 1946, 22–25; Vac-

seem determined by the posture of the figure: both knees are indicated through the lower drapery, which falls into heavy folds between the legs. Here we see a conscious departure from the decorative tying and draping that was operative in the *Isaiah*, completed three years earlier.

As described in chapter 3, the *Saint Luke* has a noticeable relationship with Roman portraits of the Trajanic-Hadrianic type (fig. 40). Rosenauer (1991) suggested that the smile of the *Saint Luke* be compared with that of the French Gothic *Saint Joseph* at Reims. No specific monumental models arise for the posture of Nanni di Banco's *Saint Luke*. The personification of *Prudence* by Giovanni d'Ambrogio at the Loggia dei Lanzi, which was cited by Wundram (1969) as an influential model, seems irrelevant. From the goldsmiths' world, the seated *San Jacopo* by Gilio Pisano (1352) from the silver altar at Pistoia somehow anticipates the *Saint Luke* in the projection of the chest and the downward glance of the eyes, but the similarity is typological and coincidental (see Gai 1986). The volumetric solidity and organic containment of forms in the *Saint Luke* have a general affinity for the works of Arnolfo di Cambio. Arnolfo's *Enthroned Madonna and Child* (1302) was situated on the facade of the Florentine cathedral above the central portal. Had Nanni traveled to Rome, he would have known Arnolfo's seated *Charles of Anjou* at the Campidoglio and, more importantly, the life-

carino 1950, 29–34; Brunetti 1951, 105–6; Paatz, 1952–56, 3:565 n. 476, 572 n. 493; Pope-Hennessy 1955, 52–53; Janson 1957, 14–18, 20; Wundram 1959, 85–101; Castelfranco, 1963, 23–33; Bellosi 1966, 3–4; Seymour 1966, 55–57; Levey 1967, 163; Janson 1968, 77–96; Weise 1968, 107–13; Becherucci and Brunetti 1969, cat. nos. 117–120; Wundram 1969, 86–92, 147, 150, 158; Avery 1970, 55–56; Janson 1972, 549; Pope-Hennessy 1972, 5–13; Fehl 1973, 291–307; Rosenauer 1974, 28–30; Goldner 1978, 48–52; Rosenauer 1978, 345–52; Ferrali 1979, 52; Beck 1980, 30–31; Munman 1980, 210–15; Parronchi 1980, 27–37; Pope-Hennessy 1980, 17; Rose 1981, 31–41; Barocchi and Gaeta-Bertela 1985, XLVII–LIV; Munman 1985, 1–96; Pope-Hennessy 1985, 8–9; Gai 1986, 95–96, 98, 99, 100, fig. no. 211; Bergstein 1986, 7–11; Marek 1989, 265; Poeschke 1989, 149–51; White 1989, 170–82; Beck 1991, 1:54; Rosenauer 1991, 126–27; Pope-Hennessy 1993, 25; Kalusok 1996, 182–85.

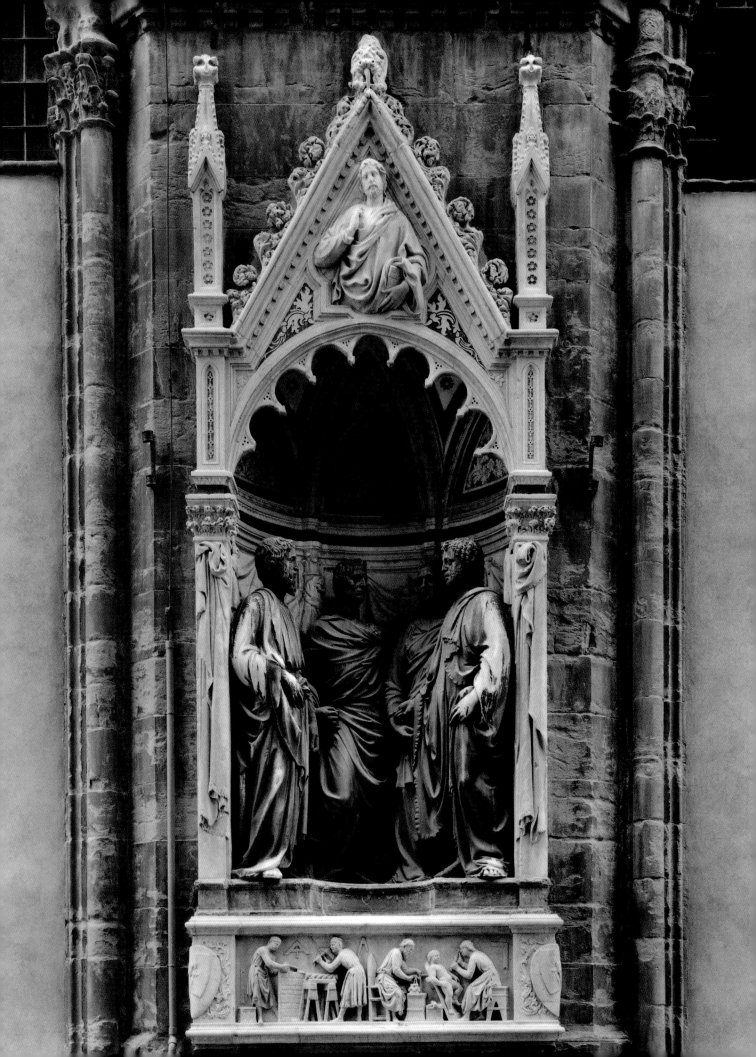

1.6 Quattro Santi Coronati

ca. 1409–16/17

Marble, height of statues ca. 72 in. (183 cm)

Orsanmichele, Florence

Marble statues stand in a marble polychrome niche on the north facade of Orsanmichele, with relief sculptures in pediment and socle. The two right-hand (viewer's right) figures are carved from a single block. The vaults and squinches of the ceiling of the niche are articulated in elaborate polychrome intarsia with "verde di Prato" and blue faience (pasta vitrea); the exterior pinnacles, too, show traces of color. The platform on which the statues stand is reveted in gray veined marble, and the revetment wraps around the bases of the outer "stipiti" (framing jambs) of the niche. The niche has been restored, but the statues remain blackened by pollution and dirt (1999).

The outdoor tabernacle dedicated to the Four Crowned Martyr Saints, or Quattro Santi Coronati, patron saints of the Arte di Maestri di pietra e legname (guild of stonemasons and carpenters), is one of the most pioneering works of the Florentine Renaissance. A dynamic interaction of sculpture with architecture renders an unprecedented pictoriality to the composition; this is achieved through the use of actual, rather than graphic, space. The work is divided into three zones: (1) the pediment where a half-length figure of Christ Blessing projects in high relief (fig. 99); (2) the niche space, which is divided into three bays by colonnette capitals draped with a fictive curtain, and inside a group of four statues of men — the two at the viewer's right intersecting, and in fact carved from the same block — stand on a concave semicircular platform, which forms the floor of the niche; (3) the socle (bracketed with guild "stemmi" at either end) with a relief

vignette of four stonemasons (builders, stonecarvers, and sculptors) at work (fig. 100).

ATTRIBUTION AND DATING

Although the commission is not documented, a tradition from Francesco Albertini (1510) onward has universally ascribed the ensemble to Nanni di Banco (Carmignani 1978; Horster 1987). Dating of the group remained problematic until new documents were brought to bear on the question (Bergstein 1988). Wulff (1913), Schubring (1915), and Seymour (1966) all considered the *Quattro Coronati* to be Nanni's first work at Orsanmichele; Seymour nevertheless gave it the relatively "late" date of 1415. Reymond (1897), Paatz (1952), Vaccarino (1950), and Grassi (1951) estimated a dating of ca. 1408–11; the two former scholars saw it begun after the *Saint Philip* and before the *Saint Eligius*. Planiscig (1946) placed it around 1413; he imagined it after the *Saint Eligius* and before the *Saint Philip*; and Krautheimer (1956) dated the ensemble to ca. 1412 in the same sequence. Bellosi (1966) and Janson (1968) both settled for a somewhat broader dating of 1410–14. Wundram (1969) adhered to the idea put forward by earlier scholars that the group was made after the *Saint Philip* but before the *Saint Eligius*, with the execution of the greater part of the ensemble between

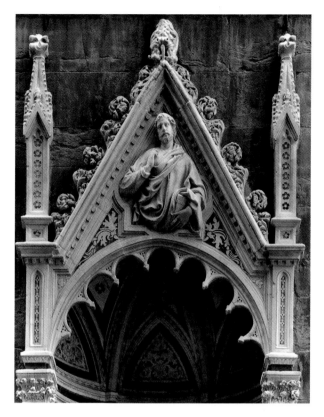

Fig. 99. Nanni di Banco, *Quattro Santi Coronati* (cat. 1-6, detail), ca. 1409–16/17. Marble. Orsanmichele, Florence

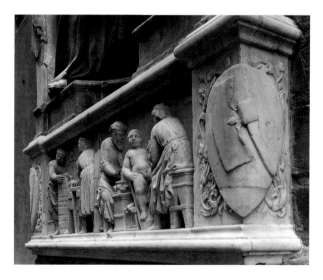

Fig. 100. Nanni di Banco, socle relief for *Quattro Santi Coronati* (cat. 1-6, detail), ca. 1409–16/17. Marble. Orsanmichele, Florence

1413 and 1415. Herzner (1973b) estimated a date of "1414/15 to 1417/18" for the conception and execution of the whole. Beck (1991) considered the *Quattro Coronati*, which he dated around 1413 to 1415, the last of Nanni di Banco's projects at Orsanmichele, made after the completion of both the *Saint Philip* and *Saint Eligius*. Negri-Arnoldi (1994) also saw the *Quattro Coronati*, which he dated 1412–16, as Nanni's latest work at Orsanmichele. Kalusok (1996) maintained that the niche must have been the first that Nanni constructed at Orsanmichele, begun by 1410. Lányi (1932–33), Vaccarino (1950), Brunetti (1968), and Kalusok (1996) considered the second saint from the viewer's left to have been the earliest, whereas Wundram (1969) and Herzner (1973b) saw the pair of figures at the viewer's right to have been the first produced.

A sale of marble from the Florentine Opera del Duomo to the stonemasons' guild in 1415 (docs. 121–22) indicates that the work was in progress at that time and that the ensemble as a whole be dated ca. 1409 to 1416 or 1417. The variety of dates and chronologies suggested before 1988 was due not only to lack of primary documentation, but also to the reluctance of historians to acknowledge the length of time taken by large-scale sculptural projects, an issue that was also addressed by Wundram (1969). Had the relevant series of payments for the single figure of *Saint Luke Evangelist* not been available, for example, scholars may never have concluded that it was commissioned late in 1408 and carved in the years 1410 to 1412/13. It is permissible to allow an even broader span of time for a project such as the *Quattro Coronati*, which — composed as it is of four figures, two reliefs, and other architectural and decorative elements — involved greater complexity in planning and execution. On 12 September 1415 the Operai of the Duomo agreed to sell 4,000 *libbre* of white marble to the Arte dei Maestri di pietra e legname at the low rate of 10 lire per 1,000 *libbre* (doc. 121). The actual sale was registered on 9 October 1415, at which point the marble (4,000 *libbre antiche* would equal about 1,333 kilograms) is described as "tres tabulae marmoris albi" (doc. 122). These marble slabs must have been acquired by the stonemasons for their niche at Orsanmichele, as the guild had no other corporate building projects underway at that time (see Goldthwaite 1980). The sale therefore shows that the *Quattro Coronati* ensemble was in progress by October 1415. A comparable transaction, similarly recorded, would be the purchase of marble from the Opera by the Arte dei Corazzai e Spadai in February

1416/17, which was apparently to be used for the pedestal base of Donatello's *Saint George*, and has allowed art historians to date the completion of that statue accordingly (see doc. 130). Because the marbles acquired by the stonemasons' guild are described as *tabulae* (slabs rather than blocks), we can infer that they were not used for the statues, but rather for relief panels and/or architectural facings; we may therefore assume that some amount of work had been done on the niche before their acquisition in 1415. The three *tabulae* of unknown surface dimensions would have been used for the relief decoration of the tabernacle in areas such as the gable, socle, and fictive cloth of honor behind the statues.

When the structural relationship of Nanni di Banco's four figures to their architectural setting is examined, it becomes clear that the acquisition of stones in October 1415 need not be a *terminus post quem* for the entire work but is more likely to be one episode in the history of an ambitious project. A photograph of the niche with the statues removed (fig. 101) shows that the back panel sections of fictive drapery do not extend over the entire space of the three bays; instead what exists behind the statues are only fragments of drapery designed to be seen through the interstices of the four saints, creating the illusion of a continuous curtain. This scenic facing, therefore, must have been carved to measure after the completion (or near the completion) of the four standing figures. It appears that the building blocks of the niche may have been excavated *ex post facto* in places to accommodate the statues where they most recede into depth, and the obvious measuring of parts contradicts Vasari's legend of Nanni's clumsy attempt to fit all four figures into a given space. If the purchase of marble in 1415 is imagined as an approximate *terminus post quem* for at least a portion of the architectural reliefs, presumably including the curtain, then it may provide a *terminus ante quem* for the figures; it thus becomes possible to set up a working time frame for the conception and execution of the whole ensemble.

With October 1415 as a "point during which," when the niche had already been built and the standing figures carved, an already flexible time frame for the *Quattro Coronati* must be stretched even further to accommodate what amounted to one full year that Nanni di Banco spent out of town as a local administrator in the Florentine territories, and to account for the time he may have spent working on the *Assumption* relief for the Porta della Mandorla. Nanni was absent from Florence at Montagna Fiorentina from 22

Fig. 101. Nanni di Banco, niche for *Quattro Santi Coronati* (cat. 1-6, detail), ca. 1409–16/17. Marble. Orsanmichele, Florence

August 1414 until 22 February 1414/15 (doc. 105), and for another six months beginning 9 July 1416 while serving as *Podestà* of Castelfranco di Sopra (doc. 126). He had been assigned the project for the Porta della Mandorla on 19 June 1414 (doc. 108), seven weeks before leaving for the Casentino, having already been selected as *Podestà* in April, and he received payments for work done on the Porta della Mandorla in May and August 1415 (docs. 117, 120), and again, after returning from Castelfranco in May 1417 (doc. 131).

Stylistic analysis of the statues of the *Quattro Coronati*, using as comparison the securely dated buttress figure *Isaiah* (finished December 1408) and the seated *Saint Luke* for the cathedral facade (finished February 1412/13), provides an idea of their internal temporal sequence. The "youngest" saint (fig. 92), whose animated contrapposto reflects that of the *Isaiah* so strongly, must be dated to some point between this statue and the *Saint Luke*. The togate garb of the young saint retains the same graceful, wet-drapery effect around the relaxed leg and foot that is seen in the *Isaiah*, and the spilling backwards of drapery from hand to forearm on each side recalls that peculiarly Ghibertian feature of the *Isaiah* as well. But the dialogue played out between the pos-

Fig. 102. Ambrogio di Baldese and Smeraldo di Giovanni, *Santi Coronati* (detail of fig. 8), 1403. Mural painting. Orsanmichele, Florence

ture of the young saint's body and the imaginative folds of his toga may be perceived as a developmental passage between the *Isaiah* and all other standing figures by Nanni di Banco. The garment here, although possibly modeled on a remote variation of the "double toga" of the late Roman Empire (Wilson 1942), does not conform to any known ancient style of draping a toga, but rather to the prevailing Ghibertian idiom (cf. Horster 1987). Schmarsow (1889) considered the numerous transversal folds a "gothic habit." The head of the young *Coronato*, in its vigorous modeling of features and bold staring gaze, derives immediately from the *Isaiah*. Here in the "youngest" *Coronato*, however, Nanni has undertaken to explore realistic details that he would refine in subsequent works such as the *Saint Luke* and the other three saints in the *Quattro Coronati* group: the naturalistic waves of hair, creased forehead, inscribed eyebrows, pronounced sinuses and bags under the eyes, short beard, and even the clumsily exposed ears show this head clearly to be a work of transition between the *Isaiah* and the *Saint Luke*. It can therefore be considered the first carved of the *Quattro Coronati*, datable within the years 1409–12.

The second figure executed would probably be the

"oldest" saint, the one at the extreme left, whose head, with lowered, creased eyelids and furrowed brow, seems to anticipate the psychological mobility of the *Saint Luke*; it may be dated to ca. 1410–12/13. The two figures at the right (henceforth called the "middle-aged saint" and "speaking saint" respectively), carved from a single block, are the most sophisticated of the group. The naturalism of their poses and gestures, the un-idealized peculiarities of each head, and the situation of the pair in relation to the architectural setting place them on a qualitative par with the *Saint Luke*, but their conception is more adventurous and experimental. Because the individuality of the heads tends to depart from the normative beauty that was arrived at in the *Saint Luke*, as if physiognomic variations on a theme, I would be inclined to date them somewhat later, ca. 1413–15, or, in other words, some time between the conclusion of the *Saint Luke* (February 1412/13) and the guild's purchase of marble slabs in October 1415, allowing time for Nanni's six-month sojourn in the Casentino in 1414. The relief elements, made from the marble acquired in October 1415, would have been carved in the months bracketing Nanni's residence in Castelfranco di Sopra, and presumably before the period of 1417/18–19 when his activity on the *Assumption* relief was most intense.

The *Quattro Coronati* ensemble, in progress by 1415, was probably begun as early as 1409 and finished around 1416–17, a conclusion that actually embraces most of the diverse dates given by scholars to this work (Bergstein 1988). If Nanni di Banco had received the commission for the *Quattro Coronati* following closely upon the *Saint Luke Evangelist* assignment of December 1408, it might explain his absence from the "colossal Hercules" project for the cathedral buttresses, which was continued by Donatello alone. It may also be significant that Antonio di Banco served as one of the four consuls of the stonemasons' guild from January 1408/9 to April 1409, thus helping to obtain the commission for his son (doc. 72). Most importantly, the present analysis indicates that Nanni's work on a group of major sculptural monuments overlapped to such an extent that they may not be pulled apart into a distinct linear chronology.

The *Quattro Coronati* were patron saints of the Florentine guild of stonemasons and carpenters, one of the five "middle guilds" and twelfth in the honorific order of the city's trade corporations; its membership included all those employed in construction work of any kind, from chief architects and stone sculptors to cesspool diggers (Goldthwaite 1980; Zervas 1996). Nanni di Banco's treatment of

Fig. 103. Ambrogio di Baldese and Smeraldo di Giovanni, *Santi Coronati* (detail of fig. 8), 1403. Mural painting. Orsanmichele, Florence

Fig. 104. Niccolò di Pietro Gerini, *Scourging of the Santi Coronati*, ca. 1390. Tempera and tooled gold on panel, 23 ¾ x 17 in. (60.5 x 43.2 cm). John G. Johnson Collection, Philadelphia Museum of Art

the *Quattro Coronati* pays little attention to the complicated legend of the (five) Roman martyrs from Pannonia, who, during the reign of Diocletian, chose death rather than carve a cult image of the god Aesculapius (*Acta Sanctorum* 1910; Delehaye 1913; Voragine 1924; Du Colombier 1952; Amore 1968; for a thorough study of the medieval and Renaissance iconography of the *Quattro Coronati* see King [1991], who has analyzed several depictions, including the eight-faceted capital at the Doge's Palace in Venice of 1340, and Butters [1996], who has studied the legend of the four crowned martyrs as it was presented in passionary manuscripts in medieval Rome and Tuscany). The story most familiar to Nanni di Banco and his patrons (fellow guildsmen) would have been the one in the trecento Tuscan edition of the *Golden Legend* (Voragine 1924). The *Quattro Coronati* were not frequently depicted in Italian art, and few other Tuscan renditions are known. The Aretine guild of stonemasons had a chapel in San Francesco, Arezzo, decorated with mural scenes of the *Quattro Coronati* (now destroyed) by Loretino d'Arezzo or Parri Spinelli (Salmi 1951, 1974). In Florence, some trecento references to a group of "quactor santorum choronatorum," for Santa Maria del Fiore might have suggested a "Quattro Coronati"

group predating that of Nanni di Banco (docs. 35, 36, 38); it is more likely that the figures, designed by Agnolo Gaddi (doc. 35) and executed by Niccolò Lamberti and Piero di Giovanni Tedesco (doc. 36), represented the Church Fathers wearing crowns of laurel; they are identifiable as those statues extant in the Museo dell'Opera del Duomo (Wundram 1962). A panel painting, possibly of the "Quattro Santi Coronati," put up for sale by the Opera of Santa Maria del Fiore in 1439 (doc. 177), might be associated with the panels attributed to Niccolò di Pietro Gerini (as discussed below) or with the "disegno" made by Agnolo Gaddi in 1395 (doc. 35).

Nanni di Banco, however, had a very recent precedent in the painting on the opposite side of the same northern pier, on the interior wall of Orsanmichele, by Ambrogio di Baldese and Smeraldo di Giovanni (fig. 8). This image was made for the stonemasons in 1403 (doc. 45; see Horne 1909; Brunetti 1947; Artusi and Gabbrielli 1982; Butters 1996; Zervas 1996). Zervas (1996) proposed that the pilaster mural itself may have substituted for an earlier polyptych by Niccolò di Pietro Gerini, the panels of which are now dispersed (fig. 104).

Fig. 105. Lorenzo Ghiberti, *Raising of Lazarus*. Bronze, 15 ¼ x 15 ¼ in. (39 x 39 cm). North Doors, 1403–24, San Giovanni, Florence

Fig. 106. Lorenzo Ghiberti, *The Last Supper*. Bronze, 15 ¼ x 15 ¼ in. (39 x 39 cm). North Doors, 1403–24, San Giovanni, Florence

In any case, Ambrogio and Smeraldo created a conservative and iconographically orthodox version of the saints' legend at Orsanmichele. All five saints of the original legend (the four Christian sculptors and their converted pagan colleague) are arranged in a stacked pyramidal composition. They stand almost frontally along the vertical length of the pilaster, haloed, in contemporary Florentine dress, holding up their tools as attributes (fig. 102). This solemn display of calipers and chisels, tools that call to mind the instruments of Christ's Passion, suggests the display of objects charged with sacredness. A hexagonal frame in the upper zone of

the pilaster contains an image of the (four) martyrs in Paradise; the hexagon is supported by two angels while another pair of angels holds a crown over the heavenly zone (fig. 103). The "predella" section of the frescoed pilaster, which is now ruined, with only a few spots of paint remaining, presumably illustrated the condemnation and martyrdom, when the saints were scourged at the pillar and then tossed into the sea in lead coffins (fig. 102) (Brunetti 1947; Artusi and Gabbrielli 1982; Zervas 1996). The scourging at the pillar, as we see in Niccolò di Pietro Gerini's panel (fig. 104), would have recalled the Passion of Christ, in keeping with the tools displayed in the iconic zone. The reveals of the pilaster are filled with rows of musical angels, adhering to a convention best known in the borders of the central panel of Fra Angelico's *Linaiuoli Altarpiece*. Butters's (1996) suggestion that the colors of the saints' gowns were intended to suggest the porphyry and serpentine of Cosmati work is possible.

Nanni di Banco's interpretation of the same theme outdoors is radically different from its interior precedent (Bergstein 1987a). The only element of overtly Christian context in Nanni's ensemble is the Blessing Christ in the uppermost zone. Below, the statues of four men stand in grave but harmonious conversation: three of them are dressed *all'antica* in variations of the toga and wear Roman sandals; they display neither haloes, nor crowns, nor attributes, nor palms of martyrdom. The socle relief, instead of narrating an episode from the martyrdom, shows stonemasons (*muratori, lastraiuoli, and scarpellatori*) at work fifteenth-century style, in contemporary dress, with the sculptor at the right completing the image of a wingless, nude boy, a pagan-style putto.

The relief of the tabernacle socle is ultimately derived from grave stelae of ancient Roman artisans, such as the example in Aquileia from the late first century after Christ (fig. 119), showing metalsmiths at work (Horster 1987; Zimmer 1982). Such reliefs were present throughout Italy and must have been known to Andrea Pisano as well, whose Campanile reliefs devoted to metallurgy (fig. 120) and sculpture follow their form closely. As in much of Nanni di Banco's relief sculpture, the impact of Roman art is mediated by the relief repertoire of Andrea Pisano (see Moskowitz 1986; Niehaus 1998).

The heads of the four saints, although clearly informed by a variety of antique sources, do not attempt to repeat the idiomatic language of any single style of Roman

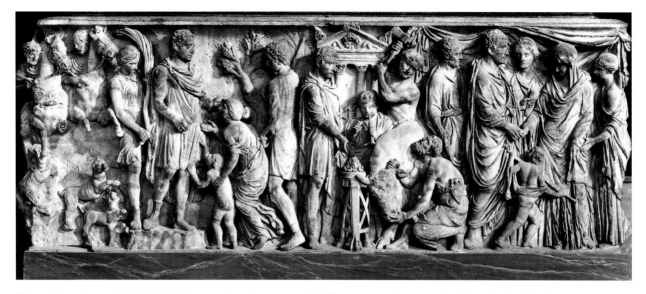

Fig. 107. Sarcophagus with the Life of a Roman General, ca. A.D. 170. Marble, 37 x 96 in. (94 x 243 cm). Galleria degli Uffizi, Florence

art (chapter 3). The bearded statue at the far left of the group (the "oldest" saint) has a vaguely Aurelian air but cannot be identified with any known portrait of Marcus Aurelius; neither is Horster's (1987) reference to a bronze head of *Septimius Severus* at Brussels (Musées Royaux) entirely satisfactory. The "oldest" bearded saint bears a superficial resemblance to late Roman "philosopher" heads such as the third-century *Plotinus* at Ostia (see Strong 1980). The saint at the viewer's extreme right can be related in certain of its details to third-century imperial portraiture. The second and third saints in the group have a strong affinity with the "Lucius Junius Brutus" in Rome (fig. 44). Janson (1962) proposed a portrait head of a Roman from the early third century in Berlin (Staatliche Museen) as a *locus classicus* for the head of the second saint from the viewer's left. Similarly, the saint second from the viewer's right resembles third-century imperial portraiture such as the bronze *Trebonianus Gallus* (fig. 46) in Florence. Also pertinent to the *Quattro Coronati* is the *Head of Antinoüs* from the Camposanto at Pisa (cat. II-14), which was probably recarved (incised) by a medieval or Renaissance sculptor formerly identified as Nanni di Banco.

Horster (1987) proposed that Nanni di Banco deliberately selected Roman togate statues of the "vir consularis" type as models for the *Quattro Coronati* in order to express the dignity of the guild consuls who commissioned the work. But we have seen that the complicated toga worn by the "youngest" saint (fig. 92) is a hybrid garment, the design of which depended as much upon formal require-ments of the whole ensemble as on togate figures from the sculpture of the Roman past. Rather, the bold diagonal slashes of drapery are connected to the Ghibertian aesthetic of Nanni's *Isaiah*, the present statue recalling from Ghiberti's oeuvre nothing so much as the winding cloth of the *Lazarus* from the Baptistry doors (fig. 105). The two right-hand saints, on the other hand, do wear togate draperies and conform to Roman Republican precedents. Certainly Herzner (1973b) was correct in that the oratorical gesture of the saint at the outer right is conflated with use of the *dextrarum iunctio* of Roman Republican matrimonial sepulchral sculpture as in the funerary portrait of husband and wife in the Vatican (fig. 49).

The luxurious curtain, tied off in bays on the interior of the niche and culminating in two sweeping flourishes on the outer pilasters, is a motif taken from ancient funerary sculpture and reinvented here *ad hoc* as a Christian cloth of honor. A similar curtain was used by Ghiberti in his *Last Supper* relief for the Baptistry doors (fig. 106). Antique sculptural models of this genre exist in large numbers: Roman sarcophagus reliefs frequently used the device of knotted drapery falling either into a single sheet or multiple bays to set off an episode of a mythological scene or to frame the deceased and his family. Such sarcophagi were plentiful in Florence and Pisa; indeed, one of them, still extant outside the Museo dell'Opera del Duomo, had been described since the time of Dante as being located beside the south door of the Florentine Baptistry (Chastel 1959; Seymour 1966). Several such reliefs were present in the

Fig. 108. Masaccio, *Tribute Money* (detail), 1424–28. Fresco. Brancacci Chapel, Santa Maria del Carmine, Florence

precinct of the cathedral complex: a fragment of the Orestes sarcophagus with a central draped sheet has its provenance at Santa Maria del Fiore (Becherucci and Brunetti 1969), and a sarcophagus adapted in 1230 for the tomb of Bishop Giovanni of Florence in the Baptistry employs the same motif. The Camposanto at Pisa provided a wealth of similar sepulchral reliefs, including the famous Phaedra sarcophagus, where the nude Hippolytus stands framed by an elegant drapery (fig. 21). The type of relief most likely to have been a conceptual stimulus for Nanni di Banco occurs on a Roman sarcophagus of ca. A.D. 170, now in the Uffizi (fig. 107). The frieze shows various phases in the life of an illustrious man: at the right one episode, possibly his marriage, is separated off by an exquisitely carved curtain with a nonfrontal, almost elliptical group of five interacting adult figures before it. Not only are the heads of the two men there carved with a stark naturalism that anticipates Nanni's vision in the *Quattro Coronati*, but in a series of interlocking gestures the husband and wife join hands and the central figure places one hand on the shoulder of each. If Nanni had studied this particular sculpture, it would reinforce the hypothesis of an early journey to Rome, because the sarcophagus is documented as having been above ground in Rome during the fifteenth century. We know that this relief enjoyed considerable renown among Florentine artists of the later fifteenth century, as it appears in a drawing in the *Codex Escurialensis*, a Roman sketchbook from the workshop of Domenico Ghirlandaio, along with drawings of other important monuments such as the Colosseum and the Pantheon (Egger 1906). The sar-

cophagus remained a rich source of ideas for Renaissance artists and was even consulted by Raphael for the tapestry design of his *Sacrifice at Lystra* (Shearman 1972).

Critics may classify the semicircular group of togate figures standing before a curtain suspended from engaged Corinthian pilasters as a composition *all'antica*, but in fact no genre of Roman art could have provided a model for such a grouping of life-size statues in a unified concave space. Horster (1987) pointed to the Hadrianic "Diana Medallion" from the Arch of Constantine, but the comparison is distant at best. The "philosopher" sarcophagi of late antiquity, such as the one in Rome, now at Palazzo Massimo, may be the ancient genre closest to that of the *Quattro Santi*, but the "philosopher" figures are piled up in a convex relief without any attempt to represent a measurable space (see Hanfmann 1975), and the sarcophagi lack just that comfortable relation of solid to void to which we apply the generic adjective "classical" in the *Quattro Coronati* niche. The adaptation of antique forms here is harmoniously combined with contemporary features such as the elaborate Gothic vault with ribs and formerets dramatically outlined in black, the multilobed arch, and florid foliage around the pediment (see Wundram 1960a).

The *Quattro Coronati* had an important impact on Italian art of the fifteenth and sixteenth centuries. Its first and most obvious impact occurs in the elliptical configuration of Apostles in Masaccio's *Tribute Money* (fig. 108) (Kreytenberg 1986), where the head of the "speaking saint" is interpreted as Saint John Evangelist (fig. 43). The semicircular arrangement of figures finds its ultimate elaboration in Raphael's *School of Athens* and *Disputation of the Sacrament* murals in the Stanza della Segnatura at the Vatican.

DOCUMENTATION

Docs. 121, 122.

SOURCES

1423, Gregorio Dati: "Dalla parte di fuori di detti pilastri [di Orsanmichele] v'è dentro un santo di marmo intagliato e [uno] in quale v'è ne quattro, e due n'è di bronzo di maravigliosa bellezza."

1510, Albertini: "I quattro statue insieme e sancto Jacopo è per mane di Io. Bachi."

1516–30, Antonio Billi: [Nanni di Banco] "fecie . . . i quattro Santi in decto luogho [Orsanmichele]."

1537–42, Anonimo Gaddiano: [Nanni di Banco]: "Sono anchora di sua mano e quattri santj in uno de dettj pilastrj."

1550, Vasari: "Sotto a questa nicchia sono Quattro Santi di marmo fatti per l'arte de' fabbri legnaiuoli e muratori, et lavorati da Nanni d' Antonio. Dicesi, che avendoli finiti tutti tondi, et spiccati l'uno dal'altro, et murata la nicchia, che a mala fatica non ve ne entravono dentro se non tre, avendo egli nelle attitudini loro ed alcuni aperte le braccia: perche disperato et mal contento andò a trovar Donato e contandoli la disgrazia et pocha acortezza sua; rise Donato di questo caso, e disse: se tu mi paghi una cena con tutti i miei giovani di bottegha mi da il core di farli entrar nella nicchia senza fastidio nessuno: et così convenutosi lo mandò a Prato a pigliare alcune misure, dove aveva d'andare esso Donato. Et così Nanni partito, et Donato preso i discepoli andatosene al lavoro, scantonò a quelle statue a chi le spalle, e a chi le braccia: talmente che facendo luogo l'una all'altra, le accostò insieme; facendo apparire una mano sopra le spalle di una di loro. Et le commesse così unite, che co' l savio giudizio suo, ricoperse lo errore di Nanni di maniera che murate ancora in quel luogo mostrono indizii manifestissimi, di concordia et di fratellanza: Et chi non sa la cosa, non si accorge di quello errore. Nanni trovato nel suo ritorno, che Donato aveva corretto il tutto, e rimediato ad ogni disordine; gli rendette grazie infinite: et a lui insieme con suoi creati pagò la cena; la quale lietamente e con grandissime risa fu da loro finita."

ca. 1550–63, G. B. Gelli: [Nanni di Banco] "Fecie . . . quei 4 santi che sono in detto luogo [Orsanmichele].

1568, Vasari-Milanesi: same as 1550, with the addition of the following: "Sotto i piedi di questi quattro Santi, nel ornamento del tabernacolo, è nel marmo, di mezzo rilievo, una storia, dove uno scultore fa un fanciullo molto pronto, e un maestro che mura con due che l'aiutano, e queste tutte figurine si veggiono molto bendisposte ed attente a quello che fanno."

BIBLIOGRAPHY

Schmarsow 1889, 3–4; Reymond 1897–98, 1:202; Egger 1906, 1:28; Horne 1909, 167; Marrai 1909, 250–55; Poggi-Haines 1:XXXIII and doc. no. 121; *Acta Sanctorum* 3, 1910, 748–84; Delehaye 1913, 63–71; Wulff 1913, 143, 148; Schubring 1915, 13–14; Voragine 1924, 3:1396; Lányi 1932–33, 126–31; Wilson 1942, fig. nos. 57, 58; Planiscig 1946, 26, 332–38; Brunetti 1947, 217–19; Antal 1948, 305–6; Vaccarino 1950, 33–39; Grassi 1951, 30; Salmi 1951, 31; Carboneri 1951–52, 231–35; Du Colombier 1952, 209–18; Kaftal 1952, 383; Paatz 1952–56, 4:492 n.90, 494–95, n. 110, n. 111; Pope-Hennessy 1955, 53, 218; Krautheimer 1956, 72, 125, 295–314; Mansuelli 1958, 1:cat. no. 253; Chastel 1959, fig. no. XLI-B; Wundram 1960, 161–76; Einem 1962, 68–79; Janson 1962, 435–36, Wundram 1962, 82; Bellosi 1966, 119–35; Janson 1966, 97; Seymour 1966, 59–63; Brunetti 1968, 277–82; Cannata 1968, cols. 1276–86; Grassi 1968, 59–68; Janson 1968, 93; Sellers 1968, 205–13; Seymour 1968, 198–205; Wundram 1969, 119–35; Avery 1970, 59; Alberti 1972, 55–57, 69; Pope-Hennessy 1972, 14–15; Shearman 1972, 122; Herzner 1973b, 89–93; Salmi 1974, 87–88; Hanfmann 1975, 121–22; Mustari 1975, 279, 282, 286; Sinding-Larsen 1975, 163–212; Beck 1976, 120; Lisner 1977, 135; Carmignani 1978, 180, 183–84; Goldner 1978, 63; Herzner 1979b, 177; Macchioni 1979, 140; Beck 1980, 128–33; Cole 1980, 161–62; Goldthwaite 1980, 266–69; Parronchi 1980, 31; Poeschke 1980, 12–13; Strong 1980, 254–55; Beck 1981, 60–62, 127–29; Haskell and Penny 1981, cat. no. 14; Artusi and Gabbrielli 1982, 52; Zimmer 1982, 140, 185–88; Moskowitz 1983, 49–59; Kreytenberg 1986, 11–20; Moskowitz 1986, 119; Bergstein 1987a, 69–77; Horster 1987, 59–79; Bergstein 1988, 910–13; Beck 1991, 1:79–80; King 1991, 81–89; Negri-Arnoldi 1994, 17; Butters 1996, 1:175–79; Kalusok 1996, 156–59; Zervas 1996, 1:486–88, 500–502, 636; Niehaus 1998, 124–26.

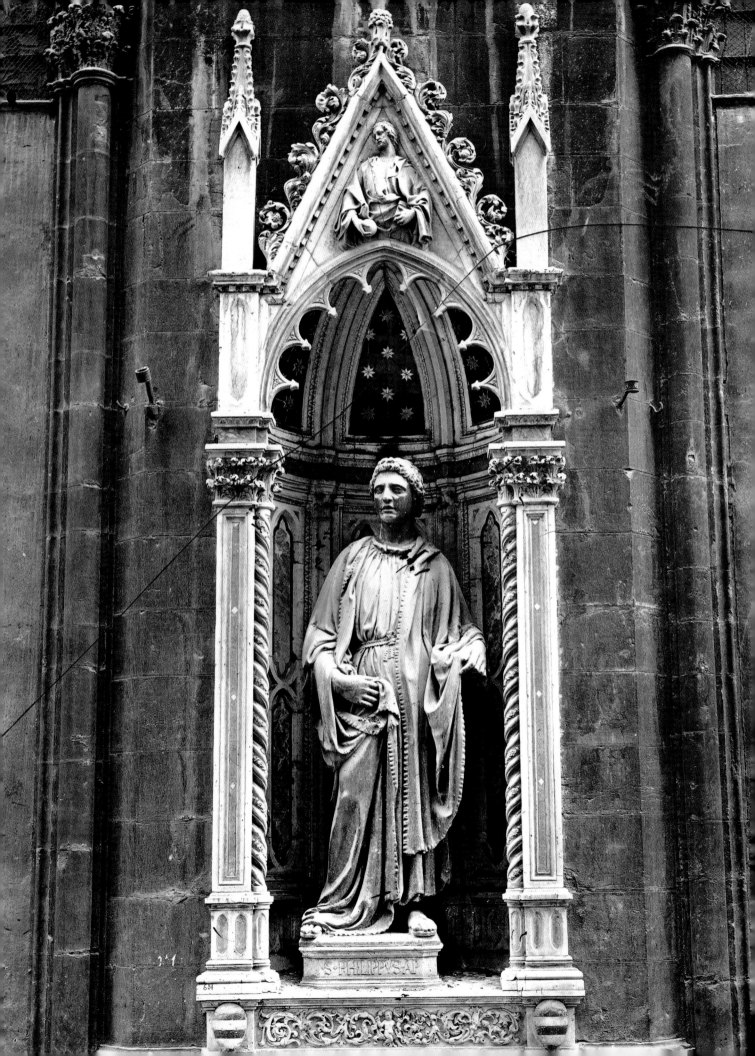

1.7 Saint Philip

ca. 1410–12
Apuan marble, height of statue 75 in. (191 cm)
Orsanmichele, Florence

The statue has been removed from its niche to the indoor museum of Orsanmichele. Recent cleaning has revealed traces of gold on the hair, and the collar, belt, and hem of the garment, and traces of color on the sandals and pages of the book. The base is inscribed "S. PHILIPPUS. AP".

The niche (second niche from the east on the north side of Orsan-michele) is decorated with white, green-black, and red marble, with gold- and blue-colored glass tiles ("pasta vitrea") in the ceiling; it presently contains a replacement cast of the statue. Each wall section is cut into lozenge frames containing red marble panels outlined in green-black ("verde di Prato"). The outer pilasters are faced with red marble. Two ovoid guild "stemmi," composed of alternating "black" and white stripes of marble, flank the socle. The cusp of the tabernacle has appar-ently been replaced, with the original broken fragment presently con-served in the second room of the Foresteria at the Lapidarium of San Marco, Florence (fig. 109).

ATTRIBUTION AND DATING

The original commission of the *Saint Philip* tabernacle to Nanni di Banco is recorded by a later hand in an undated *spoglia* of Calzolai guild documents (statutes, matricula-tions, and *provvisioni*) ranging in date from 1313 to 1489 (doc. 179). Sixteenth-century sources and modern scholars (who presumably did not know the document presented here) maintained an attribution to Nanni di Banco unanimously.

Fig. 109. Nanni di Banco, fragmentary cusp of *Saint Philip* niche (cat. 1-7, detail), ca. 1410–12. Marble. San Marco, Florence

Specific dating of the *Saint Philip* and its sequential relation-ship to other key works, such as Donatello's *Saint Mark* and Nanni di Banco's other ensembles at Orsanmichele, how-ever, have remained in question. Some scholars have been willing to date the *Saint Philip* as early as ca. 1405, placing it first in the chronology of Nanni's known works (Reymond 1897–98; Grassi 1951). Others have argued for a late date,

considering the *Saint Philip* the last of Nanni's Orsanmichele statues, a work whose basic pose was openly derived from Donatello's *Saint Mark* and whose style of carving was closely linked with the *Saint Thomas* of the Porta della Mandorla. Those who dated the *Saint Philip* relatively early, to before or during the execution of the *Quattro Coronati* (Schlosser 1898; Fabriczy 1900; Pachaly 1907; Venturi 1908; Vaccarino 1950; Wundram 1969; Goldner 1978; Negri-Arnoldi 1994), tended to see the most classical moment in Nanni's career occurring early with a later "decline" into the "gothic/baroque" period of the *Saint Eligius* and the *Assumption* of the Porta della Mandorla toward 1420. (For the idea of Nanni di Banco's return to a gothic aesthetic following a classical period see Pope-Hennessy 1955 and Wundram 1969.) Other writers envision the sequence of Nanni's statues at Orsanmichele evolving from the "gothic" *Saint Eligius* to the "classical" *Quattro Coronati*, to a mature, classically reductive and congealed solution of the *Saint Philip* (Semper 1875; Schmarsow 1889; Kauffmann 1936; Planiscig 1946; Paatz 1952; Krautheimer 1956; Bellosi 1966; Seymour 1966). Herzner (1975) proposed a chronology of *Eligius-Philip-Coronati*, dating the *Saint Philip* to "possibly between 1413/14 to 1414/15." Beck (1991) argued for the following order, *Philip-Eligius-Coronati*, with the *Saint Philip* dated to 1410/1411. Kalusok (1996) placed the *Saint Philip* after the *Quattro Coronati* and before the *Saint Eligius*, postulating that the whole ensemble (figure and niche) was begun after 1416. These judgments were all made on the basis of stylistic arguments and theories.

In the present study, various parts of the *Quattro Coronati* have been dated around the documented purchase of marbles in 1415 and gauged against the stylistic development of the documented statues of the *Isaiah* and the *Saint Luke*: the *Saint Philip* and *Saint Eligius* ensembles can therefore be compared with the variously dated components of the *Quattro Coronati* ensemble, which range from ca. 1409 to ca. 1416–17. With this information in hand — analysis of the standing figure, the architectural format of the niche, and the relief style of the gable — the *Saint Philip* ensemble must be dated to ca. 1410–12. This conclusion corroborates that arrived at by Wundram (1969) through a different argument. It was already observed by Vaccarino (1950) that the statue of *Saint Philip* represents a comfortable developmental step between the "youngest" and "oldest" of the *Coronati* (second and first from viewer's left respectively), which are here dated to ca. 1409–12 and ca. 1412/13. *Saint Philip*'s pose

and costume seem to have anticipated those of the "oldest" *Coronato*: each wears a belted tunic falling in straight fluted folds with a simple open cloak thrown over the shoulders and held against the body in a gathered bunch with the right hand. In each figure the engaged leg is emphasized by vertical drapery folds and an exposed ankle, while the relaxed leg is swathed in a heavy, but revealing, curvilinear stuff. If, when photographed alone in a frontal position, out of context (Seymour 1966), the contrapposto of the bearded saint seems a bit less secure, more withheld, than that of the *Saint Philip*, it is because the former figure was designed to be inserted in a group, in a predominantly non-frontal view. Nanni di Banco took the rigorous contrapposto pose arrived at in the *Saint Philip* and modified it as he rotated the "oldest" *Coronato* more than 180 degrees, placing him at the outer edge of a group of four: thus the *Coronato* is identifiable as a variation on the theme of the *Saint Philip*. The "youngest" *Coronato*, instead, has a springy, swaying pose, still generically linked to the exaggerated attitude of the *Isaiah*, and contains reflections of Ghiberti's "International Gothic" style. Although the *Saint Philip* displays techniques similar to those used in the *Isaiah* and the "youngest" *Coronato* to suggest potential motion — namely, the exposed ankle of the engaged leg, adherent drapery around the free leg, and the turn of the head in space — the *Philip* has lost the so-called "gothic sway" of its predecessors in favor of a columnar stability and a legible bilateral balance of weights. To the extent that it is possible to chart a linear progression of figure types in the framework of Nanni's career, the *Saint Philip* would be inserted between the "youngest" and "oldest" of the four *Coronati*, serving as an immediate precedent for the latter, and dated to ca. 1410–12, that is, before the completion of the seated *Saint Luke*. Wundram, too (1969), had specified his dating of the statue as "completed during the period of intensification of work on the *Saint Luke*," with a *terminus ante quem* of 1412.

The architecture of the *Saint Philip* niche has been analyzed accurately by Wundram (1960, 1969), who undertook to establish a typological progression of all the niches at Orsanmichele. Wundram correctly grouped the *Saint Philip* niche with the tabernacles of Ghiberti's *Saint John Baptist* and Donatello's *Saint Mark* as a set: all three niches adhere to the format invented by Niccolò Lamberti in the tabernacle of the *Saint Luke* (protector of judges and notaries) made at Orsanmichele in 1403–6 (fig. 110) (Wundram 1960, 1967; for Lamberti's *Saint Luke* see Goldner 1978). Niccolò Lamberti

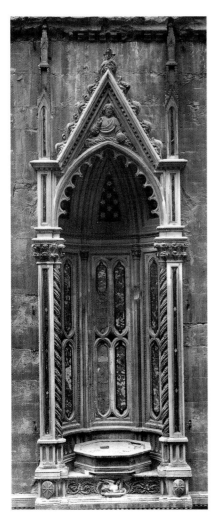

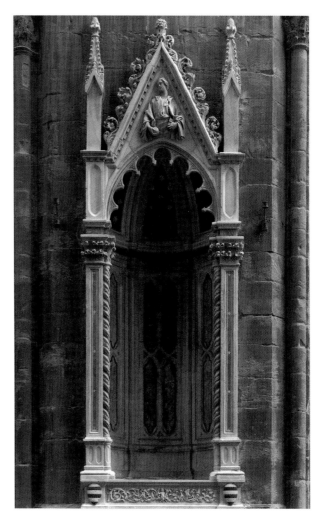

Fig. 110. Niccolò Lamberti, niche for *Saint Luke*,
1403–6. Orsanmichele, Florence

Fig. 111. Nanni di Banco, niche for *Saint Philip* (cat. 1-7, detail),
ca. 1410–12. Marble. Orsanmichele, Florence

had undertaken a basic revision of the trecento niche type (exemplified by the wool guild's tabernacle of 1340, which now houses Ghiberti's *Saint Stephen*): the *Saint Luke* niche introduced spiral-channeled colonnettes inside the outer pilasters, shock-absorbing impost blocks where the framing pilasters meet the socle, a relief "predella" consisting of an emblematic tendril design, and a strongly modeled bust of Christ in the face of the gable, which replaced the static guild *stemmi* of earlier niches (Wundram 1967). Documents show that the *Saint Mark* niche was commissioned in April 1411 according to the design of a specific drawing, and that the Calimala's *Saint John Baptist* niche was underway by 1412. The contract for the *Saint Mark* niche to Perfetto di Giovanni and Albizzo di Piero was recorded by Gualandi (1843) and cited by Wundram (1960a). Regarding the *Saint John Baptist* niche, Carlo Strozzi's excerpts from the books of the Arte della Calimala show that as early as 1412 Frate

Bernardo da Stefano of Santa Maria Novella was paid for glass mosaic work on the tabernacle; in 1414 and 1416 Giuliano Arrigo (called "Pesello") was active in this connection, and Albizzo di Piero received a payment in 1415 (Krautheimer 1956; Wundram 1960a; Even 1984). The curvilinear Venetian-style outlines and florid decoration of the pediment zones of the Linaiuoli and Calimala niches probably reflect the signature style of Albizzo di Piero, the stonemason employed in both projects (Krautheimer 1956; Wundram 1960a). The outlined square panels of the walls and ceiling vaults of the Linaiuoli niche were required of the patron, in a contract stating that "dentro debbe stare chome sta el tabernacholo si sancto stefano dell'arte della Lana," a deliberate repetition of a trecento feature (Wundram 1960a). Of the typologically coherent group of three — the *Saint John Baptist*, *Saint Mark*, and *Saint Philip* — the *Saint Philip* niche (fig. 111) is closest to that of Niccolò Lam-

berti's *Saint Luke*. Excepting some minor details, Nanni di Banco's niche is identical to that of Lamberti, indicating that Nanni was the first to follow the new quattrocento tabernacle design. Nor is it surprising that Nanni di Banco and his patrons, the shoemakers, would choose to duplicate the niche made for the prestigious guild of judges and notaries by the most fashionable stone sculptor in Florence. Indeed, Niccolò was probably Nanni di Banco's most established rival: they had worked together on the archivolt reveals of the Porta della Mandorla and the two console *Atlanti* nearby, and had begun the *Evangelists* for the cathedral facade, all during this same period. It is natural that a relationship of shared ideas would extend to the tabernacles at Orsanmichele. The two niches, nearly identical in proportions and decoration, even share a common pattern for the interior walls, which are composed of outlined panels of red marble set into beveled lozenges. This closeness in detail may suggest that Niccolò Lamberti and Nanni di Banco employed a common assistant: Antonio di Banco? Piero di Niccolò Lamberti? Albizzo di Piero? Vittorio di Giovanni? Nanni di Banco's modifications in the *Saint Philip* niche were minor: he widened the foliated predella, enlarged the relief area of the gable (which enabled him to monumentalize the bust of Christ), reduced the number of arch lobes from thirteen to nine, made the ribs of the vaulted ceiling a bit narrower with the mosaic surface correspondingly greater, inserted his traditional stripe of black molding at the level of the statue's eyes, and mitigated the niche's verticality by creating shorter, more massive finials and larger, rounder foliage around the cornice of the gable. All these innovations suggest that Nanni was directly "revising" the *Saint Luke* niche devised by Niccolò. A reverse relationship, with Lamberti imitating Nanni's architecture, would be highly unlikely: the figure styles of Lamberti's *Saint Luke* (Bargello) and Nanni's *Saint Philip* are far too different in concept to permit a chronological comparison; but within the framework of Nanni's own artistic growth, it seems obvious that the *Saint Philip* could not have been produced before the *Isaiah* of 1408. The *Saint Philip* niche, then, can be placed in the general Orsanmichele chronology between Niccolò Lamberti's niche of 1403–6 and the niches executed by Albizzo di Piero beginning 1411 and 1412: a logical dating of ca. 1410–12 therefore arises once more, for architecture and figure alike.

One other important element contributes to a relative dating of the *Saint Philip*: namely, the relief image of Christ in the gable (fig. 53). Niccolò Lamberti's deity (Christ the Redeemer? God the Father?) has a purely frontal orientation and staring countenance. The figure is nested at the waist in choppy, linear striations of clouds; drapery folds are produced with simplistic, stiffly excavated creases, reminiscent of some of the angel busts in the lower right reveal sections of the Porta della Mandorla. In the pediment of the *Saint Philip* tabernacle Nanni di Banco has monumentalized the torso and arms of Christ in scale and actual projecting volume, and brought the drapery into being as an abundant plastic presence. He has turned the head beyond a three-quarter view, tilted it slightly down, and imbued Christ's face with a naturalistic pathos, which would be developed in subsequent works, notably the *Saint Luke Evangelist* of 1412/13. The blessing Christ of the *Quattro Coronati* niche is even more confident: larger in scale and higher in relief, with a dynamic counterpose of the arms playing off the lobes of the frame. Bolder and more animated than that of the *Saint Philip* niche, the *Quattro Coronati* Christ also demonstrates a more able carving of the hands (always a difficulty for Nanni di Banco) and greater subtlety in the modeling of the head, with a more mobile expression of the eyes. Analysis of the reliefs in the upper zones of the Orsanmichele tabernacles thus indicates a chronology in which the *Saint Philip* takes an early place. The works may be dated in the following progression: Niccolò Lamberti's *Saint Luke* relief of 1403–6; Nanni's *Saint Philip* relief, ca. 1410–12; the *Quattro Coronati* relief, ca. 1415–17; and finally the *Saint Eligius* niche, which is dated in this study to ca. 1417–21.

The pictorial focus of the *Saint Philip* tabernacle is the statue's own vertical center of balance. Nanni placed the supporting pedestal (inscribed "S. PHILIPPUS. AP") in a position to the viewer's left of the central axis of the architecture, so that the two-dimensional contour of the statue and the frontal view of the niche interact in equilibrium. All the internal and external coordinates are measured by the relationship of the putto at the center of the acanthus frieze in the socle to the twelve semi-gothic letters inscribed on the face of the asymmetrically placed plinth. The off-center position of the plinth centers the vertical axis of Philip's body within the tabernacle. These diagrammatic elements are orchestrated to emphasize the torsion with which the saint's attention is turned away from his engaged leg toward the northeast. Such an orientation is emphasized in the gable by the relief bust of Christ, whose head is rendered

between three-quarter and profile view; the putto strad-dling the socle frieze mimics the attitude of Christ and *Saint Philip* as he looks over his shoulder to the northeast. (For the pictorial nature of niche and figure in quattro-cento sculpture, see Poeschke 1980 and 1989; Rosenauer 1975; and Maginnis and Ladis 1995.) The asymmetrical position of the plinth has been mentioned by Vaccarino (1950) and Kalusok (1996). Drawings and prints from before the Second World War, such as the image by Francesco Pieraccini, show that the position of the plinth as it stands now is original. Wundram (1969) considered the relation of the statue to the surrounding tabernacle in two-dimensional space a "defect" that was to be "corrected" in Nanni's later niche statues. Nanni di Banco, and not Albizzo di Piero, as has been proposed by Wundram, must have planned and executed all of the sculptured parts, including the socle frieze (cf. Wundram 1960a, 1969). Nanni di Banco no doubt had stonemasons to help him with the construction of the tabernacle, but the extraordinary coor-dination of the sculptural decoration of the niche with the statue in contrapposto indicates that the architect of the niche was Nanni himself.

Saint Philip the Apostle has at times been incorrectly identified as the patron saint of the Florentine guild of tan-ners, or *conciapelli* (Kaftal 1952; Sframeli 1989). Instead, Saint Philip was protector saint of the *calzolai* (shoemakers), including all artisans who worked with prepared leather, such as makers of leather heraldry, decorations, and acces-sories including shoes. These artisans were designated in the fourteenth and fifteenth centuries as "calzolai" and "pianellai." They belonged to the guild of Calzolai, which had its meeting hall behind the Loggia dei Lanzi. The shoe-makers were one of the five middle guilds, taking ninth place in the honorific order of Florentine guilds (Zervas 1996). The standards of the Calzolai, as described in tre-cento commentaries, consisted of alternating black and white stripes (Davidsohn 1965), seen here in the *stemmi* of the *Saint Philip* niche. The *Saint Philip* may be considered the most academic of Nanni di Banco's works insofar as the sculptor has chosen to minimize iconographic or descrip-tive "local" surface details in favor of an elucidation of the figure *per se*. Tuscan painters had traditionally portrayed the Apostle Philip as a bearded saint, whose attributes — a stone, a slender cross for his martyrdom, a book, or a scroll — were prominently displayed (Kaftal 1952; Casanova 1964). A painting of *Saint Philip Apostle* (school of Jacopo di

Cione) is located inside Orsanmichele on the east wall. This fresco portrays Saint Philip with a beard, carrying a slender cross in his right hand and the stone of his martyrdom (rather than a "small loaf of bread" as was stated by Artusi and Gabbrielli 1982) in his left (Zervas 1996). In Nanni di Banco's version, Christ the Redeemer in the gable relief holds what appears to be the stone of Saint Philip's martyr-dom. Nanni's approach to this iconography is typically reductive (in the manner of the *Isaiah*, *Man of Sorrows*, and *Quattro Coronati*). The apostle is young and beardless, reviv-ing, be it deliberately or not, an image of the Apostle Philip known through early Christian or Byzantine sculpture (Casanova 1964). Such an image existed in the Florentine cathedral in a small hammered-silver image of *Saint Philip* with a Greek inscription, probably from the twelfth cen-tury, attached to the actual bone in the accreted reliquary that housed the arm of the saint (Becherucci and Brunetti 1969, 2: cat. no. 11).

Nanni di Banco's *Saint Philip* has only one accessory, a book, which is virtually hidden under the loosely draped cloak, serving as a physical buttress for the arm to rest at his jutting engaged hip. Schmarsow (1889) stated, "He keeps the book hidden under his wrist as if ashamed to carry it around town." No specific allowance seems to have been made for the *Saint Philip* to carry a cross, his most expected attribute, and no such object appears to have been placed in his right hand. Decoration on the predella consists of a tra-ditional acanthus frieze inhabited by a single nude puttino. Were it not for the inscription on the plinth and the *stemmi* of the Calzolai, the identity of this statue might have remained in question.

The head of *Saint Philip* (fig. 112) is directly inspired by the antique (chapter 3). Nanni di Banco's *Saint Philip* at Orsanmichele seems to have inspired the *Reliquary of the Arm of Saint Philip* of 1425 (fig. 57), attributed to Antonio di Piero del Vagliente on a model provided by Michelozzo, with the togate *Saint Philip* possibly crafted by Michelozzo himself (Brunetti 1977; Natali 1996).

Nanni's *Saint Philip* should be considered with Donatello's *Saint Mark* (fig. 28). A committee of Linaiuoli chose Donatello to carve a statue of their protector, Saint Mark, on 3 April 1411, with the request that it be completed and installed by 1 November 1412 (Gualandi 1843). Two full years later the *Saint Mark* was not finished, and in April 1413 the impatient guildsmen pressured Donatello (as well as the stonemasons contracted to build the tabernacle, Albizzo di

Fig. 112. Nanni di Banco, *Saint Philip* (cat. 1-7, detail after restoration of 1989), ca. 1410–12. Marble with traces of gold. Orsanmichele, Florence

Piero and Perfetto di Giovanni) to complete the project. A small group was appointed to "fare finire la figura et tabernacholo di sancto Marcho che debbe stare a Orto Sancto Michele di quanto vi mancha" (ASF, Arte dei Rigattieri, Linaiuoli, e Sarti, cod. 20, c. 97, published by Wundram, 1960a). The phrase "di quanto vi mancha" had traditionally led scholars to believe that the statue was well underway by that point and only needed to be finished with details, gilded, and installed (Janson 1957). The documentary silence following this notice corroborated the idea that the *Saint Mark* must have been completed at the patrons' urging. As no record of final payment is preserved, scholars estimated that work on the project ended in the months following this last dictum. A date of 1411–13 was established for the *Saint Mark*, which then — on the basis of documentary as well as stylistic evidence — assumed a place before the *Saint John Evangelist* in Donatello's chronology (Janson 1957). A dissenting view was presented by Wundram (1960a, 1969), who pointed to a five-year lapse in the (otherwise intact) series of guild records, where a lacuna extends from April 1415 to early 1420. Wundram assumed that since payment for the *Saint Mark* and its tabernacle are not mentioned in the earlier documents, they were completed during this "missing" period, with a *terminus post quem* of April 1415. He dated the statue to 1415; and in this way he ascertained that

Nanni di Banco's *Saint Philip* (1410–12) was its model, thereby stripping the *Saint Mark* of its primacy: according to Wundram, the *Saint Mark* could no longer be considered what Janson (1957) had called "the earliest unequivocal instance of a Renaissance figure." Wundram (1969) argued that Nanni di Banco was the unique discoverer of this counterposed statue type, which was then further developed by Donatello, and called the *Saint Mark* a "direct interpretation" of Nanni's *Saint Philip* (cf. Herzner 1973b).

Although a dating of 1411–13 still seems more likely for the *Saint Mark* than one of 1415 (to 1420), neither is it unlikely that the *Saint Philip* (ca. 1410–12) was completed first. Supposing Nanni di Banco's figure was finished in 1412, Donatello's might well have been underway, given the commission date of 1411. Purely visual evidence suggests that the statues were worked out simultaneously: they even enjoy a visual "mirror image" relationship analogous to that of the *Isaiah* and *David* of 1408–9. Neither statue is wholly derivative of the other, and comparisons and contrasts tend to reveal the different ways in which the two sculptors thought, within the context of their mutual influence. A linear chronology, in which one statue "followed" the other probably does not exist to be discovered, as there is an active margin between the state of conception and that of completion for every monumental statue of this kind. Assuming that the *Saint Philip* was completed somewhat earlier than the *Saint Mark*, the following observations can be made. Nanni di Banco's style of carving is severe, and his approach to contrapposto is more diagrammatic or expository than that of Donatello, which is emotionally expressive. The classically derived head and exposed neck of the *Saint Philip* are of a different purpose and genre than the emotionally agitated head and gothic-style beard of the powerful *Saint Mark*. In the *Saint Mark*, as in Donatello's *Saint John Evangelist*, every structural element takes on an expressive life of its own through texture and torsion: contrast between the columnar folds over the engaged leg versus paper-thin "wet" drapery over the free leg is extreme; the clinging tissue of drapery plastered to the saint's chest reveals forces of corporeality in a mode never even attempted by Nanni di Banco. Donatello dramatized the counterbalance of *Saint Mark*'s hips and slanted shoulders by applying diagonal sashes of gratuitously layered cloth. Finally, the entire body of the *Saint Mark* is rotated in space on an invisible central pivot, suggesting a spiral of energy throughout the statue's being, whereby the right shoulder

and engaged leg are pulled back significantly into diagonal space behind the free members. The *Saint Philip* is far more conservative with respect to contrapposto; and only the upper part of the body is turned in space. Through the apparent rotation of the figure in space Donatello has persuasively expressed a figure in the round to be seen in the setting of a niche. As was the case with the Evangelists, however, the *Saint Mark* is actually more relief-like and graphic than the *Saint Philip*, which is physically more stable and complete, if less visually persuasive.

DOCUMENTATION

Doc. 179.

SOURCES

ca. 1516–30, Antonio Billi: [Nanni di Banco] "fecie la fiura do s.to Filippo di Marmo nel pilastro di Orsanmichele."

ca. 1537–42, Anonimo Gaddiano: "Et infra l'altre opere sua si vede la fiura di san Filippo di marmo nel pilastro d'Orsanmichele."

1550, Vasari: "Veggonsi de le opere sue in Fiorenza, il San Filippo di marmo in un pilastro a San Michele in orto, allogato dall'arte de calzolai a Donato; et per discordia fra loro del prezzo riallogato di poi a Nanni, per far dispetto a Donato: promettendo Nanni pigliar tutto quel pagamento, che detti consoli gli darebbono. Finì la statua, e condottola al suo luogo domandava il premio delle fatiche sue, prezzo maggiore, che Donato non aveva chiesto. Rimisero la stima della figura in Donato per compromesso; credendosi al fermo i consoli, che per invidia, non l'avendo egli fatta, la stimasse meno dell'opera sua. Ma egli molto più la stimò, che Nanni non chiese; et che i Consoli non credettero pagarli. Per il che gran romore nacque fra i consoli; i quali gridando dicevano a Donato; tu adunque la facevi per minor prezzo; et ora giudichi questa opera molto piu della tua e che egli non chiede? et pur sai, ch'ella è manco buona delle fatiche, che in essa aresti fatto tu. Ripose Donato ridendo; questo povero huomo non è tale nell'arte, quale sono io: et dura nel lavorare assai piu fatica di me: sete forzati volendo sodisfarlo, come huomini giusti che mi parete; pagarlo del tempo, che v'ha speso. Et fu per Donato il lodo della figura finito con danno loro."

ca. 1550–63, G. B. Gelli: "Fecie ancora costui [Nanni di Banco] la figura di san Filippo, la quale è ne' pilastri d'Orsanmichele."

1568, Vasari: same as 1550, with the addition of the following: "Questa opera posa assai bene, e ha buona grazia e vivezza nella testa; i panni non sono crudi, e non sono se non bene in dosso alla figura accomodati."

BIBLIOGRAPHY

Baldinucci 1681–1728, 1:424–25; Richa 1754–62, 1:22; Gualandi 1843, 107; Cavallucci 1873, 58; Semper 1875, 81; Schmarsow 1889, 3–4, Reymond 1897–98, 2:22; Fabriczy 1900, 246; Pachaly 1907, 41–42; Venturi 1908, 6:206; Kauffmann 1936, 198–99; Planiscig 1946, 37–38, 54; Bianchi-Bandinelli 1946, 2–3; Vaccarino 1950, 34–36; Grassi 1951, 30–34; Paatz 1952–56, 4:438; Kaftal 1952, cols. 841–46, cat. no. 248; Pope-Hennessy 1955, 44–45; Krautheimer 1956, 84–90, 260–61; Janson 1957, 29–32; Wundram 1960a, 161–76; Casanova 1964, cols. 706–19; Davidsohn 1965, 6:206–18; Bellosi 1966, 5; Seymour 1966, 64; Wundram 1967, 194–96; Wundram 1969, 109–17, 132–35, 143–49; Herzner 1973b, 95; Herzner 1975, 94; Rosenauer 1975, 15–20; Brunetti 1977, 180–81; Carmigniani 1978, 181–82; Goldner 1978, 32–35, 65–66; Poeschke 1980, 21 and passim; Artusi and Gabbrielli 1982, 56; Even 1984, 19–20 and Appendix A-IX; Anonimo Fiorentino 1986, 73, 99, 141, 212; Bergstein 1987a, 285–89; Bergstein 1988, 910–13; Poeschke 1989, 149–50; Sframeli 1989, cat. no. 53; Zervas 1989, 101–7, 172–76; Beck 1991, 1:79–80; Bergstein 1992, 10–16; Capecchi 1992, 24–35; Zervas 1993, 39–51; Negri-Arnoldi 1994, 17; Maginnis and Ladis 1995, 41–54; Kalusok 1996, 151–53, 158–59; Natali 1996, 18–21; Zervas 1996, 1:482–83, 525, 619.

1.8 *Arms of the Brunelleschi Family*

ca. 1400–1410

Pietra serena, 20 ½ x 16 ½ in. (52 x 42 cm)

Lapidarium of San Marco, Florence

The relief, which comes from the houses of the Brunelleschi family (piazzetta Brunelleschi, interior of the Ghetto), is in a good state of conservation. A rectangular relief slab encloses the arms of the Brunelleschi family: a pear-shaped escutcheon, or scudo, with carved fascia. The scudo is bordered in the frame by two clusters of leaves and stems giving to flowers above. A lower margin of the frame accommodates the two lines of inscription in gothic letters: "S[EPOLCRO] DI PIERO DI SIMONE / BRUNELLESCHI".

ATTRIBUTION AND DATING

It has been observed correctly by Chiara Cecchi (in Sframeli 1989), who dates the relief to the end of the fourteenth or beginning of the fifteenth century, that the carving of this foliage is analogous in its type to decorative passages by Nanni di Banco such as the socle zone of the *Saint Philip* tabernacle at Orsanmichele (cat. 1-7). This small, simple relief can be associated with Nanni's oeuvre not only because of typological similarity, but also on account of the method of carving, particularly in the strongly organic asymmetry in the unfolding of the two clusters of leaves and the ductile strength with which the foliation embraces the *scudo*. This slab is attributable to Nanni di Banco and may be dated to the years ca. 1400–1410.

BIBLIOGRAPHY

Carocci 1906, 116; Sframeli 1989, cat. no. 10.

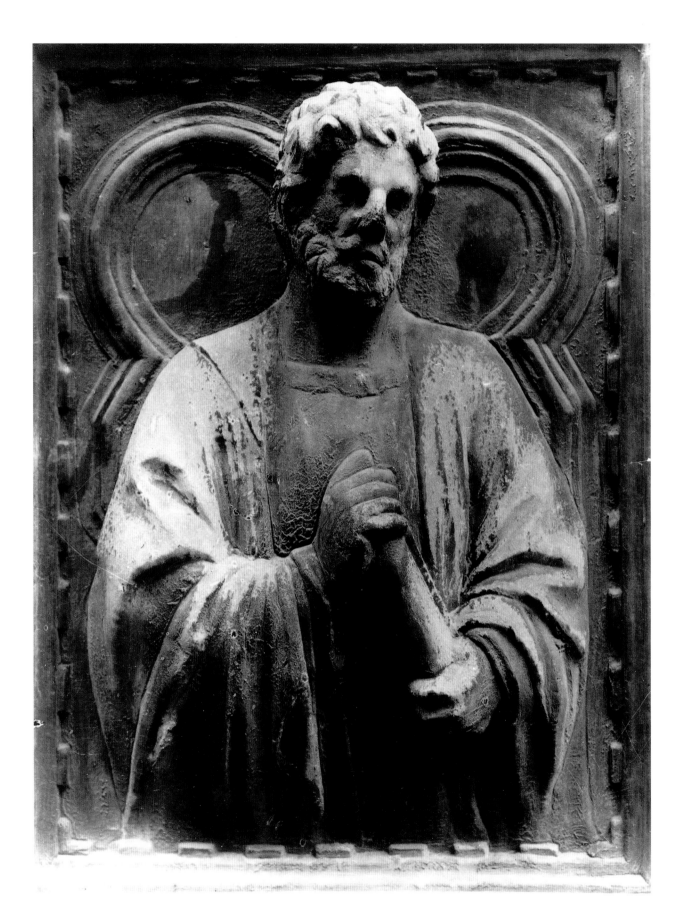

1.9 *Prophet with Scroll*

ca. 1410
Marble, 17 ⅜ x 15 in. (44 x 38 cm)
Orsanmichele, Florence

Situated on the north exterior wall, inserted into the arch-infill imme-diately to the right of the "Quattro Coronati" tabernacle, a bearded prophet is carved in a recangular relief panel. Much of the panel's sur-face detail has been lost through corrosion and abrasion, especially in the face and hair. Presented in three-quarter length, the figure, grasping a scroll with both hands, gazes off to the right. A beveled, dentilated frame encloses the composition, and the figure's head transcends a multibeveled backdrop lozenge of two large lobes. The legs of the lozenge disappear behind the length of the prophet's cloak.

ATTRIBUTION AND DATING

Brunetti (1930) was the first to attribute this small relief to Nanni di Banco, likening it to the *Saint Luke* (cat. 1-5) and the *Man of Sorrows* (cat. 1-2). The attribution was accepted by Valentiner (1935) and Middeldorf (1936). Planiscig (1946) dated the relief to the early quattrocento but consid-ered the attribution to Nanni di Banco risky.

The relatively dynamic relationship of the three-quar-ter-length figure to the lobed frame behind him and the execution of the hands holding the scroll recall the style of the gable compositions of Nanni's Orsanmichele taberna-cles. The plasticity of the *Prophet*'s hair and beard, the ele-gant symmetry of his situation within a series of beveled, concentric frames, and the rather summary quality of the

hands indicate that this relief is attributable to Nanni di Banco in the first or second decade of the fifteenth century.

The attribution to Nanni di Banco is based firmly on visual evidence. But the panel was not made for its current location, and its original context remains obscure. The provenance of this work is especially problematic because its setting into the arch-infill was not completed until 1429 (Zervas 1996). This complicates, but does not negate, the ascription to Nanni di Banco, who died in 1421. A further complication is that the outer frame and format of the *Prophet* are similar to those of the fourteenth-century *Apostles* and *Virtues* that were embedded into the arch-infills of the exterior walls of Orsanmichele during the fifteenth century. Identified as a prophet by his beard and scroll, the precise identity of the figure represented in this relief is not known.

BIBLIOGRAPHY

Brunetti 1930, 229–30; Valentiner 1935, 151; Middeldorf 1936, 579 n. 13; Planiscig 1946, 39; Zervas 1996, 1:489.

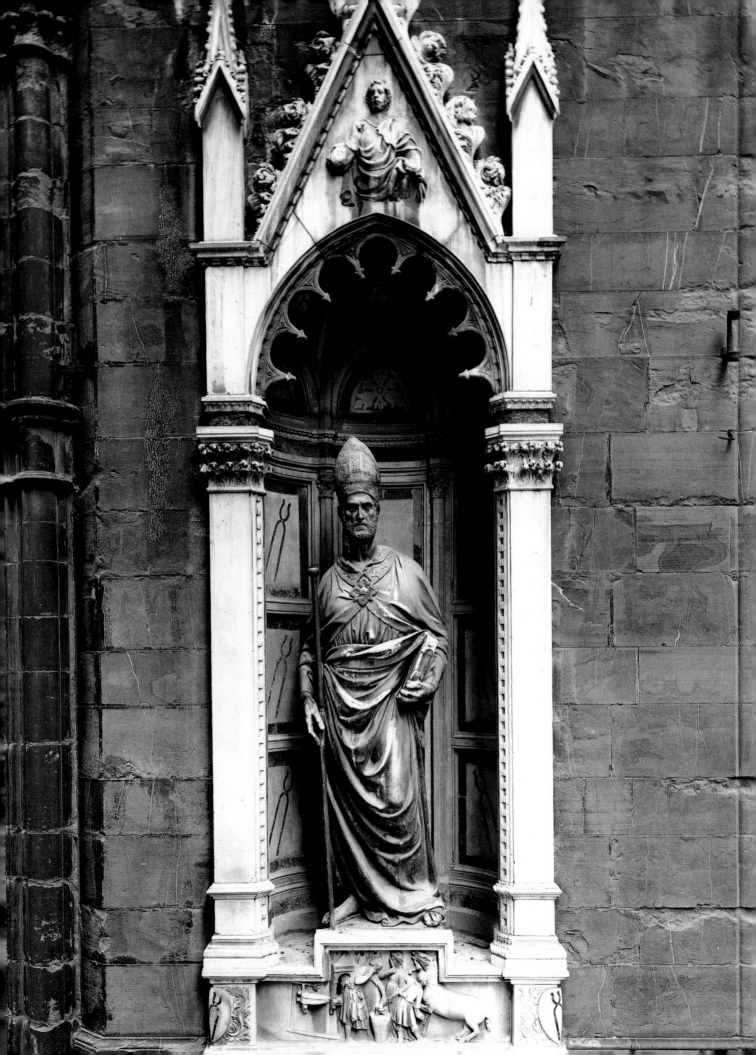

1.10 *Saint Eligius*

ca. 1417–21, installed ca. 1422
Apuan marble, height of statue 89¾ in. (228 cm)
Orsanmichele, Florence

The figure has been moved indoors to the museum of Orsanmichele. It is in fair condition with damage to the surface of the marble, especially the nose; the statue's right hand, including part of the pastoral staff, is substituted with a sculptured passage made in the nineteenth century; also the upper part of the book was remade at this time. The thumb and middle finger of the left hand were damaged and the miter and toes have been corroded with rainwater. The pastoral staff (originally in metal and presumably gilded) has disappeared, with at least two replacements stolen at the beginning of the twentieth century (in 1906 and 1911). Recent (1989) cleaning and removal of residues of the late bronzatura applied to the entire marble surface have revealed traces of decoration in gold leaf and lapis lazuli, and traces of color on the eyebrows, eyes, and book. Touches of gold leaf remain on the saint's hair and beard. "Azzurro" (lapis lazuli) was used to decorate the borders of the bishop's garments; and there are traces of gold patterns on the cuffs, fermaglio, miter, and vestments of the statue, those on the cuffs and vestments suggesting brocade decoration. These traces of color were visible to Vaccarino (1950) and are now again visible to the unaided eye.

The niche is located on the west side of Orsanmichele between Ghiberti's "Saint Matthew" and "Saint Stephen," facing the via dell'arte della Lana. Composed of white and "black" (verde di Prato) stones, its interior panels bear images of tenaglie, the forceps that were a sign of the guild of "fabbri," or blacksmiths. Guild "stemmi" wrapping around the bases of the socle contain escutcheons with inlaid "black" tenaglie and acanthus leaves articulated with points of very deep drill work, as if to accommodate tiny studs of gold or glass. A raised socle relief that forms an elevated step for the statue narrates a workshop scene of Saint Eligius working as a blacksmith. The gable relief shows a Blessing Christ. Abundant traces of blue paint surround white inlaid rosettes in the ceiling vaults. A cast of the original statue presently stands in the niche.

ATTRIBUTION AND DATING

Saint Eligius, bishop of Noyon, was protector saint of the Florentine blacksmiths' guild (Fabbri), one of the five middle guilds and tenth in the honorific guild hierarchy (Zervas 1996). Trecento guild statutes of the Fabbri record: "beatissimi Loe sancti Loysii patroni et defensoris totius fabrorum civitas comitatus et districtus Florentiae" and "beatissimus Loe patronus et defensor artis fabrorum" (*Statuti* 1957). By 1344 the Fabbri had a hospital dedicated to Saint Eligius, to which guild members were expected to contribute funds: "(. . .) et camerarius bonorum hospitalis sancti Loe et capitanei dicti hospitalis." The shoeing of horses, mules, asses, and oxen was only a part of the work of a *fabbro*, whose primary work consisted of making iron objects, including all tools used by stonemasons and architects, chains, knives, saws, razors, whetstones ("ruotas pro arrotondo ferros

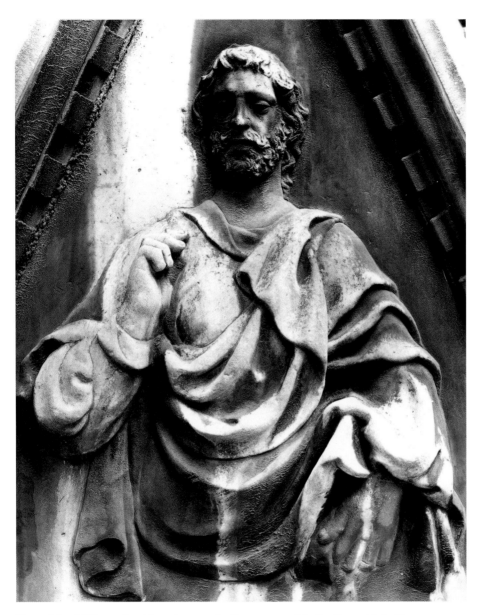

Fig. 113. Nanni di Banco, *Saint Eligius* (cat. 1-10, detail), ca. 1417–21. Marble. Orsanmichele, Florence

incisoria"), axes, forbices, and so forth (*Statuti* 1957).

Unlike the *Saint Philip*, and especially unlike the *Quattro Santi Coronati*, which have engaged the public throughout history with an immediate visual appeal, the *Saint Eligius* has been traditionally passed over. The Gaddiano and Vasari's attribution to Nanni was maintained in the seventeenth and eighteenth centuries by Bocchi (1677) and Richa (1754–62), and more tentatively by Baldinucci (1681–1728). After Burckhardt's *Cicerone* (1855) all scholarship concurred upon Nanni's authorship of the ensemble. Modern and contemporary writers have continued this undoubtedly correct, though undocumented, attribution (Carmignani 1978). Only the dating of the *Saint Eligius* ensemble has remained

in question, and this problem is naturally linked with the chronological placement of the work in relation to the *Quattro Coronati* and the *Saint Philip*.

A strong, centrally concentrated, ascendant verticality dominates the *Saint Eligius* ensemble when the statue is in the niche, endowing the composition with a slightly archaic quality. This feeling is heightened by certain details of the figure itself: the saint's decorated miter leads into the similarly peaked, similarly encrusted vaulting of the ceiling, and his prescribed clerical garment, which appears to be an unresolved hybrid — a bishop's cloak at the top and a classical toga at the bottom, worn with sandals — makes for a peculiarly high-waisted statue with apparently sloping

shoulders. A somewhat severe facial set, physically sparer of flesh than any of Nanni's other statues, contributes to this gothic tenor. Critics who have proposed the *Saint Eligius* to be Nanni's earliest work at Orsanmichele (Schmarsow 1887; Kauffmann 1936; Planiscig 1946; Brunetti 1947; Krautheimer 1956; Bellosi 1966; Herzner 1973; Carmignani 1978; Macchioni 1979) describe these traits as gothic reminiscences — an old-fashioned aesthetic presumably left over from Nanni's apprenticeship in the trecento. Those who would date it last in the Orsanmichele series (Reymond 1892; Wulff 1909; Antal 1948; Vaccarino 1950; Wundram 1960, 1969; Janson 1972; Parronchi 1980) adhere to the theory that Nanni, in a late phase of his career that culminated in the *Assumption* of the Porta della Mandorla, experienced a newfound fascination with the expressive potential of gothic forms. There is indeed a compositional extremity — an almost strident vertical direction — about the *Saint Eligius* ensemble that many scholars have sought to explain by placing it either significantly early or late in the artist's oeuvre. Seymour (1966) located it in a "hard, stoic interlude along with the *Quattro Coronati.*" Beck (1991) placed it second (*Philip-Eligius-Quattro Coronati*) of Nanni's works at Orsanmichele with a dating of 1412/1413, as did Negri-Arnoldi (1994), who dated it 1415.

A stylistic analysis of Nanni di Banco's gable reliefs (cat. 1-7) suggested that the *Saint Eligius* was Nanni's last work at Orsanmichele. The relief of Christ Blessing possesses an atmospheric depth achieved by *schiacciato* carving and loose modeling: for the first time in Nanni di Banco's relief oeuvre the spatially distant aspects of the image sink back into the surface of the picture plane (fig. 113). A graphic surface texture, seen in the impressionistic effects of Christ's hair, and especially in the linearity with which his left hand is drawn — this is particularly effective as it is juxtaposed with the almost fully three-dimensional projection of his blessing right hand — suggests a melting of the neutral ground, and denies the unity and closure that had characterized earlier relief works. The effect created is comparable only to certain passages of the *Assumption of the Virgin* (cat. 1-12). This experimentation with *schiacciato* carving was most likely provoked by Donatello's *God the Father* and *Saint George Slaying the Dragon* (fig. 114) from the Corazzai tabernacle of around 1417. Nanni's new style, in which high and low relief are contrasted and graduated to suggest atmospheric color, would be developed in the *Agnus Dei* of 1419 (cat. 1-11) and in the angels surrounding the ascending Virgin in the tympa-

Fig. 114. Donatello, *Saint George Slaying the Dragon* (socle relief of *Saint George* niche), ca. 1417, Marble, 15 ½ x 47 ¼ in. (39 x 120 cm). Orsanmichele, Florence

num of the Porta della Mandorla (cat. 1-12). Kalusok (following Bergstein 1987b) dated the statue and niche to after 1417, last in the series at Orsanmichele, because of the relief style of Christ Blessing in the gable and the "advanced" situation of the statue in its niche (1996).

Several aspects of the *Saint Eligius* ensemble indicate that it was a "nonfinito," assembled and installed after Nanni's death. It was probably put together and installed around 1421–22 from parts that had been executed by Nanni (possibly with the help of assistants) ca. 1417–21. Zervas, who accepted this dating (in 1991 and 1996), brought forth new documentary evidence that supports this supposition, showing that the western portals of Orsanmichele were conceived in 1410 and took ten years to finish. Therefore, it is extremely unlikely that the *Saint Eligius* (or any statue, for that matter) would have been installed on the west side of the church before about 1420, the date of Ghiberti's *Saint Matthew*. In the *Saint Eligius* the entire socle zone, the statue, and the gable relief were without a doubt designed and made by Nanni di Banco. But the arrangement of parts in this tabernacle is not entirely harmonious: it may be significant that when the statue stands outside its niche, it appears to have a more robust and volumetric bearing. The situation of the statue on an elevated step (actually the center of the socle), which seems to have expanded upward as a result of the pure force of the concentrated pictorial dynamics of the relief, is an original solution to the problem of creating a base for a tabernacle statue. In this case the base functions simultaneously and organically as the frame of a picture — a conception very much in step with Nanni's sensibility toward design. But the figure still appears to be overwhelmed by the depth, the width, and especially the sheer height of his niche (cf. Kalusok 1996). To appreciate the way in which the *Saint Eligius* composition fails, one need only contrast it with Ghiberti's contempo-

rary *Saint Matthew* (fig. 96): in Ghiberti's composition the decoration of a deliberately shallow niche allows the statue an expansive, majestic bearing, where applied Corinthian pilasters flourish into capitals at the figure's shoulders, and his head rises well above the horizontal molding to be set off against the radiating flutes and arrises of a scallop-shell design (Krautheimer 1956). The head of *Saint Eligius*, on the other hand, does not even reach the stripe of green-black molding at the springing of the ceiling vaults, although the steep shape of his miter (echoing the peaked vaults) makes it look as though the figure would aspire to greater height. A similar figure-to-architecture proportion was used in the *Quattro Coronati* (cat. 1-6), where it was successful because of the relatively great breadth of the tabernacle, which was necessary to accommodate four statues that more than fill the horizontal space. There, the ratio of the figures to the niche (with all heads below the springing of the ceiling vaults) actually increased the pictorial presence of the statues by creating a "dioramic" environment. The ample *Saint Philip* also fills his niche with a proportionately great horizontal area, and the shifting of the statue's base on the niche floor (significantly to the viewer's left) creates a strong side-to-side interest that mitigates the vertical components of the architecture. *Saint Philip*'s presence is in no way confined to the central bay of a tripartite niche: his contrapposto stance interacts with every other figurative and decorative element of the ensemble — socle, gable, and base. Had Nanni di Banco himself supervised the installation of the *Saint Eligius* ensemble, he might somehow have adjusted the relative height of the figure, possibly by inserting a molded slab as a base between the top of the socle frame and the statue's feet. As it is now, the thin octagonal base is set somewhat uncomfortably behind the top frame of the socle relief. (The challenge of portraying a bishop saint in a tabernacle niche at Orsanmichele was effectively solved by Donatello in his *Saint Louis of Toulouse* for the Parte Guelfa, ca. 1425.)

The vertical centrality of Nanni's *Saint Eligius* composition recalls Niccolò Lamberti's *Saint James* (cat. 11-8) on the north side of Orsanmichele, and in fact the two works were probably designed and made during the same years. One might even imagine that in creating the *Saint Eligius* Nanni was receptive to a last gasp of influence from his former mentor, Niccolò. In fact, the tabernacle of the furriers' guild, made by Niccolò with his son Piero, is a tremendously successful work of art. The Lamberti's stiff, hieratic ensemble, with its prickly, choppy decoration, the uncompromising frontality of the statue, and even the charmingly innocent profile image of the saint, who is crammed into the gable praying in heaven for the guildsmen, constitutes a whole design that is at once tenser and more satisfying than that of Nanni's *Saint Eligius*. But even if Nanni were deliberately working in a gothic mode, it hardly seems likely that he would be unable to compete with Niccolò's coeval ensemble in terms of pictorial presence.

In addition to what has been mentioned above, several other architectural or mechanical aspects of the *Saint Eligius* tabernacle indicate that it may have been assembled hastily after Nanni's death. The relative poverty of decoration on the front of the niche is disturbing: whereas the *Saint Philip* niche, for example, has richly embellished front pilaster faces, which are beveled and inlaid with colored marbles, lower imposts articulated with small lozenges, and the upper pilasters (at the springing of the arch and gable) set with larger single lozenges, these areas of the *Saint Eligius* niche are left blank; and instead of interior twisted colonnettes, the pilasters reveal inward to bands of monotonous dentilation (fig. 115). Such dissimilarities might be explained by specific financial limitations dealt the sculptor by his corporate patrons. The blacksmiths were neither a wealthy nor a sophisticated group; in fact, their rank was among the lowest of the tradesmen's guilds, and, unlike the stonemasons, the blacksmiths themselves rarely made what we would call works of art. (Goldsmiths, who did make works of art, rather than tools, from metal belonged to the major guild of the Por Santa Maria.) But the bareness of the pilasters is not even visually harmonious within the design, or episcopal decorum, of the rest of the ensemble: indeed, remaining traces of gold leaf all over the statue and of rich blue pigment in the interior incrustation of the ceiling suggest that financial considerations were not inhibiting. Another disturbing feature here is that the expressive Blessing Christ in the upper zone is set into a gable that appears too large for the image, and the relief is framed by steep raking cornices articulated by rows of dentils without the usual refinement of a delicate lower bevel like those on the gables of the *Saint Philip* and *Quattro Coronati* niches. Compared with Donatello's God the Father Blessing in the gable of the *Saint George* niche, from which Nanni presumably learned about *schiacciato* carving, Nanni's relief "swims" even too freely in the designated triangular picture plane, not satisfactorily bounded by the limits of a frame. Wundram

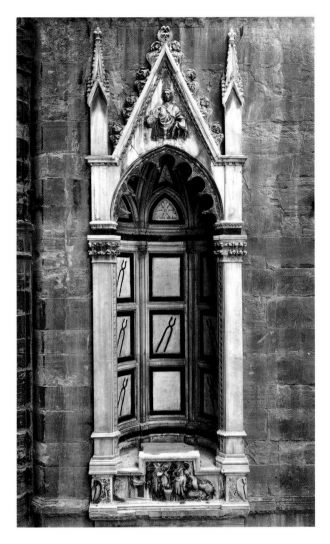

Fig. 115. Nanni di Banco, niche for *Saint Eligius* (cat. 1-10, detail), ca. 1417–21. Marble. Orsanmichele, Florence

(1969) attributed the entire gable zone to an (unspecified) assistant for this reason, as well as for the innovative style of carving. I believe, instead, that the relief carving itself represents an understandable part of Nanni di Banco's development, which is advanced far beyond the gable carvings of his earlier niches: only its situation in the architecture may be owed to the intervention of others. It may be argued, therefore, that the figured portion of the frontispiece of the gable was found, as is, in Nanni's shop by assistants, and summarily set into a decorative context that they left spare to the point of emptiness. Such circumstances would explain, too, the uncomfortably steep angle of the raking cornices (relative to the relief image and the statue) as a result of that part of the design that had been hastily formulated and constructed by assistants.

Finally, the least happy aspect of the *Saint Eligius* com-

position is the "black" and white marble inlay pattern that decorates the interior walls of the niche. The three bays of the wall are bounded by applied Corinthian colonnettes, within which beveled frames form nine vertical rectangular panels, whose interiors are outlined in bold green-black bands. These rectangles (excepting the central top and central bottom ones) contain inlaid images of the heraldic image of the blacksmiths: a large pair of *tenaglie* (tongs) is placed on a slight diagonal in each section, echoed by the smaller pairs inlaid on eliptical *scudi* that wrap around the tendriled corners of the socle zone. This pattern of repeated pincers has an unfortunate relationship with the statue: the *tenaglie* point inward and upward, conceptually pinning the bishop saint to a central vertical position, as though the whole composition were organized according to an heraldic order. Even polychromed and gilded, with an elaborate metal staff in his hand, the statue of St. Eligius would have been overwhelmed by the relentless direction of the *tenaglie* on the lateral walls. A view of the empty niche yields further evidence that the inlaid blocks of the walls were installed by misguided assistants: the central column of rectangles, just behind the statue, has tongs only in the middle frame. Whereas the middle frame is blocked off by the statue from almost any angle, the rectangle behind the saint's head would "need" a *tenaglia* to unify the composition. Balance would have been achieved had the figured middle block been placed in the top section: this because the figure's contrapposto determines the position of his head to the viewer's left, and the tongs from the central block move diagonally from left to right.

The handling of the fictive curtain in the *Quattro Coronati* group demonstrated Nanni's sophisticated pictorial approach to the tabernacle interior as a continuous, actual space into which (or against which) figures are placed. Surely in the *Saint Eligius* niche he would also have chosen to invent a continuous rather than a heraldically arranged background — to create pictorial depth rather than emblematic closure. The large, stiff pattern of *tenaglie* seems too crude and graceless to have been Nanni's own design, although its invention may possibly be owed to a committee of overzealous blacksmiths, especially since Saint Eligius was also the protector saint of goldsmiths, who in turn collectively denied the fact that Eligius had ever worked as a blacksmith (*Vita prodigiosa* 1767). Yet the awkward compositional direction of the tongs and the irrational placement of the single figured panel behind the

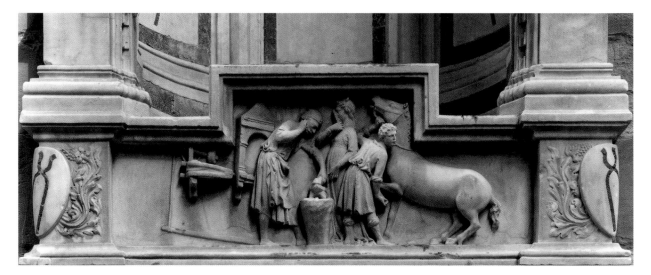

Fig. 116. Nanni di Banco, socle relief for *Saint Eligius* (cat. 1-10, detail), ca. 1417–21. Marble. Orsanmichele, Florence

middle of the saint's body (with a blank panel behind his head) suggest that the installation, and possibly also the production, of this part of the niche was in the hands of an artisan other than Nanni di Banco.

It may be concluded, then, that the figural parts of the *Saint Eligius* tabernacle were made by Nanni ca. 1417–21, while he was also fully involved in the production of the *Assumption* relief for the Porta della Mandorla. During this time of intensive work, which Wundram (1969) described as the peak of the incomparably diligent artist's "Arbeitskraft," Nanni was sure to have operated with the assistance of several helpers. This fact alone could account for the disjointed, unfinished appearance of the *Saint Eligius* niche, assuming that Nanni executed the gable relief, socle relief, and statue with his own hands, leaving the niche construction and decorative elements to others. Nanni lived and worked at full productive capacity until he wrote his will on 9 February 1420/21, and chances are that the *Assumption* was not the only project underway at that time. The *Saint Eligius* may have been summarily finished and assembled by assistants after the master's death.

Who were the members of Nanni di Banco's shop at this point? Seymour (1963b) was the first to propose that Luca della Robbia was Nanni's assistant in figurative sections of the *Assumption of the Virgin* at the Porta della Mandorla, an idea that has met with acceptance but is not supported by documents. There are several other artisans who might have worked for Nanni di Banco either before or after his father's death in 1415. Likely candidates include Nanni di Fruosino called "Testa" (see doc. 147), a stone-

mason who specialized in the painting and decoration of sculpture; Jacopo di Niccolò di Succhielli, Nanni di Banco's uncle, who lived until January 1429/30 and was legally entitled to payments owed to the Banco workshop in 1427 (doc. 170); Tommaso di Niccolò Succhielli, Nanni di Banco's younger cousin, who became *capomaestro* of Santa Maria del Fiore in 1451/52 (doc. 178); and Jacopo "Papi" di Corso, who at various times owed money to the Succhielli (doc. 170), indicating that he may have worked with them. No one of these masters' hands is identifiable, however, and one would be hard pressed to "locate" the young Luca della Robbia in any of the figurative carving here in the *Saint Eligius* ensemble.

As in the *Quattro Coronati* ensemble, where a group of classicizing statues is contrasted with a contemporary workshop scene in the "predella" below, Nanni has used the Orsanmichele niche format to represent two different aspects of the story of *Saint Eligius*, "sanctum episcopum et artificem," in an "upstairs-downstairs" relationship. The statue portrays the saint in the dignity of his historical, clerical role as bishop of Noyon-Tournai, whereas the relief space of the socle is given over to the depiction of a scene from a popular (and apocryphal) legend of Eligius's life as a blacksmith (fig. 116). Saint Eligius's biography arrived in Italy from France in a convoluted state, with various stories and themes intertwined and conflated by oral tradition along the way (Medin 1910–11). As guilds and confraternities gained importance throughout Europe, Eligius's historical persona — born ca. 590, he was a goldsmith and courtier to Dagobert II, after whose death in 611 he took

orders and was elected (639) bishop of Noyon-Tournai —
became eclipsed by his image as a more humble artisan, a
blacksmith (Medin 1910–11; Negri-Arnoldi 1964). Miracu-
lous episodes in his life as a blacksmith are not codified in
any known written text; instead, their various permutations
are known to us primarily through artistic representations
and oral tradition. In fact, an authoritative story of Saint
Eligius published in Pisa in the mid-eighteenth century
(*Vita prodigiosa* 1767) asserts that even though Renaissance
Italians erroneously depicted Eligius as a blacksmith curing
horses, he was a goldsmith by profession and never a black-
smith. The author of the *Vita prodigiosa* insisted that this
needed to be repeated "a gloria della Civilissima Arte degli
Orefici."

Nanni di Banco's socle relief, which at first glance
appears to represent a discrete narrative episode, in fact
conflates (or at least alludes to) several strands of the saint's
legend. One version of the story has it that Eligius, as the
finest blacksmith in his city, hung a sign above his shop
door proclaiming himself "master of all masters." Christ
found it necessary to humble this excessively proud artisan
and arrived at Eligius's shop disguised as an apprentice; he
then outdistanced the blacksmith's skill by bloodlessly
detaching a horse's leg in order to shoe the hoof. Eligius
tried the same procedure and failed; he was thus finally
humbled and fell to his knees before God. After such an
honest humiliation the apprentice (Christ) allowed Eligius
to repeat the miracle himself (Medin 1910–11). Indeed,
almost all known representations depict Saint Eligius per-
forming the miracle, with the apprentice merely tending the
forge or restraining the hoofless horse (Medin 1910–11).
According to Medin (1910–11), variations on this legend
extended as far from France as Finland: the Finlanders' ver-
sion begins with Christ and Saint Peter passing Eligius's
blacksmith shop together on a sled; in French art the rider
of the horse to be shod was Saint George the dragon-slayer.
Nanni di Banco's relief also incorporates elements of an
older legend, which had become attached to the story of
various blacksmith saints in France, England, and Italy: the
resident blacksmith of a monastery (Saint Dunstan, Saint
Apellen, or Saint Eligius) was working one night when the
devil arrived in the guise of an alluring woman. Eligius
burned her face and body with a hot iron, at which point
the demon screamed and ran away; from this moment on
the saint was able to hold hot irons in his hand without
burning himself (Medin 1910–11).

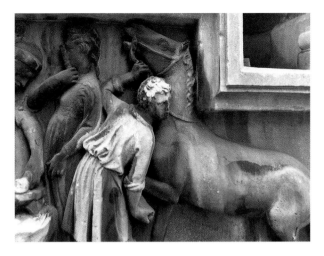

Fig. 117. Nanni di Banco, *Saint Eligius* (cat. 1-10, detail), ca. 1417–21.
Marble. Orsanmichele, Florence

An awareness of these various strands of the complex
legend ultimately makes Nanni's relief panel comprehensi-
ble. In the context of the blacksmith's shop, which is
appointed with bellows, furnace, forge, and various irons
hanging on the wall, Saint Eligius himself, dressed in an
apron and workman's hat, is intent upon the shoeing of a
disembodied hoof while a handsome young apprentice
restrains the horse. The demon glides silently between the
apprentice and the master, and counter to the direction of
their gazes. She is an elegant young lady in a high-waisted
dress with an embroidered bodice and shirred sleeves: her
diabolical nature is revealed in the horns sprouting from
her coiffeur, a cloven hoof emerging from under the hem of
her dress, and the fact that she covers her face with a bundle
of small rods, concealing what appears to be a sly smile.
There is no satisfactory explanation for what this bundle of
small sticks, which occurs in all known Tuscan versions of
this scene, might represent; Vaccarino's (1950) identification
of the female character as a personification of Superbia is
attractive but probably unjustified. Nanni's conception of
the group of figures shows the blacksmith saint unaware of
the temptress even though she quite literally touches both
figures, and her stance is actually entwined with that of
Eligius's helper as her dress and cloven hoof wrap around
the inside of the apprentice's left foot. As a floating, imma-
terial entity (presumably still invisible to Saint Eligius) she
glides from right to left, focusing her attention upon the
saint. In formal terms, two strong currents of motion inter-
sect: the downward gazes of the master and apprentice and
the physical effort of their bodies' action move diagonally
from left to right; such a motion is countered by a right-to-

Fig. 118. Nanni di Banco, *Saint Eligius* (cat. 1-10, detail after restoration of 1989), ca. 1417–21. Marble with traces of gold and polychrome. Orsanmichele, Florence

left direction of the gliding, elegantly sway-backed female and the rearing horse. Contrary to what several historians (including Vasari) have written, the horse (fig. 117) does not strictly speaking represent a "mad" or "possessed" companion of the devil (cf. Wundram 1969). Nevertheless, the iconographic association of a horse with lust is unmistakable; in this connection, Bellosi's (1966) suggestion that Nanni's *Saint Eligius* relief is related to Greek sculpture of the fourth or fifth century B.C., possibly known to the artist through Roman derivations, becomes tangentially appropriate. Even in a strictly formal reading of this composition, the horse surely alludes to the evil of "unbridled" passion, the same evil with which the devil would attempt to seduce Eligius. In holding back the raging horse, the

apprentice (Christ) seems also to be protecting Eligius from the passions aroused by the demonic woman, thus formulating a visual scene that encompasses and blends two narratives.

Apart from the bishop's miter, the head of *Saint Eligius* (fig. 118) may have been inspired by an ancient portrait such as *Caracalla* (fig. 36). The statue as a whole may have been influenced by a kind of composite statuary, in which the original medieval head was replaced by an ancient or *all'antica* substitute, as in the statue of a saint in Paris (Louvre), which has a Florentine provenance (figs. 37, 38; see chapter 3).

The relief scene of the *Saint Eligius* socle zone has precedents among Roman funerary reliefs, in particular one such carving from the National Museum at Aquileia (fig.

Fig. 119. Funerary Relief of Roman Blacksmith, late 1st century after Christ. Limestone, 16 ¼ in. (41 cm). Museo Archeologico di Aquileia

Fig. 120. Andrea Pisano, *Metallurgy*, 1334–37. Marble, 32 ¾ x 27 ⅛ in. (83 x 69 cm). Museo dell'Opera del Duomo, Florence

119). Zervas (1996) suggested that the excited horse in this relief is based on the *Dioscuri* (horse-tamers) on the Quirinal in Rome. Not surprisingly, the impact of Roman grave reliefs of tradesmen is mediated by the marble relief repertoire of Andrea Pisano: the image of *Metallurgy* for the Campanile (fig. 120) is fundamental here (Moskowitz 1983; Niehaus 1998). The story of Saint Eligius survives in only a few Italian paintings and reliefs, and Nanni di Banco's relief composition is without a known compositional precedent. The Pisan *Vita prodigiosa* (1767) tells us that scenes of Saint Eligius were commonly placed above entrances to blacksmiths' shops in Tuscany. A Tuscan panel at Avignon (fig. 121) is shaped as if to conform to a lintel and may belong to that genre of *bottega* decoration. In this particular example a woman with cloven hoofs and bat wings stands at the left behind bellows and the saint, who shoes a disembodied hoof at a forge; to the right stands a white horse, whose injured leg is held by his bearded owner, wearing the triangular hat of a Jew or some other kind of oriental. The panel has been attributed to Niccolò di Pietro Gerini by Kaftal (1952), Boskovits (1975), and Laclotte and Mognetti (1987). Zervas (1996), who accepted the attribution to Gerini, and also accepted Gerini as the author of the dismembered *Quattro Coronati* triptych (cat. 1-6), maintained that this panel served as the predella of a larger work com-

Fig. 121. Attributed to Niccolò di Pietro Gerini, *Miracle of Saint Eligius*, ca. 1390. Tempera on panel, 8 ½ x 19 ¼ in. (22 x 49 cm). Musée du Petit Palais, Avignon

Fig. 122. Sandro Botticelli, *Coronation of the Virgin with Saints John the Evangelist, Augustine, Jerome, and Eligius* (altarpiece), ca. 1490–93. Tempera on panel, 149 x 102 in. (378 x 258 cm). Galleria degli Uffizi, Florence

missioned by the blacksmiths' guild for its interior pier at Orsanmichele sometime during the 1380s, a theory which is plausible but not proven. Whether or not the Avignon panel has a provenance in Orsanmichele, it was probably not the only such representation available to Nanni di

Banco in Florence: we may assume, for instance, that the guild hall of the Fabbri, which was located behind the Loggia dei Signori near the stonemasons' guild (Goldthwaite 1980), contained at least one image of their patron saint in his role as a blacksmith.

Nanni di Banco's *Saint Eligius* at Orsanmichele was the immediate prototype for Botticelli's *Coronation of the Virgin with Saints John the Evangelist, Augustine, Jerome, and Eligius* (fig. 122) made for the guild of Por Santa Maria (silk guild) to decorate the goldsmiths' chapel ("la Cappella di Sancto Alò") dedicated to Saint Eligius at San Marco (Medin 1910–11). As in Nanni's tabernacle, Botticelli shows Eligius as a bearded bishop in the central panel, whereas the predella below contains a scene from his life as a craftsman. Although the altarpiece was dedicated to Saint Eligius as patron of the goldsmiths' rather than the blacksmiths' guild, the predella scene (fig. 123) is taken straight from Nanni di Banco's Orsanmichele relief with only subtle variations, such as the fact that the saint is shown full face rather than in three-quarter view, and the boy who holds the horse is actively rotated in space with billowing drapery (Horne 1909; Kaftal 1978; Lightbown 1978). The devil disguised as a woman floats through space from right to left as Nanni's figure does, with the same horns sprouting from her forehead and *bastoncini* (bundle of sticks) held before her face. Lightbown (1978) cited documentation of the altarpiece having been made "alla cappella dell'arte diorsancta maria che si chiama la cappella di Sancto Alò"; the arms of the silk guild were painted on the frame. That the goldsmiths, belonging to the powerful silk guild, would choose

Fig. 123. Detail of fig. 122 predella with Saint Eligius

to portray Saint Eligius as a simple *fabbro* working at a forge, derived from a model commissioned by the blacksmiths, rather than as the courtier-goldsmith, shows a special historical fondness for Nanni's composition.

SOURCES

ca. 1537–42, Anonimo Gaddiano: "Et anchora in uno di dettj pilastri è di sua mano [Nanni di Banco] la fiura di santo Lo."

1550, Vasari: "Et stimasi che il Santo Lò intorno ad Orsan Michele che è della arte de' Maniscalchi sia medesimamente sua." [Nanni di Banco]

ca. 1550–63, G. B. Gelli: [Nanni di Banco at Orsanmichele]: "et la figura di santo Lorenzo."

1568, Vasari: "Stimasi ancora, che il Santo Lò che è intorno al detto Oratorio d'Or San Michele, stato fatto fare dall'Arte de' maniscalchi, sia di mano del medesimo Nanni; e così il tabernacolo di marmo, nel basamento del quale è da basso in una storia San Lò maniscalco che ferra un cavallo indemoniato, tanto ben fatto, che ne meritò Nanni molto lode: ma in altre opere l'avrebbe molto maggiore meritata e conseguita, se non fusse morto, come fece, giovane."

BIBLIOGRAPHY

Bocchi 1677, 69; Baldinucci, 1681–1728 (ed. 1974), 246; Richa, 1754–62, 1:21; *Vita prodigiosa* 1767, 24–25, 66–72, 159–60; Burckhardt 1855 (ed. 1952), 656; Schmarsow 1887, 229–30; Reymond 1892, 2:202; Venturi 1906–8, 6:212n. 1; Wulff 1909, 27–29; Horne 1909, 173; Medin 1910–11, 776–88; Vitry 1922, cat. no. 578; Brunetti 1932, 16–17; Kauffmann 1936, 198; Planiscig 1946, 38; Brunetti 1947, 217–19; Antal 1948, 306; Kaftal 1952, figs. 383–84; Pope-Hennessy 1955, 52–54; Krautheimer 1956, 87–88; Janson 1957, pl. 20; *Statuti* 1957, 127–29, 164–65, 195, 239; Seymour 1963b, 92–119; Negri-Arnoldi 1964, 4: cols. 1064–73; Bellosi 1966, 4; Seymour 1966, 31–32, 64; Wundram 1969, 137–44; Janson 1972, 547; Herzner 1973b, 93–95; Boskovits 1975, 403; Mustari 1975, 297–99; Carmignani 1978, 185–86; Kaftal 1978, cols. 273–84; Lightbown 1978, cat. no. B-55; Macchioni 1979, 139; Goldthwaite 1980, 269; Parronchi 1980, 57; Zimmer 1982, 180–82; Moskowitz 1983, 49–59; Laclotte and Mognetti 1987, cat. no. 79; Giusti 1989, 180–84; Natali 1990, 145–49; Beck 1991, 1:79–80; Zervas 1991, 755–304; Zervas 1993, 46; Negri-Arnoldi 1994, 17; Kalusok 1996, 165–67; Zervas 1996, 1:441–43, 624–25, 635–36; Nichaus 1998, 125–26.

Agnus Dei: Stemma of the Wool Guild

1419

Macigno, 35 ½ x 30 ¼ in. (90 x 77 cm)

Santa Maria Novella, Florence

In May 1419 Nanni di Banco carved two "Agnus Dei" reliefs to ornament the facade of the papal residence at Santa Maria Novella. These arms of the wool guild remain in situ on the western wall of the Chiostro Grande; one of the pieces is badly damaged but the other (under discussion here) is well preserved, revealing a high quality of design and execution. The "Agnus Dei" panel is sheltered by the upper cloister of the adjacent wall, and it can be seen under optimum conditions by exiting from what is now the infirmary of the Scuola Sottufficiali Carabinieri onto the second story of the cloister. The composition itself is set back deeply within a rectangular beveled and dentilated frame: a row of five fleurs-de-lis forms an upper border (the Angevin "lambello"), below which a flat square frame is inscribed with a circular one, intersecting at all four sides. The four corners are filled with traditional rosette decoration, and the central "tondo" recedes into a concave dish shape within its frame. A lamb (who does not have the traditional halo) bearing a banner with the cross of the Popolo stands in this circular, concave space. The panel is in fair condition, retaining a moderately intact patina and relatively crisp detail despite random chips, breaks, and abrasions. The state of preservation results from its sheltered position beneath the roof of the cloister. Its companion relief is situated at the extreme left of the group of various "stemmi" in very poor condition: it is completely depatinated and crumbling from exposure; possibly shattered and remounted. Although no traces of polychrome are visible today, the reliefs were probably painted as they were

at the guild hall of the Linaiuoli where a similar arrangement of escutcheons on the facade was carved by Andrea di Nofri and painted by Lorenzo di Piero.

ATTRIBUTION AND DATING

On the first of January 1418/19 a Florentine embassy was sent to Mantua to invite Pope Martin V to Florence (Brucker 1977). Later that month (25 January) a government *provvisione* declared that the secular hospice that had existed at the Dominican convent of Santa Maria Novella for a century be rebuilt to accommodate the pope and his entourage (Richa 1754–62; Wood Brown 1902; Quinterio 1978; Baldini 1981). The old hospice-apartment was conceded to the *venerabile padre* Leonardo di Stagio, Generale dei Frati predicatori, in 1421 (ASF, *Carte Strozziane* II, 78, c. 62, cited by Even 1984). The rebuilding project was entrusted to the Opera del Duomo with a budget of 1,500 florins: the Operai began deliberations immediately, and decoration continued for almost the entire duration of the pope's stay (most of the rooms were completed in 1419: ASF, *Carte Strozziane* II, 78, c. 48, cited by Even 1984).

The papal residence was located in the upper story of the Chiostro Grande at Santa Maria Novella. The apartments have been remodeled over the centuries, but clues do

exist as to the original appearance of the complex (Richa 1754–62; Paatz 1952). A great *salone*, called the "Sala Magna," was located behind the west wall of the cloister (Bulli 1935; Paatz 1952–56; Quinterio 1978). Martin V's bedroom and sitting room were decorated with colorful frescoes and draperies, in green and with a floral pattern respectively (Paatz 1952–56). Decoration of the interior spaces was assigned to builders and painters of little reknown, e.g., "Giovanni di Guccio e compagni pittori" (ASF, *Carte Strozziane* II, 78, cited by Even 1984). Only the pope's chapel (Cappella dei Papi) remains intact, with painted decorations by Pontormo and Ridolfo Ghirlandaio dating from the reign of Leo X (Berti in Camporeale 1980). Entry to the apartments from the city was provided by a staircase leading to the eponymous via della Scala (Richa 1754–62). On the inward-facing side of the wing, a portal with a freestanding stairway led directly from the Sala Magna to the Chiostro Grande, allowing the pope passage into the convent, from where he could then proceed through the Chiostro Verde into the Dominican church (Richa 1754–62; Paatz 1952–56; Baldini 1981). In 1924 the north and west wings of the Chiostro Grande were given by the city of Florence to the Scuola Allievi Sottufficiali dei Carabinieri; today the Carabinieri occupy the entire cloister and all adjacent buildings except the southern part of the east wing, which belongs to the museum of Santa Maria Novella (Quinterio 1978; Lunardi 1983).

Shortly after the initial provision was made to construct a new residence, it was deliberated (8 February 1418/19) that a set of four escutcheons, including the arms of the Popolo, *Comune*, Parte Guelfa, and Arte della Lana be made for the building (doc. 138). The ensemble would be located "in the wall of the Sala Magna of the papal residence of Santa Maria Novella, on the side facing the cloister, on the upper exterior of the cloister" (doc. 139). On 15 April 1419 the project was amended to include the arms of the Roman Church, and two, rather than one, *scudi* of the wool guild; these last were to be hung below and a bit to the side of the arms of the *Comune* and the Parte Guelfa (doc. 139). Nanni di Banco was paid fourteen lire on 10 May 1419 for the escutcheons of the wool guild, described as "2 chonpassi dentrovi il segnio del'Arte dela Lana" (doc. 140). Produced within thirty-five days, Nanni's contribution was the first part of the group to be finished and presumably installed. Two days later it was decided that the arms of Oddo Colonna (Martin V) be added to the ensemble —

probably at his own request, for at this point the pope had been in residence for nearly three months (doc. 141).

Nanni di Piero, called "Ticcio," who was one of Brunelleschi's principal assistants, finished the escutcheon with the lily of the Commune in June (doc. 144); Pippo di Cristofano, called "Cerbio," delivered the arms of the Colonna, the Roman Church, and the Parte Guelfa in August (doc. 146). In October Andrea di Nofri completed the arms of the Popolo along with some fittings for the door above the freestanding stair that connected the Sala Magna with the cloister (doc. 153). Andrea di Nofri, an artistic personality recently charted by Annalisa Bricoli (in Sframeli 1989), was a logical choice for this kind of work, since he had already carved the entire decoration (including a set of splendid civic escutcheons) for the main portal of the guild hall of the Rigattieri and Linaiuoli in 1414 (fig. 59) and had probably worked on the portal of the guild hall of Oliandoli and Pizzicagnoli as well as other such projects (Sframeli 1989).

The staircase had been begun in August by Pippo di Giovanni according to a design by Lorenzo Ghiberti, which had been chosen by the Operai in May from a selection of drawings submitted by Ghiberti, Giuliano d'Arrigo called "Pesello," and the same Pippo: there is some question as to whether Ghiberti, Pesello, and Pippo submitted their designs in competition or cooperation, because a few weeks after Ghiberti's drawing was chosen, Pippo was asked to submit another drawing (a working plan? with modifications?) and to begin building the stairway. In an analysis of this project, Even (1984) concluded that the working relationship between the three masters was cooperative (see Krautheimer 1956). When Brunelleschi, Ghiberti, and Battista d'Antonio were elected *Provveditori* of the Duomo together in 1420, Filippo ("Pippo") di Giovanni was named one of the *muratori* to construct the cupola (Guasti 1875), and in 1423 he was called in along with several other *maestri* to see the model (Guasti 1875). Pippo di Giovanni can probably be identified as the Pisan Filippo di Giovanni di Gante (see Beck 1978). Donatello's *Marzocco* (fig. 58), apparently made to decorate the newel post of the outdoor stairway, was finished in February 1419/20 (Janson 1957; Fader 1977; Barocchi 1985). No trace of Ghiberti's stairway remains since its apparent destruction in the sixteenth century (Paatz 1952–56; Krautheimer 1956; Janson 1957). The portal was demolished in the eighteenth century (Richa 1754–62), and the *Marzocco* was moved to Piazza della Si-

gnoria in the nineteenth century, then later to the Bargello (Janson 1957; Fader 1977; Barocchi 1985). The ensemble of *scudi*, except for the arms of the family of Martin V, has been maintained in situ. Martin V's arms consisted of a column surmounted by a crown, above which float the papal tiara and keys, as seen on his tomb in Saint John Lateran, Rome (Galbreath 1972).

Nanni di Banco's two panels are mounted at the extreme ends of the upper story of the west wall of the cloister; between them, and a bit above, are the larger pieces: the lily of the Comune, the pontifical keys, the cross of the Popolo, and the eagle of the captains of the Parte Guelfa. These last follow a standard format in which a large shield is suspended from a small lion's head by ribbons, with rosette decoration filling in the remaining space of the rectangle.

Nanni's reliefs were considered lost by Planiscig (1946) and Paatz (1952–56); but they had remained *in situ* throughout the centuries. Pier Paolo Petriboni described them as being in place, as did his sixteenth-century editor Giovanni Cambi in 1511. An undated reference was also reported in the *Repertorio Strozziano di memorie laiche* (ASF, cod. Strozziano XX, c. 49, cited by Wood-Brown 1902). Nanni di Banco's reliefs were recognized in the twentieth century by Barile (1941). The *Agnus Dei* was carved around the same time that Nanni di Banco was producing the last figures for the *Assumption of the Virgin* at the Porta della Mandorla; despite its limited content, it shows the harmony of design, sophisticated use of two- and three-dimensional space, and observation of nature that characterize his mature works. Nanni's entire design — and especially the carving of the animal — possesses an equilibrium and naturalism that are typical of the art of the early Renaissance. The equipoise of Nanni's lamb within his tondo is achieved by a higher horizon (more space under the animal's hooves), a strong verticality of the lamb's engaged legs, and the curve of the neck out from the supported torso to gaze back over his shoulder at the animated flag. Nanni's treatment of a full-figure animal in relief here is consonant with that of the horse in his *Saint Eligius* relief.

DOCUMENTATION

Docs. 138–41, 144, 146, 153.

SOURCES

ca. 1414–59, Petriboni-Rinaldi, c. 99: "Et chosì fu fatto nel secundo chiostro della detta chiesa chollarme del comune et dappie l'arme dell'arte della lana."

1511, Giovanni Cambi, "Istorie," in *Delizie*, 20: 143: "e così si se nel secondo chiostro grande una sala grande con altri abitazioni, e messonvi l'arme del Chomune, e appie quelle dell'arte della lana come si vede al dì d'oggi 1511."

BIBLIOGRAPHY

Richa 1754–62, 3:114–18; Guasti 1857, doc. nos. 56, 71; Wood Brown 1902, 90; Bulli 1935, 2; Barile 1941, 7; Planiscig 1946, 48; Paatz 1952–56, 3:671, 676, 678–79, 692–93, 755; Krautheimer 1956, 256, 405, doc. no. 265; Janson 1957, 41–42; Galbreath 1972, 82; Trexler 1973, 125–44; Brucker 1977, 421; Fader 1977, 46–52; Beck 1978, 36–39; Quinterio 1978, 489–91; Berti in Camporeale 1980, 233–37; Baldini 1981, 334; Lunardi 1983, 15–18; Even 1984, 37–41; Barocchi 1985, 176–89; Sframeli 1989, cat. nos. 272, 292, 293.

1.12 *Assumption of the Virgin*

1414–22
Marble, overall height ca. 13 ft. (400 cm)
Santa Maria del Fiore, Florence

Made from white Carrara marble, red marble, green-black marbles, and green granite, the composition is situated within the steeply triangular tympanum above the Porta della Mandorla. It is composed of eleven sections of white marble fitted together within a segmented band of green-black "verde di Prato." The pictorial relief occupies a steep triangular space broken at the bottom in such a way that the sides become parallel and the base inverted to conform to the shape of the archivolts below; the space is framed by a broad band of plain "black" marble and a beveled white molding. Beyond the molded frame the picture is bounded by elaborate decorative friezes: a white, "black," and red inlay design of chandeliers rendered in perspective; slender dentil and egg-and-dart frames; finally, it is crowned by a series of individualized, extravagantly florid acanthus volutes. At the center of the framed triangular space a solid and elegantly beveled mandorla contains the ascendant Virgin. Carved in high relief, she turns on her axis to hand her cintola to Saint Thomas, who genuflects with raised hands in the lower left corner. In the opposite corner a bear, scrambling over some rocks, embraces an oak tree, as if to gather acorns. Four flanking adolescent angels propel the mandorla upward; two younger children play shawms above; another young angel stands poised at the apex of the triangle with a bagpipe, gazing down at the rest of the scene. Two cherubs whose heads and torsos are carved in some detail are nestled on either side of the Virgin, inside the mandorla, and the head and wings of another such cherub occupies the lower tip of the mandorla at the

Virgin's feet. The figure of the Virgin has suffered from abrasions and fissures: two fleur-de-lis finials of her crown are broken, and both hands have been repaired. All parts of the frontispiece are badly stained and corroded from pollutants carried by rainwater and other misfortunes (1999).

ATTRIBUTION AND DATING

The earliest sources were consonant with what is now taken to be fact: even the normally taciturn Francesco Albertini (1510) credited Nanni di Banco with the *Assumption*; he was followed by Antonio Billi and the Anonimo Gaddiano. Vasari, however, made a point of contradicting this attribution in his first edition, where in the lives of Nanni di Banco and Jacopo della Quercia he assigned the relief to Quercia. Vasari considered the *Assumption* a fine work of such progressive conception that he was reluctant to associate it with Nanni, especially as it fitted Quercia's relief style so well. In the 1568 edition of the *Vite*, Vasari's only discussion of the *Assumption* occurs in the life of Jacopo della Quercia, as if its authorship were no longer open to question. G. B. Gelli admired the "varia e bella compositione" as much as Vasari did, but he was affirmative in giving the work to Nanni di Banco. Although Gelli seems to have written under the influence of Vasari on many issues, here

he held firmly to a different view. Nevertheless, Bocchi (1591) still maintained that the tympanum relief was by Jacopo della Quercia. Baldinucci (1681–1728) expressed surprise that Vasari could have had such poor judgment regarding Nanni di Banco's best work of art and pointed to the payment documents (later published in full by Poggi) preserved in the archive of the Opera del Duomo. Poggi's full publication of the relevant documents in 1909 (see Poggi-Haines) vindicated Nanni di Banco's authorship.

Primary documentation of Nanni di Banco's *Assumption* is recorded in consecutive deliberations and payments in the archive of the Opera del Duomo. On 19 June 1414, with Antonio di Banco in the office of *capomaestro*, Nanni was commissioned the frontispiece ("unum frontem") above the Porta della Mandorla (doc. 108). Nanni himself was a consul of the stonemasons' guild at the time (doc. 106), and on 28 April he had been selected to serve as Podestà of Montagna Fiorentina for a period of six months, to commence 22 August 1414 (doc. 105). This six-month sojourn in the Casentino, along with the progress of ongoing projects at Orsanmichele, will explain why Nanni received his first payment for the tympanum almost a year after he was given the original commission: five days after his father died — the same day that Nanni's uncle Jacopo Succhielli took over as *capomaestro* — the Operai gave Nanni thirty florins for "figuris et laborerio quas et quod facit et facere debet" (doc. 117), indicating that the assignment was fully claimed by Nanni, if not actually underway. Another payment of thirty florins followed on 20 August (doc. 120). Then the documents are silent for about a year, after which Nanni became Podestà of Castelfranco di Sopra in the Arno valley for the months July–December 1416 (doc. 126). On 13 May 1417 he was finally awarded another isolated payment, for the sum of twenty-seven florins (doc. 131); nine months later (February 1417/18) he received thirty florins for work on the relief "per eum incepti" (doc. 133). At this point work seems to have gotten underway seriously, and the payments that follow are more frequent and specific: twenty florins in June 1418 (doc. 135); fifty florins in October 1418, "in mutuum super sex figuris marmoreis" (doc. 136); forty florins in December 1418 (doc. 137); twenty florins in May 1419 (doc. 143). The following October (1419) he was paid thirty florins "super pluribus figuris marmoreis" (doc. 154), clearly indicating that by this time several figures in addition to the six figures mentioned a year before had been carved. A payment of eighty florins on

21 February 1419/20 (doc. 156) shows that at this time most, if not all, of the figurative carving must have been completed. During the following year (1419/20–1420/21) no payments were made at all for the *Assumption*, although Nanni kept a fairly high profile in government and as an advisor to the Operai for Brunelleschi's cupola. Janson (1963) concluded that between one-half and two-thirds of all the figures were completed in 1418 and that the actual production of the relief filled the last three years of Nanni's life; Wundram also (1969) believed that Nanni first devoted intense time to the *Assumption* in 1418, completing six figures that year, and concluding the relief in 1418–20. Pope-Hennessy (1955) stated that the work was "substantially concluded" before Nanni's death and that most of the work was accomplished between 1418 and 1420 (1980).

A year after the receipt of his last and largest payment Nanni died, and it was deliberated that the total value of the frontispiece be appraised in its "unfinished" state (doc. 161). As Pope-Hennessy (1980) observed, we cannot know whether Nanni's practice was to complete each section of an ensemble individually or whether the sections were all blocked out and worked to a finished state together at the end of the project. After a lapse of seven months (September 1421) *capomaestro* Battista d'Antonio concluded that the balance owed Nanni's heirs was 326 ⅔ florins, a sum including the price of the frames, friezes, and foliation that Nanni had made or supervised (doc. 162). Battista's deliberation brings the grand total of known payments for the whole project to 683 ⅔ florins: this would seem to be a reasonable sum for an ensemble consisting of figurative sculpture and architectural decoration together. (The cost of the building and decoration of a niche at Orsanmichele, including detailed mosaic inlay, was about 200 florins; a life-size statue such as the seated Evangelists for the cathedral facade would fetch around 150 florins, and so forth.) Assuming the later payments were made for finished work, the documents of the Opera tell us that the figured relief section of the tympanum, including "sex figuris" and "pluribus figuris" was not only blocked out, but largely brought to completion by Nanni and his shop during his lifetime, indeed probably before the payment of February 1419/20. All of the components, including the decorative elements, were found in a state described as "imperfecta derelicta" at the artist's death, and certain parts, including perhaps some of the frames and friezes, and the panel at the lower tip of the mandorla, were still incomplete ("non-

dum fuisse integre satisfactum") (docs. 161, 162). The documentary picture yields no evidence whatsoever that any of the figures were missing or left in a state so rough as to be turned over to another artist. Work on the "storia foglaminis" apparently did continue over the next months, because on 14 January 1421/22 the finished parts were installed, at which point it was calculated that Nanni's shop was owed some seventeen-odd lire (doc. 163). An ultimate settling of accounts took place in April 1422 when Nanni's heirs (unfortunately not specified by name) were paid in silver the odd amount of 567 lire, 17 soldi, and 4 denari, owed to them for concluding the "istoria marmoris sculta et intagliati sub figura beate virginis marie" (doc. 165). The puzzling phrase "sub figura . . . marie" might refer to any and all passage(s) in the figurative or decorative zones of the frontispiece, and not necessarily to the relief sections physically below the Virgin. The series of payments allows us to conclude with reasonable certainty that even if the first few installments were given *pro forma*, Nanni had begun the figural part of the *Assumption* by February 1417/18 and had more or less finished the pictorial composition by February 1419/20. Not only is the authenticity of the relief proved, but the dating can be focused into a relatively brief period of about two years, thereby corroborating the coherent stylistic closure of the work.

After the installation of the frontispiece ensemble, additions were still to be made. In February 1421/22 the stone sculptor Antonio de' Servi was hired to clean, polish, or paint ("ischiarare") a lily that was placed in the hand of Nanni di Banco's ascendant Virgin (doc. 164). The document (doc. 164) refers to "il giglio tiene nostra Donna dela porta della Nunziata," but there has been controversy as to where the lily was actually located. Brunetti (Becherucci and Brunetti 1969) thought the scribe here referred to a lily in the hand of a statue of Gabriel, which she believed was placed in the lunette of the northeast door in 1409: Brunetti believed that the statues of Gabriel and the Virgin then standing in the lunette were the enigmatic *Annunciation* group now in the Museo dell'Opera del Duomo (cat. II-7) and that the scribe mistook Gabriel for "nostra Donna" because the angel has a more feminine countenance than that of the Virgin. There is, however, no reason to believe that this particular pair of statues was ever located in the outdoor lunette zone of the Porta della Mandorla; and Pope-Hennessy (1980) is correct that the metal lily must have been placed in the hand[s] of Nanni di Banco's ascen-

dant Virgin, who was known, even throughout the sixteenth century, as "nostra Donna dela porta della Nunziata." (The practice of placing metal flowers in the hands of stone statues was not uncommon in Italian art: other examples include Lorenzo Maitani's *Enthroned Virgin* at Orvieto and the figure of *Charity* by an assistant of Niccolò Lamberti at San Marco in Venice.)

Donatello carved two small prophets' heads (figs. 62, 63) in profile relief, tucked into the corners under the raking cornices of Nanni's friezes (doc. 166). A silk sash, or *cintola*, with gold borders or tassels was produced for the feast of the Assumption of the Virgin in August 1422 by the workshop of Bartolommeo di Vieri (doc. 167); it was replaced in 1435 with one made of copper by the Sienese goldsmith Andrea di Ciecho (doc. 176). These ephemeral *cintole* were designed as facsimiles of the relic at Prato (Schoenholzer-Nichols 1995). The background of the relief seems to have been painted blue; the exposed white marble of the figures was probably highlighted with gold (docs. 174, 175) (Pope-Hennessy 1980).

The outermost reveals of the Porta della Mandorla are decorated with eight lion heads of green granite in relief (now considerably broken), inserted in white Carrara marble quatrefoils, the lobes of which are encrusted with red Florentine lilies (fig. 84). Although particularly beautiful and iconographically meaningful, the outer reveal friezes have been neglected by scholars except brief mention by Semper (1875) and Gatti (1992). Semper (1875) ascribed the manufacture of the friezes to Antonio and Nanni di Banco together with Niccolò Lamberti in the early years of the fifteenth century. Gatti (1992) was correct in his assertions that they are one of the most prominent features of the portal. The outermost reveal friezes (fig. 84), which are as exquisitely designed as the candelabra intarsia of the tympanum, serve to underscore the meaning of the Porta della Mandorla as a civic site. I propose they were designed and manufactured by Nanni di Banco (and his shop) together with the tympanum of the portal, in the project of 1414–22. The lion and lily frames, whose side faces are intricately set with geometric intarsia and rosettes, probably belong to the group of various "frames and friezes" that were made and arranged by Nanni di Banco (docs. 162, 163).

The theological history and iconography of the Assumption of the Virgin, and the history of the "Madonna della Cintola" in Tuscany have been discussed by Gatti (1992), Gherardini (1995), and Lessanutti (1996).

Jacopo da Voragine's relatively long narrative about the Dormition, Assumption, and Coronation of the Virgin (1924) was composed from various hymns, homilies, sermons, popular legends, and scriptural references evolved over the centuries (Rossi 1940). Because the sacred *cintola* of the Virgin is preserved as the principal relic of the cathedral of Prato, the episode of the ascendant Virgin handing her sash down to Saint Thomas was a favorite theme of manuscript illuminations, panel paintings, frescoes, and sculpture in Tuscany (Grassi 1995). Nanni di Banco's version, which shows the Assumption of Mary (who is borne aloft in a mandorla by musical angels) and the donation of the *cintola* to Saint Thomas taking place in a single instantaneous moment, does not deviate from the local tradition of pictorial precedents as typified by Orcagna's Tabernacle of the Virgin (fig. 68).

It is clear that Nanni di Banco followed an explicit iconographic program for the tympanum, because in 1422, Donatello was hired to complete the work by making relief profile busts of *Prophets* (figs. 62, 63) to be inserted at the outer corners of the bordering frieze (doc. 166). Had these *Prophets* not been part of an original iconographic itinerary, it would have been easier to simply fill the two small spaces with decorative carving or marble intarsia: as it is, the two heads are practically invisible from the street below. These busts (like the more conventional standing prophets that flank Orcagna's *Assumption*) probably represent two of the several Old Testament figures most frequently quoted in the religious literature of Mary's Assumption, and not Saints Peter and John Evangelist as argued by Baldinucci (1681–1728). Here they are tentatively identified as King Solomon paired with either Queen Esther or the Queen of Sheba (see chapter 5) and not a sibyl, as has been assumed (Janson 1957, 1963).

An intarsia frieze of alternating candelabra is rendered in striking perspective, as if seen from below, in black (*verde di Prato*) and red on a white ground. One of the lamps is a circular affair, a *corona* hung from three cords, and the other module is composed of six prongs emanating from a central spherical body. Del Bravo (1977) proposed that the design for this intarsia frieze was supplied to Nanni di Banco by Filippo Brunelleschi, but this claim is unsubstantiated. Dan (1985) characterized the candelabra as being of the imperial "sacro-romanic" type as seen at Aachen (Palatine Chapel) and Hildesheim.

The lower right corner of Nanni di Banco's *Assumption*

is occupied by a bear scrambling toward an oak tree in a rocky landscape. The animal's rampant posture closes the triangular composition and mirrors (left-to-right) the figure of Saint Thomas. The meaning of this bear has eluded all known commentators from Renaissance times to the present, representing one of the most intriguing iconographic puzzles in Italian art. Although Orcagna's *Assumption* does include an oak tree in the lower right corner, Nanni's bear is unprecedented among all known Assumption scenes, and no bear is mentioned in known narrative texts. Just as the bear has no precedents, it is equally perplexing that none of the reliefs derived by later artists from the Porta della Mandorla *Assumption* takes on this feature (e.g. fig. 128). Beginning in the sixteenth century critical interpretations of the bear have been hesitant and unpersuasive. In Vasari's first edition (1550), he admitted that there were divergent opinions about its meaning, but that he himself believed the bear represented the devil. In the second edition (1568), Vasari claimed the bear was simply a kind of caprice; he demonstrates his unconcern by mistaking the oak for a pear tree. The older modern scholarship put forth some improbable suggestions, such as the idea that the Assumption of the Virgin was prefigured by the ascension of Elijah, and Nanni di Banco therefore plucked the bear from the passages relevant to Elijah in the Book of Kings (4:2, 23) and grafted it to the *Assumption* of the Porta della Mandorla (Venturi 1908). Venturi's hypothesis was elaborated by Rose (1981). Eisler (1961) proposed that the sash ("girdle") and the bear (Ursus major) are attributes of Artemis, who is alluded to at the Porta della Mandorla as a prefiguration of the Virgin Mary. Janson (1963), correctly pointing to the bear in Andrea Pisano's *Adam and Eve in the Wilderness* (fig. 77) as a prototype for the motif used by Nanni, concluded that the bear symbolizes the wilderness of sin. Seymour (1966), Bellosi (1966), and Hartt (1987) basically supported Janson's line of thought, as did I (1987b) and Gatti (1992). Taucci (1963, 1976) introduced the possibility of a reference to Saint Gall, for whom the bear is an attribute: the bear would function as an emblem for the section of Florence north of the Porta della Mandorla called San Gallo, in which a hospice for pilgrims, Santa Maria in San Gallo, was located. In an unpublished seminar paper of 1983 (Columbia University), William Stargard, elaborating on Taucci's hypothesis, suggested that if the bear symbolized Saint Gall, the oak tree would represent the source from which the bear gathered firewood at Saint

Gall's request. The most recent interpretations of the bear (Gatti 1992 and Emison 1992) have differed widely in method. Gatti (1992) undertook extremely specific historical research, ultimately pointing to the role of the bear in a symbolic theological system, within which precise ideas about Florentine political liberty were fitted without conflict. Emison (1992), instead, proposed that the bear was meant to be understood as a metaphor taken from vernacular Italian poetry and speech, and that it "serves to convey the idea of jubilation [at the Assumption of the Virgin] inadequately expressed by the figure of Saint Thomas."

Janson (1963) attempted to find precedents for the bear occurring as a representation of desert or wilderness, but his examples (culled from German medieval and Sassanian mythological art) failed to support his argument that the meaning of the motif was well enough codified in Italy to explain its use at Santa Maria del Fiore. Janson's intuition was correct, but he need not have looked as far afield as the pre-Islamic Sassanian world for proof, because several examples exist in the Tuscan art of the late Middle Ages. The most dramatic examples occur in a group of Sienese panel paintings from the circle of Guido da Siena representing the "Stigmatization of Saint Francis" (Torriti 1980; and see Getty, inv. no. 86. PB. 490). Although by no means a constant feature of Tuscan stigmatization scenes, these are examples in which bears seek fruit from trees while Saint Francis lifts his hands to be pierced by the luminous seraph. These bears (figs. 75, 76), while nowhere mentioned in the legends of Saint Francis, are apparently meant to represent the remote and wild location of Monte della Verna in the Casentino — a place described in the legend as "alto e appartato" — where, according to Saint Bonaventure (1951), the stigmatization took place. The figuration of Saint Francis at the viewer's left with arms raised toward a celestial figure, as against a rampant, tree-climbing bear at the right, is analogous to Nanni's Saint Thomas in form as well as content. Other examples of grazing bears representing the wilderness occur in the sculpture of the Florentine Baptistry and in the iconography of baptism in general. On the Baptismal Font in Florence, wilderness scenes with various kinds of trees and animals in the backgrounds of relief panels with scenes of baptism appear to refer to the state of original sin, or the human condition outside baptism. In the *Baptism of the Neophytes* (fig. 78), the background is a woods populated by a reclining stag, a bear, and a lion; in *Christ Baptizing Saint John*, a lion is devouring a stag while two boys gesticulate over the event; and in the *Baptism of Christ*, a lion reclines in a cave under the Baptist's feet while in the woods above, a stag munches fruit from a tree. Similar iconography is used in the *Silver Altar of the Baptist*, as seen in a detail of the dossal by Leonardo di Ser Giovanni and Betto di Geri, where above a scene of the Baptist preaching is depicted the vignette of a bear facing a fox or weasel who climbs a tree for fruit (Becherucci and Brunetti 1969).

When Nanni received his assignment for the relief in 1414 he had several local models of more or less recent stamp from which to choose, including Orcagna's tabernacle at Orsanmichele, Niccolò del Mercia's relief at Prato (Lapi-Ballerini 1995), and Agnolo Gaddi's fresco cycle at Prato in the Cappella della Cintola, which was made in a campaign supervised by Nanni di Banco's associate, Giovanni d'Ambrogio (Ciatti 1995). These sources have long been recognized and discussed (Pope-Hennessy 1955; Janson 1963; Wundram 1965). Nanni adapted a traditional Tuscan design to the steep triangular space of the tympanum above the northeast door of the cathedral.

Kauffmann, in his classic analysis of the *cantorie* by Donatello and Luca della Robbia (1936), stressed that individual elements of sculpture at the Florentine Duomo could be fully understood only in connection with the entire cycle of decoration dedicated to the Virgin Mary there. In keeping with this idea, the medieval ancestry of the tympanum relief is to be sought first and foremost in the scheme of the cathedral itself. By the time the *Assumption* was planned in 1414 Santa Maria del Fiore was encrusted with many images of the Virgin: sculpture above the portals of the facade by Arnolfo di Cambio included the *Virgin and Child Enthroned*, the *Dormition of the Virgin*, and the *Nativity of Christ*. The pair of *Annunciation* figures from niches above the southwest portal of the cathedral, the so-called "Porta del Campanile," stands out as particularly fine (Becherucci 1977; Kreytenberg 1981). The lunette above the Porta dei Canonici was given over to Niccolò di Lamberti's standing *Madonna della Rosa* in 1402, and a stained glass window dedicated to the *Coronation of the Virgin* in the oculus of the west facade was designed by Ghiberti or Mariotto di Nardo in 1404. The *Coronation* had been represented in a mosaic on the retro-facade attributed to Gaddo Gaddi around 1296 (Verdon 1995). By 1414 an *Assumption of the Virgin* was the subject selected to decorate the last of the tympana and complete the pictorial cycle. Nanni di Banco must have been

Fig. 124. *Virgin Annunciate* from Porta del Campanile (detail of fig. 71), 14th century. Marble. Museo dell'Opera del Duomo, Florence

keenly aware of the historical place and iconographic importance of his own contribution to this program, the major theme of which was the glorification of the Virgin Mary. As Nanni's contemporary, Gregorio Dati, described the cathedral in the earliest years of the fifteenth century, the external decoration was a living project, moving gradually toward imminent completion: "Ivi si lavora di continuo e non è compiuta; di fuori è tutto marmo bianco e porfido configure di maravigliosa bellezza intagliate" (Dati 1904). Dati's statement that "la quale chiesa di grandezza e di belezza per tempo avanzerà tutte l'altre che si truovono nel mondo che mai si ricordono," came true in part, especially upon completion of Brunelleschi's cupola; and Dati lived to witness the consecration by Pope Eugenius IV, which must have signaled for many the inauguration of a unified artistic venture. (Dati's optimism was misplaced in one respect, as the facade would be destroyed by the Medici dukes in the sixteenth century.) The sculptural decoration at the time, then, with an eye toward completion, was synthetic and coherent as well as grand.

The two main protagonists of Nanni di Banco's *Assumption* are related to earlier figures in Tuscan sculpture. The elongated torsion of the *Virgin Assunta* finds an early prototype in the seated *Sibyls* by Giovanni Pisano in the pulpit at Sant'Andrea, Pistoia. Since Jacopo della Quercia's *Temperance* from the *Fonte Gaia* in Siena also follows the Giovanni Pisano type, Wundram (1965) proposed that this was a reason that Vasari took the *Assumption* to be a work by Quercia. The Saint Thomas is quoted from Orcagna's Saint Thomas in the lower left section of his Orsanmichele tabernacle relief. The more vertical space occupied by Nanni's figure to some extent cramps the breadth of gesture and eliminates the flying drapery of Orcagna's model; but the contours of the pose, distribution of drapery, pure profile view of the head, and to some extent even the configuration of the hands, are similar. In Nanni's Saint Thomas the construction of the drapery is more vigorous, and the head generally softer than Orcagna's prototype, with the characteristic plastic modeling of hair that we know from works such as the *Saint Philip*.

The typological source for the Virgin in the mandorla is the life-size standing *Annunciate* that was recently moved into the Museo dell'Opera del Duomo from the right-hand tabernacle above the southwest portal (Porta del Campanile), probably carved in the later years of the trecento (figs. 71, 124). (For the *Annunciate* see Becherucci 1977 and Kreytenberg 1981, 1995. For the connection with Nanni's figure see Bergstein 1987b; followed by Neri-Lusanna 1996.) Although all major statues of the Virgin at the Florentine Duomo wear fleur-de-lis crowns and flowing veils, the costume of Nanni's *Assunta* (the only image of the Madonna that we know to have been carved by him) seems to have deliberately appropriated the style of crown and veils, and the superabundance of fabric in the cloak and dress, from the *Annunciate* on the south side of the church. That the two figures portray the same person at two different historical moments of her life is emphasized by details in each costume: the trecento *Annunciate* wears a conspicuously long and tasseled cintola, presumably modeled on the relic at Prato, as were the (silk or metal) sashes that Nanni's Virgin would hand down to Saint Thomas. Whereas the neck of the earlier Virgin *Annunciate* is left uncovered, that of the Porta della Mandorla Virgin is encased in the traditional coif of an older woman, such as the one worn by Orcagna's Virgin, and by the statue presently above the northwest door of the cathedral (Planiscig 1946). It is clear that Nanni di Banco arrived at the notion of monumental feminine grace expressed in his Virgin of the Mandorla by orienting his work to the matrix offered by this earlier statue from the Porta del Campanile. A comparison of the two figures shows that Nanni took from the earlier work the elongated proportions of the head and the typological make-up, if not carving style, of the facial features. The tilt of the head on a long slender neck is the same, as are the lines of the veil in relation to the turned head, neck, and shoulders. Indeed, the monumental, long-legged proportions of the two figures are similar, as is the idea of the expressionistic use of large amounts of soft, clinging drapery. Each figure possesses an underlying *flessuosità*, strength, and the affectation of a graceful torsion, qualities foreign, for example, to Arnolfo di Cambio's *Enthroned Madonna* or Niccolò Lamberti's *Madonna della Rosa* from the Porta dei Canonici. Nanni's choice of a prototype for his *Assunta* was motivated by more complex reasons than simply a nostalgic gothic revival: such typological continuity was not only a formal means to an end; it was a conscious expression of unity in the sculptural cycle of the cathedral, which culminated here in the frontispiece of the Porta della Mandorla, the last of the portals to be decorated. In this vein, it is no surprise that the style of the landscape details of Nanni's relief — an oak tree and an outcropping of jagged rocks — seems to have been influenced by the charming relief panel of an oak tree with two dogs currently in the courtyard of Palazzo Medici-Riccardi, because at the time this fragment was in situ on the facade of the cathedral as part of an *Annunciation to the Shepherds* (Weinberger 1941).

Nanni's *Assumption* relief retains the familiar device of an absolutely flat, neutral ground from which all figuration emerges. But the varied depth of carving here, from the very low, almost *schiacciato*, flattening of forms toward the ground, to passages that are articulated in full three-dimensionality, produces a depth into pictorial space that pulses and breathes with atmospheric color (Niehaus 1998). This can be observed even within the precinct of the mandorla: here the flat, graphic quality of the Virgin's covered foot, which in all three dimensions rests on the crest of a wing, and on the edge of the mandorla frame; from between the Virgin's extended hands the personage of a cherub pushes himself forth from the neutral background into gradually higher and higher relief, whereas his lateral cherubic counterpart sinks back behind the mandorla frame. Subtle modeling toward and away from the ground plane is char-

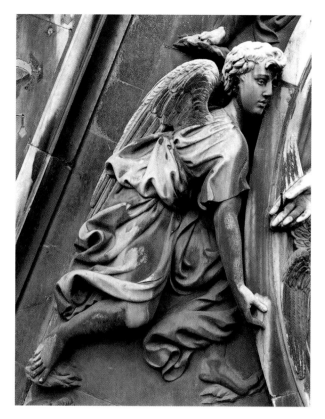

Fig. 125. Nanni di Banco, *Assumption of the Virgin* (cat. 1-12, detail), 1414–22. Marble. Santa Maria del Fiore, Florence

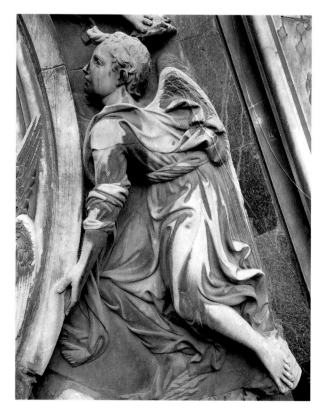

Fig. 126. Nanni di Banco, *Assumption of the Virgin* (cat. 1-12, detail), 1414–22. Marble. Santa Maria del Fiore, Florence

acteristic of the handling of draperies, wings, and limbs of all the angels, creating a pictorial atmosphere that includes an almost infinite variety of levels of depth. Such variety in the sculptural planes of masses can be effectively contrasted, for example, to Orcagna's composition where the (equally impenetrable) background asserts itself in a complex, beautiful, and obviously expensive, marble mosaic pattern. Orcagna's figures and trees float comfortably in front of this ground: the depth of their forms is in no way capable of compromising the flatness and hardness of this inlaid surface; even the mandorla, which possesses its own architectonic solidity, seems to be suspended considerably forward of the background.

Critics such as Bellosi (1966) who have referred to Nanni di Banco's *Assumption* as "baroque" probably had in mind the insistently curvilinear rhythms of the draperies, the propulsion of the angels (figs. 125, 126), and the serpentine postures of some of the figures. But a comparison with Italian sculpture of the seventeenth century is not irrelevant to the *Assumption* in terms of the technical working of marble, for here Nanni has approached the expression and optical and textural "color" that we discover two hundred years later in works like Bernini's *Apollo and Daphne*. The youthful personae in the *Assumption* hardly invite the artist to describe the topography of the face as had the earlier, more mature saints, such as *Saint Luke* and the *Quattro Coronati*: nevertheless an exquisite variety of surface color is brought forth in the crackling oak bark; pelt and claws of the bear; the alternately flame and ropelike strands that make up the hair of the lower left angel (fig. 65); the highly suggestive confection of hair and amaranth leaves crowning the seminude shawm player above (fig. 64); in the pneumatic softness of the bagpipe (fig. 127) and in the puffed cheeks of the right-hand shawm player (fig. 72). This essay into the world of sculptural color was perfectly suited to the high relief medium of the tympanum of the Porta della Mandorla. The descriptive pictorial carving is complemented by the delicate, precise geometry with which the marble intarsia frieze of alternating lamps is constructed, and by the freely undulating agitation of the acanthus volutes — each one is different from the next — with which the composition is crowned.

Several sculptural compositions in Tuscany follow directly from the design of the Porta della Mandorla *Assumption*. Among these are: the relief carved by Andrea Cavalcanti called "Il Buggiano" on Brunelleschi's design for

the pulpit at Santa Maria Novella; Antonio Rossellino's *Assumption of the Virgin* for the pulpit of the cathedral of Prato (fig. 128); Giovanni della Robbia's *Assumption of the Virgin* at Barga (Lucca). Stylistic and technical influences from Nanni di Banco's frontispiece relief can be recognized in the works of sculptors who followed him, such as Bernardo and Antonio Rossellino, Lorenzo Ghiberti, Dello Delli, Verrocchio, and others (Planiscig 1946; Seymour 1966; Wundram 1969).

Almost every scholar who has considered Nanni's *Assumption* relief carefully has come away with the conclusion that it contains the roots of Luca della Robbia's art. Pope-Hennessy (1968, 1980), Seymour (1963, 1966), Bellosi (1981), and Gentilini (1992) have all proposed, on the grounds of chronological coincidence as well as stylistic continuity, that the young Luca della Robbia received his training as an assistant to Nanni di Banco during the production of the Porta della Mandorla tympanum. Seymour (1963, 1966), followed by Becherucci and Brunetti (1969), imagined the concrete participation of Luca in the carving of the *Assumption* relief: they believed that the reason we know little or nothing of Luca della Robbia before 1431 (the year he was commissioned the marble Cantoria) is that he was not yet an independent master but rather the actual heir to Nanni di Banco's shop after Nanni's untimely death. Pope-Hennessy (1968, 1980) apprehended the problem more cautiously, suggesting the possible evidence of Luca's hand in, for example, the two cherubs flanking the Virgin inside the mandorla; he concluded that even though Luca may not have had any association at all with the *Assumption* relief, it was a work he knew well and one that had a profound influence on his style. This idea was endorsed strongly by Bellosi (1981). Even allowing, however, for the theory that Luca was Nanni's pupil and therefore may have carved passages of the *Assumption* under his master's supervision, a critical appraisal of the exact extent to which his hand appears, or whether it appears at all would be difficult. Experts agree that it is practically impossible to determine where and when the "late" style of Nanni di Banco stops and is taken up by the young Luca, or whether perhaps the master was ultimately influenced by his pupil. As Pope-Hennessy (1980) noted, Luca della Robbia was twenty-two when the tympanum relief was installed and thirty-five when he completed the Cantoria, so that a stylistic evolution connecting one work to the next should be sought cautiously.

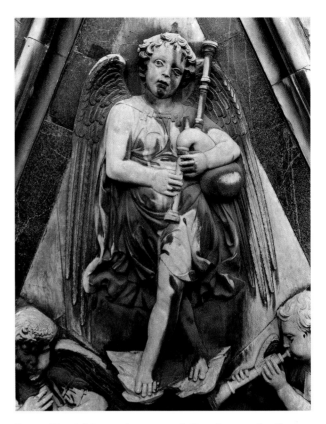

Fig. 127. Nanni di Banco, *Assumption of the Virgin* (cat. 1-12, detail), 1414-22. Marble. Santa Maria de Fiore, Florence

Fig. 128. Antonio Rossellino, *Assumption of the Virgin* (detail of pulpit), 1473. Gilded marble. Cathedral of Prato

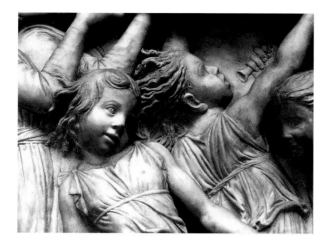

Fig. 129. Luca della Robbia, *Trumpeters* (detail), ca. 1435. Marble. Cantoria, Museo dell'Opera del Duomo, Florence

Nonetheless, a systematic visual comparison of Luca della Robbia's Cantoria reliefs against Nanni's *Assumption* does reveal some specific morphological similarities. Pope-Hennessy's (1980) identification of a "younger" hand in the heads of the cherubs in the mandorla seems plausible: the two flanking cherubs are different enough from each other to have been made by two different artists, but both of them are fairly convincing prototypes for Luca's *Cymbal Players* and *Tambourine Players*; the right-hand cherub, with his tilted head and wavy hair, anticipates the heads of the younger boys (those carved in very low relief) in the *Boys Singing from a Scroll*. Also, the head of the left-hand cherub is oddly large and strikingly three-dimensional in proportion to his body, vaguely suggesting a different hand. The interval of at least a decade between the *Assumption* and the Cantoria, and the fact that the Porta della Mandorla sculpture is corroded and depatinated from exposure, would account for certain textural differences. Perhaps these two cherubs, and the one beneath the Virgin's feet, were the parts added "sub figura . . . marie" (doc. 165).

The lower left-hand angel of the *Assumption* (fig. 65), with flying hair of a matted, ropelike texture interbraided with leaves and tendrils, is recalled by the central, reaching figure of a female child in Luca's *Trumpeters* panel (fig. 129). The facial type of the lower right angel of the *Assumption* (who stares straight out at the beholder), with bags under his eyes, fleshy neck, configuration of hair at the top of the forehead, and slightly pursed structure of the mouth, resurfaces in Luca's androgynous *Psaltery Player* of a decade later, and, to some extent in the figure at the right of the panel from one end of the Cantoria, *Boys Singing from a Scroll*. Luca

della Robbia's *Choral Dancers*, especially the central figure rendered in flat relief, derive from the piquant cross-legged stance of the angel with a bagpipe at the apex of Nanni's frontispiece. In the final analysis, all the angels of the Porta della Mandorla relief are generic precedents for Luca della Robbia's Cantoria, including the two youths who support the mandorla from above, at the central level of the triangular field: although the head of the left-hand adolescent seems to be too cool to belong to the vision of the essentially exploring, realistic Nanni, it is equally distant from Luca della Robbia's characteristic style as we know it from the Cantoria. Even considering the upturned corners of his eyes and sensuous mouth, there is little evidence (as of 1999) to believe, as Vaccarino (1950) suggested, that the head results from a later restoration.

DOCUMENTATION

Docs. 108, 117, 120, 131, 135–37, 143, 154, 156, 161–67, 174–76.

SOURCES

1510, Albertini: "La porta della Assumptione marmorea per mano di Iohanni Banchi."

1516–30, Antonio Billi: [Nanni di Banco] "et sopra la porta di s.ta Maria del Fiore che va alla Nunziata, una Asuntione di Nostra Donna bellissima."

1537–42, Anonimo Gaddiano: [Nanni di Banco] "Fece a santa Maria del Fiore sopra la porta del fiancho che va alla nunziata, di fuora una asuntione di Nostra Donna di marmo dj basso rilievo, che è bella compositione."

1550, Vasari (Life of Nanni di Banco): "Dicono alcuni che il Frontispizio sopra la porta di Santa Maria del Fiore che va a' Servi, fu di sua mano [Nanni di Banco], il che molto più lo farebbe degno di lode, se fosse così, per essere tal cosa certo rarissima. Ma gli altri lo attribuiscono a Iacopo della Fonte, per la maniera che vi si vede: la quale molto piu è di Iacopo, che di Nanni."

1550, Vasari (Life of Jacopo della Quercia): "Ora mentre che la fama di Iacopo [Jacopo della Quercia], si andava così dilatando, egli venne in Fiorenza et sopra la porta del fiancho di Santa Maria del fiore, che va a la Nunziata fece di marmo una assunta: la quale con tanta grazia et con tanta bontà e fine condusse: che oggi quella opera è guardata da gli artefici nostri per cosa maravigliosa: et in ogni età, il medesimo è sempre stata tenuta. Veggonsi le movenzie delle sue figure con una grazia et con

una bontà espresse: e le pieghe de panni suoi con bellissimo andare di falde, et maestrevole circondar d'ignudo a perfetta fine mirabilissimamente condotte. Figurò in tale opera Iacopo un San Tomaso, che la cintola piglia: et dall'altra banda fece un Orso, che monta su un pero del significato del quale perchè variamente sentono gli huomini, dirò sicuramente io ancora una mia opinione: Lasciandone tutta volta il giudizio libera chi sa trarne miglior construtto. Pare a me, che è volesse intendere, che il Diavolo significato per l'Orso ancora che egli salga nelle cime degli alberi, cio è alla altezza di qual si voglia Santo, perchè in ciascuno truova qualche cosa del suo: Non riconosce niente dimanco in questa Vergine gloriosissima nè vestigio nè segno alcuno, dove egli abbia punto che fare: Et però che in alberato, si rimane giù basso: dove ella ascende sopra le stelle. Et che di questo non si contenta, contendisi almeno de la risposta che a Luciano già fece Omero de'l principio del suo Poema, cio è, che gli venne all'ora a proposito, di fare così. Ecci opinione di molti, che questa opera fusse di mano di Nanni d'Antonio di Banco Fiorentino la qual cosa non può essere: prima perchè Nanni non lavorò le cose sue in tanta perfezzione: l'altra la maniera è da la sua differente: et alle cose di Iacopo molto più somiglia. Trovasi nella allogazione delle porte di San Giovanni, Iacopo esser stato di quelle in concorrenza fra i maestri, ch'a tal lavoro furono eletti: in far saggio d'una storia: et era egli stato in Fiorenza quattro anni, innanzi che tale opera s'allogasse. Dove non si vedendo altra opra di suo, se non questa, è sforzato ogniuno a credere, che ella sia più condotta da Iacopo che di Nanni."

1550–63, G. B. Gelli: "Se la morte non ci toglieva nella sua giovanezza Giovanni di Bancho cittadino fiorentino quella età aveva forse il quarto che l'arrecava fama, inperò che di costui si videro opere che non gli non era da sperare pocho in lui, come potrà chiaramente giudicare che considera diligentemente quella assunzione di nostra Donna che è sopra la porta di santa Maria del Fiore che va alla Nunziata, la quale è di sua mano, et l'arte e il disegno che vi è dentro sia varia e bella la sua composizione."

1568, Vasari (Life of Nanni di Banco): omits any mention of *Assumption*.

1568, Vasari (Life of Jacopo della Quercia): "Vedendo poi Iacopo a Firenze, gl'Operai di Santa Maria del Fiore, per la buona relazione avuta di lui, gli diedero a fare di marmo il frontespizio che è sopra la porta di quella chiesa, la quale va alla Nunziata; dove egli fece in una mandorla la Madonna, la quale da un coro d'Angeli è portata, sonando eglino e cantando, in cielo, con le più belle movenze e con li più belle attitudini — vedendosi che hanno moto e fierezza nel volare — che fussero insino allora state fate mai. Similmente la Madonna è vestita con tanta grazia e onestà che non si può immaginare meglio, essendo il girare delle pieghe molto bello e morbido, e vedendosi ne' lembi de' panni che e' vanno

accompagnando l'ignudo di quella figura, che scuopre coprendo ogni svoltare di membra; sotto la quale Madonna è un San Tommaso che riceve la Cintola. Insomma questa opera fu condotta in quattro anni da Iacopo con tutta quella maggior perfezione che a lui fu possibile, perciò che oltre al disiderio che aveva naturalmente di far bene, la concorrenza di Donato, di Filippo, e di Lorenzo di Bartolo, de' quali già si vedevano alcune opere molto lodate, lo sforzarono anco davantaggio a fare quello che fece; il che fu tanto, che anco oggi è dai moderni artefici guardata questa opera come cosa rarissima. Dall'altra banda della Madonna, dirimpetto a San Tomaso, fece Iacopo un orso che monta in sur un pero: sopra il quale capriccio come si disse allora molte cose; così se ne potrebbe anco da noi dire alcune altre, ma le tacerò per lasciare a ognuno sopra cotale invenzione credere e pensare a suo modo."

BIBLIOGRAPHY

Bocchi 1591, 44; Baldinucci (1681–1728) 1974, 1:421–29; Richa 1754–62, 6:25; Moroni 1841, 7:206–7; Migne 1844–46, passim; Cavallucci 1873, 20; Semper 1875, 30–31; Cavallucci 1881, 107; Bode 1884, 669; Guasti 1887, 11–13, 316–18, doc. nos. 465, 476; Schmarsow 1887, 146; Sinding 1903, passim; Dati 1904, 45; Poggi-Haines 1: doc. nos. 397, 398; Venturi 1908; Wulff 1913, 99–164; Voragine 1924, 3:977–1002; Muté 1924, 3:47; Kauffmann 1936, 71–73; Eisenhofer 1940, 110; Rossi 1940, passim; Weinberger 1941, 70–71; Planiscig 1946, 39, 43–44; Antal 1948, 306; Vaccarino 1950, 48; Bonaventure 1951, 149–52; Pope-Hennessy 1955, 220; Janson 1957, 17; Eisler 1961, 86; Janson 1963, 98–107; Seymour 1963, 99–105; Tanucci 1963, 3–5; Wundram 1965, 121–29; Bellori 1966, 5; Seymour 1966, 64–65, 176; Becherucci and Brunetti 1969, 1:255–56; Holmes 1969, 209; Righetti 1969, 2:115–20; Wundram 1969, 121–29; Avery 1970, 60; Watson 1974, 116–17; Echols 1976, 30–31, 35–36; Tanucci 1976, 104–5; Becherucci 1977, 184–95; Del Bravo 1977, 759–79; Bellosi 1978, 144; Middeldorf 1978, p. CXIII; Parronchi 1980, 30–31; Pope-Hennessy 1980, 11–19, 79–93; Saalman 1980, 9; Torritti 1980, cat. nos. 4, 5, 313; Verdier 1980, 161; Bellosi 1981, 62–71; Kreytenberg 1981, 52–61; Rose 1981, 34–35; Dan 1985, 18; Bergstein 1987a, 55–82; Bergstein 1987b, 354–420; Hartt 1987, 170; Bergstein 1991, 673–719; Emison 1992, 381–87; Gatti 1992, 42–57, 68, 235–38; Gentilini 1992, 16–17; Ciatti 1995, 163–223; Gherardini 1995, 75–77; Grassi 1995, 23–39; Kreytenberg 1995, 73–155; Lapi-Ballerini 1995, 281–91; Schoenholzer-Nichols 1995, 79–81; Verdon 1995, 19–30; Lessanutti 1996, 184–85, 200, 208, 215, 219; Neri-Lusanna 1996, 29; Niehaus 1998, 126–28.

1.13 *Four Agnus Dei reliefs*

1419
Originally located on two farmhouses at San Pietro
a Monticelli (Florence), the panels are lost

ATTRIBUTION AND DATING
In July 1419, after the production of two *stemmi* for the
papal apartments at Santa Maria Novella, the Arte della
Lana commissioned Nanni di Banco to carve four more
escutcheons of the *Agnus Dei*, this time not under the juris-
diction of the Opera del Duomo, but for two farmhouses
in the area of San Pietro a Monticelli that had recently
been acquired by the guild (docs. 142, 145). The archival
sources present some question as to whether Nanni di
Banco completed all four of the *stemmi*, abandoned the
assignment altogether, or carved two of the four *Agnus Dei*,
leaving the others to be made by another artist, Nanni di
Fruosino, called "Testa" (doc. 147). Nanni di Fruosino was
an artisan known to have done painting as well as sculpture;
his speciality within the orbit of the Opera del Duomo
seems to have been the gilding or polychrome decoration of
carved sculpture (doc. 147). It is attractive, therefore, to
imagine he and Nanni di Banco working together on the
four *Agnus Dei* of 1419, with Nanni di Banco responsible for
the carving and Nanni di Fruosino completing the painted
decoration and installation.

Although a number of old farmhouses still exist in
Monticelli near the Benedictine convent of San Pietro,
none of the four escutcheons has been located, and they
must still be considered lost works, as was confirmed by
Sac. Lamberto Mercantelli of the parish of Santissimo
Crocifisso, Monticelli, in an unpublished letter of 12 July
1985. Fortunately, the *Agnus Dei* at Santa Maria Novella (cat.
1-11), documented and intact, provides a standard by which
we could identify the stones at Monticelli should they
come to light, as well as any other such works that may sur-
face in the future.

DOCUMENTATION
Docs. 142, 145, 147.

11.1 *Saint Christopher*

Fifteenth-century European goldsmith
Bronze, height 8 ¼ in. (21 cm)
Museum of Fine Arts, Boston

The solid-cast bronze statuette is in fine condition; the staff in his right hand is broken off and looks like a scroll. Inscribed "1407" on the sole of the left foot.

The figure has a known provenance in Budapest in the collections of Steven de Marczibányi (until 1872) and I. Rakovszky (until 1912); sold to Dr. Emil Delmár in 1912; and subsequently (1951) to the Museum of Fine Arts, Arthur Tracy Cabot Fund (51.412).

ATTRIBUTION AND DATING
Early research gave the work to a variety of artists, including Peter Vischer the Elder of Nuremberg (Meller 1926), the Milanese Matteo Raverti, and Niccolò Lamberti (see Swarzenski 1951). Bibliography before 1965 was reviewed by Balogh (1965). Planiscig and Kris (1936) attributed the piece to the "circle of Brunelleschi and Ghiberti." Swarzenski (1951) was the first to bring the statuette into the orbit of Nanni di Banco, attributing it to Nanni working under the influence of Ghiberti or to an anonymous artist in the sphere of Ghiberti and Nanni; his ascription was followed by Krautheimer (1956) and Muller (1962). Lisner (1967) also saw the statuette as Florentine, placing it in direct relation to Donatello's circle, possibly by an older goldsmith, whose style was congealed by 1407. This idea was accepted informally by Brunetti (cited by Lisner 1967) who then published the opinion (Brunetti 1968). Swarzenski later settled on an attribution to Brunelleschi (1958), which was followed by Balogh (1965). Darr (1985) ascribed the statuette to the "circle of Lorenzo Ghiberti." Later Darr (1989) proposed that the date "1407" was inscribed long after the figure was chased, and not at the time of making. According to Darr (1989), the present verbal consensus (Kathleen Weil-Garris Brandt; Konrad Oberhuber; Anthony Radcliffe) is that the work is northern European in origin and dates from the later fifteenth century; this attribution has returned to the earliest speculations about the statuette.

Nanni di Banco is not known to have worked as a goldsmith; but even assuming he worked in metal, the construction of the face and beard of this piece is antithetical to his style and precludes an attribution. Were the inscription "1407" original, however, one would think of Lorenzo Ghiberti's proclaimed affinity for the northern goldsmith-teacher he called Gusmin: *Ghiberti* 1974; Bellosi 1978; Sisi 1978; Battisti 1981; Paolucci 1990.

BIBLIOGRAPHY
Meller 1926, cat. no. 5; Planiscig and Kris 1936, cat. no. 1; Swarzenski 1951, 84–95; Krautheimer 1956, 83; Swarzenski in Detroit 1958, cat. no. 220; Muller in Vienna 1962, 303; Balogh 1965, 12–49; Lisner 1967, 86 n. 14; Brunetti 1968b, 106–11; *Ghiberti* 1974, 47–50; Bellosi 1978, 26–27; Sisi 1978, 35–37; Battisti 1981, 42–45; Darr 1985, cat. no. 6; Darr 1989, 11; Paolucci 1990, 25.

11.2 *Head of an Angel*

Antonio di Banco (?), ca. 1400
Pietra dura, preserved height 6¾ in. (17.5 cm)
Museo Archeologico, Florence

Worked in the round, with several chips and abrasions, the head is presumably a fragment of a standing figure. It was possibly found in the gardens of the Palazzo della Crocetta (current seat of the Museo Archeologico) together with other sculpture from the original facade of Santa Maria del Fiore. Presently conserved in storage (inv. no. 91245).

ATTRIBUTION AND DATING

Neri-Lusanna (1996) has attributed the *Head of an Angel* to Nanni di Banco, primarily on the basis of its similarities to the half-length relief angels in the left archivolt frieze of the Porta della Mandorla, which she accepts as being by Nanni di Banco, following Wundram (1962) and Kreytenberg (1972). In the present study these archivolt angels are attributed to Antonio di Banco with much reservation. Neri-Lusanna saw a close kinship between the *Head of an Angel* and Nanni di Banco's *Isaiah* and *Saint Philip* as well, which I do not find convincing. That the head is not antique and that it is located in the storerooms of the Museo Archeologico indicate that it may have been taken in from the gardens of the Palazzo della Crocetta, along with some other fourteenth-century works that had an original provenance on the facade of the cathedral (Salmi 1940), such as the small standing *Angel with a Ribec* by Piero di Giovanni Tedesco (now in the Museo dell'Opera del Duomo). The *Head of an Angel* probably originated in the cathedral workshops around the end of the fourteenth or the beginning of the fifteenth century, as proposed by Neri-Lusanna (1996), whose association with the left archivolt frieze is also credible. The *Head of an Angel* could be given very tentatively to Antonio di Banco, around 1400.

BIBLIOGRAPHY

Salmi 1940, 134–77; Wundram 1962, 97; Kreytenberg 1972, 5–32; Neri-Lusanna 1996, 20–31.

11.3 *Headless Saint*

Florentine sculptor, ca. 1400
Marble, preserved height 63 in. (160 cm)
Museo dell'Opera del Duomo, Florence

The standing figure is missing its head and parts of some fingers of both the gesturing right hand and left hand, which holds the remains of a book. The remaining portion of the figure is in good condition. When the statue entered the museum in 1936 from the courtyard of Palazzo Medici-Riccardi, an antique head, which had been set into the statue at some point, was removed. The "Headless Saint" is generally believed to have had an original provenance in the pre-1587 facade of the cathedral.

ATTRIBUTION AND DATING

The statue was first associated with Nanni di Banco by Reymond (1897–98), and an attribution to Nanni was

claimed "con riserva" by Becherucci and Brunetti (1969). Poggi (1909) had given it to Niccolò Lamberti. Wundram (1960) stated that the figure bore a signature resemblance to the *Annunciation* figures in the same museum (cat. II-6) and concluded that the present statue was the *Saint Barnabas* of 1395–96 made by Giovanni d'Ambrogio for the facade of the cathedral. This attribution has been accepted by Kreytenberg (1972, 1984) and Schulz (1986). Giovanni d'Ambrogio's activity is dated to 1366–1418; he died 18 November 1421 (Ladis 1992), his dates closely coinciding with the career of Antonio di Banco (see docs. 9, 116).

The general relationship of the drapery to the body structure underneath may be associated with standing figures by Nanni di Banco, especially in such passages as the flexed right leg. But certain morphological details deny the possibility of Nanni di Banco's hand. For instance, the drapery gathered in the saint's left hand falls, in sharp ribbon-reversing folds, into angular peaks, an idiom foreign to Nanni's typically softer, fuller drapery style. The *Headless Saint* wears what amounts to a "gothic toga," whereas Nanni di Banco's statues at Orsanmichele tend to be clad in semitogate garments that look extremely classical in their construction.

A noticeably sophisticated definition of engaged and relaxed legs distinguishes this figure from the facade statues by Piero di Giovanni Tedesco and Jacopo di Piero Guidi, making the dating and attribution of this work truly puzzling: Giovanni d'Ambrogio may be a likely candidate. The most searching study to date was that offered by Poeschke (1980), who did not venture to name the author of the *Headless Saint* but acknowledged its importance for the formation of Florentine art. Poeschke also brought this work of sculpture into the context of contemporary fresco and panel painting by relating it to Chapters XXX and XXXI of Cennino Cennini's *Libro dell'arte*.

Whether or not this figure can be identified as the *Saint Barnabas* by Giovanni d'Ambrogio, it must have had a strong impact on Nanni di Banco. Carved around the turn of the century, the naturalistic posture and gesture would have served as an important example for the figures in the *Quattro Coronati* niche.

BIBLIOGRAPHY

Reymond 1897–98, 1:181; Poggi-Haines 1: doc. no. 149; Wundram 1960, 109–21; Becherucci and Brunetti 1969, 1: cat. no. 83; Kreytenberg 1972, 11–13, Poeschke 1980, 17–18; Kreytenberg 1984, 99; Schulz 1986, 10; Ladis 1992, 297–301.

11.4 Campanile Prophet

Giuliano di Giovanni da Poggibonsi
ca. 1410–23
Marble, height 74 in. (188 cm)
Museo dell'Opera del Duomo, Florence

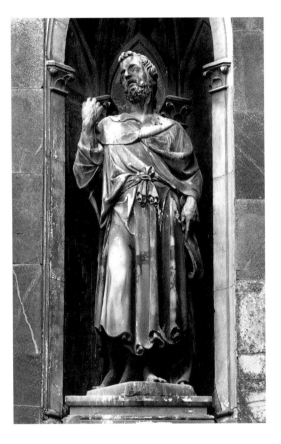

The bearded standing figure wearing a tunic, which is elaborately tied off at the level of the hip, holds a scroll at his left side and gestures upward with his right hand, his gaze directed upward and to his right. The scroll held down below the statue's left hip (spectator's right) establishes this figure's identity as a prophet. The surface is abraded and depatinated, with numerous small chips and fissures; all fingers of the right hand are missing. The remains of two iron securing clamps are embedded in the statue's back at shoulder level; the contiguous base is an irregular pentagon. In 1940 the statue was taken indoors from the second niche from the left on the east side of the Campanile, to which it had been transferred in the fifteenth century, its original location having been presumably on the facade of the cathedral.

ATTRIBUTION AND DATING

Pertinent to any study of the oeuvre of Nanni di Banco is the hypothesis of Wundram, who (following an idea of

Kauffmann 1936) identified this work as the "lost" buttress figure "Isaiah" made in 1408 by Nanni di Banco. Wundram's expanded theory, which posits that Nanni di Banco's *Isaiah* (cat. 1-4) now located in the interior nave of the cathedral is actually Donatello's buttress figure "David," was first proposed at the Donatello congress of 1966 (Wundram 1968) and became the point of departure and sustaining premise for his book *Donatello und Nanni di Banco* (1969). Because Wundram set out to reappraise the reciprocal influences of Donatello and Nanni di Banco, and to reevaluate the art-historical position of Nanni, in many cases revising standard attributions and chronologies of works of art, his argument must be reviewed (at the risk of some redundancy) with regard to the *Campanile Prophet* as well as the *Isaiah* (cat. 1-4).

Outlined synthetically, Wundram's viewpoint follows: he asserts that the statue traditionally identified as Nanni's *Isaiah* is in fact Donatello's marble *David* of 1408–9, that the *Campanile Prophet* is the real *Isaiah* (which served as a prototype for Donatello's pendant buttress statue), and that the marble *David* in the Bargello (fig. 91) was carved by Donatello in 1412, under the auspices of the Opera del Duomo, *ad hoc* for installation in the Palazzo della Signoria. Wundram had accepted Lányi's (1936) identification of the *Isaiah* as one of the two buttress figures, but rejected the Bargello *David* as the pendant: first because the base of the *David* does not correspond in plan with the tops of the buttresses, and second because the refined surface detail of carving (especially in the head of Goliath) and the smallness of the *David*'s head in proportion to the body, would not have been effective from a distance of thirty meters below (Wundram 1969). His alternative was to substitute the *Campanile Prophet* as the "other" buttress figure. Wundram reasoned on the basis of archaeological criteria that the *Campanile Prophet* was installed on the buttresses during the course of the fifteenth century, and that the pentagonal platform and "anchoring devices" (rods attached to the iron hooks in the shoulders) indicate that the figure was created to stand relatively free; it would therefore have been fashioned to stand atop one of the buttresses on the pentagonal base, secured by metal rods in the shoulders (1969).

This pair of buttress figures newly chosen, Wundram was confronted with the problem of authorship (in his argument, style takes second place to an operative premise of archaeological evidence). Realizing that Donatello was not a likely author of the *Campanile Prophet*, Wundram (1969)

concluded that Donatello must have carved the *Isaiah* in the nave of the cathedral either as a "David" without iconographic attributes or as a deliberately nameless prophet, a theory supported by early literature on the statue, which referred to it as Donatello's "Daniele."

With the *Isaiah* once and for all accounted for as Donatello's "David" of 1409, later known as "Daniele," Wundram designated the *Campanile Prophet* the "Isaiah" carved by Nanni di Banco in 1408. Within the context of Nanni di Banco's early career, Wundram pointed to a similarity between the *Campanile Prophet* and the half-length relief figures of angels in the left archivolt frieze of the Porta della Mandorla, which, whether or not they were by Nanni di Banco, would have been produced just prior to the putative "Isaiah" *(Campanile Prophet)*, a grouping felicitously reinforced by Brunetti's earlier ascription of the same combination of works to Nanni di Bartolo (1934), or to whoever might be, as Janson (1972) put it, the "Master of the Archivolt Angels."

Wundram's schema of reattribution was accepted by Herzner (1973a, 1979a) and Kreytenberg (most recently 1995), but it has been vigorously contested by others: Lisner 1967; Brunetti 1969; Gaborit 1970; Janson 1972; Rosenauer 1974, 1993; Parronchi 1980; Poeschke 1980, 1993. Janson's objections (1972) were representative of those of the other critics, centering around the fact that the *Isaiah* and the *Campanile Prophet* bear little resemblance to the known statues by Donatello and Nanni di Banco respectively. Janson asserted that the payment to Donatello of fifty florins in 1412 probably was made toward the recarving of the buttress figure, as the payment was not conclusive, and the sum was not enough for an entire over-life-sized statue. Janson pointed to the fact that the *Isaiah* has no attributes whatsoever of a "David"; he remarked that whereas the Bargello *David* is the compositional mirror image of the *Isaiah*, no such relationship exists between the *Isaiah* and the *Campanile Prophet*; and he questioned both Wundram's assumption that a pentagonal base necessarily indicated that a statue had been designed for a buttress-top and his dubious theory that the ends of the two iron rods in the shoulders of the *Campanile Prophet* were "securing rods" for a freestanding statue.

Pope-Hennessy (1993) argued that the *Campanile Prophet* and the *Isaiah* inside the cathedral correspond to the commissions of 1407/8 (docs. 63, 64) as proposed by Wundram (1969) and Herzner (1973a); but unlike Wundram and

Herzner, Pope-Hennessy recognized the figure inside the Duomo as Nanni di Banco's *Isaiah*, thus concluding that the *Campanile Prophet* was the only surviving figure to satisfy iconographic and archaeological requirements for a "King David" buttress figure by Donatello, and that it represented the ecstatic David the Psalmist, his lips parted in song. For further critique of Wundram's reattribution of the Bargello *David* and the *Isaiah* see cat. 1-4.

An abiding alternative attribution for the *Campanile Prophet* is that of Brunetti, who gave the statue to Nanni di Bartolo (1934, 1969). Apropos Wundram's hypothesis, Brunetti (1968a) briefly entertained the imaginative notion that the Operai may have actually ordered figures to crown all four buttresses of the northwest tribune of the Duomo: she would then include, on the basis of a certain formal "diagonality" and the archaeological feature of pentagonal bases, the *Campanile Prophet* (which she retained for Nanni di Bartolo) and the earliest (second from left) young saint of Nanni di Banco's *Quattro Coronati* group at Orsanmichele among four buttress figures actually produced, together with the *Isaiah* and *David* that are accepted in this study. Lányi (1935) gave the *Campanile Prophet* to Giuliano da Poggibonsi; Poeschke (1993) gave it to "Nanni di Bartolo (?)". Bellosi (1986) tentatively ascribed the statue to "Donatello (?)" and was followed by Paolucci (1990) and Pope-Hennessy (1993). The Donatello attribution was also seen favorably by Olszewski (1997).

As stated in the analysis of Nanni di Banco's *Isaiah* (cat. 1-4), Wundram's realignment of attributions around the commissions for the buttress figures may be rejected on the basis of form. The *Campanile Prophet* could not possibly have served as an exemplum for the *Isaiah*. Whereas it can be associated tangentially with passages in the left archivolt frieze of the Porta della Mandorla — itself an "equation full of unknowns" (Janson 1972) — it is distant from all known statues by Nanni di Banco, in its insistently curvilinear features and flattened stance, as well as the structural treatment of hands, feet, and joints. Lack of documented comparable works by the young Donatello makes Pope-Hennessy's (1993) suggestion equally unlikely.

Any attribution of the *Campanile Prophet* to Nanni di Banco can be summarily precluded by the glib, buoyant posture affected by this figure, the arrangement of the hair and beard in swirling clumps, and the long, downturned shape of the eyes. At close inspection, the fine articulation of wrists, fingers, toes, and the ankles and bones of the feet further prove the statue not to be by Nanni, whose carving of such passages was typically more rudimentary, particularly in the first decade of the century. The fanciful arrangement of bunched drapery in the skirt of the prophet's garment is also antithetical to Nanni di Banco's style.

Brunetti's attribution to Nanni di Bartolo may also be questioned since the *Campanile Prophet's* head and body do not approach the solid beauty of the handsome *Abdias* by Nanni di Bartolo (Becherucci and Brunetti 1969). Brunetti (1934, 1969), Toesca (1951), and Janson (1972) have associated the *Campanile Prophet* with the angels from the left archivolt frieze of the Porta della Mandorla, which are here associated, albeit most cautiously, with Antonio di Banco. Bellosi (1989) and Schulz (1997) are correct in removing the archivolt angels from the career of Nanni di Bartolo, since they would then have to be dated about a decade before his earliest maturity (around 1419) and do not resemble his known works, and in excluding the *Campanile Prophet*, too, because it has no morphological affinity with Nanni di Bartolo's autograph works. Brunetti, however, was not necessarily correct in grouping this statue together with the two smaller *Prophet Statuettes* from the east door of the Campanile (cat. 11-5). The most plausible attribution for the *Campanile Prophet* is still to Giuliano di Giovanni da Poggibonsi (Lányi 1935; Krautheimer 1956; Schulz 1997).

BIBLIOGRAPHY

Brunetti 1934, 258–72; Lányi 1935, 121–59, 245–80; Kauffmann 1936, 197 n. 21; Lányi 1936, 137–78; Toesca 1951, 636 n. 110; Krautheimer 1956, 118 n. 10; Lisner 1967, 77–92; Brunetti 1968a, 277–82; Wundram 1968, 69–75; Becherucci and Brunetti 1969, 1: cat. nos. 121–24; Wundram 1969, 3–11, 150–52, passim; Gaborit 1970, 88–89; Poeschke 1971, 10–23; Janson 1972, 549; Herzner 1973a, 4, 18; Lisner 1974, 232–343; Rosenauer 1974, 28–30; Herzner 1979a, 28; Parronchi 1980, 67; Poeschke 1980, 100; Bellosi 1985, 95–103, cat. no. 17; Bellosi 1986, 47–54; Bellosi 1989, 130–45; Paolucci 1990, 29–30; Poeschke 1993, cat. no. 34; Pope-Hennessy 1993, 17–19, 320 n. 20; Rosenauer 1993, cat. nos. 1, 80; Hirst 1994, 843–44; Kreytenberg 1995, 79; Olszewski 1997, 67–69; Schulz 1997, 71 n. 29.

11.5 *Prophet Statuettes*

Florentine sculptor
ca. 1407–10
Marble, (A) height 34 ½ in. (88 cm);
(B) height 34 ¼ in. (87.5 cm)
Museo dell'Opera del Duomo, Florence

The "Prophet with Turban" (A) must be considered together with its pendant from the east portal of the Campanile, the "Bearded Prophet" (B). Both figures are in poor condition with numerous breaks, abrasions, and mutilations. The "Bearded Prophet" is missing the point of his nose, most of the right hand, the heel of the left foot. Only a fragment behind the left shoulder remains of an ascending scroll originally held in the left hand. The two figures were taken from storage in the Opera del Duomo in 1431 and installed on the lateral pinnacles of the east portal of the campanile (Poggi-Haines 1: doc. no. 307). In this situation the "Bearded Prophet" (viewer's right pinnacle) faced its matching companion, "Prophet with Turban," which stood at the left lateral pinnacle; these flanked a third, archaic-looking "Prophet" figure on the central pinnacle. All three statues were substituted with casts in 1965 and have since been conserved in the Museo dell'Opera del Duomo. The central, archaic "Prophet" (or "Redeemer," as he is alternatively identified) clearly dates from the middle of the trecento and falls outside the scope of the discussion of the pair of figures that flanked him (see Becherucci and Brunetti 1969, 1: cat. no. 73).

Attribution and Dating

Vasari (1568), who believed the figures were *in situ* in an original position on the Campanile, gave the three statuettes to Andrea Pisano under the design of Giotto. Schmarsow (1887) attributed both lateral prophets to Niccolò Lamberti and envisioned that the three figures were arranged together as a Transfiguration scene, with the *Prophet Statuettes* representing Moses and Elijah. Toesca (1951) gave the pair of *Prophet Statuettes* to the sculptor of the left-hand archivolt angels, whom he had identified as Antonio di Banco. Brunetti (1934) had associated the *Prophet Statuettes* with the controversial *Campanile Prophet* (cat. 11-4), dating the smaller statues to around 1410, the larger to around 1422, and giving the entire group of works to Nanni di Bartolo on the basis of style. She associated them with the friezes from the left archivolt of the Porta della Mandorla dating to 1407–9 (in her view, Nanni di Bartolo working in the Lamberti shop). Brunetti's proposal was accepted by Kauffmann (1936) and Paatz (1952–56); and she maintained her original idea of the attribution to Nanni di Bartolo "in a pre-donatellian phase" in the catalogue of the Opera del Duomo (1969), adding to that group of figures the *Man of Sorrows* from the keystone of the Porta della Mandorla, which is here attributed to Nanni di Banco. Bellosi (1989) and Schulz (1997) were surely correct, however, in their logical analyses that if Nanni di Bartolo was born around 1400, he would have been too young to have participated in any of these last-mentioned works. Lányi (1935) and Krautheimer (1956) saw the works as by a single author, but assigned them to Giuliano di Giovanni da Poggibonsi, rather than Nanni di Bartolo, on the basis of some documents that refer to Giuliano from 1410–12 and 1422–23. This opinion was followed by Reggioli (1978). Swarzenski (1951) noted the pair as a fine example of the "International" style in Florence, retaining without question Brunetti's attribution to Nanni di Bartolo. Kreytenberg (1995) following Wundram (1969) assigned the *Prophet Statuettes* to Nanni di Banco, ca. 1410, on the basis of their resemblance to the *Campanile Prophet* (cat. 11-4), which Wundram (1969) had ascribed to Nanni di Banco, calling it his buttress figure "Isaiah" of 1408. Rosenauer (1993) declared the statuettes not by Donatello but accepted none of the other attributions.

All experts other than Pope-Hennessy (1993) have considered the small prophets to be a pair of figures by the same sculptor. Pope-Hennessy, instead, recently (1993) attributed the *Prophet with Turban* to Donatello and the pen-

dant *Bearded Prophet* to Nanni di Banco. According to Pope-Hennessy, these statuettes correspond to a commission of 1406 and were originally intended for installation on the Porta della Mandorla.

At issue here are two claims: Pope-Hennessy's (1993) attribution of the *Bearded Prophet* to Nanni di Banco; and Wundram (1969) and Kreytenberg's (1995) attribution of both prophets to Nanni di Banco. With regard to Pope-Hennessy's idea, it would be enchanting to find in these works the earliest essays in marble sculpture by Donatello and Nanni di Banco, possibly made in *concorso* for the Porta della Mandorla. Pope-Hennessy's proposed scenario, in which the *Prophet Statuettes* were carved during (or even in conjunction with) the second phase of decoration of the Porta della Mandorla, had been previously suggested by Schmarsow (1887), Brunetti (1934, 1969), Kauffmann (1936), Toesca (1951), and Paatz (1952–56), in their recognition of the stylistic proximity to the archivolt friezes. Since for Pope-Hennessy the *Campanile Prophet* was actually Donatello's marble "David" of 1408–9, his historical reasoning would seem to be unconflicted. Elegant as it may appear, however, Pope-Hennessy's hypothesis, which hinges on the proposal that the *Campanile Prophet* be Donatello's first *David*, is flawed, whether it be from a mistaken reading of the documents (Hirst 1994) or from an illogical stylistic grouping. The association of these small *Prophet Statuettes* with the *Campanile Prophet* and the archivolt angels on the basis of style is probably spurious. But what is fundamental in this aspect of the argument is that Pope-Hennessy's scheme lacks the stylistic/morphological evidence that might make attributions to the sculptors Donatello and Nanni di Banco, as we understand their oeuvres, convincing.

All visual information shows that the two figures are by the same sculptor, or possibly two carvers working to the specifications of a single master who finished the works in a unified style. Leaving the Donatello attributions aside for the moment, neither of the two *Prophet Statuettes* is acceptable as a work by Nanni di Banco. In general stylistic terms, the prophets are more lyrical than any work associated with Nanni di Banco. They figure as somewhat precious versions of the *Campanile Prophet* rather than as forerunners for Nanni's somber, monumental *Isaiah*. The expertly drilled excavation of the eyes, mouth, hair, and beard has nothing of the searching restraint present in the heads of *Isaiah* or *Saint Luke*. The *Prophet Statuettes* are attributable to a single mature sculptor working in Florence ca. 1407–10.

SOURCES

1568, Vasari-Milanesi 1:488, attributed to Andrea Pisano.

BIBLIOGRAPHY

Schmarsow 1887, 227; Brunetti 1934, 259; Lányi 1935, 274 n. 1; Kauffmann 1936, 208 n. 109; Swarzenski 1951, 92; Toesca 1951, 363 n. 110; Paatz 1952–56, 3;388–90; Krautheimer 1956, 118 n. 10; Becherucci and Brunetti 1969, 1: cat. nos. 121–22; Wundram 1969, 81–85, 150–52; Goldner 1974, 219–26; Reggioli 1978, 107–8; Herzner 1979a, 27–36; Bellosi 1989, 210; Pope-Hennessy 1993, 19, 320 n. 21; Rosenauer 1993, cat. nos. 76a, b; Hirst 1994, 844; Kreytenberg 1995, 79; Schulz 1997, 21.

11.6 *Annunciation Figures*

Classicizing sculptor (circle of Bartolommeo Cavaceppi?)
Marble, (A) Gabriel, height 54 ¾ in. (139 cm); (B) Virgin, height 55 in. (140 cm)
Museo dell'Opera del Duomo, Florence

Both statues are in fairly good condition. The left ear of the Virgin has been replaced in stucco. Several of the fingers have been broken and

repaired in both figures; the point of Gabriel's diadem has been broken and restored. The eyes of both figures are articulated with lead pupils; the backs of both statues show the remains of metal hooks; Gabriel's shoulders have slots, presumably for the insertion of wings. The pair of statues (possibly from the garden of a villa) was first recorded as property of the Opera del Duomo in the inventory made at the founding of the museum ("Elenco" 1887, inv. nos. 31, 32).

ATTRIBUTION AND DATING

The *Annunciation* has been attributed to Nanni di Banco, around 1407–9, by the following authors: Wulff 1913; Bode 1922; Planiscig 1946; Bottari 1948; Galassi 1949; Swarzenski 1951; Seymour 1959, 1963a, 1966; Parronchi 1976, 1980. Brunetti (1951b, 1952, 1969) argued for an attribution to the young Jacopo della Quercia around 1397, bringing the *Annunciation* figures into the stylistic realm of the reveal friezes of the Porta della Mandorla, where she believed Quercia also participated. Scalini (1990) saw Quercesque resonances in the reveal sculpture as well as the statues, but assigned them more cautiously to an "Annunciation Master." Alternative attributions, all floating close to the year 1400, have been made to Niccolò Lamberti by Rossi (1891); to Jacopo di Piero Guidi by Poggi (1904); and to Antonio di Banco by Schmarsow (1887) and Vaccarino (1950). They have also been given to Piero di Giovanni Tedesco by Reymond (1897–98), to Giovanni d'Ambrogio by Grassi (1951) and Wundram (1960b), who were followed by Cardini (1978) with reservation, and to Filippo Brunelleschi by Ragghianti (1977).

In more recent scholarship, Wasserman (1988) rightly dismissed the attribution of the figures to Nanni di Banco. Taking up the iconographic identity of the two statues, Wasserman suggested that they were "compositionally and iconographically independent of one another," and that the so-called *Virgin* actually represents a young male saint, whom he tentatively identified as *Saint John Evangelist*. Beck (1991) saw in the statues a collaboration between Giovanni d'Ambrogio and his son Lorenzo di Giovanni d'Ambrogio, ca. 1402–4. Poeschke (1993) considered the pair of statues an important enigma of the early Renaissance and dated them to the first decade of the fifteenth century. Tayler-Mitchell (1994) dated the *Gabriel* to the late trecento or early quattrocento, and saw it as a source for Verrocchio's *Saint Thomas* at Orsanmichele. Some antique sources for the heads of the two statues have been discussed by Paribeni (1961) and Greenhalgh (1982).

Scholarship once associated the original collocation of the *Annunciation* statues in the cathedral complex with an *Annunciation* that was removed from the Altar of the Trinity (inside the cathedral) in 1409 (see Poggi-Haines 1: doc. nos. 371, 372). This idea was favored by Poggi (1904) and followed by Planiscig (1946) and Brunetti (1951b, 1952, 1969), among others. Brunetti (1951b) proposed that the *Annunciation* statues were placed in the outdoor lunette of the Porta della Mandorla. Brunetti thickened the Porta della Mandorla theory by citing an archival record which declared that in February 1421/22 a metal lily, held in the hand of the Virgin of the "Porta della nuziata" was cleaned and polished (doc. 164). Brunetti (1969) brought the various documentary notations together according to the following scenario: since in Annunciations, the lily is typically held by Gabriel, and not by the Virgin ("nostra donna"), she believed that the notation of 1421/22 involved a slip of the pen, and that the scribe was in fact alluding to a statue of Gabriel, i.e., the same "Gabriel" that would have been taken from the Altar of the Trinity in 1409. Brunetti posited that the statues of the present *Annunciation* group stood in the outdoor lunette; and that the scribe mistook the angel *Gabriel* for "nostra donna" because *Gabriel* has a more feminine countenance than that of the *Virgin*. The belief, however, that this particular pair of statues ever occupied the Porta della Mandorla lunette is erroneous. Janson (1957) and Wundram (1960b) were correct in rejecting the identification of the *Annunciation* with the objects mentioned in the archival episode of 1409. Wundram (1960b) proved that the dimensions of the statues actually preclude their placement in the Porta della Mandorla lunette: they are simply too large to have fitted; and Wasserman (1988) proved that the depth of the socle strip in the lunette was too shallow to have accommodated these figures. Pope-Hennessy (1980) gave an eminently reasonable analysis when he stated that the metallic lily must have been situated in the hand of Nanni di Banco's ascendant Virgin in the *Assumption* frontispiece relief, which was always known as "nostra donna della Porta della Nunziata," and which in the course of the same campaign was adorned with a gilt-edged silk "cintola" (doc. 167). Briefly stated, the provenance of these two mysterious and beguiling *Annunciation* figures before 1886 remains unknown.

The question of the manufacture of the *Annunciation* is as puzzling as that of its function or provenance, and none of the published attributions or datings is entirely satisfac-

tory. It should be established immediately that the *Annunciation* has no relationship with Nanni di Banco's known style and that this attribution is spurious. When the *Gabriel* and *Virgin* are compared with any of the works documented, or here attributed, to Nanni di Banco, there are great differences. Nowhere in Nanni's oeuvre (and certainly not in the *Isaiah* of 1408) do we find the elegant, sophisticated structure of gestures, the delicacy of sculptural interstices — presumably the hands are restored faithfully — that exist in the *Annunciation*. The drapery folds in the garments of the *Isaiah*, *Saint Luke*, and *Saint Philip* are larger, bulkier, and coarser than those of the *Annunciation*; and the agitated draperies of the *Assumption* are far more spirited and grandiose in their scope. The faces, hands, and draperies of all Nanni di Banco's figures have a fleshy quality that is absolutely denied by the author of the *Annunciation*, where surfaces are hard, smooth, and finite. The articulation of drapery here is too self-conscious in its delicacy to have issued from Nanni's hand: the manner in which drapery falls in intricate ribbons from *Gabriel*'s left hand, for example, uses a visual language altogether unfamiliar to Nanni's sculpture.

No other attribution propelled by the art-historical literature is persuasive. The very general resemblance in type to sculpture created by masters such as Piero di Giovanni Tedesco or Giovanni d'Ambrogio may only point to a local Florentine manufacture. The figures are stylistically remote from the sculpture of Niccolò Lamberti and the known sculpture of Filippo Brunelleschi, who in any case never worked as a figurative stone carver. Antonio di Banco is a more or less unknown entity as a figurative sculptor, documented only as working in the archivolt friezes of the Porta della Mandorla. And much as Schmarsow (1887) and others might have wished to identify Antonio's style as a biological-evolutionary predecessor of Nanni (more archaizing and brittle, but at the same time more "classical"), that is probably not the case. Brunetti's theory of a youthful intervention by Jacopo della Quercia in the Florentine Opera del Duomo is tantalizing, but hypothetical at best; and as observed by Scalini (1990), only Quercia's Ferrara *Madonna* comes remotely close to the hypercrisp aesthetic encountered in the *Annunciation*.

The androgynous, even masculine, nature of the so-called *Virgin Annunciate* has disturbed all experts (fig. 130). The head of the *Virgin* suggests that its model was a youth from the world of Hellenistic art, such as the head of a Syrian prince at the Uffizi. Such an image of the Virgin

Fig. 130. *Virgin Annunciate* (cat. 11-6B, detail). Marble. Museo dell'Opera del Duomo, Florence

would be unique in the fourteenth or fifteenth century, and therefore it presents a fascinating enigma. Wasserman's (1988) proposal that the so-called *Annunciate* represents a male personage may be correct: Borghini (1584) wrote that statues of the Apostles in the cathedral precinct were portrayed holding open books "per denotare chiaramente la facilità e la chiarezza della leggere," and Richa (1754–62) stated that the sculpture on the Duomo facade included figures of Saints Lawrence and Stephen, who as young martyr saints seem to me better candidates than Saint John Evangelist. Still, assuming that the figures were produced as an ensemble, why would an announcing angel be paired with a deacon saint?

The unusual boyishness of the unveiled, close-cropped, filleted head of the *Virgin Annunciate* once tempted me to believe that the head might be a transposed antique or neo-classical substitute for a late Gothic original, indicating two different phases of work on the pair, but close inspection of the piece shows this not to be the case: both statues are seamless at the neck. The slender proportions and crisp verticality of drapery folds seem also to exclude

the possible intervention of sixteenth-century artists, such as Giovanni Bandini ("Giovanni dell'Opera"), who typically brought a preoccupation with muscularity and counterpose to bear in the sculpture that he fabricated and restored for the cathedral. Because the *Annunciation* defies specific authorship in the realm of the fourteenth, fifteenth, or sixteenth century, it would be tempting to imagine a modern sculptor (eighteenth or nineteenth century) creating church statuary of this kind in an archaizing style — mixing gothic and classical elements *ad libertas*. The relatively pristine condition of the figures might support such a conjecture, but even a cursory glance at the sculpture on the cathedral facade produced under the direction of Emilio de' Fabris denies the likelihood of a mid- or late-nineteenth-century artist.

The eighteenth century, however, with its penchant for historical mimicry, androgynous delicacy, and hard, polished surfaces in marble sculpture may provide a better path of inquiry. Bartolommeo Cavaceppi (1716–1799), or a follower, comes to mind as a plausible alternative to previous attributions of the *Annunciation* pair. Cavaceppi's work was highly influenced by Johann Joachim Winckelmann's sense of historicity, and he restored antiquities at the Villa Albani and the Vatican Museum (Pio-Clementino). The head of the present *Virgin Annunciate* recalls Cavaceppi's *Duncombe Discoforos* as well as the marble *Bust of Otto* from the Villa Mattei (see Paul 1985 and Rossi-Pinelli 1986). The tripartite coiffeur of the angel *Gabriel* with its great loop of hair doubled over in back was one that Cavaceppi favored in works such as the terracotta *Bust of Flora* in Berlin (Staatliche Museen, inv. no. 22/78). The *Annunciation* statues exhibit a love of surface, and a graceful transition from one surface to another as though carved for an audience of connoisseurs to be apprehended at close range, as in a private garden. Manufacture by an artist immersed in neo-classical historicism and in the history of the Florentine sculptural tradition might account for the fact that although the heads are highly classical, the draperies were fashioned with deliberate and meticulous "gothicizing" attention, inspired, perhaps, by Orcagna at his best.

BIBLIOGRAPHY

Borghini 1584, 91–92; Richa 1754–62, 6:53; *Elenco* 1887, inv. nos. 31, 32; Schmarsow 1887, 143; Rossi 1891, cat. nos. 95, 96; Reymond 1897–98, 1:182; Poggi 1904, cat. nos. 95–96; Wulff 1913, 115–20; Bode 1922, 65; Planiscig 1946, 15–19, 22; Bottari 1948, 162; Galassi 1949, 61–63; Vaccarino 1950, 18–19; Brunetti 1951b, 3–16; Grassi 1951, 29; Swarzenski 1951, 92; Brunetti 1952, 119–26; Janson 1957, 221; Mansuelli 1958, 1: cat. no. 16; Seymour 1959, 3–16; Wundram 1960b, 109–25; Paribeni 1961, 103–4; Seymour 1963a, 223; Seymour 1966, 51–52; Becherucci and Brunetti 1969, 1: cat. nos. 110, 111; Parronchi 1976, 51; Ragghianti 1977, 19–26; Cardini 1978, 45–46; Parronchi 1980, 53; Pope-Hennessy 1980, 17; Greenhalgh 1982, 93; Paul 1985, 438–39; Rossi-Pinelli 1986, 203–36; Wasserman 1988, 149–65; Scalini in Berti and Paolucci 1990, cat. no. 1; Beck 1991, 1:194; Poeschke 1993, 17; Tayler-Mitchell 1994, 601.

11.7 *Head of a Youth*

Florentine sculptor
Late fifteenth century (?)
Marble, height 7 in. (18 cm)
Museo dell'Opera del Duomo, Florence

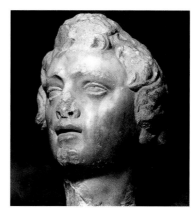

Possibly a fragment of a statue, the head is in poor condition; there are serious breaks and abrasions in the nose, chin, and hair; almost the entire left section of the neck is missing.

ATTRIBUTION AND DATING

Bottari (1948) perceived in the *Head of a Youth* a deep affinity with the *Saint Philip* at Orsanmichele and therefore proposed an attribution to Nanni di Banco. Galassi (1949) correctly recognized this affinity as one of type and mood, rather than manufacture, as did Brunetti (1951). A complete catalogue entry was given by Becherucci and Brunetti (1969) in which the attribution to Nanni di Banco was rejected. My view matches that of Brunetti (1969), who considered the effect of this head much different from those of Nanni, which are always more closed, more metallic in effect. In the

present fragment, the deeply recessed eyes and handling of mouth and chin are clearly far from the *Saint Philip*, despite a similar presentation of a youthful Apollonian type with rich curls. In summary, the fluid *all'antica* unity of this head, motivated by an ineffable inner structure, precludes an attribution to Nanni di Banco. This sculptor, a more sophisticated hand, may have worked a full century later. The *Head of a Youth*, however, demonstrates an historical awareness of the *Saint Philip* at Orsanmichele as well as of ancient statuary.

BIBLIOGRAPHY

Bottari 1948, 159–62; Galassi 1949, 248 n. 35; Brunetti 1951, 105; Becherucci and Brunetti 1969, 1: cat. no. 115.

11.8 *Saint James Major*

Niccolò Lamberti with Piero Lamberti, 1415–22
Apuan marble, height of statue 68¾ in. (175 cm)
Orsanmichele, Florence

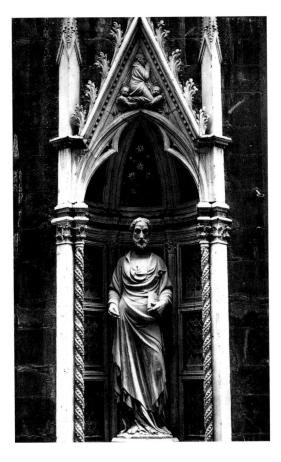

The general surface of the standing bearded figure, patron saint of the furriers' guild, is well preserved, now in the museum of Orsanmichele. The saint holds a book in his left hand, and recent restoration (1989) has revealed traces of gold in the statue's hair and undershirt, as well as gilded cufic lettering on the hems of his garments. Several fingers of the right hand were replaced in the mid-nineteenth century (1858), and earlier engravings (Masselli 1854) indicate that the right hand originally held a metal pilgrim's staff (Zervas 1996). The niche (Orsanmichele, south facade) is also in a good state of preservation; interior panels are inset with a rectangular pattern of colored glass tiles. A relief in the gable of the niche shows a kneeling figure in profile representing the soul of San Jacopo supported in his transit to heaven by two cherubs. The socle contains a central quatrefoil cartouche with a narrative relief carving of the martyrdom of Saint James Major, in a composition strongly reminiscent of Ghiberti's "Raising of Lazarus" from the north doors of the Baptistry.

ATTRIBUTION AND DATING

Albertini's attribution to Nanni di Banco carried into the eighteenth and nineteenth centuries: e.g., Richa (1754–62) and Semper (1875). Bode ascribed the socle relief to Nanni di Banco (1884), giving the statue itself to Ciuffagni. The attribution to Ciuffagni was upheld by Schmarsow (1887b) and Pope-Hennessy (1955). Reymond (1894) attributed the statue to Niccolò Lamberti, and twentieth-century scholarship (Wundram 1967, Goldner 1978, Schulz 1986, Nannelli and Giusti 1989, and Zervas 1996) has been correct in maintaining that attribution. Herzner (1988) wrongly (if bravely) argued for an attribution to Michelozzo as Ghiberti's pupil around 1420–22. Goldner saw the ensemble as finished by 1415 (1410–14 for the statue), whereas Wundram assigned a more likely date of ca. 1422, followed by Zervas (1996) who dated it ca. 1420. Schulz (1986) correctly acknowledged the influence of Ghiberti's figures (Evangelists and Church Fathers) of the north Baptistry doors.

Bode (1884) correctly sensed the presence of a younger sculptor in the socle relief, which is richly influenced by Ghiberti's *Raising of Lazarus* from the north Baptistry doors, and gave it to Nanni di Banco, thus attempting to reconcile visual evidence with the early source material (Albertini). Closer analysis of the socle composition indicates that it was probably executed by Niccolò's son, Piero Lamberti, around 1420 (Goldner 1978; Zervas 1996). For Piero di Niccolò Lamberti's activity in Florence see cat. 1-2, where his possible participation in the archivolt friezes of the Porta della Mandorla is discussed.

SOURCES

1510, Francesco Albertini: "sancto Jacopo è per mano di Johanni Banchi."

BIBLIOGRAPHY

Richa 1754–62, 1, 20; Semper 1875, 78; Bode 1884, 328 n. 2; Schmarsow 1887b, 227–30; Reymond 1894, 385–86; Wundram 1967, 193–207; Goldner 1978, 53–75, 252 n. 141; Mannini 1978, 177–79; Schulz 1986, 10; Herzner 1988, 65–75; Nannelli and Giusti 1989, 180–81; Zervas 1996, 1:453–55, 625–26.

11.9 *Saint Peter*

Follower of Nanni di Banco and Donatello
Carrara marble, height of statue including
base 93 in. (236 cm)
Orsanmichele, Florence

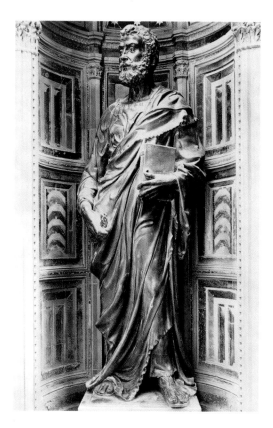

Made from fine-grained marble (formerly damaged by dirt and chipping), the restored figure is in fair condition, now in the museum at Orsanmichele. Two tarnished iron keys are held in the statue's right hand. An inscription in intarsia (now greatly depatinated) in the base reads: "S. PETRUS. AP." The niche is located in the north facade of Orsanmichele, *nearly opposite the fifteenth-century meeting hall of the butchers' guild of which Saint Peter was patron. The face of the gable has a large blank quatrefoil, presumably intended for the emblem of the guild. The interior niche walls are decorated with marble intarsia panels in a "false perspective."*

ATTRIBUTION AND DATING

Following Janson (1957), the most recent summaries of all literature on the *Saint Peter* are presented by Pecchioli (1978) and Zervas (1996). Various sources from the fifteenth, sixteenth, seventeenth, and eighteenth centuries have given the work to Donatello, or called it, as Vasari did, a collaboration between Donatello and Brunelleschi. Scholarly opinions that followed were split between an attribution to Donatello (Semper 1875; Schmarsow 1889, no. 12; Reymond 1897–98) and to Nanni di Banco (Pastor 1892; Knapp 1903; Schottmüller 1904; Schubring 1907; Wulff 1909). Lányi (1935) assigned the *Saint Peter* to Ciuffagni, an attribution endorsed by Janson (1957), who gave it to Ciuffagni midway in his development between the *Evangelist Matthew* of 1415 and the *King David* of 1428; followed by Seymour (1966). Middeldorf (1936) took the opportunity to "protest solemnly against the ascriptions of the most various and often insignificant works to the great artist Nanni di Banco," calling the *Saint Peter* the work of a mediocre follower of Donatello. Planiscig (1946) denounced the statue as a miserable thing, which looked like a collaboration between Ciuffagni, Donatello, and Nanni di Bartolo. Wundram (1969) considered it "later in date than is usually assumed," presumably by a follower of Donatello. Beck (1980) reasserted Vasari's joint attribution to Donatello and Brunelleschi, as had several earlier authors. Poeschke (1980) accepted the *Saint Peter* as autograph Donatello, whereas Bennett and Wilkins (1984) remained uncommitted. Herzner (1988) supported the earlier attribution to Ciuffagni, as did Rosenauer (1993). Bellosi (1993) attributed the statue to Brunelleschi. Zervas (1996) proposed that both the niche and statue were by Brunelleschi and executed by Ciuffagni, with a *terminus ante quem* of 29 June (Saint Peter's day) 1412, when the Company of Orsanmichele gave the butchers' guild a gift of fir branches and candles to decorate the niche.

Proposals of joint authorship can resolve attribution problems with a certain rhetorical ease, and the device has been used freely from the fifteenth through the twentieth century. But in fact it is difficult to visualize two (or three, as

Planiscig would have it) independent sculptors collaborating on a single figure. The division of labor would be awkward and pointless unless the statue were blocked out by one sculptor and finished by another. Nevertheless, I agree with Middeldorf (1936), Planiscig (1946), and Wundram (1969) that the *Saint Peter* ensemble has the look of a pastiche.

The intarsia panels, with their mazelike, perspectival play inside the niche, appear to reflect the vision of Brunelleschi, and the lower (inscribed) section of the base fits well with these panels. The statue itself, which stands on a second, molded base, is derivative of Donatello's Prophets for the Campanile and Nanni di Banco's *Quattro Coronati*. The alternatively "wet" and "starched" drapery effects of the shirt and toga and the torsion of *Saint Peter*'s stance presume knowledge of the *Jeremiah*, *Zuccone*, and *Abraham* from the Campanile; but the arrid, rigidly carved, expressionless head has little to do with Donatello. Indeed, the head, as well as the crimped hem of the toga, betray what can only be described as an inept imitation of Nanni di Banco's *Quattro Coronati*. Could the figure be a relatively late (1420s) production of Brunelleschi or his shop? Must it be assigned to the sculptural scapegoat, Bernardo Ciuffagni? (The head of Ciuffagni's *Saint Mark Evangelist* from the cathedral facade indeed has a similarly brittle construction.) Or could it be, as Wundram (1969) hinted, a more modern (sixteenth-century) work, produced to substitute for an early original? The somewhat mannered torsion of the statue and its placement upon what appears to be an older base, along with the openly derivative qualities of the head and drapery, suggest that the *Saint Peter* may not have been the first statue to have occupied this niche. The dedicatory inscription ("S. PETRUS. AP.") and the crimped edges of drapery, both of which elements follow those of Nanni di Banco's *Saint Philip*, and the facial type, which derives from the *Quattro Coronati*, suggest that the statue of *Saint Peter* may have been designed to conform to the style of the neighboring statues by Nanni di Banco. The interior niche design might be by Brunelleschi, but Middeldorf's ascription of the statue to a "Donatello follower" remains incontrovertible.

SOURCES

Antonio Manetti (before 1472) and Albertini (1510) attributed the *Saint Peter* to Donatello. Following Antonio Billi (1516–30) and the Anonimo Gaddiano (ca. 1537–42), Vasari (1568) called it a collaboration between Donatello and Brunelleschi, finished by Donatello alone.

BIBLIOGRAPHY

Semper 1875, 85–87; Schmarsow 1889, no. 12, 3–5; Pastor 1892, 28–29; Reymond 1897–98, 2:89–90; Knapp 1903, 436; Schottmüller 1904, 63–64; Schubring 1907, 193; Wulff 1909, 29; Lányi 1935, 129; Middeldorf 1936, 579; Planiscig 1946, 27; Janson 1957, 222–25; Seymour 1966, 66; Wundram 1969, 129; Pecchioli 1978, 196–97; Beck 1980, 125–28; Poeschke 1980, 25–26; Bennett and Wilkins 1984, 46; Herzner 1988, 61; Bellosi 1993, 15–40; Rosenauer 1993, cat. no. 83; Zervas 1996, 1:479–80, 620–22.

11.10 *Crucifix*

Donatello
ca. 1407–9
Polychromed wood, 68 x 66 in. (173 x 168 cm)
Santa Croce, Florence

The *Crucifix* has been in place above the altar of the Bardi Chapel since 1571. Older sources state that it was made for the Barbigia family, to be placed above the fourth altar in the left nave of Santa Croce. It is in good condition, most recently restored in 1974. The figure has movable arms, which can also be adjusted in length according to metal inserts at the wrists.

ATTRIBUTION AND DATING

Lányi (1937) was the first to attribute the *Crucifix*, traditionally accepted as Donatello's proverbial "contadino in croce," to Nanni di Banco, on the basis of its likeness to the *Man of Sorrows* from the Porta della Mandorla, which is here attributed to Nanni di Banco. Lányi's observations, which posit the *Crucifix* as the only work of sculpture in wood by Nanni di Banco, had a certain impact, and in the wake of his essays scholars who maintained the traditional attribution of the *Crucifix* to Donatello tended to attribute the *Man of Sorrows* to Donatello as well; those who saw the *Crucifix* as a work by Nanni di Banco took up the *Man of Sorrows* as stylistic evidence of that challenging attribution. The two major proponents of this ordering, both of whom presume a strong stylistic connection between the *Man of Sorrows* and the *Crucifix*, are Lisner (1962, 1970), who gave both works to Donatello, and Parronchi (1976, 1980), who claimed them for Nanni. Lányi's attribution was elaborated by Parronchi (1976, 1980), who proposed the stunning *Crucifix* at Bosco ai Frati as Donatello's "contadino." Janson (1957), however, argued that the similarity between the *Man of Sorrows* and the Santa Croce *Crucifix* (Donatello) indicated "no more than a fairly close chronological relationship between the two pieces." Pope-Hennessy (1976) also retained the Santa Croce *Crucifix* for Donatello and published it as autograph in two monographs (1985, 1993). The consensus in the literature holds that the *Crucifix* was made by Donatello ca. 1407–15 (Martini 1978; Bellosi 1986; Natali 1986; Scalini 1990), which would bring the *Crucifix* closer in date to the period of Donatello's apprenticeship with Ghiberti, 1404–7. Bellosi (1989) called it "the most Ghibertian and therefore earliest work in the canonical catalogue of Donatello," dated around 1410. Avery (1991) gave it to Donatello under the influence of Ghiberti, ca. 1412. Poeschke (1993) gave the crucifix to Donatello ca. 1407–8 and saw it as the model for Nanni di Banco's *Man of Sorrows* from the Porta della Mandorla. Pope-Hennessy (1993) saw a doubtless attribution to Donatello dated to "about 1412 or 1415." Rosenauer instead (1993) favored the attribution to Nanni di Banco and dated the *Crucifix* to ca. 1406–9 for its proximity to Nanni's *Man of Sorrows* (cat. 1-2).

A comparison of the head, arms, and torso of the wooden *Crucifix* with the smaller *Man of Sorrows* relief shows the *Crucifix* to have been made by an artist other than Nanni di Banco. Analysis of the structure, proportion, and surface of the two torsos show the wooden *Crucifix* and small stone relief to be by different sculptors: the *Crucifix* is proportionally thinner, tighter, more angular, and tensile in every part, with the head sunk down deeply between emaciated shoulders. The relief Christ, instead, is characterized by a fullness of forms, and heavy, muscular bulk; the head falls to the left without disturbing the positive symmetry of the shoulders, collarbone, torso, abdomen, and arms. In the *Man of Sorrows* the weight of torso and abdomen project forward strongly; the forearms, themselves exaggeratedly heavy and fleshy, literally reach out, away from the ground and frame. In the Santa Croce *Crucifix* the entire torso and abdomen are sucked in around the tensile structure of muscles and ribs: all of the weight and bulk is pulled back, denied in favor of an exposition of the underlying skeletal and muscular structure, suggesting an early antecedent for Donatello's bronze *Crucifix* at Padua.

Even when the movable arms of the Santa Croce *Crucifix* are let down to imitate the posture of a *Man of Sorrows* type, as in a photograph published by Parronchi (1980, fig. no. 13), the sensation remains inward and ascendant compared to the ponderous weight present in every single anatomical part of Nanni's *Man of Sorrows* from the Porta della Mandorla. The skin of the wooden *Crucifix* responds to interior muscle and bone, while the skin of the Porta della Mandorla relief covers a blunter muscularity that is bolstered by flesh. The Christ of the Santa Croce *Crucifix* has a generally narrow body structure and elongated head versus the wide torso and squarish head of the relief. These dissimilarities cannot be explained away by pointing to the difference in material (stone as opposed to wood) or a proposed chronological progression of four or five years — the absolute *terminus ante quem* for the *Crucifix* being 1415 (Scalini 1990). In my view, which is supported by Poeschke (1993), the visual relationship between the two works points to the perennial exchange of sculptural ideas between Donatello and Nanni di Banco, an exchange that has been discussed throughout the essays and catalogue entries here: since the *Man of Sorrows* relief by Nanni can be dated to ca. 1407–9, Scalini's idea that Donatello's Santa Croce *Crucifix* be pulled back toward an early period of Donatello's activity (ca. 1404–7) is persuasive, leading me to suggest a hypothetical date of 1407–9 for the Santa Croce *Crucifix*.

SOURCES

Vasari-Milanesi 1568, 1:573, to Donatello. This is the Crucifix traditionally accepted as the one in Vasari's anecdote in which Brunelleschi

accuses Donatello of having "put a peasant on the cross, and not the body of Christ."

BIBLIOGRAPHY

Lányi 1937, 128; Janson 1957, 10 n. 1; Lisner 1962, 65–66; Lisner 1968, 126–27; Lisner 1970, 55–56; Parronchi 1976, 50; Pope-Hennessy 1976, 79; Martini 1978, 212–16; Parronchi 1980, 51–85; Bellosi 1985, 95–103; Pope-Hennessy 1985, 42–45; Bellosi 1986, 47–54; Martini 1986, 126–27, cat. no. 18; Natali 1986, 30–32; Bellosi 1989, 133; Scalini 1990, cat. no. 35; Avery 1991, cat. no. 3; Poeschke 1993, cat. no. 40; Pope-Hennessy 1993, 27, 321, 322 n. 30; Rosenauer 1993, cat. no. 77.

shows this fragment not to be by Nanni di Banco, whose relief carving style was more rounded and volumetric.

BIBLIOGRAPHY

Sframeli 1989, cat. no. 29.

11.12 *Profetino*

Follower of Nanni di Banco: Luca della Robbia (?)
Marble, height 51½ in. (131 cm)
Santa Maria del Fiore, Florence

11.11 *Fragment of a Tabernacle*

Florentine, first decades of the 15th century
Pietra serena, 15¾ x 11½ in. (40 x 29 cm)
San Marco, Florence

This corner of a polylobed arch with a vegetal seed-pod motif, presently in the Lapidarium of San Marco, is originally from the Florentine church of San Leo.

ATTRIBUTION AND DATING

Chiara Cecchi (in Sframeli 1989) was correct in recognizing analogous motifs in the lateral friezes of the Porta della Mandorla and in the socle relief of Nanni di Banco's *Saint Philip* tabernacle at Orsanmichele. Close inspection, however,

Three small statues occupied the side and central pinnacles of the Porta della Mandorla: the Profetino occupied the finial at the viewer's right. A pendant figure, possibly an Angel Gabriel attributed to Donatello and dated around 1406, stood on the left finial (Natali in Berti and Paolucci 1990, cat. no. 32), and an archaic-looking bearded Prophet (Piero di Giovanni Tedesco?) stood at the apex of the cornices. The surface is corroded from exposure; stained by pollutants carried by rainwater. The head was carved separately from the body and may belong to a later period.

Attribution and Dating

The three pinnacle statues from the Porta della Mandorla were probably installed after Nanni di Banco's death in 1421: they may have been brought there from elsewhere in the cathedral complex to trim the pedimental zone of the portal, presumably after the intarsia facing was made for the tri-segmented lateral finials. Only one of the three figures is sometimes assumed to have been carved *ad hoc*, and it has been assigned to Nanni's oeuvre by scholarship: the *Profetino*. Janson (1957) gave a complete analysis of the pinnacle figures, including the *Profetino*, and their literature; more recent scholarship was summarized by Bellosi (1986). The *Profetino* was given to Nanni di Banco by Schottmüller (1904) and Planiscig (1942, 1946), who associated its completion with a payment of sixteen florins to Antonio di Banco and Nanni of 31 December 1407 (doc. 61). The attribution to Nanni was accepted by Brunetti (1947), Bottari (1948), Galassi (1949), Valentiner (1949), Grassi (1951), and Janson (1957), who saw it as an example of Nanni's later style, related to the *Assumption* relief in the gable of the Porta della Mandorla. The attribution to Nanni di Banco was accepted by Macchioni (1979) and tentatively by Rosenauer (1993). Ragghianti (1977) gave the head to Nanni and the body to Donatello.

Whereas the left-hand pinnacle figure, here referred to as *Gabriel*, and the bearded *Prophet* at the top-center of the Porta della Mandorla reflect the hands of Donatello (around 1406) and Piero di Giovanni Tedesco (toward the turn of the fourteenth century) respectively, the *Profetino* ranges out toward the vision of Luca della Robbia. Seymour (1966) and Bellosi (1981) hypothesized that of the three installed figures this was probably the only one to have been created expressly for the Porta della Mandorla pinnacles. That theory rings true, as does their observation that the *Profetino* is the only one of the three statues to imitate Nanni di Banco's style.

Recent examination of this statue at close range has led scholars to consolidate visual analyses. Bellosi (1986) ascribed the *Profetino* to Luca della Robbia as Nanni's pupil. Natali (1990), although persuaded by Bellosi's view, still sensed particular somatic traits of Nanni's *Isaiah* and *Assumption* relief in the *Profetino*, and therefore he ascribed it to Nanni di Banco and Luca della Robbia, finished in the 1420s. This last attribution could explain the separate manufacture of head and body. Avery (1991) gave the *Profetino* and the *Gabriel* to the young Donatello; as did Kreytenberg

(1995). Gentilini (1992) considered the *Profetino* a work by Luca della Robbia dated around 1420, if not later. Pope-Hennessy (1993) maintained the attribution to Nanni di Banco, and Rosenauer (1993) accepted it with reservation.

The ascription of the *Profetino* to Luca della Robbia during the early 1420s (Bellosi 1986; Natali 1990; Gentilini 1992) is reasonable, not only because of morphological traits as an individual figure, but because of its physical location, which brings it into the context of Nanni's last work, the *Assumption*, where Luca della Robbia presumably began his career as an assistant. Several components of the *Assumption* ensemble were produced and installed after Nanni di Banco's death in 1421, but the *Profetino* — which was in any case designed to stand apart from the pedimental relief — could have been made by Luca della Robbia at any point between 1418 and the mid-1430s when he produced the *Cantoria*.

One possibility yet unexplored with regard to the *Profetino* is that the entire figure, or at least the head, which appears to be a later substitute, may have issued from a considerably later restoration. The uncanny resemblance of the *Profetino*'s head to a *Cherubino* — a relief fragment consisting of a bust of a young angel in a hexagonal frame (apparently made to replace a section of the archivolt frieze of the Porta della Mandorla but never put to use) — has gone unacknowledged. The *Profetino* has the same tufted hair, large blank eyes, downturned, pouting mouth, and dimpled chin of the relief *Cherubino* in the Opera del Duomo. Brunetti (1969) saw the *Cherubino* as composed in a late quattrocento vocabulary of forms; aware of its derivative sweetness, she opened the idea that it may have been carved as recently as the nineteenth century. In addition to showing a general affinity with the *Cherubino*, the *Profetino* itself seems to speak a derivative rather than exploratory language. Although there is no question that the *Profetino* was designed after the fashion of Nanni di Banco, it could have been produced by a pupil (Luca della Robbia in the 1420s) or a "follower" of a considerably later, even modern, sculptural campaign.

Bibliography

Semper 1875, 53; Schottmüller 1904, 58; Planiscig 1942, 125–37; Planiscig 1946, 10–11; Brunetti 1947, 217; Bottari 1948, 162; Galassi 1949, 61; Valentiner 1949, 26; Vaccarino 1950, 21–22; Grassi 1951, 39–40; Janson 1957, 219–22; Seymour 1966, 51; Becherucci and Brunetti 1969, 1: cat. no. 197; Ragghianti 1977, 14; Macchioni 1979, 140; Bellosi 1981, 66–68; Bellosi

1986, cat. nos. 15, 16; Gentilini 1990, 280; Natali 1990, cat. no. 16; Avery 1991, cat. no. 1; Gentilini 1992, 16–17; Rosenauer 1993, cat. no. 79; Pope-Hennessy 1993, 17, 320 n. 16; Kreytenberg 1995, 149.

11.13 *Virgin Mary and Saint John*

Master of the Fava Tomb
ca. 1440
Marble, height of each seated figure ca. 39 in. (100 cm)
Cathedral of San Martino, Pietrasanta

Located in situ in a lunette-shaped tympanum above the central west portal is a Crucifixion scene with two nude flying angels. The Virgin Mary is seated in a landscape at Christ's lower right; Saint John Evangelist seated in a landscape at Christ's lower left. The relief figures are in fair condition, with the face of Mary broken below the eyes.

ATTRIBUTION AND DATING

The tympanum relief is made from three separate uneven blocks; the *Virgin* and *Saint John* (outer panels) are somewhat larger in scale than the central *Crucified Christ* (central panel), which indicated to some specialists the possible participation of two distinct hands or campaigns. The central tympanum appears to be contemporary with the lunette above the right portal, consisting of a *Pietà* with Christ on the lap of the Virgin Mary flanked by two standing angels wearing peplos-style robes. Aru (1906, 1908) had attributed the entire *Crucifixion* relief to the circle of the Versilian

sculptor Riccomanno Riccomanni, who flourished in the 1430s. Paoletti (1980) challenged that attribution and proposed the figures of the *Virgin Mary* and *Saint John* as youthful works by Nanni di Banco, datable ca. 1400–1408. According to Paoletti, the central lunette was made by two different artists at different times, with the figures of *Mary* and *Saint John* following that of the crucified *Christ*. Paoletti maintained that the *Virgin Mary* and *Saint John* at Pietrasanta would take a chronological place (between 1400 and 1408) among the earliest figurative works by Nanni di Banco. Paoletti's attribution of the two lunette figures to Nanni di Banco was rejected by Beck (1991) on stylistic grounds, who found an attribution to Antonio Pardini of Pietrasanta (presumably Jacopo della Quercia's teacher and one-time *capomaestro* of the cathedral of Lucca) around 1400–1405 more persuasive.

The Pietrasanta *Virgin Mary* and *Saint John* can be excluded from Nanni's oeuvre according to formal criteria. First, it is clear that all the figures in the central and right-hand lunettes were made by the same sculptor and should be considered as a group. Second, Paoletti's association of the *Saint John* with Nanni's freestanding *Isaiah* is not convincing. Even if the figures here may reveal the ontogenic "awkwardness and hesitancies of a young sculptor" (Paoletti 1980), they appear rather more advanced in the greater scheme of the phylogenic development of Italian art and probably date from closer to the middle of the fifteenth century, perhaps the 1430s or 1440s. This later dating is indicated by the rather unsurprised delight shown in linear perspectival foreshortening, as it is used (albeit awkwardly) in the treatment of the legs and feet. Furthermore, Nanni's relation of pictorial field to architectural framework was consistently tight, whereas these figures have much less obvious relationship to their two-dimensional space than, say, the *Man of Sorrows* above the Porta della Mandorla of ca. 1408.

The Pietrasanta lunette figures, rendered as they are — with some lack of dexterity, but according to established pictorial formulas — do seem to anticipate projects of the mid-quattrocento in which Leonardo Riccomanni played a large role. But in light of recent scholarship, Aru's (1906, 1908) attribution of the lunette figures to the workshop of Riccomanno Riccomanni cannot be maintained. A visual investigation of the Pietrasanta reliefs by Aldo Galli (1998) showed the central and right lunettes to be by the "Master of the Fava Tomb," a follower of Jacopo della Quercia who

worked in Bologna and Adria around 1440 (Piccinini 1986). The Pietrasanta *Saint John*, for example, is closely comparable with figures from the terracotta tomb of Niccolò Fava at Bologna, as well as with fragments from the *Dormitio Virginis* altar pala at the cathedral of Adria. The facial structure, the articulation of hair in straight clumps, the compulsively triangular drapery folds, and the awkwardly foreshortened feet are characteristic features of this sculptor, who should be known as the "Master of the Fava Tomb."

BIBLIOGRAPHY

Aru 1906, 463–72; Aru 1908, 421–22; Paoletti 1980, 105–10; Piccinini 1986, 99–103; Beck 1991, 1:15 n. 27; Galli 1998.

11.14 *Antinoüs*

Roman Antinoüs (ca. A.D. 130–133)
Recarved ca. 1410
Marble, 11 in. (28 cm)
Museo dell'Opera del Duomo, Pisa

The head is probably a fragment of an antique statue of Antinoüs, which was recarved in its detached state by a later hand. The sculptural palimpsest as a whole is in fair condition, with some abrasions, chips, and a gash in the right cheek. Located in a corner of the Pisan church of San Giorgio degli Innocenti (formerly San Giorgio ai Tedeschi) in the

nineteenth century, it was moved in 1932 (when San Giorgio underwent major renovation) to the Camposanto. Since the establishment of the Pisan Museo dell'Opera del Duomo in 1984, it has been conserved there.

ATTRIBUTION AND DATING

Bianchi-Bandinelli produced a classic essay on this object, which was published in English (1946) and then anthologized in its original Italian version "Antico non antico" (1979). Bianchi-Bandinelli envisioned that this marble head (for which he proposed an early Renaissance provenance in the Palazzo Medici in Florence) was an antique portrait of Antinoüs (A.D. 130–133), recarved by an early-fifteenth-century Tuscan sculptor to represent a Christian saint. Whereas the Graeco-Roman composition of the original (unrevised) portrait head would have had a plastic, generalizing, idealizing unity, the technique of intaglio carving and accretiously accumulated physiognomic parts, with each empirically perceived facial feature essentially independent of the other, was observed by Bianchi-Bandinelli to be a trait of early Renaissance sculpture. A typological likeness and similarity in the mode of carving to the statue of the "youngest" saint in Nanni's *Quattro Coronati* at Orsanmichele (fig. 13) led Bianchi-Bandinelli to believe that the intervening artist in this reworked head may have been Nanni di Banco. He theorized that if this were the case, the ancient head was reworked by Nanni di Banco "to train his hand and his taste."

Lucia Faedo (1984) agreed that this head was an ancient head of Antinoüs that was altered by a radical recarving at some later time. Rossi-Pinelli (1986) followed Faedo but dated the recarving to the thirteenth century. Faedo definitively established a Pisan provenance in the church of San Giorgio degli Innocenti, overturning Bianchi-Bandinelli's identification of the piece with a head from the Riccardi Collection in Florence. Faedo considered Bianchi-Bandinelli's attribution to Nanni di Banco weak. Nevertheless, she, too, placed the reworking of the head to around 1410. Faedo conjectured that the recarving was among the works commissioned by Archbishop Ricci when the church of San Giorgio was annexed to the hospital of the Innocenti in 1410. At this time the former church of San Giorgio ai Tedeschi (founded ca. 1330) lost its function as a Pisan war memorial to the Germans who fought in the battles of Lucca and Montecatini and was rededicated to the Innocenti (Paliaga and Renzoni 1991). The trecento

church had originally been decorated with *spoglia* from the battles of Lucca and Montecatini, and the rededication of 1410 may well have been the occasion for the transformation of this antique *Antinoüs* head (war *spoglia?*) into that of a Christian saint. Thus Faedo's hypothesis served to enhance rather than contradict Bianchi-Bandinelli's attribution of the intervention to Nanni di Banco: if the head (*Antinoüs*) had been recarved around 1410, it would be contemporaneous with the "youngest" (and earliest) saint of the *Quattro Coronati*, dated 1409–12.

As a purveyor of Carrara marbles Nanni di Banco visited Pisa, the center of the Tuscan heroic style in sculpture (Seymour 1963a) (doc. 96). It is plausible to place Nanni in Pisa around 1410, working on the renovation of sculpture at San Giorgio. But several morphological details would indicate that Nanni di Banco's hand is not present here. Whereas the beard of the present work is literally scratched into the surface of the face, that of Nanni's young *Coronato* is modeled with some degree of plasticity. Certain features of this piece that originated in the recarving, such as the drilled excavation of points in the hair, upturned pupils of the eyes, and corners of the mouth, are also foreign to Nanni's style. The recarving of the Pisan *Antinoüs* does not correspond closely enough to Nanni's sculpture to consider it an attributable work.

Bianchi-Bandinelli's hypothesis remains intellectually vital, however, because in a literary sense, his "Antico non antico" revives a Renaissance topos. An adventurous historiographer might intuit that it was in fact a close reading of early sources that had (almost unconsciously) sensitized Bianchi-Bandinelli to such issues with regard to the reworked head in Pisa. Coincidentally or not, the Pisan Camposanto and the courtyard of Palazzo Medici in via Larga are the Vasarian settings for significant, prototypical, early "restorations" of antique sculpture: two Roman *Marsyas* figures in the Medici collection were, according to Vasari, revised in the early Renaissance — one by Donatello and the other by Verrocchio — and apparently displayed in the courtyard of Palazzo Medici (Vasari-Milanesi 2:407 and Vasari-Milanesi 3:366–67). And the prime instance of such activity (Vasari-Milanesi 1:293–95) took place in Pisa, where toward the middle of the thirteenth century Nicola Pisano was supposed to have restored (retraced for visual emphasis as well as his own schooling) the nude figure of Hippolytus in the Pisan Phaedra sarcophagus (fig. 21), which was at that time

embedded in the facade of the Pisan cathedral in use as a Christian tomb. The larger questions raised by Bianchi-Bandinelli are pertinent not only to the formation of Nanni di Banco as an individual artist, but also to Renaissance attitudes toward existing antiquities, to the actual working practices of Italian Renaissance sculptors around 1410, and to Vasari's presentation of Renaissance *renovatio*.

BIBLIOGRAPHY

Bianchi-Bandinelli 1946, 1–9; Seymour 1961, 207–26; Bianchi-Bandinelli 1979, 264–76; Faedo 1984, 142–44; Rossi-Pinelli 1986, 193; Settis 1986, 179–91; Paliaga and Renzoni 1991, cat. no. 28.

11.15 *Madonna and Child*

Florentine sculptor
ca. 1415–25
Stucco with polychrome, 40 ½ in. (103 cm)
Collection of Pietro Scarpa, Venice

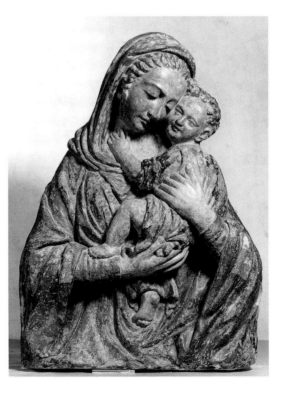

This large convex relief is generally similar in facture and format to the numerous press-mold Madonnas that are associated with Lorenzo

Ghiberti's workshop. Acquired from the Borromeo Collection in Rome, a 1984 restoration by Ottorino Nonfarmale (Bologna) revealed what we now see as the Madonna's blue cloak, pale ochre veil, reddish tunic, and traces of gilding on the hair of both figures.

ATTRIBUTION AND DATING

The composition of the *Madonna and Child* was current in Tuscan painting and sculpture in the late fourteenth to mid-fifteenth century, as in Filippo Lippi's *Tarquinia Madonna* in Rome. As in Lippi's painting, the present *Madonna's* veil is slipped back to reveal her face, forehead, and hair. Direct human contact is expressed as the energetic Christ child reaches her throat without the interference of drapery.

In producing such works fifteenth-century sculptors typically followed the format of a sample prototype to be selected by the patron and embellished the work with sculptural modifications, variations in small iconographic details such as family *stemmi*, glass inlays, and painted color. This work, however, seems to be a unique composition rather than one of a press-mold series; and its size and monumentality set it apart from the many such works made for domestic use. It is too large to have been set upon the altar of a chapel and too well-preserved to have been situated in a street tabernacle. One speculates that the *Madonna* was a public commission, perhaps made for installation above the protected portal of a building such as a hospital.

A written communication (1972) from Ulrich Middeldorf proposed that the Scarpa *Madonna* was Florentine and datable to the first half of the quattrocento. Middeldorf (1972) suggested the possible authorship of Michele da Firenze working under the inspiration of Ghiberti and Donatello. Ursula Schlegel, in a subsequent verbal communication to Pietro Scarpa, was the first to attribute the work to Nanni di Banco. Passavant (1987) continued the attribution to Nanni di Banco with some reservation, dating it ca. 1410 (see Bellosi 1989). Passavant envisioned the *Madonna and Child* as an early and decisive model for Madonna reliefs as they evolved during the first half of the quattrocento in Tuscany and sought an author in the circle of the progressive young artists of early-fifteenth-century Florence (Donatello, Ghiberti, Nanni di Banco). He eliminated Donatello and Ghiberti according to morphological analysis but found that the juxtaposition of classicizing drapery and hair with the rather clumsy articulation of the Madonna's hands, with her long flat fingers, made this work comparable with the seated *Saint Luke* by Nanni di Banco.

The stylistic evidence introduced by Passavant is too slight to attribute the Scarpa *Madonna and Child* to Nanni di Banco. Indeed, it is difficult to imagine any stucco relief by Nanni di Banco given the lack of viable comparanda in his oeuvre. The intimate naturalistic mood of the *Madonna* is far from the ascendant Virgin of the Porta della Mandorla, not to mention the difference in materials, size, scope, and intended audience. But the association of the *Madonna and Child* with a sculptor in Nanni's circle at the Opera del Duomo in the second decade of the fifteenth century remains compelling. Certainly the relief fits nicely into the Tuscan sculptural landscape around the second or third decade of the quattrocento: Nanni di Bartolo, Dello Delli, Jacopo della Quercia, and Luca della Robbia come to mind.

BIBLIOGRAPHY

Middeldorf 1972 (unpublished letter of 6 November 1972); Schlegel 1979, 21–26; Passavant 1987, 196–236; Bellosi 1989, 130–45.

Register of Documents

This register consists of a compilation of documents pertinent to the life and works of Nanni di Banco and to his father, Antonio di Banco di Falco. Previously published documents are integrated with those cited for the first time, according to chronological order. Each entry includes a full citation and summary in English, followed by bibliography and commentary.

As the Florentine year began on 25 March, the Feast of the Annunciation, documents falling into the period between 1 January and 25 March of any year are marked according to both Florentine and modern usage: for example, doc. 8 is dated "1 February 1359/60." Following the cataloguing practices of the archives in which they are housed, manuscript pages are numbered by *carta* (c., cc.), recto or verso.

DOCUMENT 1 21 July 1352
Benedetto di Falco mentioned as member of stonemasons' guild.
Source: ASF, Arte dei Maestri di pietra e legname 1, c. 4v.
Bibliography: Cited in Wundram 1961, 25.
Comment: Benedetto may have been a relative of Nanni di Banco.

DOCUMENT 2 14 June 1357
Banco di Falco and Agostino di Falco listed as "maestri" in the payrolls of the Opera del Duomo.
Source: AOSMF, Marsili II-4-1, c. 33r.
Bibliography: Published in Guasti 1887, 92–93.

DOCUMENT 3 18 August 1357
Agostino di Falco listed as stonemason in Opera del Duomo.
Source: AOSMF, Marsili II-4-1, c. 41r.
Bibliography: Published in Guasti 1887, 105.

DOCUMENT 4 17 November 1357
Banco di Falco to build a fireplace in the house of canon Piero Ruspi.
Source: AOSMF, Marsili II-4-1, c. 45v.
Bibliography: Published in Guasti 1887, 111.

DOCUMENT 5 1358 (Florentine calendar)
Banco di Falco recorded as member of stonemasons' guild.
Source: ASF, Arte dei Maestri di pietra e legname 1, c. 4r.
Bibliography: Cited in Wundram 1961, 24–25; published in Bergstein 1987a, 56.

DOCUMENT 6 1358 (Florentine calendar)
Agostino di Falco matriculates to stonemasons' guild.
Source: ASF, Arte dei Maestri di pietra e legname 1, c. 1v.
Bibliography: Cited in Wundram 1961, 25; cited in Bergstein 1987a, 56.

DOCUMENT 7 1359 (Florentine calendar)
Sandra, sister of Banco and Agostino, sons of Falco di Banco, is given in marriage to Biondo di Lippo of S. Ambrogio.
Source: ASF, Carte dell'Ancisa, CC, Manoscritti 350, c. 19v.
Bibliography: Cited in Bergstein 1987a, 56.

DOCUMENT 8 1 February 1359/60
Banco di Falco appears as guarantor for Lorenzo di Filippo's matriculation to stonemasons' guild.
Source: ASF, Arte dei Maestri di pietra e legname 1, c. 51v.
Bibliography: Cited in Wundram 1961, 25.
Comment: Lorenzo di Filippo eventually became *capomaestro* of the Opera del Duomo.

DOCUMENT 9 1368 (Florentine calendar)
Banco di Falco di Banco's son, Antonio di Banco, marries Giovanna.
Source: ASF, Carte dell'Ancisa, CC, Manoscritti 350, c. 20r.
Bibliography: Published in Brunetti 1951a, 105; cited in Bergstein 1987a, 58.
Comment: Repeated in ASF, Ms. 364, Ancisa-Zibaldone II, c. 199r.

DOCUMENT 10 30 October 1372
Antonio di Banco matriculates to stonemasons' guild.
Source: ASF, Arte dei Maestri di pietra e legname 1, c. 2r.
Bibliography: Published in Semper 1875, 298; cited in Wundram 1961, 23; cited in Bergstein 1987a, 59.

DOCUMENT 11 11 October 1373
Agostino di Falco, listed as resident in via Scanpitori, is taxed two florins and six soldi in Prestanza.
Source: ASF, Prestanze no. 231, c. 131.
Bibliography: Unpublished.
Comment: The tax is medium for the neighborhood, where it ranges from about sixteen florins (high) to sixteen soldi (low) in this Prestanza.

DOCUMENT 12 13 January 1374/75
Antonio di Banco and Michele di Giovanni paid twenty-six lire for black marble.
Source: AOSMF, Deliberazioni II-1-3, c. 7r.
Bibliography: Cited in Wundram 1961, 26.

DOCUMENT 13 19 January 1374/75
Antonio di Banco, Tommaso di Matteo, and Michele di Giovanni are paid forty lire for the quarrying of black marble.

Source: AOSMF, Deliberazioni II-1-3, c. 3r.
Bibliography: Published in Wundram 1961, 26.

DOCUMENT 14 21 March 1374/75
Antonio di Banco and Michele di Giovanni are paid twenty-four florins, one lira, fifteen soldi, one denaro for delivery of black marble and for other, unspecified work.
Source: AOSMF, Deliberazioni II-1-3, c. 14r.
Bibliography: Published in Wundram 1961, 26.

DOCUMENT 15 20 June 1375
Antonio di Banco and Michele di Giovanni paid thirty lire for the delivery of black marbles.
Source: AOSMF, Deliberazioni II-1-3, c. 29v.
Bibliography: Cited in Wundram 1961, 26.

DOCUMENT 16 24 March 1375/76
Benedetto di Falco and Agostino di Falco listed at daily summer wage of eighteen soldi; Antonio di Banco listed at sixteen soldi, six denari.
Source: AOSMF, Deliberazioni II-1-4, cc. 6v–7r.
Bibliography: Cited in Wundram 1961, 25.

DOCUMENT 17 May 1376
Banco and Agostino di Falco are named part of a council to investigate the structural solidity of a wall.
Source: AOSMF, Consigli I-1-1-B, c. 13r.
Bibliography: Published in Guasti 1887, doc. no. 254.

DOCUMENT 18 6 November 1376
Antonio di Banco is listed on Opera del Duomo payrolls for daily winter wage of fourteen soldi, along with his father and uncle at seventeen soldi, and Lorenzo di Filippo at eighteen soldi.
Source: AOSMF, Deliberazioni II-1-5, c. 21r.
Bibliography: Cited in Bergstein 1987a, 59.

DOCUMENT 19 1382 (Florentine calendar)
Antonio di Banco appears at the Gabelle as witness to an unspecified contract.
Source: ASF, Carte dell' Ancisa, CC, Manoscritti 350, c. 24v.
Bibliography: Unpublished.

DOCUMENT 20 6 July 1384
Banco di Falco and Agostino di Falco are named as master builders in the Opera del Duomo.
Source: AOSMF, Consigli I-1-1-A, c. 17r.
Bibliography: Published in Guasti 1887, doc. no. 355.

DOCUMENT 21 19 April 1385
Banco di Falco entitled to daily summer wage of seventeen soldi.
Source: AOSMF, Deliberazioni II-1-20, c. 16r.
Bibliography: Cited in Wundram 1961, 25.

DOCUMENT 22 8 November 1385
Banco di Falco taxed three soldi, ten denari on behalf of himself and his sons ("figliouli") in Prestanza.
Source: ASF, Prestanze 416, c. 304v.
Bibliography: Unpublished.

DOCUMENT 23 17 November 1385
Banco and Agostino di Falco listed in Opera del Duomo payrolls under the rubric of

masons *("magistri concii") rather than carvers ("magistri scarpelli").*
Source: AOSMF, Deliberazioni II-1-20, c. 47r.
Bibliography: Cited in Wundram 1961, 25.

DOCUMENT 24 15 May 1386
Banco and Agostino di Falco listed as stonemasons at daily wages of sixteen and seventeen soldi respectively.
Source: AOSMF, Deliberazioni II-1-21, c. 23r.
Bibliography: Cited in Wundram 1961, 25.

DOCUMENT 25 15 November 1386
Banco and Agostino di Falco are two of only four masters in the Opera del Duomo who are listed under the rubric of those qualified as carvers as well as builders and masons (those earning the highest wage).
Source: AOSMF, Deliberazioni II-1-22, c. 34r.
Bibliography: Cited in Wundram 1961, 25.

DOCUMENT 26 17 April 1391
Antonio di Banco is among the minor guildsmen to be scrutinized for the Priorate and receives fifty-three votes, insufficient to be "imborsato."
Source: ASF, Tratte 397, c. 169v (mod. 166v).
Bibliography: Published in Bergstein 1987a, doc. no. 1.
Comment: See ibid. c. 171r (mod. 168r) where Antonio is listed under a series of names put forth by the minor guilds after the principal voting. The number of votes is not registered on this list. Agostino di Falco was scrutinized on the same occasion and received nine votes (ibid. c. 170r (mod. 167r)

DOCUMENT 27 29 May 1391
Agostino di Falco, listed as living in the via dei Pilastri, taxed for one florin, one soldo, two denari in Prestanza.
Source: ASF, Prestanze 1312, c. 201v.
Bibliography: Unpublished.

DOCUMENT 28 8 June 1391
Antonio di Banco, listed as living in the via dei Pentolini (near the via di Borgo Allegri), taxed for one florin in Prestanza.
Source: ASF, Prestanze 1312, c. 211v.
Bibliography: Unpublished.

DOCUMENT 29 30 October 1394
Antonio di Banco paid forty-two lire, thirteen soldi, eleven denari by the Opera del Duomo for undescribed work.
Source: AOSMF, Deliberazioni II-1-34, c. 17r.
Bibliography: Cited in Wundram 1961, 26.

DOCUMENT 30 14 December 1394
Antonio di Banco paid eight lire, three soldi, eight denari for undescribed work. Masters named in the same entry include Giovanni d'Ambrogio, Niccolò di Pietro (Lamberti), Lorenzo di Filippo.
Source: AOSMF, Deliberazioni II-1-34, cc. 27r–28r.
Bibliography: Cited in Semper 1875, 298; cited in Pachaly 1907, 4; cited in Wundram 1961, 26.

DOCUMENT 31 1 January 1394/95
Antonio di Banco named consul of stonemasons' guild from January 1394/95 through April 1395.
Source: ASF, Arte dei Maestri di pietra e legname 2, c. 55r.

Bibliography: Cited in Wundram 1961, 23; cited in Bergstein 1987a, 61.

DOCUMENT 32 3 February 1394/95
Antonio di Banco paid fifty-six lire, eighteen soldi, two denari for the carving of imposts, moldings, and column capitals in pietra forte.
Source: AOSMF, Deliberazioni II-1-35, cc. 4v–5r.
Bibliography: Cited in Wundram 1961, 27.

DOCUMENT 33 16 August 1395
Antonio di Banco listed next to Lorenzo di Filippo in Opera payrolls.
Source: AOSMF, Deliberazioni II-1-36, c. 7r.
Bibliography: Cited in Wundram 1961, 27.

DOCUMENT 34 15 October 1395
It is deliberated that Piero di Giovanni Tedesco and Niccolò di Pietro Lamberti make marble figures of the four saints [Quattro Santi Coronati; or the Four Evangelists; or four Church Doctors] for the Arnolfian façade of the Duomo.
Source: AOSMF, Deliberazioni II-1-36, c. 12r.
Bibliography: Published in Poggi-Haines 1: doc. no. 111.

DOCUMENT 35 21 October 1395
The painter Agnolo Gaddi paid six florins for a drawing of four saints.
Source: AOSMF, Deliberazioni II-1-36, c. 12v.
Bibliography: Published in Poggi-Haines 1: doc. no. 112.

DOCUMENT 36 2 December 1395
Piero di Giovanni Tedesco and Niccolò di Pietro Lamberti paid for quarrying and blocking out figures of four saints.
Source: AOSMF, Deliberazioni II-1-36, c. 18r.
Bibliography: Published in Poggi-Haines 1: doc. no. 114.

DOCUMENT 37 9 December 1395
Antonio di Banco paid for stonemasonry conducted under capomaestro *Lorenzo di Filippo.*
Source: AOSMF, Deliberazioni II-1-36, cc. 19r–19v.
Bibliography: Cited in Semper 1875, 298; cited in Pachaly 1907, 4; cited in Wundram 1961, 27.

DOCUMENT 38 14 July 1396
Piero di Giovanni Tedesco is allocated the job of carving one of the "four crowned saints" for the façade; the marble to be chosen by Piero from those previously quarried.
Source: AOSMF, Deliberazioni II-1-38, c. 7r.
Bibliography: Published in Poggi-Haines 1: doc. no. 121.

DOCUMENT 39 18 May 1397
Antonio di Banco, "scharpellatore," taxed one florin in Prestanza.
Source: ASF, Prestanze no. 1610, c. 6r.
Bibliography: Unpublished.
Comment: Taxpayers listed by name rather than address; in any case, Agostino di Falco is no longer listed as head of household.

DOCUMENT 40 22 August 1397
A stonemason named Giovanni d'Antonio from Santa Reparata (San Giovanni) appears on list of guild members.
Source: ASF, Arte dei Maestri di pietra e legname 2, c. 7v.
Bibliography: Unpublished.
Comment: Since this "Giovanni d'Antonio" is not known to me as an individual stonemason from other documents, the name may refer to

Nanni di Banco. The parish of Sant'Ambrogio was part of the *quartiere* of Santa Reparata (San Giovanni).

DOCUMENT 41 5 October 1397
Antonio di Banco paid one hundred lire for consoles; their destination is not specified.
Source: AOSMF, Deliberazioni II-1-39, c. 16r.
Bibliography: Cited in Wundram 1961, 27.
Comment: This entry is preceded by payments to Lorenzo di Giovanni d'Ambrogio and Niccolò di Pietro Lamberti, who were working on the reveal friezes of the Porta della Mandorla.

DOCUMENT 42 7 April 1398
Antonio di Banco paid forty-four lire, sixteen soldi, eight denari for thirty-one impost blocks (for arches?) and cornices.
Source: AOSMF, Deliberazioni II-1-40, c. 26v.
Bibliography: Published in Semper 1875, 298; cited in Pachaly 1907, 4; cited in Wundram 1961, 23.

DOCUMENT 43 27 August 1398
Antonio di Banco paid nine lire, sixteen soldi, and four denari for a portion of the thirty consoles he made "in pilastro."
Source: AOSMF, Deliberazioni II-1-41, c. 10v.
Bibliography: Cited in Wundram 1961, 27.

DOCUMENT 44 1 January 1398/99
Antonio di Banco named consul of stonemasons' guild for the period of January 1398/99 through April 1399.
Source: ASF, Arte dei Maestri di pietra e legname 2, c. 8v.
Bibliography: Cited in Wundram 1961, 23; cited in Bergstein 1987a, 61.

DOCUMENT 45 31 October 1403
The stonemasons' guild owes Ambrogio di Baldese and Smeraldo di Giovanni twelve lire, six soldi, eight denari for gold leaf used to decorate the pier with the "Quattro Santi Coronati" on the interior of Orsanmichele.
Source: ASF, Capitani di Orsanmichele no. 210, c. 7.
Bibliography: Published in Gamba 1904, cat. no. II; cited in Brunetti 1947, 218; published in Zervas 1996b, doc. no. 280.
Comment: Ambrogio di Baldese made figurative and decorative paintings for the Opera del Duomo: 18 June 1398, AOSMF, Deliberazioni II-1-40, c. 56v (published in Poggi-Haines 1: doc. no. 1011); 27 June 1398, AOSMF, Deliberazioni II-1-40, cc. 63r, 65r, 68r–v (published in Poggi-Haines 1: doc. no. 1012); 18 September 1398, AOSMF, Deliberazioni II-1-41, c. 15v (published in Poggi-Haines 1: doc. no. 1014). For the activities of Ambrogio di Baldese and Smeraldo di Giovanni working as a team in the Opera del Duomo: 16 January 1405, AOSMF, Deliberazioni II-1-49, c. 1v (published in Poggi-Haines 2: doc. no. 2187).

DOCUMENT 46 1 January 1403/4
Antonio di Banco is named to the Consiglio del Comune for a term of four months, January 1403/4 through April 1404.
Source: ASF, Tratte 147, c. 182v.
Bibliography: Published in Bergstein 1987a, doc. no. 2.
Comment: Antonio served on the Consiglio del Comune for the gonfalone Chiavi together with members of the Albizzi, Ammannati, and Arrighi families; during the same years Chiarissimo di Bernardo Chiarissimi and Giovanni di Bicci de' Medici were operative in the legislative councils (see Tratte 147, passim).

DOCUMENT 47 23 December 1404

It is deliberated by the Operai that the decoration of the northeast portal of the cathedral be completed.

Source: AOSMF, Deliberazioni II-1-48, c. 34v.

Bibliography: Published in Guasti 1887, doc. no. 429; published in Poggi-Haines 1: doc. no. 360.

DOCUMENT 48 2 February 1404/5

Nanni di Banco matriculates to the stonemasons' guild.

Source: ASF, Arte dei Maestri di pietra e legname 2, c. 13v.

Bibliography: Cited in Semper 1875, 299; published in Vaccarino 1950, 12; cited in Wundram 1961, 30.

DOCUMENT 49 3 June 1405

Niccolò di Pietro Lamberti and Lorenzo di Giovanni d'Ambrogio are reimbursed expenses in traveling to Carrara to quarry and block marble for statues of the Evangelists.

Source: AOSMF, Deliberazioni II-1-49, c. 17.

Bibliography: Published in Poggi-Haines 1: doc. no. 162; cited in Vaccarino 1950, 29.

Comment: Giovanni Bardini, called "Barullo," was to have transported the marbles to Florence (already cut into blocks), but this endeavor was interrupted by war with Pisa: see Poggi-Haines 1: doc. no. 163, and below doc. 50.

DOCUMENT 50 27 June 1405

Transport of marbles from Carrara delayed by war between Florence and Pisa.

Source: AOSMF, Deliberazioni II-1-49, c. 20r.

Bibliography: Published in Poggi-Haines 1: doc. no. 164; cited in Vaccarino 1950, 29.

Comment: Florence conquered Pisa in 1406; see Mallett 1968, 403.

DOCUMENT 51 1 September 1405

Antonio di Banco named consul of stonemasons' guild September through December 1405.

Source: ASF, Arte dei Maestri di pietra e legname 2, c. 14r.

Bibliography: Cited in Wundram 1961, 23; cited in Bergstein 1987a, 61.

DOCUMENT 52 5 October 1406

Antonio di Banco paid twenty gold florins for work on the archivolt zone of the Porta della Mandorla.

Source: AOSMF, Deliberazioni II-1-51, c. 7r.

Bibliography: Published in Poggi-Haines 1: doc. no. 361; cited in Vaccarino 1950, 25.

DOCUMENT 53 29 November 1406

Niccolò di Pietro (Lamberti) paid fifteen gold florins for part of the archivolt.

Source: AOSMF, Deliberazioni II-1-51, c. 12v.

Bibliography: Published in Poggi-Haines 1: doc. no. 363.

DOCUMENT 54 18 March 1406/7

Antonio di Banco and his son Nanni paid seven gold florins for unspecified work.

Source: AOSMF, Deliberazioni II-1-52, c. 4.

Bibliography: Published in Wundram 1961, 27.

Comment: Wundram suggested that this payment may have been toward work on the archivolt of the Porta della Mandorla.

DOCUMENT 55 22 March 1406/7

Antonio di Banco paid six lire for delivery of stone intended for a house.

Source: AOSMF, Stanziamenti II-4-7, c. 10r.

Bibliography: Cited in Wundram 1961, 27.

Comment: The page was entirely erased by the flood of 1966.

DOCUMENT 56 2 June 1407

Antonio di Banco is chosen for committee to advise the construction and decoration of the north tribune of the cathedral according to the design of Giovanni d'Ambrogio.

Source: AOSMF, Deliberazioni II-1-52, c. 14v.

Bibliography: Published in Guasti 1887, doc. no. 440; cited in Wundram 1961, 23.

Comment: Decoration of the north tribune windows was probably carried out toward 1408.

DOCUMENT 57 8 June 1407

Antonio di Banco paid for 150 braccia of work for Opera del Duomo.

Source: AOSMF, Deliberazioni II-1-52, c. 15r.

Bibliography: Published in Pachaly 1907, 4; cited in Wundram 1961, 28.

DOCUMENT 58 20 August 1407

Antonio di Banco paid sixty-eight lire and one denaro for eighty-nine and a half braccia of stone for the "doccia" (gutter) of the choir tribune.

Source: AOSMF, Stanziamenti II-4-7, c. 15v; flooded in 1966.

Bibliography: Published in Pachaly 1907, 6; cited in Wundram 1961, 28.

DOCUMENT 59 20 August 1407

Antonio di Banco paid eighty lire, eight soldi, and eight denari for 204½ braccia of stones for the floor of the cathedral.

Source: AOSMF, Stanziamenti II-4-7, c. 15v; flooded in 1966.

Bibliography: Published in Pachaly 1907, 6; cited in Wundram 1961, 28.

DOCUMENT 60 24 November 1407

Antonio di Banco paid two lire for stones ("macigno") for a window frame in the house of canon Jacopo Spini.

Source: AOSMF, Stanziamenti II-4-7, c. 19r.

Bibliography: Cited in Wundram 1961, 28.

DOCUMENT 61 31 December 1407

Antonio and Nanni di Banco are owed sixteen gold florins. Antonio and Nanni are carving: a piece of foliated marble frame to go under the column of the second arch of the Porta della Mandorla; a piece of reveal frieze, which follows the column, in which are carved angels in cartouches holding scrolls, and alternating with the angels, passages of foliation with figures, at the rate of ten florins per braccio; a piece of twisted column with mandorle in it with a suitably foliated frame and in the middle a small frame with mandorle and rosettes, at six florins per braccio; a piece of twisted column, which follows the middle one with angels, with foliation around black stones framed within the leaves, at four florins per braccio. Niccolò di Pietro Lamberti is carving a frieze that goes above the door jambs of the Porta della Mandorla in which is a belt of foliation with a foliated frame around it at seven florins per braccio; a piece of twisted column with mandorle and rosettes; a piece of reveal frieze with angels in cartouches holding scrolls: between one angel and another, passages of foliation with figures at ten florins per braccio.

Source: AOSMF, Deliberazioni II-1-54, cc. 8v–9r.

Bibliography: Published in Poggi-Haines 1: doc. no. 364, with acknowledgment of many lacunae and omissions in the original.

DOCUMENT 62 12 January 1407/8

An artisan named Pace will be responsible for the installation of the archivolt frieze of the Porta della Mandorla and his daily wages are established: seventeen soldi, six denari for winter days; eighteen soldi, six denari for summer days. On this same occasion Antonio

di Banco with his son Nanni, and Niccolò di Pietro (Lamberti) are paid twenty-five gold florins each for work on the archivolt.
Source: AOSMF, Deliberazioni II-1-53, cc. 10v–11r.
Bibliography: Published in Poggi-Haines 1: doc. no. 365.

DOCUMENT 63 24 January 1407/8
Statue of the prophet Isaiah, three braccia high, is commissioned to Antonio di Banco with his son Nanni; the price to be decided according to the opinion of the Operai or their successors.
Source: AOSMF, Deliberazioni II-1-53, c. 11v.
Bibliography: Published in Poggi-Haines 1: doc. no. 405; cited in Vaccarino 1950, 27.

DOCUMENT 64 20 February 1407/8
Donatello assigned to make a statue of the prophet David, under the same terms and conditions as Nanni di Banco's statue of Isaiah, which is to be placed upon the buttress of one of the tribunes.
Source: AOSMF, Deliberazioni II-1-53, c. 15v.
Bibliography: Published in Poggi-Haines 1: doc. no. 406; published in Seymour 1967b, doc. no. 2; cited in Herzner 1979b, doc. no. 6.

DOCUMENT 65 5 May 1408
Niccolò di Pietro (Lamberti) threatened with fine of twenty-five florins if he does not correct work on the arch of the northeast door.
Source: AOSMF, Deliberazioni II-1-54, c. 8v.
Bibliography: Published in Guasti 1887, doc. no. 449; published in Poggi-Haines 1: doc. no. 367.
Comment: Niccolò Lamberti subsequently received ten gold florins on 11 September 1408 (Poggi-Haines 1: doc. no. 368) and twenty gold florins on 19 December 1408 (Poggi-Haines 1: doc. no. 369).

DOCUMENT 66 21 June 1408
Donatello paid ten gold florins for a figure he is carving.
Source: AOSMF, Deliberazioni II-1-54, c. 28r (reflected in Stanziamenti II-4-7, c. 24v).
Bibliography: Published in Poggi-Haines 1: doc. no. 407; published in Seymour 1967b, doc. no. 3; published in Herzner 1979b, doc. no. 7.

DOCUMENT 67 11 September 1408
Donatello receives fifteen florins for work in progress on figures for the Opera del Duomo.
Source: AOSMF, Deliberazioni II-1-54, c. 29v.
Bibliography: Published in Poggi-Haines 1: doc. no. 408; published in Seymour 1967b, doc. no. 4; cited in Herzner 1979b, doc. no. 8.

DOCUMENT 68 3 December 1408
Antonio di Banco named as consul of stonemasons' guild, January 1408/9 through April 1409.
Source: ASF, Arte dei Maestri di pietra e legname 2, cc. 17r, 68v.
Bibliography: Cited in Wundram 1961, 23; cited in Bergstein 1987a, 61.

DOCUMENT 69 15 December 1408
Antonio di Banco paid eighty-five gold florins for a figure made by his son, Nanni.
Source: AOSMF, Deliberazioni II-1-55, c. 4v.
Bibliography: Published in Poggi-Haines 1: doc. no. 409.

DOCUMENT 70 15 December 1408
Donatello paid twenty-four florins, partial payment for a figure in progress.
Source: AOSMF, Deliberazioni II-1-56, c. 4v.

Bibliography: Published in Poggi-Haines 1: doc. no. 409; cited in Herzner 1979b, doc. no. 9.

DOCUMENT 71 19 December 1408
Three of the four Evangelists are commissioned to Niccolò di Pietro Lamberti, Donatello, and Nanni di Banco; the fourth stone to be assigned to whoever of this group carves the best figure.
Source: AOSMF, Deliberazioni II-1-55, c. 6r.
Bibliography: Published in Poggi-Haines 1: doc. no. 172; cited in Herzner 1979b, doc. no. 10.

DOCUMENT 72 1 January 1408/9
Antonio di Banco elected consul of the stonemasons' guild from January 1408/9 through April 1409.
Source: ASF, Arte dei Maestri di pietra e legname 2, cc. 17r, 68v.
Bibliography: Cited in Wundram 1961, 23; cited in Bergstein 1987a, 61.

DOCUMENT 73 4 February 1408/9
Antonio di Banco and Niccolò di Pietro paid balance due for work done on the northeast portal of the cathedral.
Source: AOSMF, Deliberazioni II-1-55, cc. 8r–v.
Bibliography: Published in Poggi-Haines 1: doc. no. 370.
Comment: The page of text is badly flooded and was damaged even in Poggi's time.

DOCUMENT 74 17 March 1408/9
Antonio di Banco is paid for stones to be used in the house of the canon "Messer Cappone."
Source: AOSMF, Stanziamenti II-4-7, c. 22v.
Bibliography: Cited in Wundram 1961, 28.

DOCUMENT 75 27 March 1409
Donatello is paid fifteen gold florins in partial payment for figures that he is making for the Opera del Duomo.
Source: AOSMF, Deliberazioni II-1-56, c. 2v.
Bibliography: Published in Poggi-Haines 1: doc. nos. 174, 410; published in Seymour 1967b, doc. no. 6; cited in Herzner 1979b, doc. no. 12.

DOCUMENT 76 13 June 1409
It is deliberated that Donatello receive a total of one hundred florins for a figure of a prophet; he is paid the balance of thirty-six florins owed him on that statue.
Source: AOSMF, Deliberazioni II-1-56, c. 7v.
Bibliography: Published in Poggi-Haines 1: doc. no. 411; published in Seymour 1967b, doc. no. 7; cited in Herzner, 1979b, doc. no. 13.

DOCUMENT 77 14 June 1409
It is deliberated that Cristoforo di Bernardo and the others who evaluated Donatello's prophet receive the sum of twenty soldi each, six lire in all.
Source: AOSMF, Deliberazioni II-1-56, c. 8r.
Bibliography: Published in Poggi-Haines 1: doc. no. 412; published in Seymour 1967b, doc. no. 8; cited in Herzner 1979b, doc. no. 14.

DOCUMENT 78 3 July 1409
It is deliberated that a figure of a prophet that had been placed on a tribune buttress be taken down.
Source: AOSMF, Deliberazioni II-1-56, c. 10v.
Bibliography: Published in Poggi-Haines 1: doc. no. 413; published in Vaccarino 1950, 27; published in Seymour 1967b, doc. no. 9; cited in Herzner 1979b, doc. no. 15.

DOCUMENT 79 29 May 1410

A statue of Saint Matthew Evangelist commissioned to Bernardo Ciuffagni.

Source: AOSMF, Deliberazioni II-1-58, c. 8v.

Bibliography: Published in Poggi-Haines 1: doc. no. 183.

Comment: See doc. 71, above.

DOCUMENT 80 12 June 1410

Nanni di Banco receives forty gold florins toward the figure of Saint Luke Evangelist.

Source: AOSMF, Deliberazioni II-1-58, c. 11r.

Bibliography: Published in Poggi-Haines 1: doc. no. 184.

DOCUMENT 81 17 July 1410

It is deliberated that the chapels in which the Evangelists are being carved be closed under lock and key.

Source: AOSMF, Deliberazioni II-1-58, c. 17r.

Bibliography: Published in Poggi-Haines 1: doc. no. 186.

DOCUMENT 82 27 August 1410

First reference to a terracotta buttress figure: a lock is ordered for its work space.

Source: AOSMF, Stanziamenti II-4-7, c. 39r.

Bibliography: Published in Poggi-Haines 1: doc. no. 414; cited in Herzner 1979b, doc. no. 19.

DOCUMENT 83 31 October 1410

Nanni di Banco paid twenty-five florins toward the statue of Saint Luke. The phrase "con duo angioli" (with two angels) is added and then struck out.

Source: AOSMF, Deliberazioni II-1-59, c. 4r.

Bibliography: Published in Poggi-Haines 1: doc. no. 189.

Comment: The words "con duo angioli" (struck out) are not transcribed in Poggi-Haines.

DOCUMENT 84 12–24 December 1410

Materials purchased for the terracotta buttress figure: a piece of sandstone, linseed oil, varnish, and whitewash.

Source: AOSMF, Stanziamenti II-4-7, c. 41r.

Bibliography: Published in Poggi-Haines 1: doc. no. 415; published in Seymour 1967b, doc. no. 11; cited in Herzner 1979b, doc. no. 20.

DOCUMENT 85 1 January 1410/11

Antonio di Banco is named consul of stonemasons' guild from January 1410/11 through April 1411.

Source: ASF, Arte dei Maestri di pietra e legname 2, cc. 19r, 70r.

Bibliography: Cited in Wundram 1961, 23; cited in Bergstein 1987a, 61.

DOCUMENT 86 15 January 1410/11

Barnaba di Michele paid ten lire for the whitewashing of a terracotta figure placed above the corner buttress that faces the via dei Servi.

Source: AOSMF, Deliberazioni II-1-59, c. 9v.

Bibliography: Published in Guasti 1887, doc. no. 459; published in Poggi-Haines 1: doc. no. 416; published in Seymour 1967b, doc. no. 12; cited in Herzner 1979b, doc. no. 21.

DOCUMENT 87 1411 (Florentine calendar)

Antonio and Nanni di Banco scrutinized for the Priorate; they receive seventy-seven and forty-three votes respectively, in neither case sufficient to be imborsato.

Source: ASF, Tratte 45, c. 92.

Bibliography: Published in Bergstein 1987a, doc. no. 3.

Comment: Notice of this scrutiny was published by Brunetti 1930, 233

(citing ASF, Carte dell'Ancisa, KK, Manoscritti 358, c. 530v). Brunetti believed the phrase "squittinato per la minore" indicated a scrutiny for one of the minor offices, whereas it actually indicated candidates who were minor guildsmen. (The notation is repeated in ASF, Carte dell'Ancisa, GG, Manoscritti 354, c. 540r.)

DOCUMENT 88 1 January 1411/12

Nanni di Banco is named consul of the stonemasons' guild from January 1411/12 through April 1412.

Source: ASF, Arte dei Maestri di pietra e legname 2, c. 19v.

Bibliography: Cited in Wundram 1969, 146; published in Bergstein 1987a, doc. no. 3.

DOCUMENT 89 9 February 1411/12

Barnaba di Michele is hired to whiten the "homo magnus et albus" that has been placed above a buttress at the cathedral.

Source: AOSMF, Deliberazioni II-1-61, c. 13v.

Bibliography: Published in Poggi-Haines 1: doc. no. 417; published in Seymour 1967b, doc. no. 13; cited in Herzner 1979b, doc. no. 26.

DOCUMENT 90 8 June 1412

Nanni di Banco is paid thirty-two florins toward his statue of Saint Luke.

Source: AOSMF, Deliberazioni II-1-62, c. 28r.

Bibliography: Published in Poggi-Haines 1: doc. no. 198.

DOCUMENT 91 28 June 1412

Barnaba di Michele paid for whitening the figure of Joshua, on a buttress of the cathedral.

Source: AOSMF, Stanziamenti II-4-7, c. 58v.

Bibliography: Published in Poggi-Haines 1: doc. no. 418; published in Seymour 1967b, doc. no. 14; cited in Herzner 1979b, doc. no. 27.

DOCUMENT 92 27 July 1412

Donatello paid fifty florins as partial payment for the figure of Joshua.

Source: AOSMF, Deliberazioni II-1-62, c. 33r.

Bibliography: Published in Poggi-Haines 1: doc. no. 419; published in Seymour 1967b, doc. no. 15; cited in Herzner 1979b, doc. no. 28.

DOCUMENT 93 12 August 1412

The total price for Donatello's Joshua, "que posita est super dicta ecclesia," is estimated by the Operai at 128 gold florins.

Source: AOSMF, Deliberazioni II-1-62, c. 9v.

Bibliography: Published in Poggi-Haines 1: doc. no. 420; published in Seymour 1967b, doc. no. 16; published in Herzner 1979b, doc. no. 29.

DOCUMENT 94 12 August 1412

Donatello given fifty florins in partial payment for a figure of Saint John Evangelist and a Prophet David.

Source: AOSMF, Deliberazioni II-1-62, cc. 9v, 33r.

Bibliography: Published in Poggi-Haines 1: doc. no. 199; cited in Herzner 1979b, doc. no. 30.

DOCUMENT 95 1 September 1412

Antonio di Banco named to the Consiglio del Comune from September through December 1412.

Source: ASF, Tratte 151, c. 67r.

Bibliography: Published in Bergstein 1987a, doc. no. 4.

Comment: The notation is repeated in ASF, Tratte 150, c. 106r.

DOCUMENT 96 3 September 1412

Antonio di Banco and his son (Nanni di Banco) are responsible for obtaining marbles in the city of Pisa, probably quarried in Carrara.

Source: AOSMF, Deliberazioni II-1-62, cc. 12v–13r.

Bibliography: Unpublished.

Comment: Cf. Pachaly 1907, 6 (no date or location given, the original possibly flooded): "Antonius Banchi lastraiuolus est fideiussor [für einem] Maffiolus Johannis habitator a Carraria [für eine Lieferung von] miliaria liberarum de marmo." This indicates that Antonio dealt with Maffiolo di Giovanni da Como, who had settled in Carrara and is known as a wholesaler of marbles to Pisans and Florentines in the 1420s and later; for Maffiolo and his family, see Klapisch-Zuber 1969, 83, 90, 100, 103, 129, 154, 197, 256, 263–64.

DOCUMENT 97 23 September 1412

Antonio di Banco paid twenty-two lire, thirteen soldi, four denari for work or stones not described.

Source: AOSMF, Stanziamenti II-4-7, c. 61v.

Bibliography: Cited in Wundram 1961, 28.

Comment: The page is largely erased by flooding of 1966.

DOCUMENT 98 28 October 1412

Antonio di Banco is paid six lire, eleven soldi for stones for a door and a window at Orsanmichele.

Source: ASF, Capitani di Orsanmichele no. 61, c. 66v.

Bibliography: Cited in Wundram 1961, 28; published in Bergstein 1987a, 61.

Comment: Wundram (1961, 28) refers to an entry in ASF, Capitani di Orsanmichele no. 61, c. 67v, as a separate sale of stones. In fact, this entry is canceled with the marginal notation to "see c. 66"; it therefore repeats that of 28 October.

DOCUMENT 99 1 January 1412/13

Antonio di Banco named consul of stonemasons' guild from January 1412/13 through April 1413.

Source: ASF, Arte dei Maestri di pietra e legname 2, cc. 20v, 71r.

Bibliography: Cited in Wundram 1961, 23.

DOCUMENT 100 16 February 1412/13

Nanni di Banco paid the balance of forty florins for the statue of Saint Luke.

Source: AOSMF, Stanziamenti II-4-7, c. 69r.

Bibliography: Published in Poggi-Haines 1: doc. no. 205.

DOCUMENT 101 28 November 1413

Antonio di Banco paid six lire, eleven soldi for stones delivered to the Compagnia of Orsanmichele during 1413.

Source: ASF, Capitani di Orsanmichele no. 20, c. 99v.

Bibliography: Cited in Wundram 1961, 28; cited in Bergstein 1987a, 61. Wundram misinterpreted the word 'hostiam' to mean "Hostenschrein," or tabernacle of the Host, whereas it simply means door. Therefore the entry here may be misdated, and actually triplicate the first and second entries in Capitani di Orsanmichele, no. 61, given the coincidence of work, pay sums, and date: see doc. 98, above.

DOCUMENT 102 May 1413

Antonio di Banco pays one florin in Prestanza; address listed as "via di Borgo Alegri."

Source: ASF, Prestanze 2900, cc. 72r, 77r.

Bibliography: Cited in Bergstein 1987a, 56.

DOCUMENT 103 23 December 1413

The Arte della Lana names Antonio di Banco "capomaestro" of the cathedral.

Source: ASF, Arte della Lana 49, c. 32v.

Bibliography: Published in Saalman 1980, doc. no. 24-I.

DOCUMENT 104 2 April 1414

Antonio di Banco paid salary of twenty-four florins for three months (January through March) as "capomaestro."

Source: AOSMF, Stanziamenti II-4-7, c. 82r (reflected in Deliberazioni II-1-65, c. 3v).

Bibliography: Cited in Wundram 1961, 23; published in Saalman 1980, doc. no. 24-II.

DOCUMENT 105 28 April 1414

Nanni di Banco elected podestà of Montagna Fiorentina for six months beginning 22 August 1414.

Source: ASF, Tratte 1125, c. 12r.

Bibliography: Published in Brunetti 1930, 233; published in Bergstein 1987a, doc. no. 5.

Comment: Notation reflected in ASF, Tratte 134, c. 63v and Tratte 66, c. 67r: the two documents, both dated "XXII augusti 14 [14]," are published in Brunetti 1930, 233.

DOCUMENT 106 1 May 1414

Nanni di Banco elected consul of stonemasons' guild from May through August 1414.

Source: ASF, Arte dei Maestri di pietra e legname 2, c. 73r.

Bibliography: Cited in Semper 1875, 299; Semper's date of 1416, which is quoted by Brunetti 1930, 232, is mistaken; cf. Bergstein 1987a, 64.

DOCUMENT 107 19 June 1414

Antonio di Banco continues to receive salary of eight florins per month as "capomaestro."

Source: AOSMF, Deliberazioni II-1-65, c. 12v.

Bibliography: Unpublished.

DOCUMENT 108 19 June 1414

Nanni di Banco commissioned for frontispiece above the northeast portal of the cathedral (Porta della Mandorla), which faces the Servite church.

Source: AOSMF, Deliberazioni II-1-65, c. 13r.

Bibliography: Published in Guasti 1887, doc. no. 470; published in Poggi-Haines 1: doc. no. 375.

DOCUMENT 109 17 August 1414

Antonio di Banco appointed to supervise the building of the second cathedral tribune, along with Operai Antonio di Tedice degli Albizzi and Francesco di Niccolò Manelli.

Source: AOSMF, Deliberazioni II-1-65, c. 17r.

Bibliography: Published in Guasti 1887, doc. no. 471; cited in Saalman 1980, doc. no. 28.

DOCUMENT 110 11 September 1414

Antonio di Banco (as "capomaestro") and Filippo di Otto di Sapiti (as "provveditore") are to engage workers for the cathedral.

Source: AOSMF, Deliberazioni II-1-65, c. 18v.

Bibliography: Unpublished.

DOCUMENT 111 29 October 1414

Nanni di Banco drawn for the office of Podestà of Tizzana, but disqualified.

Source: ASF, Tratte 1125, c. 87r.

Bibliography: Published in Bergstein 1987a, doc. no. 6; previously published by Brunetti (1930, 234), who neglected to include the annotation "divieto" (disqualified).

DOCUMENT 112 5 January 1414/15

Nanni di Banco drawn for the office of Podestà of Buggiano, but disqualified.

Source: ASF, Tratte 1125, c. 112v.

Bibliography: Published in Bergstein 1987a, doc. no. 7; cf. Brunetti (1930, 234), who neglected to include the annotation "divieto."

DOCUMENT 113 31 March 1415

Antonio di Banco continues to receive eight florins per month as "capomaestro" (January 1414/15–March 1415).

Source: AOSMF, Stanziamenti II-4-7, c. 95v.

Bibliography: Cited in Saalman 1980, doc. no. 24.

DOCUMENT 114 1 May 1415

Antonio di Banco elected consul of stonemasons' guild from May through August 1415. A subsequently added, undated notation indicates that he was replaced by Jacopo di Niccolò Succhielli at his death.

Source: ASF, Arte dei Maestri di pietra e legname 2, c. 74r.

Bibliography: Cited in Wundram 1961, 23; cited in Bergstein 1987a, 61.

Comment: Jacopo di Niccolò Succhielli was elected consul in his own right on the following dates: 1 September 1391 (ASF, Arte dei Maestri di pietra e legname 2, c. 2v); 1 January 1401/2 (ASF, Arte dei Maestri 2, cc. 11r, 62or); 1 May 1404 (ASF, Arte dei Maestri 2, cc. 13r, 63v); 1 January 1406/7 (ASF, Arte dei Maestri 2, cc. 15v, 66v); 1 May 1409 (ASF, Arte dei Maestri 2, c. 17v); 1 September 1412 (ASF, Arte dei Maestri 2, cc. 20r, 70v); 1 January 1418/19 (ASF, Arte dei Maestri 2, c. 26v); 1 January 1424/25 (ASF, Arte dei Maestri 2, c. 31r); 1 January 1426/27 (ASF, Arte dei Maestri 2, cc. 35r, 86r). He dies during the last term. Antonio di Banco and Jacopo di Niccolò Succhielli served as consuls together during the term beginning 1 January 1410/11 (ASF, Arte dei Maestri 2, cc. 19r, 70r).

DOCUMENT 115 15 May 1415

It is deliberated that Antonio di Banco, Galeotto di Niccolò Mannelli, and Simone di Francesco journey to inspect the forests of the Opera del Duomo.

Source: AOSMF, Deliberazioni II-1-66, c. 40r, flooded in 1966; only the names are visible.

Bibliography: Cited in Guasti 1887, 315 n. 1; cited in Wundram 1961, 23; cited in Bergstein 1987a, 64.

Comment: For the forests owned by the Opera of Santa Maria del Fiore, see Saalman 1980, 199–201.

DOCUMENT 116 28 May 1415

Antonio di Banco's pro tem substitutes as "capomaestro" named: Jacopo di Niccolò Succhielli (a stonemason) and Francesco di Niccolò Manelli ("provveditore").

Source: AOSMF, Deliberazioni II-1-66, c. 41v.

Bibliography: Cited in Haines 1985, 97.

Comment: On 3 July 1415 (ASF, Arte della Lana 49, c. 47r, cited by Saalman 1980, doc. no. 31), Giovanni d'Ambrogio is re-elected *capomaestro* after Antonio's death.

DOCUMENT 117 28 May 1415

Nanni di Banco paid thirty gold florins for figures made and to be made for above the cathedral portal that leads to the Servite church of Santissima Annunziata.

Source: AOSMF, Deliberazioni II-1-66, c. 6v.

Bibliography: Published in Poggi-Haines 1: doc. no. 376.

DOCUMENT 118 3 June 1415

Nanni di Banco to receive pay for one month, twenty-two days (1 April – 22 May 1415) on behalf of his late father as sole heir; he is paid on 10 June.

Source: AOSMF, Deliberazioni II-1-66, c. 7r.

Bibliography: Cited in Wundram 1961, 23; cited in Saalman 1980, doc. no. 24-III.

DOCUMENT 119 3 June 1415

Galeotto di Niccolò Manelli is reimbursed for expenses for Antonio di Banco's funeral and the return of his body to Florence.

Source: AOSMF, Deliberazioni II-1-66, c. 7r.

Bibliography: Published in Guasti 1887, doc. no. 472; cited in Saalman 1980, doc. no. 24-IV; cited in Bergstein 1987a, 64.

DOCUMENT 120 20 August 1415

Nanni di Banco paid thirty gold florins for part of the figuration of the "Assumption."

Source: AOSMF, Deliberazioni II-1-67, c. 34v (reflected in Stanziamenti II-4-7, c. 101v).

Bibliography: Published in Poggi-Haines 1: doc. no. 377.

DOCUMENT 121 12 September 1415

The Operai of the Duomo deliberate to sell 4,000 libbre of white marble to the guild of stonemasons at the low rate of ten lire ("florenorum parvorum") per 1,000 libbre, or a total price of 40 lire.

Source: AOSMF, Deliberazioni II-1-67, c. 10v.

Bibliography: Published in Bergstein 1988, 911.

Comment: Three *libbre antiche* would be equal to about one modern kilogram; 4,000 *libbre* would therefore equal about 1,333 modern kilograms.

DOCUMENT 122 9 October 1415

The Opera del Duomo registers the sale of 4,000 libbre (three flat slabs, or "tabulae") of marble to the stonemasons' guild.

Source: AOSMF, Deliberazioni II-1-67, c. 12r.

Bibliography: Published in Bergstein 1988, 911.

Comment: The standard "lapida di marmo da sepultura" measured four *braccia* in length, one-and-a-half *braccia* in width, was one-third *braccio* deep, and weighed 6,000 *libbre*: blocks of this size were used for carving large statues, such as the Evangelists for the Duomo facade. With this in mind, we may imagine that the *tabulae* sold to the stonemasons' guild, weighing a total of 4,000 *libbre*, were three rather shallow slabs, whose total volume was less than that of a standard sarcophagus lid; the stones must have been used for architectural decoration. In April 1422 the Opera del Duomo sold over 9,000 *libbre* of marble to the Arte del Cambio for its tabernacle at Orsanmichele. The price of 10 lire per 1,000 *libbre* of white marble was remarkably low, even by quattrocento standards: blocks for the seated Evangelists of the Duomo, purchased in 1407, weighing 6,000 *libbre* each, cost 114 lire. It appears that the stonemasons, on account of their obvious association with the cathedral workshop, received a special discount.

DOCUMENT 123 9 October 1415

Brunelleschi and Donatello are given ten florins as partial payment for a small stone figure clad in lead — a model for the manufacture of large figures to stand on the buttresses.

Source: AOSMF, Stanziamenti II-4-7, c. 103r (reflected in Deliberazioni II-1-62, c. 36r).

Bibliography: Published in Guasti 1887, doc. no. 473; published in Poggi-Haines 1: doc. no. 423; published in Seymour 1967b, doc. no. 18;

cited in Herzner 1979b, doc. no. 40.

Comment: See 29 January 1415/16, AOSMF, Deliberazioni II-1-68, c. 34r (Poggi-Haines 1: doc. no. 424), where Brunelleschi is obliged to deliver the lead for the project before 15 February.

DOCUMENT 124 11 March 1415/16

Nanni di Banco is Donatello's guarantor for an advance payment of ten gold florins for the Campanile Prophets.

Source: AOSMF, Deliberazioni II-1-68, c. 6r.

Bibliography: Published in Poggi-Haines 1: doc. no. 224; cited in Herzner 1979b, doc. no. 43.

DOCUMENT 125 6 July 1416

The Priors of the Signoria request that the Operai send the marble figure of David presently in the cathedral workshop to be installed at the Palazzo della Signoria. The operation is to be overseen by Giovanni d'Ambrogio ("capomaestro") and Francesco di Niccolò Manelli ("provveditore").

Source: AOSMF, Deliberazioni II-1-69, c. 33v.

Bibliography: Published in Poggi-Haines 1: doc. no. 425; published in Seymour 1967b, doc. no. 20; cited in Herzner 1979b, doc. no. 44.

DOCUMENT 126 9 July 1416

Nanni di Banco begins six-month term as Podestà of Castelfranco di Sopra.

Source: ASF, Tratte 329, c.65r.

Bibliography: Published in Brunetti 1930, 233–34; published in Bergstein 1987a, doc. no. 8.

Comment: The dates of the actual *tratte* which occurred before the terms of office are not preserved for the year 1416. See this notation reflected, however, in ASF, Tratte 66, c. 117, where the terms of the appointment are described, and Tratte 134, c. 65r.

DOCUMENT 127 27 August 1416

Donatello is paid five gold florins for completing and adapting the figure of David to be sent to the Palazzo della Signoria.

Source: AOSMF, Deliberazioni II-1-69, c. 8r (reflected in Stanziamenti II-4-7, c. 127v).

Bibliography: Published in Poggi-Haines 1: doc. no. 426; published in Seymour 1967b, doc. no. 21; published in Herzner 1979b, doc. no. 47.

DOCUMENT 128 18 September 1416

Expenses for the figure of David to be sent to the Palazzo della Signoria are itemized, including a payment of twelve lire, fourteen soldi, and eight denari to Nanni di Fruosino.

Source: AOSMF, Stanziamenti II-4-7, c. 125v.

Bibliography: Published in Poggi-Haines 1: doc. no. 427; published in Seymour 1967b, no. 22; cited in Herzner 1979b, no. 46.

DOCUMENT 129 1 January 1416/17

Nanni di Banco named guild consul January 1416/17 through April 1417.

Source: ASF, Arte dei Maestri di pietra e legname 2, c. 23r.

Bibliography: Cited in Semper 1875, 299; cited in Bergstein 1987a, 65.

Comment: The entry is incomplete, lacking a date, but the chronological logic of the codex shows that the term indicated was January 1416/17 through April 1417.

DOCUMENT 130 7 February 1416/17

The Opera del Duomo sells marble to the guild of Corazzai for the base of the statue of Saint George at Orsanmichele.

Source: AOSMF, Deliberazioni II-1-70, c. 8r.

Bibliography: Published in Wundram 1960a, 176; cited in Herzner 1979b, doc. no. 48; published in Bergstein 1988, 912.

Comment: Janson (1957, 23–24) believed the marble to have been used for the lowest section of the tabernacle, and dated the statue, as well as the *schiacciato* relief of Saint George Slaying the Dragon to ca. 1415–17. Beck (1980, 128–33) dated the statue itself to ca. 1410–16/17 (with the relief below coming considerably later) as the marble purchased was clearly to be used for the beveled rectangular base ("per basi") on which Saint George stands, and not for the relief in the socle zone. Beck's observation is substantiated by the fact that the circulation of the price in "soldi per 100 *libbre*" rather than "lire per 1,000" indicates a small volume of stone such as would have been used for the pedestal alone.

DOCUMENT 131 13 May 1417

Nanni di Banco paid twenty-seven florins, partial payment for several figures of the "Assumption."

Source: AOSMF, Stanziamenti II-4-8, c. 4r.

Bibliography: Published in Poggi-Haines 1: doc no. 378.

DOCUMENT 132 1 January 1417/18

Nanni di Banco named consul of the stonemasons' guild for January 1417/18 through April 1418.

Source: ASF, Arte dei Maestri di pietra e legname 2, c. 26r.

Bibliography: Cited in Bergstein 1987a, 65.

DOCUMENT 133 18 February 1417/18

Nanni di Banco paid thirty florins for work begun on the "Assumption."

Source: AOSMF, Deliberazioni II-1-72, c. 21v (reflected in Stanziamenti II-4-8, c. 14r).

Bibliography: Published in Poggi-Haines 1: doc. no. 379.

DOCUMENT 134 28 June 1418

Nanni di Banco serves as guarantor for advance payment of twenty florins from the Opera del Duomo to Donatello for a figure in progress.

Source: AOSMF, Deliberazioni II-1-73, c. 24r (reflected in Stanziamenti II-4-8, c. 23r).

Bibliography: Published in Poggi-Haines 1: doc. no. 227; cited in Herzner 1979b, doc. no. 50.

DOCUMENT 135 28 June 1418

Nanni di Banco paid twenty florins for figures carved by him for the "Assumption."

Source: AOSMF, Deliberazioni II-1-73, c. 24r (reflected in Stanziamenti II-4-8, c. 23r).

Bibliography: Published in Poggi-Haines 1: doc. no. 380.

DOCUMENT 136 12 October 1418

Nanni di Banco paid fifty florins for six marble figures for the "Assumption."

Source: AOSMF, Deliberazioni II-1-74, c. 38v (reflected in Stanziamenti II-4-8, c. 29r).

Bibliography: Published in Poggi-Haines 1: doc. no. 381.

DOCUMENT 137 23 December 1418

Nanni di Banco paid forty florins toward some figures for the "Assumption."

Source: AOSMF, Deliberazioni II-1-74, c. 60r (reflected in Stanziamenti II-4-8, c. 36v).

Bibliography: Published in Poggi-Haines 1: doc. no. 382.

DOCUMENT 138 8 February 1418/19

The Operai deliberate that four "scudi" with the arms of the Popolo, Comune, Parte Guelfa, and Arte della Lana be made for the papal apartments at Santa Maria Novella.

Source: AOSMF, Deliberazioni II-1-75, c. 7r.

Bibliography: Unpublished; provided by Margaret Haines.

DOCUMENT 139 15 April 1419

It is deliberated that an arrangement of escutcheons be hung at the papal apartments at Santa Maria Novella: the arms of the Parte Guelfa, the Florentine Popolo, the Roman Church, and the Florentine Comune. Two smaller escutcheons containing the Agnus Dei of the Arte della Lana would be placed below those of the Comune and the Parte Guelfa.

Source: AOSMF, Deliberazioni II-1-75, c. 16r.

Bibliography: Unpublished; provided by Margaret Haines.

Comment: See ASF, Arte della Lana 147, c. 11v, 16 May 1419.

DOCUMENT 140 10 May 1419

Nanni di Banco paid for two "tondi" containing Agnus Dei, the emblem of the Arte della Lana, to be placed on the outer wall of the papal apartments of Santa Maria Novella.

Source: AOSMF, Deliberazioni II-1-75, c. 50r.

Bibliography: Published in Semper 1875, doc. no. 23, but with an incorrect date of 11 May.

Comment: The payment to Nanni for two tondi is repeated in AOSMF, Stanziamenti II-4-8, cc. 43r and 49r.

DOCUMENT 141 12 May 1419

Arrangement of escutcheons for the papal apartments described: the pope's arms (the arms of the Colonna) are being added.

Source: AOSMF, Deliberazioni II-1-75, c. 27v.

Bibliography: Unpublished; provided by Margaret Haines.

Comment: See ASF, Carte Strozziane II, 78, cc. 33, 40, 99.

DOCUMENT 142 20 May 1419

Extracts from the act by which part of the Orlandi property is rented indicate that it is in the parish of San Pietro a Monticelli (church still existing near the intersection of the via di Soffiano and the via Pisana).

Source: ASF, Arte della Lana 149, c. 14r.

Bibliography: Unpublished; provided by Margaret Haines.

DOCUMENT 143 31 May 1419

Nanni di Banco paid twenty gold florins for marble figures made for the "Assumption."

Source: AOSMF, Deliberazioni II-1-75, c. 51r (reflected in Stanziamenti II-4-8, c. 45r).

Bibliography: Published in Poggi-Haines 1: doc. no. 383.

DOCUMENT 144 22 June 1419

Nanni di Piero called "Ticcio" paid fifteen lire for escutcheon with the lily of the Comune.

Source: AOSMF, Deliberazioni II-1-75, c. 51v.

Bibliography: Unpublished; provided by Margaret Haines.

Comment: Reflected in AOSMF, Stanziamenti II-4-8, cc. 40, 56v. Nanni di Piero, called "Ticcio" matriculated to the stonemasons' guild 4 March 1418/19 (ASF, Arte dei Maestri di pietra e legname 2, c. 26v, unpublished). As one of Brunelleschi's primary assistants, he built the pulpit at Santa Maria Novella on Brunelleschi's design and allocated the reliefs to "Il Buggiano" (Poggi 1905, 81–82). In the Opera del Duomo, Nanni di Piero Ticcio (Giovanni di Piero del Ticcio) supplied most of the Carrara marbles for the Cantoria of Luca della Robbia (see Poggi-Haines 1: doc. no. 1284). For other references to his activity in the Opera

del Duomo, ibid. 1: doc. nos. 743, 1095, 1175; ibid. 2: doc. no. 1518.

DOCUMENT 145 11 July 1419

Nanni di Banco paid sixteen lire for four "stemmi" of the Agnus Dei carved of stone for the Arte della Lana, made and installed by him in a farmhouse or houses.

Source: ASF, Arte della Lana 147, c. 46r.

Bibliography: Published in Brunetti 1930, 232–33.

DOCUMENT 146 7 August 1419

Pippo di Cristofano, called "Cerbio," is paid thirteen florins for escutcheons with the arms of Pope Martin V, the Roman Church, and the Parte Guelfa.

Source: AOSMF, Deliberazioni II-1-76, c. 47v (reflected in Stanziamenti II-4-8, c. 15v).

Bibliography: Unpublished; provided by Margaret Haines.

Comment: For Filippo di Cristofano, called "Cerbio," at work in the Opera del Duomo as a stonemason, see Poggi-Haines 1: doc. no. 262; ibid. 2: doc. no. 2090. He also worked on tabernacles at the residence of the Capitani del Bigallo (1412/13).

DOCUMENT 147 31 August 1419

Nanni di Fruosino paid ten lire for two stone Agnus Dei, arms of the Arte della Lana, made and installed by him on a farmhouse (or houses) on land purchased with the bequest of Silvestro Orlandi.

Source: ASF, Arte della Lana 147, c. 87r.

Bibliography: Unpublished; provided by Margaret Haines.

Comment: Nanni di Fruosino, called "Testa," was an artist known to have done painting as well as sculpture. He assisted Donatello in preparing the David of 1409 for installation in the Palazzo della Signoria in 1416; after Donatello's "recarving" of the piece, Nanni di Fruosino was reimbursed by the Opera del Duomo for gold leaf, silver leaf, pigments of blue, vermilion, and lake, and glass tiles (see Poggi-Haines 1: doc. nos. 427, 436, 1028, 1030, 1169).

DOCUMENT 148 1 September 1419

Nanni di Banco is named consul of stonemasons' guild from September 1419 through December 1419.

Source: ASF, Arte dei Maestri di pietra e legname 2, c. 37.

Bibliography: Cited in Bergstein 1987a, 65.

DOCUMENT 149 12 September 1419

Nanni di Banco is drawn for the Dodici Buonuomini for the term of three months beginning 15 September 1419.

Source: ASF, Tratte 197, c. XXXIIIIr.

Bibliography: Published in Bergstein 1987a, doc. no. 9.

Comment: The number "91" following his name refers to the bag that was begun with the scrutiny of 1391, from which this name-tag was extracted. Nanni's name was therefore at a certain point placed in the bag of 1391: the *tratte* pulled tickets from the oldest bags first, therefore giving precedence to the longest-standing "imborsati"; see Najemy 1982, 185. A so-called *rimbotto* of 1416 established that the names of candidates over the age of twenty-five could be considered for insertion in the bag of the 1391 scrutiny (19 June 1416; ASF, Archivi della Repubblica, cc. 32v–35r, cited in Brucker 1977, 412). The *rimbotto* of 1416 was used to favor eligibles of a certain age and social stratum. It is therefore noteworthy that Nanni, although a "new man," was included in this group. (See docs. 26 and 87 above, and 172 below.) The above document is reflected in a later summary: ASF, Tratte 11, c. 163v (published by Brunetti 1930, 235), where in a marginal notation it is marked that after his death

Nanni was drawn for the Priorate: "Morto; Signori — 29 augusti 1427" (as in doc. 172 below).

DOCUMENT 150 15 September 1419
Nanni di Banco, as a member of the Dodici, grants the privilege to circulate in the city after curfew to a citizen of his choice, Biagio di Lorenzo.
Source: ASF, Tratte 1107, c. 162r.
Bibliography: Published in Bergstein 1987a, doc. no. 10; previously published by Brunetti (1930, 235), who mistook the words "pro de nocte" for a reference to the "Ufficiali di Notte," an office instituted in 1432 to enforce laws against sodomy; see 12 April 1432, ASF, Archivi della Repubblica, Provvisioni, Registri no. 123, cc. 31v–35r, cited by Trexler 1980a, 380. The "apodisse" were in fact permission slips that the members of the Tre Maggiori were authorized to carry and to distribute at their discretion (see Tratte 1107, c. 145r).
Comment: On 15 September 1414 Guariento di Jacopo had granted an *apodissa* "pro de nocte" to Nanni di Banco for a period of two months beginning 22 March 1414/15 (Tratte 1107, c. 149 bis).

DOCUMENT 151 16 September 1419
Nanni di Banco, as a member of the Dodici, is drawn as an auditor regarding the petition of Matteo di Agnolo Malatesta.
Source: ASF, Tratte 23, c. 10r.
Bibliography: Published in Bergstein 1987a, doc. no. 11.

DOCUMENT 152 25 September 1419
Nanni di Banco is drawn as auditor regarding the petition of Corso di Geppo.
Source: ASF, Tratte 23, c. 10v.
Bibliography: Published in Bergstein 1987a, doc. no. 12.

DOCUMENT 153 7 October 1419
Andrea di Nofri is paid a total of forty-one lire, thirteen soldi, and two denari for: one scudo with the arms of the Popolo, two foliated brackets, a cornice, and a lintel carved with the arms of the Comune to go above the door to the stairway of the papal apartments, and a carved frame to go above the arms of the pope.
Source: AOSMF, Deliberazioni II-1-76, c. 52v (reflected in Stanziamenti II-4-8, c. 56v).
Bibliography: Unpublished; provided by Margaret Haines.
Comment: Andrea di Nofri has recently been "discovered" as an artistic personality by Annalisa Bricoli in Sframeli 1989. In 1414 he carved the decorated architrave for the portal of the guild residence of the Rigattieri, Linaioli, and Sarti (see Sframeli 1989, cat. no. 272). The architrave, carved in the rich, graceful idiom that anticipates the work of artists such as Benedetto da Maiano, consists of a dentilated, corniced structure, the field of which is sprinkled with Florentine lilies. A formella in the shape of an eight-pointed star sprinkled with Florentine lilies and containing a scudo with the arms of the guild of Oliandoli and Pizzicagnoli — a rampant lion holding an olive branch — has also been attributed to Andrea di Nofri (Museo Bardini; see Sframeli 1989, cat. no. 293). Bricoli attributes the relief to Andrea di Nofri with reservation on the basis of its similarity to the architrave *scudi* carved for the Rigattieri. Andrea carved similarly ornate pieces for the Bigallo, San Miniato, San Lorenzo, the cathedral, and the hospital of San Paolo: for this and for the subsequent fortunes of Andrea di Nofri see Goldthwaite 1980, 277–78.

DOCUMENT 154 11 October 1419
Nanni di Banco paid thirty gold florins for several figures for the "Assumption."
Source: AOSMF, Deliberazioni II-1-76, c. 53r (reflected in AOSMF, Stanziamenti II-4-8, c. 56v).
Bibliography: Published in Poggi-Haines 1: doc. no. 384.

DOCUMENT 155 29 December 1419
Filippo Brunelleschi, Nanni di Banco, and Donatello are paid a total of forty-five gold florins for a scale model of the cupola made without armature.
Source: AOSMF, Deliberazioni II-1-77, c. 51v (reflected in AOSMF, Stanziamenti II-4-8, c. 60v).
Bibliography: Published in Guasti 1857, doc. no. 43; cited in Herzner 1979b, doc. no. 58; cited in Saalman 1980, doc. nos. 88, 91.

DOCUMENT 156 21 February 1419/20
Nanni di Banco paid eighty florins for work done on the "Assumption."
Source: AOSMF, Deliberazioni II-1-77, c. 58v (reflected in AOSMF Stanziamenti II-4-8, c. 68r).
Bibliography: Published in Poggi-Haines 1: doc. no. 385.

DOCUMENT 157 27 March 1420
Nanni di Banco represents the Quartiere of San Giovanni in a committee of four citizens to approve the statutes of the Podesteria of Valdambra.
Source: ASF, Tratte 1080, c. 35r.
Bibliography: Published in Bergstein 1987a, doc. no. 13. Previously published in Brunetti (1930, 235) as (spurious) evidence that Nanni was drawn to hold an office in the podesteria of Valdambra. Instead, statutes for the various communities in the Florentine territory were reviewed by a committee of four men, composed of a representative from each quarter: a rotation system ensured that one member be a minor guildsman.

DOCUMENT 158 1 April 1420
Nanni di Banco paid one gold florin for work and advice on the design of Brunelleschi's cupola along with others, including Giovanni di Gherardo da Prato, Donatello, and Pesello.
Source: AOSMF, Deliberazioni II-1-77, c. 64r.
Bibliography: Published in Guasti 1857, doc. no. 46; cited in Herzner 1979b, doc. no. 60; cited in Saalman 1980, doc. no. 101.

DOCUMENT 159 16 January 1420/21
Nanni di Banco enters the Consiglio del Ducento and is marked as deceased during the six-month term.
Source: ASF, Tratte 153, c. 29v.
Bibliography: Published in Bergstein 1987a, doc. no. 14.

DOCUMENT 160 9 February 1420/21
Nanni di Banco makes his will in favor of his wife.
Source: ASF, Archivio generale dei contratti di Firenze, Libro dei Testamenti, Rogato di ser Cetto di ser Agnolo di ser Cecco da Loro.
Bibliography: Excerpted in Vasari-Milanesi 2:164–65.
Comment: The document is no longer to be found at ASF among the material notarized by ser Cetto di ser Agnolo di ser Cecco da Loro.

DOCUMENT 161 12 February 1420/21
Nanni di Banco is noted as deceased by the Opera del Duomo; the total value of the "Assumption" to be appraised in its unfinished state.
Source: AOSMF, Deliberazioni II-1-78, c. 8r.
Bibliography: Published in Guasti 1887, doc. no. 483; published in Poggi-Haines 1: doc. no. 386.

DOCUMENT 162 17 September 1421

It is stated that Nanni di Banco made and supervised (arranged) the frames, frieze, and foliation for the frontispiece of the Porta della Mandorla, which is not yet wholly completed. "Capomaestro" Battista d'Antonio estimates that the Opera owed Nanni di Banco a total sum of 326⅔ florins.

Source: AOSMF, Deliberazioni II-1-79, c. 27r.

Bibliography: Published in Poggi-Haines 1: doc. no. 387.

DOCUMENT 163 14 January 1421/22

Nanni di Banco (or his shop) is owed seventy-one lire, fourteen soldi, and eight denari for foliated frames made for the frontispiece of the Porta della Mandorla.

Source: AOSMF, Deliberazioni II-1-80, c. 6r.

Bibliography: Published in Poggi-Haines 1: doc. no. 388.

DOCUMENT 164 10 February 1421/22

The sculptor Antonio da' Servi is paid two soldi to clean, polish, or paint the lily held by the Virgin of the Porta della Mandorla.

Source: AOSMF, Stanziamenti II-4-8, c. 24r.

Bibliography: Published in Poggi-Haines 1: doc. no. 389.

DOCUMENT 165 21 April 1422

Nanni di Banco's heir(s), who are not named, are paid 567 lire, seventeen soldi, and four denari for remaining work on the "Assumption."

Source: AOSMF, Deliberazioni II-1-80, c. 69v (reflected in Stanziamenti II-4-9, c. 23r).

Bibliography: Published in Poggi-Haines 1: doc. no. 390.

DOCUMENT 166 13 May 1422

Donatello paid six florins for two prophets' heads made for Nanni di Banco's "Assumption"; the prophets' heads had previously been lacking.

Source: AOSMF, Deliberazioni II-1-80, c. 71v (reflected in Stanziamenti II-4-9, c. 26v).

Bibliography: Published in Poggi-Haines 1: doc. no. 391; cited in Herzner 1979b, doc. no. 70.

DOCUMENT 167 14 August 1422

Bartolomeo di Vieri and colleagues paid twelve "grosi" for a belt of silk edged with gold for Nanni di Banco's Virgin Assunta.

Source: AOSMF, Stanziamenti II-4-9, c. 35r (reflected in Deliberazioni II-1-81, c. 70r).

Bibliography: Published in Poggi-Haines 1: doc. no. 392.

Comment: The sash was presumably to be installed for the following day, 15 August, the feast of the Assumption of the Virgin.

DOCUMENT 168 1423 (Florentine calendar)

Giovanna Succhielli, daughter of the late Niccolò Succhielli and widow of Antonio da Banco, names her brother Jacopo di Niccolò Succhielli (known as "Papero") as her heir.

Source: BNF, Gargani no. 179, "Banchelli-Bancucci," c. 72r; BNF, Gargani no. 1961, "Suagini-Succhielli," c. nn; BNF, Migliore, c. 98r.

Bibliography: Cited in Brunetti 1951, 105; published in Bergstein 1987a, 58 n. 6.

Comment: The notation in Gargani no. 1961, c. nn, is repeated in BNF, Gargani no. 250, c. nn; the word "zia" would be an error in transcription from no. 179 ("Banchelli-Bancucci"), c. 72r: Giovanna and Jacopo were both the children of Niccolò Succhielli.

DOCUMENT 169 7 September 1424

Giovanna Succhielli dies of old age.

Source: BNF, Gargani no. 180, c. 183r; (reflected in ASF, Carte dell' Ancisa CC, Manoscritti 350, c. 23v).

Bibliography: Cited in Brunetti 1951, 105.

DOCUMENT 170 1427 (Florentine calendar)

Jacopo di Niccolò Succhielli was to receive credit for old debts for stones from Antonio di Banco's shop owed by Carlo di Matteo della Scelta and brothers; Jacopo had inherited a farm made up of eleven "parcels of land" in the parish of Santa Maria in Settignano from Giovanna Succhielli.

Source: ASF, Catasto no. 37, c. 698v.

Bibliography: Unpublished; provided by Margaret Haines.

Comment: See 1430 Portata of Maso di Jacopo Succhielli (Jacopo di Niccolò died 16 January 1429/30), ASF, Catasto no. 359, c. 957r; no. 453, c. 601r; no. 666, c. 55r; no. 702, c. 502v; no. 408, c. 599v. One of the Succhielli's debtors was Jacopo ("Papi") di Corso: in 1427 he owed Jacopo di Niccolò Succhielli thirty-two lire. In 1430 the Portata of Maso Succhielli states that since Jacopo di Corso had been in Siena for five years, his debt of forty-six lire was canceled. Such references suggest that Jacopo di Corso may have been an assistant to Antonio or Nanni di Banco; he, too, resided in the gonfalone Chiavi, and appears on a cumulative list of eligibles for the sixteen Gonfalonieri di Compagnia: n.d. ASF, Tratte 64, c. nn. For further information on the career of Jacopo di Corso, see Even 1984, 200–203 and Wundram 1960a, 163.

DOCUMENT 171 1427 (Florentine calendar)

Jacopo di Niccolò Succhielli's list of creditors in 1427 included seven priests who were witnesses to the testament of Giovanna Succhielli.

Source: ASF, Catasto no. 73, c. 121r.

Bibliography: Unpublished; provided by Margaret Haines.

Comment: See doc. 168 above.

DOCUMENT 172 29 August 1427

Nanni di Banco's name is drawn for the Priorate of the Signoria; he is noted as deceased.

Source: ASF, Tratte 197, c. CLXVIIIr.

Bibliography: Published in Bergstein 1987a, doc. no. 15.

Comment: See doc. 159 above.

DOCUMENT 173 28 April 1429

Nanni di Banco's name is drawn for Gonfaloniere di Compagnia of the gonfalone Chiavi; he is noted as deceased.

Source: ASF, Tratte 198, c. 29v.

Bibliography: Published in Bergstein 1987a, doc. no. 16.

Comment: See the two documents related to this fact in Brunetti 1930, 235–36. The first (ASF, Tratte 11, c. 182r) is from a later *spoglio* — an alphabetical listing of names drawn for major office. (The notation is followed by the phrase, still in the same hand of the later compiler, "potrebbe dire Jo. Antonius," which, then canceled, is rewritten next to another name on the list, "Joannes Antonii Filippi Lorini.") The presence of a cross indicates that we are dealing with a spoglio based on the original Tratta of 28 April 1429, when Nanni was already dead; therefore Brunetti's statement that Nanni served as one of the Sedici is in error. The second document is reported by Brunetti as well, but without having brought it into rapport with the previous one: it is from an old (but not original) list of candidates from the minor guilds who were "imborsati" for the office of Gonfaloniere di Compagnia in the gonfalone of Chiavi (ASF, Tratte 64, c. 105r (113 mod.); for the rotation system under which the names in this group were drawn, see ASF Tratte 198, cc. 29v, 65r, etc.) Here, under the rubric of "pro Vex [illifero] clav-

ium — Artifices" appears, without a date, "Johannes Antonii Banchi, magister" with a cross. Also this document, then, refers to a posthumous *tratta*; it does not mean that Nanni served as Gonfaloniere di Compagnia, either before or after his appointment to the Dodici.

DOCUMENT 174 2 June 1430
Payments made for blue paint and gold leaf to be applied to the arches above the Porta della Mandorla and the Porta dei Canonici. It is likely these materials were used to decorate the exterior sculpture above the portals.
Source: AOSMF, Stanziamenti II-4-9, c. 136v.
Bibliography: Published in Poggi-Haines 1: doc. no. 397.

DOCUMENT 175 18 September 1430
Bicci di Lorenzo is paid for having painted the arches above two doors of the cathedral (the Porta della Mandorla and the Porta dei Canonici) blue.
Source: AOSMF, Stanziamenti II-4-9, c. 138r.
Bibliography: Published in Poggi-Haines 1: doc. no. 396.

DOCUMENT 176 26 April 1435
Andrea di Ciecho of Siena is paid for a copper sash ("cintola") to be added to Nanni di Banco's Virgin above the Porta della Mandorla.
Source: AOSMF, Stanziamenti II-4-13, c. 95v.
Bibliography: Published in Poggi-Haines 1: doc. no. 398.

DOCUMENT 177 1439 (?)
The Florentine Opera lists a panel painting of four saints as among those that can be sold.
Source: AOSMF, Stanziamenti II-4-19, c. 92r.
Bibliography: Published in Poggi-Haines 2: doc. no. 2122.

DOCUMENT 178 1443, 1457, 1464 (Florentine calendar)
References to Maso di Jacopo Succhielli, Nanni's cousin, the son of Nanni's mother's heir (Jacopo), sculptor from Sant'Ambrogio (with workshop in Santa Croce), who became "capomaestro" of the Opera del Duomo in 1451/52.
Source: BNF, Gargani, no. 250.
Bibliography: Brunetti 1951, passim, without citation.
Comment: Regarding Maso di Jacopo Succhielli see Guasti 1857, doc. no. 322; Haines 1985, 97–99.

DOCUMENT 179 n.d.
Guild of Shoemakers commissions Nanni di Banco to carve a statue of their patron, Saint Philip, at Orsanmichele.
Source: ASF, Notizie sull'arte dei Calzolai, Ms. 844, c. nn. (spogli di original documents in the hand of a later compiler).
Bibliography: Cited in Bergstein 1992, 10.
Comment: Despite the misleading rubric "Provvisioni 1378–79" [1378–1479?], this notation presumably records the original commission of the Saint Philip statue to Nanni di Banco. The author of Manoscritto 844 was working from several earlier manuscripts, including, among those known to me: ASF, Arte dei Calzolai 1 bis, 1, 2, 3, and 4. Arte dei Calzolai, "Provvisioni 1378–79" [*sic*], may have been a separate codex, no longer conserved at ASF.

Bibliography

MANUSCRIPT SOURCES

Archivio dell'Opera di Santa Maria del Fiore, Florence (AOSMF)

AOSMF, Consigli I-1-1-A
Libro di consigli resi sopra la Fabbrica. Libro del Provveditore Stieri degli Albizzi, 1356–84. Series I, class 1, item 1, vol. A.

AOSMF, Consigli I-1-1-B
Libro di consigli resi sopra la Fabbrica. Libro dei consigli del notaio, 1366–88. Series I, class 1, item 1, vol. B.

AOSMF, Deliberazioni
Bastardelli di Deliberazioni. Series II, class 1, items 3–5, 20–22, 34–36, 38–41, 49, 51–56, 58–59, 61–62, 65–70, 72–81.

AOSMF, Marsili II-4-1
Ricordanze del Provveditore, Filippo Marsili, Bastardello di Ricordanze, 5 April 1353–27 March 1357/58.

AOSMF, Stanziamenti II-4-7
Stanziamenti del Provveditore, marked QQ, 1405–16.

AOSMF, Stanziamenti II-4-8
Stanziamenti del Provveditore, marked RR, 1417–21.

AOSMF, Stanziamenti II-4-9
Stanziamenti del Provveditore, marked SS, 1421–25.

AOSMF, Stanziamenti II-4-13
Stanziamenti del Provveditore, marked CC, 1430–36.

AOSMF, Stanziamenti II-4-19
Stanziamenti del Provveditore, marked I, 1462–73.

Archivio di Stato, Florence (ASF)

ASF, Archivi della Reppublica
Provvisioni, Registri no. 106, 27 March 1416–19 March 1417.

ASF, Arte dei Calzolai 1
Statuti dell'arte. Addendum. Includes material from the fifteenth century through 1523.

ASF, Arte dei Calzolai 1 bis
Statuti dell'arte dei Calzolai e loro riforme e approvazioni, 1355 (mutilated by humidity).

ASF, Arte dei Calzolai 2
Matricole, 1313–16 February 1322/23.

ASF, Arte dei Calzolai 3
Matricole, 30 June 1323–13 March 1408/9. Matriculations of guildsmen from the Florentine territories practicing in Florence.

ASF, Arte dei Calzolai 4
Matricole, 29 August 1416–13 March 1489/90.

ASF, Arte dei Maestri di pietra e legname, 1 and 2
Matricole, beginning 1358.

ASF, Arte della Lana 49
Deliberazioni, Protocollo di riformagioni dei Consoli dell'Arte della Lana (formerly number 48), 27 October 1408–27 August 1427.

ASF, Arte della Lana 147
Partiti, atti e sentenze (formerly number 137), 2 January 1417/18–30 April 1418.

ASF, Arte della Lana 149
Atti e partiti, May–August 1420.

ASF, Capitani di Orsanmichele no. 20
4 November 1412–27 October 1413. Written by Ser Stefano di ser Riccardo di ser Angiolo da Poggibonsi.

ASF, Capitani di Orsanmichele no. 61

Ricordi. Marked 268. One hundred separate pages extracted from a notebook of Ricordi.

ASF, Capitani di Orsanmichele no. 210

Bastardello of notations, marked 57, 1403–4. Fifty-nine separate pages kept by the *camarlingo*, Simone di Vanni Simoni.

ASF, Carte dell'Ancisa

A series of notations extracted from the Gabella dei Contratti by Vittorio dell'Ancisa: Carte dell'Ancisa, CC, Manoscritti 350; Carte dell'Ancisa, GG, Manoscritti 354; Carte dell'Ancisa, KK, Manoscritti 358; Carte dell'Ancisa, I, Manoscritti 345, Zibaldone primo, Spoglio della gabella; Carte dell'Ancisa, Z, Manoscritti 346, Zibaldone secondo, Spoglio della gabella; or Manoscritti 363, Zibaldone prima; Manoscritti 364, Zibaldone secondo.

ASF, Carte Strozziane II, 78

Spoglio e memorie diverse cavate da' libri dell'Opera di Santa Maria del Fiore del sen. Carlo di Tommaso Strozzi, 1670. Series II, no. 78.

ASF, Catasto no. 37

Portata dei cittadini, Santa Croce, Ruote, 1427.

ASF, Catasto no. 73

Campione, Santa Croce, Ruote, 1427.

ASF, Catasto no. 359

Portata dei cittadini, Santa Croce, Ruote, 1430.

ASF, Catasto no. 408

Portata dei cittadini, San Giovanni, Drago, 1430.

ASF, Catasto no. 453

Portata dei cittadini, Santa Croce, Ruote, 1433.

ASF, Catasto no. 666

Portata dei cittadini, Santa Croce, Ruote, 1451.

ASF, Catasto no. 702

Portata dei cittadini, Santa Croce, Ruote, 1451.

ASF, Notizie dell'Arte dei Calzolai

Manoscritto 844. "Notizie sull'arte dei Calzolai, in Università dei Maestri di Cuoime." A nineteenth-century compiler working from original manuscripts.

ASF, Prestanze no. 231

San Giovanni, Chiavi, 1373.

ASF, Prestanze no. 416

Registro del Residuo dei primi 4 estimi, S. Giovanni, April 1380 [*sic*].

ASF, Prestanze no. 1312

Prestanza detta di grano, S. Giovanni, May 1391.

ASF, Prestanze no. 1610

Prestanza Decima, S. Giovanni, Chiavi, 1397.

ASF, Prestanze no. 2763

Prestanza della Novina, S. Giovanni, Chiavi, 1411.

ASF, Prestanze no. 2882

Fifteenth and Sixteenth Prestanze, S. Giovanni, Chiavi, 1412.

ASF, Prestanze no. 2900

Residuo di piacenti e novine, S. Giovanni, Chiavi, May 1413.

ASF, Tratte 11

Filza dei veduti: Quartiere San Giovanni, 1349–1478. Vol. 11.

ASF, Tratte 23

Registro degli auditori sulle petizioni, 1419–28. Vol. 23.

ASF, Tratte 45

Squittinio al Priorato del 1411. Vol. 45.

ASF, Tratte 64

Registro di varie tratte ed elenchi di anni incerti, secc. XIV e XV. Vol. 64.

ASF, Tratte 66

Registro membranaceo di seduti per gli uffici estrinseci, 1408–18. Vol. 66.

ASF, Tratte 134

Tratte di Uffici interni e esterni, 1412–32. Vol. 134.

ASF, Tratte 147

Giornale delle Tratte per i consigli del Popolo e del Comune, 1401–5. Vol. 147.

ASF, Tratte 150

Consigli Pubblici, 1410–13. Vol. 150.

ASF, Tratte 151

Giornale delle Tratte per i consigli del Popolo e del Comune, 1410–14. Vol. 151.

ASF, Tratte 153

Giornale delle Tratte per i consigli del Popolo, Comune, Dugento, e Capitani degli Arti. Vol. 153.

ASF, Tratte 197

Tratte dei Signori e Collegi, 1417–29. Vol. 197.

ASF, Tratte 198

Tratte dei Signori e Collegi, 1429–34. Vol. 198.

ASF, Tratte 329

Nomi dei Rettori del Dominio fiorentino, 1414–32. Vol. 329.

ASF, Tratte 397

Squittinio al Priorato del 1391. Vol. 397.

ASF, Tratte 1080

Registro degli estratti per l'approvazione degli statuti delle communità, 1414–18. Vol. 1080.

ASF, Tratte 1107

Registro delle apodisse "pro de nocte" ai mandatori di vari ufficiali, 1412–18. Vol. 1107.

ASF, Tratte 1125
Registro diurnale dell'Ufficio delle Tratte, 1414–15. Vol. 1125.

Biblioteca Nazionale Centrale, Florence (BNF)

BNF, Buonaccorso Ghiberti
Zibaldone. MS. B.R. 228.

BNF, Convenevole da Prato
Ad Robertum Siciliae regem. Cod. rara, 38.

BNF, Gargani
Poligrafo Gargani. File nos. 179, 180 "Banchelli-Bancucci." File nos. 250, 1961 "Suagini-Succhielli."

BNF, Giusto d'Anghiari
Memorie, 1437–82. Class 1, XXV, cod. 496.

BNF, Migliore
Ferdinando Leopoldo del Migliore. Zibaldone generale. MS. Magliabecchiana, class 26, cod. 143.

BNF, Petriboni-Rinaldi
Priorista. BNF, Conventi soppressi, class 4, 895.

Biblioteca Riccardiana, Florence (RIC)

RIC, Ms. Riccardiano no. 683, M. Iv. 33
Rubrica XI, "Canzone in lode della Signoria di Firenze."

OTHER WORKS CITED

Acidini-Luchinat 1995a
Acidini-Luchinat, Cristina, ed. *La Cattedrale di Santa Maria del Fiore a Firenze II.* Florence, 1995.

Acidini-Luchinat 1995b
Acidini-Luchinat, Cristina. "Le Vetrate." In Acidini-Luchinat 1995a, 273–301.

Alberti 1972
Alberti, Leon Battista. *On Painting and on Sculpture: The Latin Texts of De Pictura and De Statua.* Ed. and trans. Cecil Grayson. London, 1972.

Alberti 1976
Alberti, Leon Battista. *Leon Battista Alberti On Painting.* Ed. John R. Spencer. New Haven, 1976.

Albertini 1972
Albertini, Francesco. "Memoriale di molte statue et picture di Florentia." 1510. In *Five Early Guides to Rome and Florence,* ed. Peter Murray. Farnborough, 1972.

Amato 1988
Amato, Pietro, ed. *Imago Mariae: tesori d'arte della civiltà cristiana.* Rome, 1988.

Ambrose 1844–66
Ambrose. *De Verginitatis, XV.* In Migne 1844–66, 16: cols. 289–90.

Andrews 1995
Andrews, Lew. *Story and Space in Renaissance Art: The Rebirth of Continuous Narrative.* New York, 1995.

Angiola 1977
Angiola, Eloise M. "Nicola Pisano, Federigo Visconti, and the Classical Style in Pisa." *Art Bulletin* 59 (1977): 1–27.

Angiola 1978
Angiola, Eloise M. "'Gates of Paradise' and the Florentine Baptistry." *Art Bulletin* 60 (1978): 242–48.

Anonimo Fiorentino 1986
Anonimo Fiorentino. *Alle bocche della piazza, Diario di Anonimo Fiorentino (1382–1401), BNF Panchiatichiano, 158.* Ed. Anthony Molho and Franek Sznura. Florence, 1986.

Anonimo Gaddiano 1893
Anonimo Gaddiano. "Il Codice dell'Anonimo Gaddiano (Codice Magliabechiano XVII, 17) nella Biblioteca Nazionale di Firenze." Ed. Cornelius von Fabriczy. *Archivio storico italiano* 12 (1893): 15–94, 275–334.

Anson 1948
Anson, Peter Frederick. *Churches: Their Plan and Furnishing.* Milwaukee, 1948.

Antal 1948
Antal, Frederick. *Florentine Painting and Its Social Background.* 1948. Reprint, London and Cambridge, Mass., 1986.

Anthony of Padua 1979
Anthony of Padua. *S. Antonii Patavini, O. min. Doctoris evangelici: Sermones Dominicales et festiva.* 3 vols. Padua, 1979.

Antoninus 1681
Antoninus. *Summae Sacrae Theologiae, Iusris, Pontificij, & Caesarei, Quarta Pars.* 4 vols. Venice, 1681.

Artusi and Gabbrielli 1982
Artusi, Luciano, and Silvano Gabbrielli. *Orsanmichele in Firenze.* Florence, 1982.

Aru 1906
Aru, Carlo. "Gli Scultori di Pietrasanta." *L'Arte* 9 (1906): 463–72.

Aru 1908
Aru, Carlo. "Gli Scultori della Versilia." *Bollettino d'arte* 2 (1908): 280–97, 403–22.

Avery 1970
Avery, Charles. *Florentine Renaissance Sculpture.* London and New York, 1970.

Avery 1991
Avery, Charles. *Donatello: Catalogo completo delle opere.* Florence, 1991.

Bagnoli 1981
Bagnoli, Alessandro. "Novità su Nicola Pisano scultore nel Duomo di Siena." *Prospettiva* 27 (1981): 27–46.

Baldini 1981
Baldini, Umberto. *Santa Maria Novella: la basilica, il convento, i chiostri monumentali.* Florence, 1981.

Baldinucci 1974
Baldinucci, Filippo. *Notizie dei professori del disegno da Cimabue in qua.* (1681–1728). 7 vols. Florence, 1845. Reprint, Florence, 1974.

Balogh 1962
Balogh, Johan. "Un Capolavoro sconosciuto del Verrocchio." *Acta Historium Artium* 8 (1962): 79–98.

Balogh 1965
Balogh, Johan. "Studi sulla collezione di sculture del Museo delle Belle Arti di Budapest." *Acta Historium Artium* 11 (1965): 1–67.

Baracchini and Caleca 1973
Baracchini, Clara, and Antonino Caleca. *Il Duomo di Lucca.* Lucca, 1973.

Barasch 1975
Barasch, Moshe. "Character and Physiognomy: Bocchi on Donatello's St. George. A Renaissance Text on Expression in Art." *Journal of the History of Ideas* 36 (1975): 413–30.

Bargellini 1969
Bargellini, Piero. *Orsanmichele a Firenze.* Milan, 1969.

Barile 1941
Barile, Vincenzo. *La Caserma della scuola centrale dei carabinieri reali in Firenze.* Rome, 1941.

Barocchi 1985
Barocchi, Paola, ed. *Omaggio a Donatello.* Exh. cat. Florence: Museo Nazionale del Bargello, 1985.

Barocchi and Gaeta Bertelà 1985
Barocchi, Paola, and Giovanna Gaeta Bertelà. "L'esposizione donatelliana del 1887 e la fortuna dei calchi." In Bernardini 1985, XLVII – LIV.

Baron 1966
Baron, Hans. *The Crisis of the Early Italian Renaissance.* 1955. 2d rev. ed. Princeton, 1966.

Battisti 1960
Battisti, Eugenio. "Il Mondo visuale delle fiabe." In *Il Mondo visuale delle fiabe: umanesimo e esoterismo,* ed. Enrico Castelli, 308–20. Atti del V convegno internazionale di studi umanistici, Oberhofen, 1960. Padua, 1960.

Battisti 1980
Battisti, Eugenio. "A caccia del gesto teatrale." In *Il teatro italiano del rinscimento,* ed. Maristella de Panizza-Lorch, 403–23. Milan, 1980.

Battisti 1981
Battisti, Eugenio. *Brunelleschi: The Complete Work.* New York, 1981.

Baxandall 1972
Baxandall, Michael. *Painting and Experience in Fifteenth-Century Italy.* Oxford, 1972.

Beaulieu 1957
Beaulieu, Michèle, Marguerite Charageas, and Gerard Hubert. *Les Sculptures au Musée du Louvre.* Paris, 1957.

Becherucci and Brunetti 1969
Becherucci, Luisa, and Giulia Brunetti. *Il Museo dell'Opera del Duomo.* 2 vols. Florence, n.d. [1969].

Becherucci 1977
Becherucci, Luisa. "Un' Annunciatione nel Duomo di Firenze." In *Scritti di Storia dell'arte in onore di Ugo Procacci,* ed. Maria Grazia Ciardi Dupré dal Poggetto and Paolo dal Poggetto, 1:184–95. 2 vols. Milan, 1977.

Beck 1970
Beck, James. *Jacopo della Quercia e il portale di San Petronio a Bologna: ricerche storiche, documentarie, e iconografiche.* Bologna, 1970.

Beck 1978
Beck, James. *Masaccio: The Documents.* Locust Valley, 1978.

Beck 1980
Beck, James. "Ghiberti giovane, Donatello giovanissimo." In *Lorenzo Ghiberti nel suo tempo,* 1:111–34. 2 vols. Florence, 1980.

Beck 1991
Beck, James. *Jacopo della Quercia.* 2 vols. New York, 1991.

Becker 1968
Becker, Marvin. "The Florentine Territorial State and Civic Humanism in the Early Renaissance." In Rubinstein 1968, 109–39.

Bellosi 1966
Bellosi, Luciano. *Nanni di Banco.* Milan, 1966.

Bellosi 1977
Bellosi, Luciano. "Ipotesi sull'origine delle terrecotte quattrocentesche." In *Jacopo della Quercia fra Gotico e Rinascimento,* ed. Giulietta Chelazzi-Dini, 163–79. Atti del convegno di studi, Siena, 2–3 ottobre 1975. Florence, 1977.

Bellosi 1978
Bellosi, Luciano. "Ghiberti e la cultura figurativa europea al 1400." In *Lorenzo Ghiberti* 1978, 26–27.

Bellosi 1981
Bellosi, Luciano. "Per Luca della Robbia." *Prospettiva* 27 (1981): 62–71.

Bellosi 1984
Bellosi, Luciano. "Gano a Massa Marittima." *Prospettiva* 37 (1984): 19–22.

Bellosi 1985
Bellosi, Luciano. "Donatello's Early Works in Terracotta." In *Italian Renaissance Sculpture in the Time of Donatello,* ed. Alan Phipps Darr, 95–103. Exh. cat. Detroit: Detroit Institute of Arts, 1985.

Bellosi 1986
Bellosi, Luciano. "I problemi dell'attività giovanile." In Darr and Bonsanti 1986, 47–54.

Bellosi 1988–89
Bellosi, Luciano. "Da una costola di Donatello: Nanni di Bartolo." *Prospettiva* 53–56 (1988–89): 200–213.

Bellosi 1989
Bellosi, Luciano. "Donatello e il recupero della scultura in terracotta." In Cämmerer 1989, 130–45.

Bellosi 1993
Bellosi, Luciano. "Il San Pietro di Orsanmichele e il Brunelleschi." In Luciano Bellosi, *Il Restauro della statua marmorea di San Pietro*, 15–40. Florence, 1993.

Benigni 1977
Benigni, Paola, ed. *Filippo Brunelleschi: l'uomo e l'artista.* Exh. cat. Florence: Biblioteca Medicea Laurenziana, 1977.

Benivieni 1500
Benivieni, Girolamo. *Commento sopra a più sue canzoni e sonetti dello amore e della belezza divina.* Florence, 1500.

Bennett and Wilkins 1984
Bennett, Bonnie, and David Wilkins. *Donatello.* Oxford, 1984.

Benvenuti-Papi 1994
Benvenuti-Papi, Anna. "Da San Salvatore a Santa Maria del Fiore: itinerario di una cattedrale." In Gurrieri 1994, 286–91.

Berenson 1932
Berenson, Bernard. *Italian Paintings of the Renaissance.* Oxford, 1932.

Bergstein 1986
Bergstein, Mary. "Nanni di Banco, Donatello, and Realism in the Testa Virile." *Source* 3 (Spring 1986): 7–11.

Bergstein 1987a
Bergstein, Mary. "La vita civica di Nanni di Banco." *Rivista d'arte* 39 (1987): 55–82.

Bergstein 1987b
Bergstein, Mary. "The Sculpture of Nanni di Banco." Ph.D. diss., Columbia University, 1987.

Bergstein 1988
Bergstein, Mary. "The Date of Nanni di Banco's Quattro Santi Coronati." *Burlington Magazine* 103 (December 1988): 910–13.

Bergstein 1989
Bergstein, Mary. "Two Early Renaissance Putti: Niccolò di Pietro Lamberti and Nanni di Banco." *Zeitschrift für Kunstgeschichte* 52 (1989): 82–88.

Bergstein 1991
Bergstein, Mary. "Marian Politics in Quattrocento Florence: The 1412 Dedication of Santa Maria del Fiore." *Renaissance Quarterly* (Winter 1991): 673–719.

Bergstein 1992
Bergstein, Mary. "Contrapposto as Form and Meaning in Nanni di Banco's St. Philip." *Source* 11 (Winter 1992): 10–16.

Bernard of Clairvaux 1980
Bernard of Clairvaux. *Gli scritti mariani di San Bernardo di Chiaravalle.* Ed. and trans. Paolino Limongi. Rome, 1980.

Bernardini 1985
Bernardini, Luisella, Annarita Caputo Calloud, and Mila Mastrorocco, eds. *Donatello e il primo Rinascimento nei calchi della Gipsoteca.* Exh. cat. Florence: Istituto Statale d'arte, Gipsoteca, 1985.

Berti and Paolucci 1990
Berti, Luciano, and Antonio Paolucci, eds. *L'Età di Masaccio: il primo quattrocento a Firenze.* Exh. cat. Florence: Palazzo Vecchio, 1990.

Bertini 1985
Bertini, Ferruccio. "Gli animali nella favolistica medioevale dal Romulus al secolo XII." In *L'Uomo di fronte al mondo animale nell'alto medioevo*, 2:1031–51. Settimane di Studio del Centro Italiano di Studi sull'Alto Medioevo, no. 31. 2 vols. Spoleto, 1985.

Bettini 1950
Bettini, Piera. "Tre sconosciute sculture arnolfiane." *Rivista d'arte* 26 (1950): 185–92.

Biadi 1824
Biadi, Luigi. *Notizie sulle antiche Fabbriche di Firenze non terminate.* Florence, 1824.

Bianchi-Bandinelli 1946
Bianchi-Bandinelli, Ranuccio. "An 'Antique' Reworking of an Antique Head." *Journal of the Warburg and Courtauld Institutes* 9 (1946): 1–9.

Bianchi-Bandinelli 1979
Bianchi-Bandinelli, Ranuccio. "Antico non antico." In *Archeologia e cultura*, ed. Ranuccio Bianchi-Badinelli, 264–76. 1961. Reprint, Milan, 1979.

Billi 1891
Billi, Antonio. "Il Libro di Antonio Billi." Ed. Cornelius von Fabriczy. *Archivio storico italiano* 7 (1891): 299–368.

Blume 1983
Blume, Dieter. *Wandmalerei als Ordenspropaganda: Bildprogramme im Chorbereich franziskanischer Konvente Italiens bis zum Mitte des 14. Jahrhunderts.* Worms, 1983.

Blumenthal 1967
Blumenthal, Arthur R. "A Newly Identified Drawing of Brunelleschi's Stage Machinery." *Marsyas* 13 (1966–67): 20–31.

Boase 1979
Boase, T. S. R. *Giorgio Vasari: The Man and the Book.* Princeton, 1979.

Bober and Rubinstein 1986
Bober, Phyllis, and Ruth Rubinstein. *Renaissance Artists and Antique Sculpture: A Handbook of Sources.* Oxford, 1986.

Bocchi 1591
Bocchi, Francesco. *Le Bellezze della città di Fiorenza.* Florence, 1591.

Bode 1884
Bode, Wilhelm von, and Cornelius von Fabriczy, eds. Jacob Burckhardt. *Der Cicerone.* Leipzig, 1884.

Bode 1920
Bode, Wilhelm von. *Sandro Botticelli*. Berlin, 1920.

Bode 1922
Bode, Wilhelm von. *Die italienische Plastik*. Handbücher der Staatlichen Museen zu Berlin, no. 6. 6th rev. ed. Berlin, 1922.

Bode 1926
Bode, Wilhelm von. *Die Kunst der Frührenaissance*. Berlin, 1926.

Boglioni 1985
Boglioni, Pierre. "Il Santo e gli animali nell'alto medioevo." In *L'uomo di fronte al mondo animale nell'alto medioevo*, 2:935–93. Settimane di Studio del Centro Italiano di Studi sull'Alto Medioevo, no. 31. 2 vols. Spoleto, 1985.

Bonaventure 1938
Bonaventure. *Doctrina Sancti Bonaventurae de Universali Mediatione B. Virginis Mariae*. Ed. Lorenzo di Fonzo. Rome, 1938.

Bonaventure 1951
Bonaventure. *Vita di S. Francesco*. Ed. and trans. Francesco Russo. Rome, 1951.

Borghini 1584
Borghini, Raffaele. *Il riposo, in cui della pittura e della scultura si favella*. Florence, 1584.

Borsook 1966
Borsook, Eve. *The Companion Guide to Florence*. London, 1966.

Borsook 1980
Borsook, Eve. *The Mural Painters of Florence from Cimabue to Andrea del Sarto*. 2d rev. ed. Oxford, 1980.

Boskovits 1975
Boskovits, Miklos. *Pittura fiorentina alla vigilia del Rinascimento, 1370–1400*. Florence, 1975.

Bottari 1938
Bottari, Stefano. "Jacopo della Quercia." *Emporium* 38 (1938): 183–94.

Bottari 1948
Bottari, Stefano. "Una scultura di Nanni di Banco." *Emporium* 107 (1948): 159–62.

Braunfels 1964
Braunfels, Wolfgang. *Der Dom von Florenz*. Olten, 1964.

Brucker 1962
Brucker, Gene. *Florentine Politics and Society, 1343–1378*. Princeton, 1962.

Brucker 1969
Brucker, Gene. *Renaissance Florence*. New York, 1969.

Brucker 1977
Brucker, Gene. *The Civic World of Early Renaissance Florence*. Princeton, 1977.

Brunetti 1930
Brunetti, Giulia. "Un'opera sconosciuta di Nanni di Banco e nuovi documenti relativi all'artista." *Rivista d'arte* 12 (1930): 229–37.

Brunetti 1932
Brunetti, Giulia. "Giovanni d'Ambrogio." *Rivista d'arte* 14 (1932): 1–22.

Brunetti 1934
Brunetti, Giulia. "Ricerche su Nanni di Bartolo 'Il Rosso'." *Bollettino d'arte* 28 (1934): 258–72.

Brunetti 1947
Brunetti, Giulia. Review of Planiscig 1946. *Belle arti* n.n. (1947): 217–19.

Brunetti 1951a
Brunetti, Giulia. Review of Vaccarino 1950. *Belle arti* n.n. (1951): 105–6.

Brunetti 1951b
Brunetti, Giulia. "Iacopo della Quercia a Firenze." *Belle arti* n.n. (1951): 3–17.

Brunetti 1952
Brunetti, Giulia. "Jacopo della Quercia and the Porta della Mandorla." *Art Quarterly* 15 (1952): 119–31.

Brunetti 1957
Brunetti, Giulia. "Osservazioni sulla Porta dei Canonici." *Mitteilungen des Kunsthistorischen Institutes in Florenz* 8 (1957): 1–12.

Brunetti 1964
Brunetti, Giulia. "Su alcuni sculture di Orsanmichele." In *Studien zur Toskanischen Kunst, Festschrift für Ludwig H. Heydenreich*, ed. Wolfgang Lotz and Lise Lotte Möller, 29–36. Munich, 1964.

Brunetti 1968a
Brunetti, Giulia. "Riaddatiamenti e spostamenti di statue fiorentine del primo quattrocento." In *Donatello 1968*, 277–82.

Brunetti 1968b
Brunetti, Giulia. "I profeti sulla Porta del Campanile di S. Maria del Fiore." In *Festschrift Ulrich Middeldorf*, ed. Antje Kosegarten and Peter Tigler, 1:106–11. 2 vols. Berlin, 1968.

Brunetti 1969
Brunetti, Giulia. "Una testa di Donatello." *L'arte* 2 (1969): 80–93.

Brunetti 1975
Brunetti, Giulia. "Il museo dell'Opera di Santa Maria del Fiore." In *Atti della Società Leonardo da Vinci (anno 1974–75)* (1975): 19–32.

Brunetti 1977
Brunetti, Giulia. "S. Filippo." In *L'Oreficia nella Firenze del Quattrocento*, ed. Roberto Lunardi, 180–81. Exh. cat. Florence: Chiostri di Santa Maria Novella, 1977.

Brunetti 1980
Brunetti, Giulia. "Un'aggiunta sul 'profeta imberbe' di Donatello." In *Filippo Brunelleschi, la sua opera e il suo tempo*, ed. Giulio Carlo Argan, 1:273–77. 2 vols. Florence, 1980.

Bryson 1994
Bryson, Norman, Michael A. Holly, and Keith Moxey, eds. "The Social History of Art." In *Visual Culture: Images and Interpretations*, XVII–XXII. Hanover, N.H., and London, 1994.

Buck 1971
Buck, August. "Hans Baron's Contribution to the Literary History of the Renaissance." In *Renaissance Studies in Honor of Hans Baron*, ed. Anthony Molho and John A. Tedeschi, XXXI – LVIII. Florence, 1971.

Bulli 1935
Bulli, Enrico. "Cenni storici sui locali occupati in Firenze della scuola centrale dei carabinieri reali." *Rivista dei Carabinieri Reali* 2 (1935): 2.

Burckhardt 1855
Burckhardt, Jacob. *Der Cicerone: eine Einleitung zum Genus der Kunstwerke Italiens*. 1855. Reprint, Florence, 1952.

Butters 1996
Butters, Suzanne B. *The Triumph of Vulcan: Sculptors' Tools, Porphyry, and the Prince in Ducal Florence*. 2 vols. Florence, 1996.

Byam-Shaw 1957
Byam-Shaw, James J. "Vier Ansichten von Florenz von Israel Silvestre." *Mitteilungen des Kunsthistorischen Institutes in Florenz* 8 (1957): 174–78.

Cämmerer 1989
Cämmerer, Monika, ed. *Donatello Studien*. Italienische Forschungen, Kunsthistorisches Institut in Florenz, series 3, no. 16. Munich, 1989.

Cambi 1770–89
Cambi, Giovanni. "Istorie di Giovanni Cambi Cittadino Fiorentino." In *Delizie degli eruditi toscani*, ed. P. Idelfonso di San Luigi, 1:143. 24 vols. Florence, 1770–89.

Camille 1992
Camille, Michael. *Image on the Edge: The Margins of Medieval Art*. Cambridge, Mass., 1992.

Campana 1933
Campana, Emilio. *Maria nel culto cattolico*. 2 vols. Turin, 1933.

Camporeale 1980
Camporeale, Salvatore, ed. *S. M. Novella, un convento nella città: studi e fonti. VII Centenario della fondazione di S. Maria Novella 1279–1979*. II, *Memorie Domenicane*. New series, no. 11. Pistoia, 1980.

Cannata 1968
Cannata, Pietro. "Quattro Coronati." In *Bibliotheca Sanctorum* 10: cols. 1276–1303. Rome, 1964–68.

Capecchi 1992
Capecchi, Gabriella. "Non di Arnolfo, ma antichi. Due precisini su un falso Profeta e su un Dace prigioniero." *Artista* (1992): 24–35.

Carboneri 1951–52
Carboneri, Nino. "Nanni di Banco e la critica." *Rivista d'arte* 27 (1951–52): 231–35.

Cardini 1978
Cardini, Anna Maria. "La Porta della Mandorla" and "Annunciazione." In *Lorenzo Ghiberti 1978*, 44–45, 54–55.

Carmignani 1978
Carmignani, Marina. "Orsanmichele." In *Lorenzo Ghiberti 1978*, 180–86.

Carocci 1889
Carocci, Guido. "Il centro di Firenze nel 1427." In *Studi storici sul centro di Firenze pubblicati in occasione del IV congresso storico italiano*, 17–75. Florence, 1889.

Carocci 1891
Carocci, Guido. "Le arti fiorentine e le loro residenze." *Arte e storia* 2 (1891): 153–70.

Carocci 1906
Carocci, Guido. *Il Museo di Firenze antica ammesso al R. Museo di S. Marco*. Florence, 1906.

Casanova 1964–68
Casanova, Maria Letizia. "Filippo." In *Bibliotheca Sanctorum* 5: cols. 706–19. Rome, 1964–68.

Cassidy 1988
Cassidy, Brendan. "The *Assumption of the Virgin* on the Tabernacle of Orsanmichele." *Journal of the Warburg and Courtauld Institutes* 51 (1988): 174–80.

Cassidy 1992
Cassidy, Brendan. "Orcagna's Tabernacle in Florence: Design and Function." *Zeitschrift für Kunstgeschichte* 61 (1992): 180–211.

Castelfranco 1963
Castelfranco, Giorgio. *Donatello*. Milan, 1963.

Castelfranco 1967
Castelfranco, Giorgio. Review of Wundram 1969. *Bollettino d'arte* 52 (1967 [1970]): 208.

Castellazzi 1883
Castellazzi, Giuseppe. *Palazzo di Orsanmichele*. Florence and Rome, 1883.

Cavalcanti 1944
Cavalcanti, Giovanni. *Istorie fiorentine*. Ed. Guido di Pino. Milan, 1944.

Cavalcanti 1986
Cavalcanti, Guido. *Rime*. Ed. Domenico De Robertis. Turin, 1986.

Cavallucci 1873
Cavallucci, Camillo J. *Nuova guida di Firenze e contorni*. Rome, 1873.

Cavallucci 1881
Cavallucci, Camillo J. *Santa Maria del Fiore*. Florence, 1881.

Cavallucci 1896
Cavallucci, Camillo J. *Vita e opera di Donatello*. Milan, 1896.

Chambers 1971
Chambers, David S. *Patrons and Artists in the Italian Renaissance*. Columbia, S.C., 1971.

Chastel 1958
Chastel, André. "La Sculpture florentine." *Critique* 138 (1958): 960–75.

Chastel 1959
Chastel, André. *Art et humanisme en Florence*. Paris and Lille, 1959.

Chastel 1984
Chastel, André. *A Chronicle of Italian Renaissance Painting: 1280–1580.* Trans. Linda and Peter Murray. Ithaca, N.Y., 1984.

Chiminez 1960
Chiminez, Siro A. "Dante Alighieri." In *Dizionario biografico degli italiani,* 2:385–451. Rome, 1960.

Christian 1989
Christian, Karen. "Arnolfo di Cambio's Sculptural Project for the Duomo Facade in Florence: A Study in Style and Context." Ph.D. diss., New York University, 1989.

Christiansen 1982
Christiansen, Keith. *Gentile da Fabriano.* London, 1982.

Ciatti 1995
Ciatti, Marco. "Gli Affreschi della Cappella della Cintola." In Martini 1995, 163–223.

Cicero 1967
Cicero. *De Oratore.* Books 1–3 in 2 vols. Trans. E. W. Sutton. London and Cambridge, Mass., 1967.

Coffin-Hanson 1977
Coffin-Hanson, Anne. "Jacopo della Quercia fra Gotico e Rinascimento: alcuni pensieri su motivi di Ercole ed Adamo." In *Jacopo della Quercia fra Gotico e Rinascimento,* ed. Giulietta Chelazzi-Dini, 119–30. Atti del Convegno di Studi, Siena, 2–3 ottobre 1975. Florence, 1977.

Colafranceschi 1966
Colafranceschi, Caterina. "Isaia, profeta." In *Biblioteca Sanctorum* 7: cols. 927–44. Rome, 1964–68.

Cole 1980
Cole, Bruce. *Masaccio and the Art of Early Renaissance Florence.* Bloomington, Ind., 1980.

Cole-Ahl 1977
Cole-Ahl, Diane. "Fra Angelico: His Role in Quattrocento Painting and Problems of Chronology." Ph.D. diss., University of Virginia, 1977.

Condivi 1823
Condivi, Ascanio. *Vita di Michelangelo Buonarroti scritta di Ascanio Condivi suo discepolo.* Ed. Niccolò Capurro. Pisa, 1823.

Conrad of Saxony 1904
Conrad of Saxony. *Speculum Beatae Marie Virginis.* Biblioteca Franciscana Ascetica Medii Aevii, no. 2. Quaracchi, 1904.

Corazza 1894
Corazza, Bartolommeo del. "Diario fiorentino di Bartolommeo di Michele del Corazza: anni 1405–1438." Ed. Giuseppe Odoardo Corazzini. *Archivio storico italiano* 14 (1894): 233–39.

Crowe and Cavalcaselle 1864
Crowe, Joseph Archer, and Giovanni Battista Cavalcaselle. *A New History of Painting in Italy.* 2 vols. London, 1864.

Crum and Wilkins 1990
Crum, Katherine, and David Wilkins. "In the Defense of Florentine Republicanism: Saint Anne and Florentine Art, 1343–1575." In *Interpreting Cultural Symbols, Saint Anne in Late Medieval Society,* ed. Kathleen Ashley and Pamela Sheingorn, 131–68. Athens, Ga., and London, 1990.

Cruttwell 1911
Cruttwell, Maud. *Donatello.* London, 1911.

Dacos 1972
Dacos, Nicole, Antonio Giuliano, and Ulrico Pannuti. *Il Tesoro di Lorenzo il Magnifico.* I, *Le Gemme.* Exh. cat. Florence: Palazzo Medici Riccardi, Museo Mediceo, 1972.

Dal Prà 1990
Dal Prà, Laura. "Bernardo di Chiaravalle, Realtà e interpretazione nell'arte italiana." In *Bernardo di Chiaravalle nell'arte italiana dal XIV al XVIII Secolo,* ed. Laura Dal Prà, 48–71. Milan, 1990.

Damisch 1972
Damisch, Hubert. *Théorie du nuage: Pour une histoire de la peinture.* Paris, 1972.

Dammann 1964
Dammann, Rolf. "Die Florentiner Domweimotette Dufays 1436." Addendum to Braunfels 1964.

Dan 1985
Dan, Naoki. "La Tomba di Arrigo VII e le sculture intorno al cupolone del Brunelleschi." *Annuario dell'Istituto Giapponese di Cultura* 20 (1984–85): 7–39.

D'Ancona 1891
D'Ancona, Alessandro. *Origini del teatro italiano.* 2 vols. Turin, 1891.

Darr 1985
Darr, Alan Phipps, ed. *Italian Renaissance Sculpture in the Time of Donatello.* Exh. cat. Detroit: Detroit Institute of Arts, 1985.

Darr 1989
Darr, Alan Phipps. "The Donatello Exhibitions at Detroit and Florence: Results, Perspectives and New Directions." In Cämmerer 1989, 11–23.

Darr and Bonsanti 1986
Darr, Alan Phipps, and Giorgio Bonsanti, eds. *Donatello e i suoi: scultura fiorentina del primo rinascimento.* Milan, 1986.

Dati 1904
Dati, Gregorio. *L'Istoria di Firenze di Gregorio Dati dal 1380 al 1405.* Ed. Luigi Pratesi. Norcia, 1904.

Dati 1968
Dati, Gregorio. *Il libro segreto di Gregorio Dati.* Ed. Girolamo Gargiolli. 1869. Reprint, Bologna, 1968.

Davidsohn 1896–1908
Davidsohn, Robert. *Forschungen zur älteren Geschichte von Florenz.* 4 vols. Berlin, 1896–1908.

Davidsohn 1956–68
Davidsohn, Robert. *Storia di Firenze*. Trans. Giovanni Battista Klein et al. 8 vols. Florence, 1956–68.

Davis 1968
Davis, Charles. "Il buon tempo antico." In Rubinstein 1968, 45–69.

Davis 1974
Davis, Howard. "Gravity in the Paintings of Giotto." In *Giotto in Perspective*, ed. Laurie Schneider, 142–59. Engelwood Cliffs, N.J., 1974.

Debidour 1961
Debidour, Victor Henry. *Le Bestiaire sculpté du moyen age en France*. Strasbourg, 1961.

Degenhart and Schmitt 1968
Degenhart, Bernhard, and Annegrit Schmitt. *Corpus der Italienischen Zeichnungen 1300–1450*. 4 vols. Berlin, 1968.

Del Bravo 1973
Del Bravo, Carlo. "L'Umanesimo di Luca della Robbia." *Paragone* (1973): 7.

Del Bravo 1977
Del Bravo, Carlo. "La Dolcezza della immaginazione." *Annali della Scuola Normale Superiore di Pisa* 2 (1977): 759–99.

Delehaye 1913
Delehaye, Hippolyte. "Le Culte des Quatre Couronnés à Rome." *Analecta Bollandiana* 32 (Brussels, 1913): 63–71.

Della Valle 1971
Della Valle, Guglielmo. *Storia del Duomo di Orvieto*. Rome, 1971.

Descrizione 1786
Descrizione istorico-critica delle principie proseguimente della fabbrica del Duomo di Firenze. Florence, 1786.

Detroit 1958
Decorative Arts of the Italian Renaissance 1400–1600. Exh. cat. Detroit: Detroit Institute of Arts, 1958.

Dionigi 1998
Dionigi, Renzo. *SS. Quattuor Coronati: Bibliography and Iconography*. Milan, 1998.

Donatello 1968
Donatello ed il suo tempo. Atti dell'VIII convegno internazionale di studi sul Rinascimento. Florence: Istituto Nazionale di Studi sul Rinascimento, 1968.

Donatello 1988
Donatello 1386–1466: 1986 — Celebrazioni nel VI centenario della nascita. Accademia di Studi Italo-Tedeschi, no. 10. Merano, 1988.

Doren 1898
Doren, Alfred. "Zum Bau der Florentiner Domkuppel." *Repertorium für Kunstwissenschaft* 21 (1898): 249–62.

Doren 1940–58
Doren, Alfred. *Le arti fiorentini*. Florence, 1940–58.

Du Colombier 1952
Du Colombier, Pierre. "Les Quatre-couronnés patrons des tailleurs de pierre." *La revue des arts* n.n. (1952): 209–18.

Du Colombier 1973
Du Colombier, Pierre. *Les Chantiers des cathédrales*. Paris, 1973.

Echols 1976
Echols, Mary Tuck. "The Coronation of the Virgin in Fifteenth-Century Art." Ph.D. diss., University of Virginia, 1976.

Egger 1906
Egger, Hermann. *Codex Escurialensis: Ein Skizzenbuch aus der Werkstatt Domenico Ghirlandaios*. 2 vols. Vienna, 1906.

Einem 1962
Einem, Herbert von. "Bemerkungen zur Bildhauer-darstellung des Nanni di Banco." In *Festschrift für Hans Sedlmayr*, ed. Karl Oettinger and Mohammed Rassem, 68–79. Munich, 1962.

Eisenhofer 1940
Eisenhofer, Ludwig. *Compendio di liturgia*. Turin and Rome, 1940.

Eisler 1961
Eisler, Colin. "The Athlete of Virtue: The Iconography of Asceticism." In *Essays in Honor of Erwin Panofsky*, ed. Millard Meiss. *De artibus opuscula* 40 (1961): 82–97.

"Elenco" 1887
"Elenco degli oggetti d'arte appartenenti all'opera di Santa Maria del Fiore, i quali dovranno essere conservatori nel nuovo Museo dell'Opera." In *Atti del Collegio dei Professori della Regia Accademia di Belle Arti di Firenze, Anno 1886* (1887): 69.

Emison 1992
Emison, Patricia. "The Porta della Mandorla's Bear." *Mitteilungen des Kunsthistorischen Institutes in Florenz* 36 (1992): 381–87.

Ettlinger 1972
Ettlinger, Leopold D. "Hercules Florentinus." *Mitteilungen des Kunsthistorischen Institutes in Florenz* 16 (1972): 119–42.

Ettlinger 1978
Ettlinger, Leopold D. *Antonio and Piero Pollaiuolo*. Oxford, 1978.

Even 1984
Even, Yael. "Artistic Collaboration in Florentine Workshops." Ph.D. diss., Columbia University, 1984.

Fabbri 1975
Fabbri, Marcello, Elvira Garbero Zorzi, and Anna Maria Petrioli Tofani. *Il Luogo teatrale a Firenze*. Exh. cat. Florence: Palazzo Medici Riccardi, Museo Mediceo, 1975.

Fabriczy 1900
Fabriczy, Cornelius von. "Donatellos heiliger Ludwig und Sein Tabernakel an Or San Michele." *Jahrbuch der Preussischen Kunstsammlungen* 21 (1900): 242–61.

Fabriczy 1907
Fabriczy, Cornelius von. "Brunelleschiana." *Jahrbuch der Preussischen Kunstsammlungen* 28 (1907) (Addendum 40): 1–84.

Fader 1977
Fader, Martha. "Sculpture in the Piazza della Signoria." Ph.D. diss., University of Michigan, 1977.

Faedo 1984
Faedo, Lucia. "Testa di Antinoo." In *Camposanto monumentale di Pisa. Le Antichità*, ed. Salvatore Settis, 2:142–44. 2 vols. Modena, 1984.

Fanelli 1973
Fanelli, Giovanni. *Firenze, architettura e città*. Florence, 1973.

Fantozzi 1842
Fantozzi, Federigo. *Nuova guida di Firenze*. Florence, 1842.

Fehl 1973
Fehl, Phillip. "On the Representation of Character in Renaissance Sculpture." *Journal of Aesthetics and Art Criticism* (Spring 1973): 291–307.

Fehl 1982
Fehl, Phillip. "The Naked Christ in Santa Maria Novella in Florence: Reflections on an Exhibition and the Consequences." *Storia dell'arte* 45 (1982): 161–64.

Ferrali 1979
Ferrali, Sabatino. *L'Apostolo S. Jacopo il Maggiore e il suo culto a Pistoia*. Pistoia and Bologna, 1979.

Fiocco 1927–28
Fiocco, Giuseppe. "I Lamberti a Venezia." *Dedalo* 8 (1927–28): 287–314.

Fleury 1878
Fleury, Charles Rohault de. *La Sainte Vierge*. 2 vols. Paris, 1878.

Follini and Rastrelli 1789
Follini, Vincenzo, and Modesto Rastrelli. *Firenze antica e moderna illustrata*. Florence, 1789–1802.

Francastel 1965
Francastel, Pierre. *La Réalité figurative: éléments structurels de sociologie de l'art*. Paris, 1965.

Francastel 1967
Francastel, Pierre. *La Figure e la lieu: l'ordre visuel du Quattrocento*. Paris, 1967.

Franceschini 1886
Franceschini, Pietro. "A ciascuno il suo." *Il nuovo osservatore fiorentino* 46, 26 September 1886, 365–66.

Franceschini 1892
Franceschini, Pietro. *L'Oratorio di San Michele in Orto di Firenze*. Florence, 1892.

Frazier 1987
Frazier, Ian. "Bear News." In *Nobody Better, Better than Nobody*, 119–50. New York, 1987.

Gaborit 1970
Gaborit, Jean-René. Review of Wundram 1969. *Bulletin monumentale* 128 (1970): 88–89.

Gadol 1965
Gadol, Joan. "The Unity of the Renaissance: Humanism, Natural Science, and Art." In *From the Renaissance to Counter Reformation, Essays in Honor of Garrett Mattingly*, ed. Charles H. Carter, 29–55. New York, 1965.

Gadol 1969
Gadol, Joan. *Leon Battista Alberti: Universal Man of the Early Renaissance*. Chicago and London, 1969.

Gaffron 1950
Gaffron, Mercedes. "Right and Left in Pictures." *Art Quarterly* 13 (1950): 312–33.

Gai 1984
Gai, Lucia. *L'Altare argento di San Iacopo nel Duomo di Pistoia*. Turin, 1984.

Galassi 1949
Galassi, Giuseppe. *La Scultura fiorentina del Quattrocento*. Milan, 1949.

Galbreath 1972
Galbreath, Donald L. *Papal Heraldry*. 2d rev. ed. Ed. Geoffrey Briggs. London, 1972.

Galletti 1894
Galletti, Paolo. "Nel Duomo di Firenze." *Arte e storia* 13 (1894): 127.

Galli 1998
Galli, Aldo. "Uno Scultore del Quattrocento tra le Apuane e la Bassa Padane: itinerari querceschi del 'Maestro del sepolcro Fava'." *Prospettiva* 89–90 (1998): 106–24.

Gamba 1904
Gamba, Carlo. "Giovanni dal Ponte." *Rassegna d'arte* 4 (1904): 177–86.

Gambosi 1935
Gambosi, Georg. "Eine Kleinbronze Niccolò Lambertis aus dem Jahre 1407." In Helmut Schlunk, et al., *Adolph Goldschmidt zu seinen 70. Geburtstag*, 119–20. Berlin, 1935.

Gandi 1928
Gandi, Giulio. *Le Corporazioni dell'antica Firenze*. Florence, 1928.

Garin 1965
Garin, Eugenio. *Italian Humanism: Philosophy and Civic Life in the Renaissance*. Trans. Peter Münz. New York, 1965.

Garzelli 1969
Garzelli, Annarosa. *Sculture toscane nel Dugento e Trecento*. Florence, 1969.

Gatti 1992
Gatti, Luca. "The Art of Freedom: Meaning, Civic Identity, and Devotion in Early Renaissance Florence." Ph.D. diss., University of London, 1992.

Gatti 1995
Gatti, Luca. "Il Mito di Marte a Firenze e la 'Pietra Scema'. Memorie, riti e ascendenze." *Rinascimento* 35 (1995): 201–30.

Geary 1978
Geary, Patrick. *Furta Sacra: Thefts of Relics in the Central Middle Ages.* Princeton, 1978.

Geertz 1983
Geertz, Clifford. *Local Knowledge: Further Essays in Interpretive Anthropology.* New York, 1983.

Gelli 1896
Gelli, G. B. "Venti vite d'artisti." Ed. Girolamo Mancini. *Archivio storico italiano* 17 (1896): 2–62.

Gentilini 1990
Gentilini, Giancarlo. "Luca della Robbia." *Dizionario biografico degli italiani* 37:281–84. Rome, 1990.

Gentilini 1992
Gentilini, Giancarlo. *I Della Robbia: la scultura invetriata del Rinascimento.* Florence, n.d. [ca. 1992].

Gherardini 1995
Gherardini, Brunero. "Per una teologia del Sacro Cingolo." In Martini 1995, 75–77.

Ghiberti 1912
Ghiberti, Lorenzo. *Lorenzo Ghibertis Denkwurdigkeiten (I Commentarii).* Ed. Julius von Schlosser. 2 vols. Berlin, 1912.

Ghiberti 1947
Ghiberti, Lorenzo. *I Commentari.* Ed. Ottavio Morisani. Naples, 1947.

Ghiberti 1974
Ghiberti, Lorenzo. "Lorenzo Ghiberti's Second Commentary: The Translation and Interpretation of a Fundamental Renaissance Treatise on Art." Ed. Christine Fengler. Ph.D. diss., University of Wisconsin, Madison, 1974.

Gilbert 1967
Gilbert, Creighton. "When did a Man in the Renaissance Grow Old?" *Studies in the Renaissance* 14 (1967): 7–32.

Gilbert 1969
Gilbert, Creighton. "The Earliest Guide to Florentine Architecture, 1423." *Mitteilungen des Kunsthistorischen Institutes in Florenz* 14 (1969): 33–46.

Giusti 1996
Giusti, Anna Maria. "Le Sculture all'esterno del Duomo: un cantiere di restauro permanente." In Verdon 1996, 71–82.

Goffen 1986
Goffen, Rona. *Piety and Patronage in Renaissance Venice: Bellini, Titian, and the Franciscans.* New Haven, 1986.

Goldner 1974
Goldner, George R. "Two Statuettes from the Doorway of the Campanile of Florence." *Mitteilungen des Kunsthistorischen Institutes in Florenz* 18 (1974): 219–26.

Goldner 1978
Goldner, George R. *Niccolò and Piero Lamberti.* New York, 1978.

Goldthwaite 1980
Goldthwaite, Richard. *The Building of Renaissance Florence: An Economic and Social History.* Baltimore, 1980.

Gombrich 1967
Gombrich, Ernst H. "From the Revival of Letters to the Reform of the Arts." In *Essays in the History of Art Presented to Rudolf Wittkower,* ed. Douglas Fraser, Howard Hibbard, and Milton J. Lewine, 1:71–82. 2 vols. London, 1967.

Gombrich 1978
Gombrich, Ernst H. "The Early Medici as Patrons of Art." In Ernst H. Gombrich, *Norm and Form: Studies in the Art of the Renaissance,* 35–57. 2d rev. ed. New York, 1978.

Gordon 1968
Gordon, Vivian. "Lorenzo and Giovanni d'Ambrogio." M.A. thesis, Columbia University, 1968.

Gori 1987
Gori, Pietro. *Le feste fiorentine attraverso i secoli.* 1926. Reprint, Florence, 1987.

Grassi 1995
Grassi, Cesare. "La Storia del Sacro Cingolo." In Martini 1995, 23–39.

Grassi 1951
Grassi, Luigi. *Origine e aspetti del Rinascimento nella scultura fiorentina del Quattrocento.* Rome, 1951.

Grassi 1958
Grassi, Luigi. *Tutta la scultura di Donatello.* Milan, 1958.

Grassi 1968
Grassi, Luigi. "Donatello nella critica di Giorgio Vasari." In *Donatello 1968,* 59–68.

Green 1972
Green, Louis. *Chronicle into History.* Cambridge, 1972.

Greenhalgh 1982
Greenhalgh, Michael. *Donatello and His Sources.* London, 1982.

Greenhalgh 1989
Greenhalgh, Michael. *The Survival of Roman Antiquities in the Middle Ages.* London, 1989.

Grote 1959
Grote, Andreas. *Das Dombauamt in Florenz: 1285–1370. Studien zur Geschichte der Opera di Santa Reparata in vierzehnten Jahrhundert.* Munich, 1959.

Gualandi 1843
Gualandi, Michelangelo. *Memorie originali italiane risguardanti le belle arti.* Bologna, 1843.

Guasti 1857
Guasti, Cesare. *La Cupola di S. Maria del Fiore.* Florence, 1857.

Guasti 1887
Guasti, Cesare. *Santa Maria del Fiore. La Costruzione della chiesa e del campanile.* Florence, 1887.

Guasti 1908
Guasti, Cesare. *Le Feste di S. Giovanni Battista in Firenze descritte in prosa e in rima da contemporanei.* Florence, 1908.

Guiducci 1978
Guiducci, Anna Maria. "Ghiberti e l'oreficeria europea." In *Lorenzo Ghiberti 1978,* 28–31.

Gurrieri 1994
Gurrieri, Francesco, ed. *La Cattedrale di Santa Maria del Fiore a Firenze I,* Florence, 1994.

Gutwirth 1989
Gutwirth, Jacqueline A. "The Petriboni-Rinaldi *priorista:* A Chronicle of Florence, ca. 1414–1459." 2 vols. Ph.D. diss., New York University, 1989.

Haines 1984
Haines, Margaret. "La Colonna della Dovizia di Donatello." *Rivista d'arte* 37 (1984): 347–59.

Haines 1985
Haines, Margaret. "The Builders of Santa Maria del Fiore: An Episode of 1475 and an Essay toward Its Context." In *Renaissance Studies in Honor of Craig Hugh Smyth,* ed. Andrew Morrogh, 1:89–115. 2 vols. Florence, 1985.

Haines 1989
Haines, Margaret. "Brunelleschi and the Bureaucracy: The Tradition of Public Patronage at the Florentine Cathedral." *I Tatti Studies: Essays in the Renaissance* 3 (1989): 89–125.

Hanfmann 1967
Hanfmann, George M. A. *Classical Sculpture.* London, 1967.

Hanfmann 1975
Hanfmann, George M. A. *Roman Art: A Modern Survey of the Art of Imperial Rome.* New York, 1975.

Hartt 1964
Hartt, Frederick. "Art and Freedom in Quattrocento Florence." In *Essays in Memory of Karl Lehmann,* ed. Lucy Sandler, 114–31. New York, 1964.

Hartt 1994
Hartt, Frederick. *History of Italian Renaissance Art: Painting, Sculpture, and Architecture.* Ed. David G. Wilkins. New York, 1994.

Haskell and Penny 1981
Haskell, Francis, and Nicholas Penny. *Taste and the Antique.* New York, 1981.

Haskell 1993
Haskell, Francis. *History and Its Images: Art and the Interpretation of the Past.* New Haven and London, 1993.

Hay 1971
Hay, Denis. "The Place of Hans Baron in Renaissance Historiography." In *Renaissance Studies in Honor of Hans Baron,* ed. Anthony Molho and John A. Tedeschi, XI – XXIX. Florence, 1971.

Hekler 1912
Hekler, Anton. *Greek and Roman Portraits.* London, 1912.

Herlihy 1969
Herlihy, David. "Vieillir à Florence au Quattrocento." *Annales* 24 (1969): 1338–52.

Herlihy and Klapisch-Zuber 1978
Herlihy, David, and Christiane Klapisch-Zuber. *Les Toscans et leurs familles.* Paris, 1978.

Herzner 1973a
Herzner, Volker. "Donatello und Nanni di Banco: Die Prophetenfiguren für die Strebepfeiler des Florentiner Doms." *Mitteilungen des Kunsthistorischen Institutes in Florenz* 17 (1973): 1–28.

Herzner 1973b
Herzner, Volker. "Bemerkungen zu Nanni di Banco und Donatello." *Wiener Jahrbuch für Kunstgeschichte* 26 (1973): 74–95.

Herzner 1978
Herzner, Volker. "David Florentinus. I. Zum marmordavid Donatellos im Bargello." *Jahrbuch der Berliner Museen* 20 (1978): 43–115.

Herzner 1979a
Herzner, Volker. "Zwei frühwerke Donatellos. Die Prophetenstatuetten von der Porta del Campanile in Florenz." *Pantheon* 37 (1979): 27–36.

Herzner 1979b
Herzner, Volker. "Regesti donatelliani." *Rivista dell'Istituto Nazionale d'Archeologia e Storia dell'Arte* 2 (1979): 169–228.

Herzner 1988
Herzner, Volker. "Eine Hypothese zum 'Hl. Jacobus' an Orsanmichele in Florenz." *Wiener Jahrbuch für Kunstgeschichte* 41 (1988): 61–76.

Hessert 1991
Hessert, Marlis von. *Zum Bedeutungswandel der Herkules-Figur in Florenz.* Cologne, 1991.

Hibbard 1974
Hibbard, Howard. *Michelangelo.* New York, 1974.

Hill 1930
Hill, George Francis. *A Corpus of Italian Renaissance Medals before Cellini.* 2 vols. London: British Museum, 1930.

Himmelmann 1984–86
Himmelman, Nikolaus. "Nudità ideale." In *Settis 1984–86,* 2:201–78.

Hirst 1994
Hirst, Michael. Review of Poeschke 1993, Rosenauer 1993, and Pope-Hennessey 1993. *Burlington Magazine* 136 (December 1994): 843–44.

Holmes 1968
Holmes, George. "How the Medici Became the Pope's Bankers." In Rubinstein 1968, 375–80.

Holmes 1969
Holmes, George. *The Florentine Enlightenment 1400–1500*. London, 1969.

Hook 1984
Hook, Judith. *Lorenzo de' Medici*. London, 1984.

Horne 1908
Horne, Herbert P. *Alessandro Filipepi, Commonly Called Sandro Botticelli, Painter of Florence*. London, 1908.

Horne 1909
Horne, Herbert P. "A Commentary upon Vasari's Life of Jacopo del Casentino." *Rivista d'arte* 6 (1909): 156–83.

Horster 1987
Horster, Marita. "Nanni di Banco: Quattro Coronati." *Mitteilungen des Kunsthistorischen Institutes in Florenz* 31 (1987): 59–79.

Huber 1954
Huber, Raphael M. *The Immaculate Conception in the Western Church*. Rome, 1954.

Hueck 1976
Hueck, Irene. "Stifter und Patronatsrecht: Dokumente zu Zwei Kapellen der Bardi." *Mitteilungen des Kunsthistorischen Institutes in Florenz* 20 (1976): 263–70.

Hyman 1974
Hyman, Isabelle, ed. *Brunelleschi in Perspective*. Englewood Cliffs, N.J., 1974.

Jacquart and Thomasset 1988
Jacquart, Danielle, and Claude Thomasset. *Sexuality and Medicine in the Middle Ages*. Trans. Matthew Adamson. Princeton, 1988.

Janson 1952
Janson, Horst W. *Apes and Ape Lore in the Middle Ages and the Renaissance*. London, 1952.

Janson 1957
Janson, Horst W. *The Sculpture of Donatello*. 1957. 3d rev. ed. Princeton, 1979.

Janson 1961
Janson, Horst.W. "The 'Image Made by Chance' in Renaissance Art." In *De artibus opuscula: Essays in Honor of Erwin Panofsky*, ed. Millard Meiss, 254–66. New York, 1961.

Janson 1962
Janson, Horst W. *History of Art*. 1962. 3d rev. ed. New York, 1995.

Janson 1963
Janson, Horst W. "Nanni di Banco's *Assumption of the Virgin* on the Porta della Mandorla." In *Studies in Western Art* 2:98–107. Acts of the Twentieth International Congress in the History of Art, New York 1961. 4 vols. Princeton, 1963.

Janson 1964
Janson, Horst W. "Giovanni Chellini's *Libro* and Donatello." In *Studien zur Toskanischen Kunst, Festschrift für Ludwig H. Heydenreich*, ed. Wolfgang Lotz and Lise Lotte Möller, 131–38. Munich, 1964.

Janson 1966
Janson, Horst W. "The Image of Man in Renaissance Art: From Donatello to Michelangelo." In *The Renaissance Image of Man and the World*, ed. Bernard O'Kelly, 77–104. Columbus, Oh., 1966.

Janson 1968
Janson, Horst W. "Donatello and the Antique." In *Donatello 1968*, 77–96.

Janson 1972
Janson, Horst W. Review of Wundram 1969. *Art Bulletin* 54 (1972): 546–50.

Janson 1975
Janson, Horst W. Review of Rosenauer 1975. *Art Bulletin* 59 (1977): 136–39.

Joannides 1993
Joannides, Paul. *Masaccio and Masolino: A Complete Catalogue*. New York, 1993.

Johnson 1994
Johnson, Geraldine A. "In the Eye of the Beholder: Donatello's Sculpture in the Life of Renaissance Italy." Ph.D. diss., Harvard University, 1994.

Jucker 1982
Jucker, Hans. "Zwei Wunderliche Heilige." *Boreas* 5 (1982): 143–51.

Kaftal 1952
Kaftal, George. *The Iconography of the Saints in Tuscan Painting*. Florence, 1952.

Kaftal 1978
Kaftal, George. *The Iconography of the Saints in the Painting of Northeast Italy*. Florence, 1978.

Kalusok 1996
Kalusok, Michaela. *Tabernakel und Statue: Die Figurennische in der Italienischen Kunst der Mittelalters und der Renaissance*. Münster, 1996.

Kauffmann 1926
Kauffmann, Hans. "Florentiner Domplastik." *Jahrbuch der Preussischen Kunstsammlungen* 47 (1926): 141–67, 216–37.

Kauffmann 1936
Kauffmann, Hans. *Donatello: Eine Einführung in sein Bilden und Denken*. Berlin, 1936.

Keller 1956
Keller, Harald. Review of Pope-Hennessy 1955. *Kunstchronik* 9 (1956): 21–24.

Kent 1975
Kent, Dale. "The Florentine Reggimento in the Fifteenth Century." *Renaissance Quarterly* 28 (1975): 575–638.

Kent 1978
Kent, Dale. *The Rise of the Medici: Faction in Florence, 1426–1434.* New York, 1978.

Kent 1982
Kent, Francis W., and Dale V. Kent. *Neighbours and Neighbourhood in Renaissance Florence.* Locust Valley, 1982.

King 1990
King, Catherine. "Filarete's Portrait Signature on the Bronze Doors of St. Peter's: and the Dance of Bathykles and His Assistants." *Journal of the Warburg and Courtauld Institutes* 53 (1990): 296–99.

King 1991
King, Catherine. "Narrative in the Representation of the Four Crowned Martyrs: Or San Michele and the Doge's Palace." *Arte Cristiana* 79 (1991): 81–89.

Klapisch-Zuber 1969
Klapisch-Zuber, Christiane. *Les maîtres du marbre: Carrare 1300–1600.* Paris, 1969.

Kleiner 1992
Kleiner, Diana E. E. *Roman Sculpture.* New Haven, 1992.

Knapp 1903
Knapp, Fritz. "Nanni d'Antonio di Banco." In Thieme-Becker 1907–50, 2:435–36.

Kosegarten 1968
Kosegarten, Antje. "Das Grabrelief des San Aniello Abbate ins Dom von Lucca: Studien zum frühen Werken des Jacopo della Quercia." *Mitteilungen des Kunsthistorischen Institutes in Florenz* 13 (1968): 223–72.

Kosegarten 1984
Kosegarten, Antje. *Sienesisches Bildhauer am Duomo Vecchio.* Florence, 1984.

Krautheimer 1956
Krautheimer, Richard, and Trude Krautheimer-Hess. *Lorenzo Ghiberti.* 1956. 2d rev. ed. (2 vols. in 1). Princeton, 1982.

Krautheimer 1977
Krautheimer, Richard. "Fra Angelico and — Perhaps — Alberti." In *Studies in Late Medieval and Renaissance Painting in Honor of Millard Meiss,* ed. Irving Lavin and John Plummer, 290–96. New York, 1977.

Kreytenberg 1972
Kreytenberg, Gert. "Giovanni d'Ambrogio." *Jahrbuch der Berliner Museen* 14 (1972): 5–32.

Kreytenberg 1976
Kreytenberg, Gert. "Giovanni Fetti und die Porta dei Canonici des Florentiner Doms." *Mitteilungen des Kunsthistorischen Institutes in Florenz* 20 (1976): 127–58.

Kreytenberg 1979a
Kreytenberg, Gert. "Contributo all'opera di Jacopo di Piero Guidi." *Prospettiva* 16 (1979): 34–44.

Kreytenberg 1979b
Kreytenberg, Gert. "Il ballatoio del Duomo fiorentino." *Prospettiva* 16 (1979): 40–44 (app. to Kreytenberg 1979a).

Kreytenberg 1980
Kreytenberg, Gert. "Die Figurkonsolen der Loggia dei Lanzi in Florenz." *Mitteilungen des Kunsthistorischen Institutes in Florenz* 24 (1980): 275–82.

Kreytenberg 1981
Kreytenberg, Gert. "L'Annunciazione sopra la porta del Campanile nel Duomo di Firenze." *Prospettiva* 27 (1981): 52–61.

Kreytenberg 1984
Kreytenberg, Gert. *Andrea Pisano und die Toskanische Skulptur des 14. Jahrhunderts.* Munich, 1984.

Kreytenberg 1986
Kreytenberg, Gert. "Masaccio und die Skulptur Donatellos und Nanni di Bancos." In *Studien zu Renaissance und Barock Manfred Wundram zum 60. Geburtstag: Eine Festschrift herausgegeben von Michael Hesse und Max Ihmdahl,* ed. Michael Hesse and Max Ihmdahl, 11–20. Frankfurt, 1986.

Kreytenberg 1995
Kreytenberg, Gert. "Le Sculture trecentesche all'esterno e all'interno." In Acidini-Luchinat 1995a, 73–155.

Laclotte and Mognetti 1987
Laclotte, Michel, and Elisabeth Mognetti. *Avignon, Musée du Petit Palais: Peinture italienne.* Paris, 1987.

Ladis 1984
Ladis, Andrew. *Taddeo Gaddi.* Columbia, Mo., 1984.

Ladis 1986
Ladis, Andrew. "The Legend of Giotto's Wit and the Arena Chapel." *Art Bulletin* 68 (1986): 581–96.

Ladis 1992
Ladis, Andrew. "The Death of Giovanni d'Ambrogio." *Rivista d'arte* 44 (1992): 297–301.

Landi 1992
Landi, Fabrizia. "Per Nanni di Bartolo, Il Rosse." *Antichità Viva* 31 (1992): 27–31.

Lányi 1935
Lányi, Jenö. "Le Statue quattrocentesche dei profeti nel Campanile e nell'antica facciata di S. M. del Fiore." *Rivista d'arte* 17 (1935): 121–59, 245–80.

Lányi 1936
Lányi, Jenö. "Il Profeta Isaia di Nanni di Banco." *Rivista d'arte* 18 (1936): 137–78.

Lányi 1937
Lányi, Jenö. "Zur Pragmatik der Florentiner Quattrocento Skulptur (1935)." *Kritische Berichte zur Kunstgeschichtlichen Literatur* 6 (1937): 126–31.

Lapi-Ballerini 1995
Lapi-Ballerini, Isabella. "I Rilievi marmorei di Niccolò di Cecco del Mercia." In Martini 1995, 281–91.

La Sorsa 1902
La Sorsa, Saverio. *La Compagnia d'Or San Michele*. Trani, 1902.

Lavin 1967
Lavin, Irving. "Bozzetti e modelli: Notes on Sculptural Procedure from the Early Renaissance through Bernini." In *Stil und Überlieferung in der Kunst des Abendlandes*, 193–204. 2 vols. Akten des 21. Internationalen Kongresses für Kunstgeschichte in Bonn, 1964. Berlin, 1967.

Lavin 1970
Lavin, Irving. "On the Sources and Meaning of the Renaissance Portrait Bust." *Art Quarterly* 33 (1970): 357–62.

Lehmann 1945
Lehmann, Karl. "The Dome of Heaven." *Art Bulletin* 27 (1945): 1–27.

Lensi 1925–26
Lensi, Alfredo. "Il Museo Bardini — II, Le Armi." *Dedalo* 6 (1925–26): 164–83.

Lessanutti 1996
Lessanutti, Julia M. "The Madonna della Cintola in Italian Art before 1400." Ph.D. diss., University of Sydney, 1996.

Levey 1967
Levey, Michael. *Early Renaissance*. Baltimore, 1967.

Levi d'Ancona 1977
Levi d'Ancona, Mirella. *The Garden of the Renaissance: Botanical Symbolism in Italian Painting*. Florence, 1977.

Lightbown 1978
Lightbown, Ronald. *Sandro Botticelli: Life and Work*. Berkeley and Los Angeles, 1978.

Lightbown 1980
Lightbown, Ronald. *Donatello and Michelozzo: An Artistic Partnership and Its Patrons in the Early Renaissance*. 2 vols. London, 1980.

Lisner 1960
Lisner, Margrit. *Luca della Robbia: Die Sängerkanzel*. Stuttgart, 1960.

Lisner 1962
Lisner, Margrit. "Zum Frühwerke Donatellos." *Münchner Jahrbuch der Bildenden Kunst* 13 (1962): 63–68.

Lisner 1967
Lisner, Margrit. "Gedanken vor frühen Standbildern des Donatello." In *Kunstgeschichtliche Studien für Kurt Bauch*, ed. Berthold Hackelsberger, Georg Himmelheber, and Michael Meier, 77–92. Munich and Berlin, 1967.

Lisner 1968
Lisner, Margrit. "Intorno al crocifisso di Donatello in S. Croce." In *Donatello 1968*, 126–27.

Lisner 1970
Lisner, Margrit. *Holzkruzifixe in Florenz und in der Toskana*. Munich, 1970.

Lisner 1974
Lisner, Margrit. "Josua und David: Nannis und Donatellos Statuen für den Tribuna Zyklus des Florentiner Doms." *Pantheon* 32 (1974): 232–43.

Lisner 1977
Lisner, Margrit. "Die Skulpturen am Laufgang des Florentiner Doms." *Mitteilungen des Kunsthistorischen Institutes in Florenz* 21 (1977): 111–82.

List-Freytag 1986
List-Freytag, Claudia. "Quercia in Lucca." *Jahrbuch des Zentralinstituts für Kunstgeschichte* 2 (1986): 9–46.

Longhi 1927
Longhi, Roberto. "Un busto di Michelozzo." *Vita artistica* (January 1927): 16.

***Lorenzo Ghiberti* 1978**
Lorenzo Ghiberti: materia e raggionamento. Exh. cat. Florence: Museo dell'Accademia and Museo di San Marco, 1978.

Luca di Bitonto 1985
Luca di Bitonto. *Luca Apulus: un maestro francescano del secolo XIII*. Ed. Felice Moretti. Bitonto, 1985.

Lunardi 1983
Lunardi, Roberto, ed. *Arte e storia a Santa Maria Novella*. Exh. cat. Florence: Museo Comunale di Santa Maria Novella, 1983.

Lungo 1900
Lungo, Carlo del. *I Fulmini caduti sopra la cupola di S. Maria del Fiore*. Prato, 1900.

Macchioni 1979
Macchioni, Silvana. "Il S. Giorgio di Donatello." *Storia dell'arte* 36–37 (1979): 135–56.

Maginnis and Ladis 1995
Maginnis, Haydon B. J., and Andrew Ladis. "Sculpture's Pictorial Presence: Reflections on the Tabernacles of Orsanmichele." *Studi di storia dell'arte* 5–6 (1994–95): 41–54.

Mallett 1968
Mallett, Michael. "Pisa and Florence in the Fifteenth Century: Aspects of the Period of the First Florentine Domination." In Rubinstein 1968, 403–11.

Mancini 1909
Mancini, Girolamo. "Il bel S. Giovanni e le feste patronali di Firenze descritte nel 1475 da Pietro Cennini." *Rivista d'arte* 6 (1909): 185–227.

Manetti 1960
Manetti, Gianozzo. *Oratio ad clarissimum equestris ordinid virum Angelum Accaiolum equestris de secularibus et pontificalibus pompis in consecratione basilicae Florentinae habitis incipit feliciter*. Ed. Eugenio Battisti. In *Il Mondo visuale delle fiabe: umanesimo e esoteresimo*, ed. Enrico Castelli, 310–20. Atti del V convegno internazionale di studi umanistici, Oberhofen, 1960. Padua, 1960.

Manetti 1970
Manetti, Antonio. *The Life of Brunelleschi by Antonio di Tuccio Manetti.* Ed. Howard Saalman. Trans. Catherine Enggass. Philadelphia, 1970.

Manetti 1976
Manetti, Antonio. *Vita di Filippo Brunelleschi preceduta da "La novella del Grasso."* Ed. Domenico de Robertis and Giuliano Tanturli. Milan, 1976.

Manetti 1991
Manetti, Antonio. *The Fat Woodworker.* Ed. and trans. Robert L. Martone and Valerie Martone. New York, 1991.

Manetti 1994
Manetti, Antonio. "The Fat Woodcarver." Trans. Murtha Baca. In *An Italian Renaissance Sextet: Six Tales in Historical Context*, ed. Lauro Martines. New York, 1994.

Mannini 1978
Mannini, Maria Pia. "Orsanmichele. Arte dei Vaiai e Pelliccai." In *Lorenzo Ghiberti* 1978, 177–79.

Manselli 1970
Manselli, Raoul. "Bernardo di Chiaravalle." In *Enciclopedia Dantesca* 1:601–5. 2 vols. Rome, 1970.

Mansuelli 1958
Mansuelli, Guido A. *Galleria degli Uffizi: Le sculture.* 2 vols. Rome, 1958.

Marek 1989
Marek, Michaela J. "Donatellos Niccolò da Uzzano . . . 'ritrare dal naturale' und Bürgertugend." In Cammerer 1989, 263–71.

Marracchi 1694
Marracchi, Ippolito. *Polyanthea Mariana in Libros XX Distributo.* Rome, 1694.

Marrai 1909
Marrai, Bernardo. "Oratorio di Or San Michele: lavori di riordinamento e di restauro." *Rivista d'arte* 6 (1909): 250–55.

Marrow 1977
Marrow, James. "Circumdederunt me canes multi: Christ's Tormentors in Northern European Art of the Late Middle Ages and Early Renaissance." *Art Bulletin* 59 (1977): 167–81.

Martines 1963
Martines, Lauro. *The Social World of the Florentine Humanists 1390–1460.* London, 1963.

Martines 1968
Martines, Lauro. *Lawyers and Statecraft in Renaissance Florence.* Princeton, 1968.

Martines 1979
Martines, Lauro. *Power and Imagination: City States in Renaissance Italy.* New York, 1979.

Martines 1994
Martines, Lauro. "The Fat Woodcarver by Antonio Manetti: Who does he think he is ?" In *An Italian Renaissance Sextet: Six Tales in Historical Context*, ed. Lauro Martines, 213–41. New York, 1994.

Martini 1995
Martini, Claudio, et. al *La Sacra Cintola nel Duomo di Prato.* Prato, 1995.

Martini 1978
Martini, Laura. "Crocifisso" and "Cristo in pietà." In *Lorenzo Ghiberti* 1978, 212–16.

Martini 1986
Martini, Laura. "Crocifisso." In Darr and Bonsanti 1986, 126–27, cat. no. 18.

Matteo d'Aquasparta 1962
Matthaei ab Aquasparta. *Sermones de Beata Maria Virgine.* Ed. Celestino Piana. Bibliotheca Franciscana Ascetica Medii Aevii, no. 9. Quaracchi, 1962.

Medin 1910–11
Medin, Antonio. "La Leggenda popolare di S. Eligio e la sua iconografia." *Atti del Reale Istituto Veneto di Scienze, Lettere, e Arti* 70, Part 2 (1910–11): 776–802.

Meiss 1951
Meiss, Millard. *Painting in Florence and Siena after the Black Death: The Arts, Religion, and Society in the Mid-Fourteenth Century.* Princeton, 1951.

Meiss 1970
Meiss, Millard. "Light as Form and Symbol in Some Fifteenth-Century Paintings." In *Renaissance Art*, ed. Creighton Gilbert, 43–68. New York, 1970.

Meiss and Beatson 1974
Meiss, Millard, and Elizabeth H. Beatson. *The Belles Heures of Jean, Duke of Berry.* New York, 1974.

Meller 1925
Meller, Simon. *Peter Vischer der Ältere und Seine Werkstatt.* Leipzig, 1925.

Meller 1926
Meller, Simon. *Die Deutschen Bronzestatuetten der Renaissance.* Munich, 1926.

Meller 1963
Meller, Peter. "Physiognomical Theory in Renaissance Heroic Portraits." In *Studies in Western Art* 2:67–69. Acts of the Twentieth International Congress in the History of Art, New York, 1961. 4 vols. Princeton, 1963.

Middeldorf 1929
Middeldorf, Ulrich. "Giovanni Bandini detto Giovanni dell'Opera." *Rivista d'arte* 11 (1929): 481–518.

Middeldorf 1936
Middeldorf, Ulrich. Review of Kauffmann 1936. *Art Bulletin* 18 (1936): 570–85.

Middeldorf 1940
Middeldorf, Ulrich. "Heads in Sculpture." *Parnassus* 12 (1940): 18–20.

Middeldorf 1973
Middeldorf, Ulrich. "Alcuni sigilli pisani del Trecento." In *Civiltà delle arti minori in Toscana*, 185–91. Atti del I convegno Arezzo, 11–15 maggio 1971. Florence, 1973.

Migliore 1684
Migliore, Ferdinando Leopoldo del. *Firenze città nobilissima.* Florence, 1684.

Migne 1844–66
Migne, Jacques Paul, ed. *Patrologia cursus completus, Latina.* 221 vols. Paris, 1844–66.

Molho 1968
Molho, Anthony. "Politics and the Ruling Class in Early Renaissance Florence." *Nuova Rivista Storica* 52 (1968): 401–20.

Molinari 1961
Molinari, Cesare. *Spettacoli fiorentini del Quattrocento: contributi allo studio delle sacre rappresentazioni.* Venice, 1961.

Mone 1964
Mone, Franz Joseph, ed. *Lateinische Hymnen des Mittelalters.* 3 vols. 1855. Reprint, Darmstadt, 1964.

Moraldi 1971
Moraldi, Luigi. *Apocrifi del Nuovo Testamento.* 2 vols. Turin, 1971.

Morelli 1956
Giovanni di Pagolo Morelli. *Ricordi.* Ed. Vittore Branca. Florence, 1956.

Mori 1983
Mori, Masahiko. "Isaia e David." *Art History (Sendai)* 5 (1983): 98–123.

Mori and Boffito 1973
Mori, Attilio, and Giuseppe Boffito. *Firenze nelle vedute e piante: Studio storico, topografico, cartografico.* 1926. Reprint, Rome, 1973.

Moroni 1841
Moroni, Gaetano. *Dizionario di Erudizione Storico-Ecclesiastico da S. Pietro sino a Nostri Giorni.* 103 vols. Venice, 1841.

Moseley 1916
Moseley, Thomas A. E. *The "Lady" in Comparisons from the Poetry of the "Dolce Stil Nuovo."* Menasha, Wis., 1916.

Moskowitz 1978
Moskowitz, Anita. "Studies in the Sculpture of Andrea Pisano: Origins and Development of His Style." Ph.D. diss., New York University, 1978.

Moskowitz 1981
Moskowitz, Anita. "Donatello's Reliquary Bust of Saint Rossore." *Art Bulletin* 63 (1981): 41–48.

Moskowitz 1983
Moskowitz, Anita. "Trecento Classicism in the Campanile Hexagons." *Gesta* 22 (1983): 49–65.

Moskowitz 1986
Moskowitz, Anita. *The Sculpture of Andrea and Nino Pisano.* New York, 1986.

Muir 1981
Muir, Edward. *Civic Ritual in Renaissance Venice.* Princeton, 1981.

Munman 1980
Munman, Robert. "The Evangelists from the Cathedral of Florence: A Renaissance Arrangement Recovered." *Art Bulletin* 62 (1980): 207–17.

Munman 1985
Munman, Robert. *Optical Corrections in the Sculpture of Donatello. Transactions of the American Philosophical Society.* Vol. 75. Philadelphia, 1985.

Mustari 1975
Mustari, Louis F. "The Sculptor in the Fourteenth-Century Opera del Duomo." Ph.D. diss., New York University, 1975.

Najemy 1982
Najemy, John. *Corporatism and Consensus in Florentine Electoral Politics, 1280–1400.* Chapel Hill, N.C., 1982.

Nannelli and Giusti 1989
Nannelli, Francesca, and Anna Maria Giusti. "San Jacopo." *OPD Restauro: Rivista dell'Opificio delle Pietre Dure e Laboratori di Restauro di Firenze* 1 (1989): 180–84.

Natali 1986
Natali, Antonio. "Crocifisso." In Luciano Berti, Chiara Cecchi, and Antonio Natali, "Donatello." *Arte Dossier* (June, 1986): 30–32.

Natali 1990a
Natali, Antonio. "Sant Eligio." *OPD Restauro: Rivista dell'Opificio delle Pietre Dure e Laboratori di Restauro di Firenze* 2 (1990): 145–49.

Natali 1990b
Natali, Antonio. "Profetino." In Berti and Paolucci 1990, cat. no. 16.

Natali 1996
Natali, Antonio. *L'Umanesimo di Michelozzo.* Florence, 1996.

Negri-Arnoldi 1964
Negri-Arnoldi, Francesco. "Eligio." In *Biblioteca Sanctorum* 4: cols. 1069–1073. Rome, 1964–68.

Negri-Arnoldi 1994
Negri-Arnoldi, Francesco. *La Scultura del Quattrocento.* Turin, 1994.

Neri-Lusanna 1995
Neri-Lusanna, Enrica. "La Decorazione e le sculture arnolfiane dell'antica facciata." In Acidini-Luchinat 1995a, 31–72.

Neri-Lusanna 1996
Neri Lusanna, Enrica. "Una traccia per la giovinezza di Nanni di Banco." *Artista* n.n. (1996): 20–31.

Nicholson 1942
Nicholson, Alfred. "Donatello: Six Portrait Statues." *Art in America* 30 (1942): 77–104.

Niehaus 1998
Niehaus, Andrea. *Florentiner Reliefkunst von Brunelleschi bis Michelangelo.* Munich, 1998.

Nordenfalk 1985
Nordenfalk, Carl. "The Five Senses in Late Medieval and Renaissance Art." *Journal of the Warburg and Courtauld Institutes* 48 (1985): 1–22.

Olson 1992
Olson, Roberta J. M. *Italian Renaissance Sculpture*. New York and London, 1992.

Olszewski 1997
Olszewski, Edward J. "Prophecy and Prolepsis in Donatello's Marble David." *Artibus et historiae* 36 (1997): 63–79.

Paatz 1952–56
Paatz, Walter, and Elisabeth Paatz. *Die Kirchen von Florenz*. 6 vols. Frankfurt, 1952–56.

Pachaly 1907
Pachaly, Gerhard. *Nanni d'Antonio di Banco: aus der Entwicklung der Skulptur von Florenz*. Heidelberg, 1907.

Padoa-Rizzo 1993
Padoa-Rizzo, Anna. "Bernardo di Stefano Rosselli, il 'polittico Rucellai' e il polittico di San Pancrazio di Bernardo Daddi." *Studi di Storia dell'Arte* 4 (1993): 211–22.

Paliaga and Renzoni 1991
Paliaga, Franco, and Stefano Renzoni. *Le Chiese di Pisa*. Pisa, 1991.

Pampaloni 1973
Pampaloni, Guido. *Firenze al tempo di Dante: documenti sull'urbanistica fiorentina*. Rome, 1973.

Panofsky 1972
Panofsky, Erwin. *Renaissance and Renascences*. New York, 1972.

Paoletti 1978
Paoletti, John T. "The Bargello *David* and Public Sculpture in Fifteenth-Century Florence." In *Collaboration in Italian Renaissance Art*, ed. John T. Paoletti and Wendy Steadman Sheard, 99–108. New Haven, 1978.

Paoletti 1980
Paoletti, John T. "Nella mia giovanile età mi partì da Firenze. . . ." In *Lorenzo Ghiberti nel suo tempo* 1:99–110. 2 vols. Florence, 1980.

Paolucci 1990
Paolucci, Antonio. "Firenze 1400–1420: la stagione delle 'attitudini' e degli 'affetti'." In Berti and Paolucci 1990, 19–32.

Paribeni 1961
Paribeni, Enrico. "Riflessi di sculture antiche." *Archeologia classica* 13 (1961): 103–5.

Parronchi 1976
Parronchi, Alessandro. "L'autore del crocifisso di S. Croce: Nanni di Banco." *Prospettiva* 6 (1976): 50–55.

Parronchi 1980
Parronchi, Alessandro. *Donatello e il potere*. Florence, 1980.

Parronchi 1989
Parronchi, Alessandro. "Le Statue per gli sproni." *Antichità Viva* (1989): 80–85.

Partner 1958
Partner, Peter. *The Papal State under Martin V*. London, 1958.

Passavant 1987
Passavant, Günter. "Zu einigen toskanischen Terrakotta-Madonnen der Frührenaissance." *Mitteilungen des Kunsthistorischen Institutes in Florenz* 31 (1987): 197–236.

Pastor 1944–60
Pastor, Ludwig von. *Storia dei papi*. 16 vols. Rome, 1944–60.

Pastor 1892
Pastor, Willy. *Donatello*. Giessen, 1892.

Paul 1985
Paul, Eberhard. "Falsificazioni di antichità in Italia." In Settis 1984–86, 2:413–39.

Pecchioli 1978
Pecchioli, Litta Medri. "Orsanmichele. S. Pietro." In *Lorenzo Ghiberti* 1978, 195–97.

Pelikan 1990
Pelikan, Jaroslav. *Eternal Feminines: Three Theological Allegories in Dante's Paradiso*. New Brunswick, 1990.

Pelikan 1996
Pelikan, Jaroslav. *Mary through the Centuries: Her Place in the History of Culture*. New Haven and London, 1996.

Petrucci 1995
Petrucci, Francesca. "Le Sculture dell'interno." In Acidini-Luchinat 1995a, 157–92.

Phillips 1964
Phillips, Michael. "A New Interpretation of the Early Style of Nanni di Banco." *Marsyas* 11 (1962–64): 63–66.

Piana 1944
Piana, Celestino. "Contributo allo studio della teologia e della leggenda dell'Assunzione della Vergine nel secolo XIV." *Studi francescani* series 3, 16 [41] (1944): 97–117.

Piccinini 1986
Piccinini, Francesca. "Uno scultore quercesco-donatelliano ad Adria." *Ricerche di Storia dell'Arte* 30 (1986): 99–103.

Pinto 1978
Pinto, Giuliano. *Il libro del Biadaiolo*. Florence, 1978.

Plahter 1971
Plahter, Unn, and Leif Plahter. "Notes on the Deterioration of Donatello's Marble Figure of St. Mark on the Church of Or San Michele in Florence." *Studies in Conservation: Journal of the International Institute for the Conservation of Historic Works* 16 (1971): 114–18.

Planiscig 1934
Planiscig, Leo. "Niccolò di Pietro Lamberti." In Thieme-Becker 1907–50, 25:437.

Planiscig 1942
Planiscig, Leo. "I Profeti della Porta della Mandorla del Duomo Fiorentino." *Rivista d'Arte* 21 (1942): 125–42.

Planiscig 1946
Planiscig, Leo. *Nanni di Banco*. Florence, 1946.

Planiscig and Kris 1936
Planiscig, Leo, and Ernst Kris. *Kleinkunst der italienischen Frührenaissance.* Exh. cat. Vienna: Kunsthistorisches Museum, 1936.

Pochat 1978
Pochat, Götz. "Brunelleschi and the 'Ascension' of 1422." *Art Bulletin* 60 (1978): 232–34.

Poeschke 1971
Poeschke, Joachim. Review of Wundram 1969. *Kunstchronik* 24 (1971): 10–23.

Poeschke 1980
Poeschke, Joachim. *Donatello: Figur und Quadro*. Munich, 1980.

Poeschke 1986
Poeschke, Joachim. Review of Darr and Bonsanti 1986. *Kunstchronik* 39 (1986): 505–10.

Poeschke 1989
Poeschke, Joachim. "Il rapporto fra statue e spazio nel concetto del giovane Donatello." In Cämmerer 1989, 145–54.

Poeschke 1993
Poeschke, Joachim. *Donatello and His World: Sculpture of the Italian Renaissance*. New York, 1993.

Poggi 1904
Poggi, Giovanni. *Catalogo del Museo dell'Opera del Duomo*. Florence, 1904.

Poggi 1905
Poggi, Giovanni. "Andrea di Lazzaro Cavalcanti e il pulpito di S. Maria Novella." *Rivista d'arte* 3 (1905): 77–85.

Poggi 1909
See Poggi-Haines

Poggi 1932
Poggi, Giovanni. "La Cappella del Sacro Cingolo nel Duomo di Prato e gli affreschi di Agnolo Gaddi." *Rivista d'arte* 14 (1932): 355–76.

Poggi-Haines
Poggi, Giovanni. *Il Duomo di Firenze*. 2 vols. 1909. Reprint, ed. Margaret Haines, Florence, 1988.

Pollitt 1972
Pollitt, John J. *Art and Experience in Classical Greece*. Cambridge, Mass., 1972.

Pope-Hennessy 1952
Pope-Hennessy, John. Review of Vaccarino 1950. *Burlington Magazine* 94 (1952): 182.

Pope-Hennessy 1955
Pope-Hennessy, John. *Italian Gothic Sculpture*. 1955. 2d rev. ed., New York, 1985.

Pope-Hennessy 1964
Pope-Hennessy, John. *Catalogue of Italian Sculpture in the Victoria and Albert Museum*. 2 vols. London, 1964.

Pope-Hennessy 1972
Pope-Hennessy, John. *Italian Renaissance Sculpture*. 1972. 2d rev. ed., New York, 1985.

Pope-Hennessy 1974
Pope-Hennessy, John. *Fra Angelico*. London, 1974.

Pope-Hennessy 1976
Pope-Hennessy, John. Review of Lisner 1970. *Pantheon* 34 (1976): 78–80.

Pope-Hennessy 1980
Pope-Hennessy, John. *Luca della Robbia*. Oxford, 1980.

Pope-Hennessy 1985
Pope-Hennessy, John. *Donatello*. Florence, 1985.

Pope-Hennessy 1993
Pope-Hennessy, John. *Donatello Sculptor*. New York, 1993.

Previtali 1979
Previtali, Giovanni. "La periodizzazione della storia dell'arte italiana." In *Storia dell'arte italiana*. 1, *Questioni e metodi*, ed. Giovanni Previtali, 5–95. Turin 1979.

Preziosi 1989
Preziosi, Donald. *Rethinking Art History: Meditations on a Coy Science*. New Haven, 1989.

Procacci 1928
Procacci, Ugo. "Niccolò di Pietro Lamberti detto il Pela di Firenze e Niccolò di Luca Spinelli d'Arezzo." *Il Vasari* 1 (1928): 300–316.

Procacci 1960
Procacci, Ugo. "Di Jacopo di Antonio e delle compagnie di pittori del corso degli Adimari nel XV secolo." *Rivista d'arte* 35 (1960): 3–70.

Procacci 1967
Procacci, Ugo. *La Casa Buonarroti a Firenze*. Milan, 1967.

Procacci 1980
Procacci, Ugo. "Chi era Filippo di ser Brunellesco?" In *Filippo Brunelleschi, la sua opera e il suo tempo* 1:37–64. Convegno internazionale di studi, Firenze 1977. 2 vols. Florence, 1980.

Quinterio 1978
Quinterio, Francesco. "L'Architettura." In *Lorenzo Ghiberti 1978*, 452–510.

Quintilian 1968
Quintilian. *The Institutio Oratoria of Quintilian.* Trans. Harold Edgeworth Butler. 4 vols. London and Cambridge, Mass., 1968.

Ragghianti 1977
Ragghianti, Carlo. *Filippo Brunelleschi: un uomo, un universo.* Florence, 1977.

Rathe 1910
Rathe, Kurt. *Die Figurale Schmuck der Alten Domfassade in Florenz.* Vienna and Leipzig, 1910.

Reese 1975
Reese, Gustave. *Music in the Renaissance.* 2d rev. ed. New York, 1975.

Reggioli 1978
Reggioli, Donatella. "La Porta Nord. Giuliano di Giovanni di Poggibonsi e Michelozzo." In *Lorenzo Ghiberti 1978*, 107–8.

Repetti 1839
Repetti, Emanuele. *Dizionario geografico fisico storico della Toscana.* 3 vols. Florence, 1839.

Reymond 1894
Reymond, Marcel. "La sculpture florentine au XIVᵉ et au XVᵉ siècle." *Gazette des Beaux Arts* 35 (1894): 384–96.

Reymond 1897–98
Reymond, Marcel. *La sculpture florentine.* 3 vols. Florence, 1897–98.

Reymond 1905
Reymond, Marcel. "L'Antica facciata del Duomo di Firenze." *L'Arte* 8 (1905): 171–82.

Rezasco 1891
Rezasco, Giulio. *Dizionario del linguaggio italiano storico ed amministrativo.* Florence, 1891.

Richa 1754–62
Richa, Giuseppe. *Notizie istoriche delle chiese fiorentine, divise ne' suoi quartieri.* 10 vols. Florence, 1754–62.

Richter 1969
Richter, Gisela M. A. "Verism in Roman Portraiture." In *Readings in Art History*, ed. Harold Spencer, 1:117–30. 2 vols. New York, 1969.

Righetti 1969
Righetti, Mario. *L'Anno liturgico.* 4 vols. Milan, 1969.

Rodolico 1965
Rodolico, Francesco. *Le Pietre delle città d'Italia.* 2d rev. ed. Florence, 1965.

Rohr 1948
Rohr, Louis Frederick. *The Use of Sacred Scripture in the Sermons of St. Anthony of Padua.* Washington, 1948.

Romanini 1969
Romanini, Angiola Maria. *Arnolfo di Cambio e lo stile novo del gotico italiano.* Milan, 1969.

Rose 1981
Rose, Patricia. "Bears, Baldness, and the Double Spirit: The Identity of Donatello's Zuccone." *Art Bulletin* 63 (1981): 31–41.

Rosenauer 1974
Rosenauer, Artur. Review of Wundram 1969. *Mitteilungen des Gesellschaft für vergleichende Kunstforschung in Wien* 26 (1974): 28–30.

Rosenauer 1975
Rosenauer, Artur. *Studien zum frühen Donatello: Skulptur in projecktiven Raum der Neuzeit.* Vienna, 1975.

Rosenauer 1978
Rosenauer, Artur. "Die Nischen für die Evangelisten Figuren an der Florentiner Domfassade." In *Essays Presented to Myron P. Gilmore*, ed. Sergio Bertelli, and Gloria Ramakus, 2:345–52. 2 vols. Florence, 1978.

Rosenauer 1991
Rosenauer, Artur. "Das Menschliche Antlitz in Schaffen Donatellos." In *Uomo e natura nella letteratura italiana del Tre-Quattrocento*, ed. Wolfram Prinz, 125–39. Florence, 1991.

Rosenauer 1993
Rosenauer, Artur. *Donatello.* Milan, 1993.

Rossi 1940
Rossi, Silvia. *L'Assunzione di Maria.* Naples, 1940.

Rossi 1891
Rossi, Umberto. *Catalogo del Museo di Santa Maria del Fiore.* Florence, 1891.

Rossi-Pinelli 1986
Rossi-Pinelli, Orietta. "Chirurgia della memoria: scultura antica e restauri storici." In *Settis 1984–86*, 3:181–250.

Rouse 1988
Rouse, Richard H., and Mary A. Rouse. "St. Antoninus of Florence on Manuscript Production." In *Litterae Medii Aevi: Festschrift für Johanne Autenrieth zu ihrem 65. Geburtstag*, ed. Michael Borgolte and Herrad Spilling, 255–63. Sigmaringen, 1988.

Rubinstein 1942
Rubinstein, Nicolai. "The Beginnings of Political Thought in Florence: A Study of Medieval Historiography." *Journal of the Warburg and Courtauld Institutes* 5 (1942): 198–227.

Rubinstein 1966
Rubinstein, Nicolai. *The Government of Florence under the Medici, 1434–94.* Oxford, 1966.

Rubinstein 1968
Rubinstein, Nicolai, ed. *Florentine Studies: Politics and Society in Renaissance Florence.* London and Evanston, Ill., 1968.

Rubinstein 1978
Rubinstein, Nicolai. "The Piazza della Signoria in Florence." In *Festschrift Herbert Siebenhüner*, ed. Erich Hubala and Gunter Schweikhart. Würzburg, 1978.

Saalman 1980
Saalman, Howard. *Filippo Brunelleschi: The Cupola of Santa Maria del Fiore.* London, 1980.

Sacchetti 1946
Sacchetti, Franco. *Il Trecentonovelle.* Ed. Vincenzo Pernicone. Florence, 1946.

Sacchi 1829
Sacchi, Defendente. *Della condizione economica, morale, e politica degli italiani ne' tempi municipali: sulle feste, e sull'origine, stato, e decadenza de' municipii italiani nel medio evo.* Milan, 1829.

Salmi 1930
Salmi, Mario. "La giovanezza di Jacopo della Quercia." *Rivista d'arte* 12 (1930): 175–91.

Salmi 1940
Salmi, Mario. "Arnolfiana." *Rivista d'arte* 22 (1940): 162–63.

Salmi 1951
Salmi, Mario. *San Domenico e San Francesco di Arezzo.* Rome, 1951.

Salmi 1965
Salmi, Mario. "Una statua di Arnolfo." *Commentari* 16 (1965): 17–22.

Salmi 1971
Salmi, Mario. *Civiltà artistica della terra aretina.* Novara, 1971.

Salmi 1974
Salmi, Mario. *Arezzo nelle due edizioni delle 'Vite' del Vasari.* Arezzo, 1974.

Sapori 1940
Sapori, Armando. *Case e botteghe a Firenze nel Trecento.* Florence, 1940.

Scalini 1988
Scalini, Mario. *L'Arte italiana del bronzo 1000–1700.* Busto Arzizio, 1988.

Scalini 1990
Scalini, Mario. "Annunciazione." and "Crocifisso." In Berti and Paolucci 1990, cat. nos. 1, 35.

Scarini 1977
Scarini, Alfio. *Castelli del Casentino.* Arezzo, 1977.

Schäppi-Witzig 1981
Schäppi-Witzig, Heidi. *Die Florentiner Bürger und ihre Stadt.* Zurich, 1981.

Schlegel 1967
Schlegel, Ursula. "Zu Donatello und Desiderio da Settignano. Beobachtungen zur physiognomischen Gestaltung in Quattrocento." *Jahrbuch der Berliner Museen* 9 (1967): 135–55.

Schlegel 1979
Schlegel, Ursula. "Dalla Cerchia del Ghiberti: rappresentazioni della Madonna di Nanni di Bartolo." *Antichità Viva* 18 (1979): 21–26.

Schmarsow 1887a
Schmarsow, August. "Vier Statuetten in der Domopera zu Florenz." *Jahrbuch der Preussischen Kunstsammlungen* 8 (1887): 137–53.

Schmarsow 1887b
Schmarsow, August. "Bemerkungen über Niccolò d'Arezzo." *Jahrbuch der Preussischen Kunstsammlungen* 8 (1887): 227–30.

Schmarsow 1889
Schmarsow, August. "Le statue di Or San Michele." *Vita nuova* 11 (1889): 6–8; 12 (1889): 3–5; 13 (1889): 3–4.

Schoenholzer-Nichols 1995
Schoenholzer-Nichols, Thessy. "La Cintola: proposta per una lettura tecnica." In Martini 1995, 79–81.

Schottmüller 1904
Schottmüller, Frida. *Donatello.* Munich, 1904.

Schottmüller 1912
Schottmüller, Frida. "Ciuffagni." In Thieme-Becker 1907–50, 7:17–19.

Schottmüller 1913
Schottmüller, Frida. *Königliche Museen zu Berlin: Die italienischen und spanischen Bildwerke der Renaissance und des Barocks.* Berlin, 1913.

Schubring 1907
Schubring, Paul. *Donatello.* Stuttgart, 1907.

Schubring 1915
Schubring, Paul. *Italienische Plastik.* Wildpark and Potsdam, 1915.

Schulz 1986
Schulz, Anne M. "Niccolò and Pietro Lamberti." *Saggi e memorie di storia dell'arte* 15 (1986): 7–61.

Schulz 1994
Schulz, Anne M. "Nanni di Bartolo e il portale di S. Nicola a Tolentino." In *Arte e spiritualità nell'ordine agostiniano, e il Convento San Nicola a Tolentino*, 313–14. Tolentino, 1994.

Schulz 1997
Schulz, Anne M. *Nanni di Bartolo e il portale della Basilica di San Nicola a Tolentino.* Florence, 1997.

Sellers 1968
Sellers, Eugenie, ed. *The Elder Pliny's Chapters on the History of Art.* Trans. K. Jex-Blake. 1896. Reprint, Chicago, 1968.

Semper 1875
Semper, Hans. *Donatello: seine Zeit und Schule.* Vienna, 1875.

Semper 1890
Semper, Hans. "Die Vorläufer Donatellos." *Jahrbuch für Kunstgeschichte* 3 (1890): 1–70.

Settis 1984–86
Settis, Salvatore, ed. *Memoria dell'antico nell'arte italiana.* 3 vols. Turin, 1984–86.

Settis 1986
Settis, Salvatore. "Le collezione archeologiche." In *Il Museo dell'Opera del Duomo a Pisa* 1:179–91. 2 vols. Pisa, 1986.

Seymour 1959
Seymour, Charles, Jr. "The Younger Masters of the First Campaign of the Porta della Mandorla." *Art Bulletin* 41 (1959): 1–17.

Seymour 1963a
Seymour, Charles, Jr. "Invention and Revival in Nicola Pisano's 'heroic style'." In *Studies in Western Art* 1:207–26. Acts of the Twentieth International Congress in the History of Art, New York, 1961. 4 vols. Princeton, 1963.

Seymour 1963b
Seymour, Charles, Jr. "The Young Luca della Robbia." *Allen Memorial Art Museum* 20 (1962–63): 92–119.

Seymour 1966
Seymour, Charles, Jr. *Sculpture in Italy: 1400–1500.* Baltimore, 1966.

Seymour 1967a
Seymour, Charles Jr. "'Homo magnus et albus': The Quattrocento Background for Michelangelo's David of 1501–1504." In *Stil und Überlieferung in der Kunst des Abendlandes* 2:96–105. Akten des 21. Internationalen Kongresses für Kunstgeschichte in Bonn 1964. 2 vols. Berlin, 1967.

Seymour 1967b
Seymour, Charles, Jr. *Michelangelo's David: A Search for Identity.* New York, 1967.

Seymour 1968
Seymour, Charles, Jr. "Some Aspects of Donatello's Methods of Figure and Space Construction: Relationships with Alberti's *De statua* and *Della pittura*." In *Donatello 1968*, 195–206.

Sframeli 1989
Sframeli, Maria, ed. *Il centro di Firenze restituito: affreschi e frammenti lapidei nel Museo di San Marco.* Florence, 1989.

Shearman 1972
Shearman, John. *Raphael's Cartoons in the Collection of Her Majesty the Queen and the Tapestries for the Sistine Chapel.* London, 1972.

Simson 1962
Simson, Otto von. *The Gothic Cathedral: Origins of Gothic Architecture and the Medieval Concept of Order.* New York, 1962.

Sinding 1903
Sinding, Olav. *Mariae Tod und Himmelfahrt.* Christiana, 1903.

Sinding-Larsen 1975
Sinding-Larsen, Staale. "A Tale of Two Cities: Florence and Rome, a Visual Context for Fifteenth-Century Palaces." *Acta ad archeologiam et artium historiam pertinentia, Istitutum Romanum Norvegiae* 6 (1975): 163–212.

Singleton 1936
Singleton, Charles S. *Canti carnascialeschi del Rinascimento.* Bari, 1936.

Singleton 1910
Singleton, Esther D., ed. *Florence as Described by Great Writers.* New York, 1910.

Sirèn 1914
Sirèn, Osvald. "The Importance of the Antique to Donatello." *American Journal of Archeology* 17 (1914): 438–61.

Sisi 1978
Sisi, Carlo. "Ghiberti e la scultura italiana." In *Lorenzo Ghiberti 1978*, 35–37.

Spina-Barelli 1972
Spina-Barelli, Emma. "Note iconografiche in margine alla cantoria di Donatello." *Storia dell'arte* 15–16 (1972): 283–91.

Stang 1962
Stang, Raghna, and Nicolay Stang. "Donatello e il Giosue per il Campanile di S. Maria del Fiore alla luce dei documenti." *Acta ad archeologiam et artium historiam pertinentia, Istitutum Romanum Norvegiae* 1 (1962): 113–30.

Statuta 1415
Statuta popoli et communis florentiae anno salutis, MCCCCXV. 3 vols. Ed. Michael Kluch. Fribourg, 1778–83.

Statuti 1957
Statuti delle arti dei corazzai, dei chiavaioli, ferraioli, e calderai e dei fabbri di Firenze (1321–1344). Ed. Giulia Camerini Marri. Florence, 1957.

Statuti 1963
Statuti dei comuni di Castelfranco di Sopra (1394) e Castiglione degli Ubertini (1397). Ed. Giulia Camerini Marri. Florence, 1963.

Steinweg 1929
Steinweg, Klara. *Andrea Orcagna.* Strasbourg, 1929.

Strong 1980
Strong, Donald. *Roman Art.* New York, 1980.

Summers 1977
Summers, David. "Contrapposto: Style and Meaning in Renaissance Art." *Art Bulletin* 59 (1977): 336–61.

Swarzenski 1951
Swarzenski, Georg. "A Bronze Statuette of St. Christopher." *Bulletin of the Museum of Fine Arts, Boston* 49 (1951): 84–95.

Taucci 1963
Taucci, Raffaele. "La Porta della Mandorla." *La SS. Annunziata: Bollettino del Santuario di Firenze* n.n. (1963): 3–5.

Taucci 1976
Taucci, Raffaele. *Un Santuario e la città.* Florence, 1976.

Tayler-Mitchell 1994
Tayler-Mitchell, Laurie. "A Florentine Source for Verrocchio's Figure of St. Thomas at Orsanmichele." *Zeitschrift für Kunstgeschichte* 57 (1994): 600–609.

TCI Umbria 1978
Guida d'Italia del Touring Club Italiano, Umbria. Milan, 1978.

Thieme-Becker 1907–50
Thieme, Ulrich, and Felix Becker, eds. *Allgemeines Lexikon der bildenden Künstler von Fachgelehrten des In- und Auslandes.* 37 vols. Leipzig, 1907–50.

Toesca 1951
Toesca, Pietro. *Il Trecento*. Turin, 1951.

Torritti 1980
Torriti, Piero. *La Pinacoteca Nazionale di Siena: i dipinti dal XII allo XV secolo.* 2d rev. ed. Genoa, 1980.

Toscana 1980
La Toscana paese per paese. 4 vols. Florence, 1980.

Trachtenberg 1968
Trachtenberg, Marvin. "Donatello's First Work." In *Donatello* 1968, 361–67.

Trachtenberg 1971
Trachtenberg, Marvin. *The Campanile of the Florence Cathedral.* New York, 1971.

Trexler 1972
Trexler, Richard C. "Florentine Religious Experience: The Sacred Image." *Studies in the Renaissance* 19 (1972): 7–41.

Trexler 1973
Trexler, Richard C. "Ritual Behavior in Renaissance Florence: The Setting." *Medievalia et Humanistica* n.s. 4 (1973): 125–44.

Trexler 1980a
Trexler, Richard C. *Public Life in Renaissance Florence.* New York, 1980.

Trexler 1980b
Trexler, Richard C. "Florentine Theatre 1280–1500: A Checklist of Performances and Institutions." *Forum Italicum* 14 (3) (1980-A): 454–75.

Tschudi 1887
Tschudi, Hugo von. *Donatello e la critica moderna.* Turin, 1887.

Vaccarino 1950
Vaccarino, Paolo. *Nanni.* Florence, 1950.

Valentiner 1935
Valentiner, Wilhelm R. *Tino di Camaino: A Sienese Sculptor of the Fourteenth Century.* Paris, 1935.

Valentiner 1940
Valentiner, Wilhelm R. "Donatello and Ghiberti." *Art Quarterly* 3 (1940): 182–215.

Valentiner 1949
Valentiner, Wilhelm R. "Donatello or Nanni di Banco?" *La Critica d'arte* 8 (1949): 25–31.

Vasari-Milanesi
Vasari, Giorgio. *Le Vite de' più eccellenti pittori scultori ed architettori.* 4 vols. Ed. Gaetano Milanesi. Florence, 1878.

Vasari-Ricci
Vasari, Giorgio. *Le Vite del Vasari nell'edizione del MDL.* 4 vols. Ed. Corrado Ricci. Milan and Rome, n.d.

Vayer 1962
Vayer, Lajos. "L'imagine pietatis di Lorenzo Ghiberti." *Acta Historium Artium* 8 (1962): 45–53.

Venturi 1906–8
Venturi, Adolfo. *Storia dell'arte italiana.* Vols. 3–6. Milan, 1906–8.

Verdier 1980
Verdier, Philippe. *La Couronnment de la Vierge.* Montreal, 1980.

Verdon 1990
Verdon, Timothy. "'Effetti speciali' nello spettacolo e nell'arte quattrocentesca." *Biblioteca Teatrale* 19–20 (1990): 8–20.

Verdon 1995
Verdon, Timothy. "Spiritualità e arti figurativi." In Acidini-Luchinat 1995a, 19–30.

Verdon 1996
Verdon, Timothy, ed. *Alla Riscoperta di Piazza del Duomo in Firenze.* Vol. 5, *La Facciata di Santa Maria del Fiore.* Florence, 1996.

Vienna 1962
Europäische Kunst um 1400. Exh. cat. Vienna: Kunsthistorisches Museum, 1962.

Villani 1844–45
Villani, Giovanni. *Cronica.* 4 vols. Ed. Francesco Gherardi Dragomanni. Florence, 1844–45.

Villani 1825–26
Villani, Matteo. *Cronica.* 6 vols. Ed. Ignazio Moutier. Florence, 1825–26.

Villani 1857
Chroniche di Giovanni, Matteo, e Filippo Villani. Ed. Fr. A. Racheli. 2 vols. Trieste, 1857.

Villette 1964
Villette, Pierre. "Eligio." In *Biblioteca Sanctorum* 4: cols. 1064–69. Rome, 1964–68.

Vita prodigiosa 1767
Vita prodigiosa di S. Eligio. Pisa, 1767.

Vitry 1922
Vitry, Paul. *Catalogue des sculptures du Moyen Age, de la Renaissance, et des Temps Modernes. Paris, Musèe National du Louvre.* Paris: Musées Nationaux, 1922.

Voragine 1924
Jacopo da Voragine. *Leggenda Aurea: Volgarizzamento Toscano del Trecento.* 3 vols. Ed. Arrigo Levasti. Florence, 1924.

Wackernagel 1981
Wackernagel, Martin. *The World of the Florentine Renaissance Artist: Projects and Patrons, Workshop and Art Market.* German ed. 1938. Trans. Alison Luchs. Princeton, 1981.

Warren 1973
Warren, Charles W. "Brunelleschi's Dome and Dufay's Motet." *The Musical Quarterly* 59 (1973): 92–104.

Wasserman 1988
Wasserman, Jack. "Observations on Two Statues in the Museo del l'Opera del Duomo and the Porta della Mandorla in Florence." *Artibus et historiae* 17 (1988): 149–65.

Watkins 1978
Watkins, Renée. *Humanism and Liberty: Writings on Freedom from Fifteenth-Century Florence.* Columbia, S.C., 1978.

Watson 1928
Watson, Arthur. "The *Speculum Virginum* with Special Reference to the Tree of Jesse." *Speculum* 3 (1928): 445–69.

Watson 1974
Watson, Paul F. "The Queen of Sheba in Christian Tradition." In *Solomon and Sheba*, ed. James Pritchard, 115–45. London and New York, 1974.

Wehle 1947
Wehle, Harry B., and Margaretta Salinger. *The Metropolitan Museum of Art: A Catalogue of Early Flemish, Dutch, and German Paintings.* New York: Metropolitan Museum of Art, 1947.

Weigelt 1930
Weigelt, Curt. *Sienese Painting.* Florence, 1930.

Weinberger 1941
Weinberger, Martin. "The First Facade of the Cathedral of Florence." *Journal of the Warburg and Courtauld Institutes* 4 (1941): 67–79.

Weinstein 1968
Weinstein, Donald. "The Myth of Florence." In Rubinstein 1968, 15–44.

Weise 1953
Weise, Georg. *Renaissance und Antike.* Tübingen, 1953.

Weiss 1969
Weiss, Roberto. *The Renaissance Discovery of Classical Antiquity.* Oxford, 1969.

White 1966
White, John. *Art and Architecture in Italy 1250–1400.* Baltimore, 1966.

White 1989
White, John. "Personality, Text, and Meaning in Donatello's Single Figures." In Cämmerer 1989, 170–82.

Wilkins 1983
Wilkins, David. "Donatello's Lost Dovizia for the Mercato Vecchio: Wealth and Charity as Florentine Civic Virtues." *Art Bulletin* 65 (1983): 401–23.

Wilson 1942
Wilson, Lillian M. *The Roman Toga.* Baltimore, 1942.

Witt 1983
Witt, Ronald. *Hercules at the Crossroads: The Life, Works, and Thought of Coluccio Salutati.* Durham, N.C., 1982.

Witt 1994
Witt, Ronald. Review of Hessert 1991. *Renaissance Quarterly* 47 (Spring 1994): 177–78.

Wittkower 1949
Wittkower, Rudolf. *Architectural Principles in the Age of Humanism.* London, 1949.

Wohl 1991
Wohl, Helmut. Review of Cämmerer 1989. *Art Bulletin* 73 (1991): 315–23.

Wood Brown 1902
Wood Brown, James. *The Dominican Church of Santa Maria Novella.* Edinburgh, 1902.

Wright 1994
Wright, Craig. "Dufay's *Nuper Rosarum Flores*: King Solomon's Temple and the Veneration of the Virgin." *Journal of the American Musicological Society* 47 (Fall 1994): 395–441.

Wulff 1909
Wulff, Oskar. "Nanni d'Antonio di Banco und sein Verhaltnis zu Donatello." *Sitzungsberichte, Kunstgeschichtliche Gesellschaft* 5 (1909): 27–29.

Wulff 1911
Wulff, Oskar. *Altchristliche und mittelalterliche Bildwerke: Königlich Museen zu Berlin.* 2d ed. Berlin, 1911.

Wulff 1913
Wulff, Oskar. "Giovanni d'Antonio di Banco und die Anfänge der Renaissanceplastik in Florenz zur Davidstatue des Kaiser Friedrich Museums." *Jahrbuch der Preussischen Kunstsammlungen* 34 (1913): 99–164.

Wulff 1932
Wulff, Oskar. *Donatello.* Leipzig, 1932.

Wundram 1959
Wundram, Manfred. "Donatello und Ciuffagni." *Zeitschrift für Kunstgeschichte* 22 (1959): 85–101.

Wundram 1960a
Wundram, Manfred. "Albizzo di Piero." In *Das Werk des Kunstlers: Studien zur Ikonographie und Formesgeschichte. Hubert Schrade zum 60. Geburtstag,* ed. Hans Fegers, 161–76. Stuttgart, 1960.

Wundram 1960b
Wundram, Manfred. "Der Meister der Verkündigung in der Domopera zu Florenz." In *Beitrage zur Kunstgeschichte: Festgabe für H. R. Roseman,* ed. Ernst Guldan, 109–25. Munich, 1960.

Wundram 1961
Wundram, Manfred. "Antonio di Banco." *Mitteilungen des Kunsthistorischen Institutes in Florenz* 10 (1961): 23–32.

Wundram 1962
Wundram, Manfred. "Niccolò di Pietro Lamberti und die Florentiner Plastik um 1400." *Jahrbuch der Berliner Museen* 4 (1962): 79–115.

Wundram 1965
Wundram, Manfred. "Jacopo della Quercia und das Relief der Gurtelspande über der Porta della Mandorla." *Zeitschrift für Kunstgeschichte* 28 (1965): 121–29.

Wundram 1967
Wundram, Manfred. "Der heilige Jacobus an Orsanmichele in Florenz." In *Festschrift Karl Oettinger*, ed. Hans Sedlmayer and Wilhelm Messerer, 193–207. Erlangen, 1967.

Wundram 1968a
Wundram, Manfred. "Jacopo di Piero Guidi." *Mitteilungen des Kunsthistorischen Institutes in Florenz* 13 (1968): 195–222.

Wundram 1968b
Wundram, Manfred. "Donatello und Nanni di Banco negli anni 1408–09." In *Donatello 1968*, 69–75.

Wundram 1969
Wundram, Manfred. *Donatello und Nanni di Banco*. Berlin, 1969.

Zervas 1979
Zervas, Diane F. "Filippo Brunelleschi's Political Career." *Burlington Magazine* 121 (1979): 630–38.

Zervas 1989
Zervas, Diane F. *Brunelleschi, Donatello, and the Parte Guelfa*. Locust Valley, 1989.

Zervas 1991
Zervas, Diane F. "Lorenzo Monaco, Lorenzo Ghiberti, and Orsanmichele." *Burlington Magazine* 133 (1991): 748–59, 812–19.

Zervas 1993
Zervas, Diane F. "The Building and Decoration of Orsanmichele before Verrocchio." In *Verrocchio's Christ and St. Thomas: A Masterpiece of Sculpture from Renaissance Florence*, ed. Loretta Dolcini, 39–51. Exh. cat. New York: Metropolitan Museum of Art, 1993.

Zervas 1996a
Zervas, Diane F. *Orsanmichele*. 2 vols. Florence, 1996.

Zervas 1996b
Zervas, Diane F. *Orsanmichele Documents 1336–1452*. Ferrara, 1996.

Zimmer 1982
Zimmer, Gerhard. *Römische Berufdarstellungen*. Berlin, 1982.

Index

Works by and attributed to Nanni di Banco are listed individually by title; for those works, catalogue entry pages are given *in italics*. References to Roman sculpture include Roman copies after Greek originals.

Photography Credits

Alinari
Figs. 1, 2, 3, 6, 8, 9, 10, 12, 13, 14, 15, 19, 20, 22, 23, 26, 27, 28, 29, 30, 31, 32, 33, 35, 39, 41, 43, 53, 55, 58, 60, 61, 64, 65, 66, 67, 68, 69, 70, 71, 72, 73, 75, 76, 77, 78, 80, 82, 83, 84, 86, 87, 88, 91, 93, 94, 95, 96, 105, 106, 107, 108, 113, 114, 120, 122, 123, 125, 126, 127, 128, 129; cats. 1-1, 1-2, 1-4, 1-6, 1-10, 11-4, 11-7, 11-9, 11-10, 11-12, 11-14

Mary Bergstein
Figs. 7, 50; cat. 1-11

Deutsches Archäologisches Institut, Rome
Figs. 17, 21, 40, 42, 44, 45, 49, 119

Gabinetto Fotografico, Soprintendenza per i Beni Artistici e Storici, Florence
Figs. 34, 47, 56, 57, 59, 62, 63, 74, 81, 85, 92, 98, 101, 110, 115, 124; cats. 1-7, 11-8

Galli
Cat. 11-13

Kunsthistorisches Institut, Florence
Figs. 4, 16, 18, 25, 36, 48, 52, 89, 117, 130; cats. 1-3A, 1-3B, 1-9, 11-3, 11-5A, 11-5B, 11-6A, 11-6B

Laurati
Fig. 90

Ralph Lieberman
Figs. 5, 8, 11, 51, 54, 97, 99, 100, 102, 103, 111, 116; cats. 1-5, 1-12

The Metropolitan Museum of Art, New York
Fig. 79

Musée du Petit Palais, Avignon
Fig. 121

Musées Nationaux de la Réunion, Paris
Figs. 37, 38

Museum of Fine Arts, Boston
Cat. 11-1

Neri-Lusanna
Cat. 11-2

Opificio delle Pietre Dure, Florence
Figs. 24, 112, 118

Philadelphia Museum of Art
Fig. 104

Scarpa
Cat. 11-15

Sframeli
Fig. 109; cats. 1-8, 11-11

Soprintendenza Archeologica dell'Etruria, Florence
Fig. 46